Digital Photography

FOR

DUMMIES®

5TH EDITION

Digital Photography

FOR

DUMMIES®

5TH EDITION

by Julie Adair King

WILEY

Wiley Publishing, Inc.

Digital Photography For Dummies,® 5th Edition
Published by
Wiley Publishing, Inc.
111 River Street
Hoboken, NJ 07030-5774
www.wiley.com

WILEY

About the Author

Julie Adair King is the author of many books about digital photography and imaging. Her most recent titles include *Shoot Like a Pro!: Digital Photography Techniques, Julie King's Everyday Photoshop for Photographers,* and *Julie King's Everyday Photoshop Elements.* Other works include *Photo Retouching & Restoration For Dummies, Adobe PhotoDeluxe For Dummies, Adobe PhotoDeluxe 4.0 For Dummies,* and *Microsoft PhotoDraw 2000 For Dummies.* A graduate of Purdue University, King resides in Indianapolis, Indiana.

Dedication

This book is dedicated to my family (you know who you are). Thank you for putting up with me, even on my looniest days. A special thanks to the young'uns, Kristen, Matt, Adam, Brandon, and Laura, for brightening my world with your smiles and hugs.

Author's Acknowledgments

Many, many thanks to all those people who provided me with the information and support necessary to create this book. I especially want to express my appreciation to the following companies for arranging product loans and providing technical guidance:

Adobe Systems Inc.
Canon USA, Inc.
Cloud Dome, Inc.
Concord Camera Corp.
Eastman Kodak Company
Fujifilm U.S.A., Inc.
HP
Konica Minolta Photo Imaging, Inc.
Nikon Inc.
Olympus Imaging America Inc.
SanDisk
Sanyo Electric Corp., Ltd.
Seiko Epson Corporation
Wacom Technology

I also want to express my appreciation to my astute and extremely helpful technical editor, Alfred DeBat; to project editor Kim Darosett; to copy editor Rebecca Senninger; and to the entire Wiley Publishing production team. Finally, thanks to Steve Hayes and Diane Steele for presenting me with the opportunity to be involved in this project.

Publisher's Acknowledgments

We're proud of this book; please send us your comments through our online registration form located at www.dummies.com/register/.

Some of the people who helped bring this book to market include the following:

Acquisitions, Editorial, and Media Development

Project Editor: Kim Darosett

Senior Acquisitions Editor: Steven Hayes

Copy Editor: Rebecca Senninger

Technical Editor: Alfred DeBat

Editorial Manager: Leah Cameron

Editorial Assistant: Amanda Foxworth

Cartoons: Rich Tennant www.the5thwave.com

Composition Services

Project Coordinator: Maridee Ennis

Layout and Graphics: Lauren Goddard, Lynsey Osborn, Melanee Prendergast, Heather Ryan, Ron Terry

Proofreaders: Leeann Harney, Betty Kish, Joe Niesen

Indexer: Rebecca R. Plunkett

Publishing and Editorial for Technology Dummies

Richard Swadley, Vice President and Executive Group Publisher

Andy Cummings, Vice President and Publisher

Mary Bednarek, Executive Acquisitions Director

Mary C. Corder, Editorial Director

Publishing for Consumer Dummies

Diane Graves Steele, Vice President and Publisher

Joyce Pepple, Acquisitions Director

Composition Services

Gerry Fahey, Vice President of Production Services

Debbie Stailey, Director of Composition Services

Contents at a Glance

Introduction ... *1*

Part 1: Peering through the Digital Viewfinder *9*

Chapter 1: Filmless Fun, Facts, and Fiction...11

Chapter 2: Mr. Science Explains It All ...25

Chapter 3: In Search of the Perfect Camera ..49

Chapter 4: Extra Goodies for Extra Fun...77

Part II: Ready, Set, Shoot!*97*

Chapter 5: Choosing the Right Camera Settings ...99

Chapter 6: Controlling Exposure and Focus ...117

Chapter 7: Take Your Best Shot ..143

Part III: From Camera to Computer and Beyond*159*

Chapter 8: Building Your Image Warehouse..161

Chapter 9: Can I Get a Hard Copy, Please?...181

Chapter 10: On-Screen, Mr. Sulu! ...209

Part IV: Tricks of the Digital Trade*229*

Chapter 11: Making Your Image Look Presentable..231

Chapter 12: Cut, Paste, and Cover Up..267

Chapter 13: Amazing Stuff Even You Can Do ...295

Part V: The Part of Tens*329*

Chapter 14: Ten Ways to Improve Your Digital Images...................................331

Chapter 15: Ten Great Uses for Digital Images ...339

Chapter 16: Ten Great Online Resources for Digital Photographers349

Glossary ..*355*

Index ...*363*

Table of Contents

Introduction ... *1*

Why a Book for Dummies? ...2
What's in This Book? ..2
 Part I: Peering through the Digital Viewfinder3
 Part II: Ready, Set, Shoot! ...3
 Part III: From Camera to Computer and Beyond4
 Part IV: Tricks of the Digital Trade4
 Part V: The Part of Tens ...4
 Glossary ..5
 Online extras ...5
Icons Used in This Book ...5
Conventions Used in This Book ...6
What Do I Read First? ..6

Part 1: Peering through the Digital Viewfinder*9*

Chapter 1: Filmless Fun, Facts, and Fiction11

Film? We Don't Need No Stinkin' Film!12
Fine, but Why Do I Want Digital Images?13
But Can't I Do All This with a Scanner?19
Now Tell Me the Downside ..20
Just Tell Me Where to Send the Check.21
 Cameras ...22
 Memory cards ..22
 Hardware, software, and other accessories23

Chapter 2: Mr. Science Explains It All25

From Your Eyes to the Camera's Memory26
The Secret to Living Color ...27
Resolution Rules ..29
 Pixels: Building blocks of digital photos29
 Pixels and print quality ..31
 Pixels and screen images ...33
 Pixels and file size ..34
 How many pixels are enough?36
 Can't I add pixels later? ...36
 More mind-boggling resolution stuff38
 What all this resolution stuff means to you39

Lights, Camera, Exposure!..40
 Aperture, f-stops, and shutter speeds:
 The traditional way ..40
 Aperture, shutter speed, and f-stops: The digital way43
 ISO ratings and chip sensitivity...................................43
RGB, CMYK, and Other Colorful Acronyms............................45

Chapter 3: In Search of the Perfect Camera**49**

Mac or Windows — Does It Matter? ..50
Picture Quality Options..50
 You say you want a resolution....................................51
 File format flexibility ..53
Memory Matters..56
Monitor, Viewfinder, or Both?...58
SLR or Point-and-Shoot?...60
Hybrid Cameras ..62
Flash Fundamentals ..63
Through a Lens, Clearly ..64
 Fun facts about focal length....................................64
 Optical versus digital zoom67
 Focusing aids ..67
 Lens adaptability..68
Exposure Exposed...68
Still More Features to Consider...71
 Now playing, on your big-screen TV71
 Self-timer and remote control..................................72
 There's a computer in that camera!.............................72
 Action-oriented options..73
 Little things that mean a lot74
Sources for More Shopping Guidance76

Chapter 4: Extra Goodies for Extra Fun**77**

Memory Cards and Other Camera Media78
 Memory shopping tips..79
 Care and feeding of memory cards80
Download Devices...81
Storing Your Picture Files...83
On-the-Go Storage and Viewing..86
Software Solution ..87
 Image-editing software...87
 Specialty software ..91
Camera Accessories...93
Mouse Replacement Therapy: The Drawing Tablet........................95

Part II: Ready, Set, Shoot! ..97

Chapter 5: Choosing the Right Camera Settings99
Getting Started: Basic Camera Settings....................................100
Selecting a File Format ..102
 JPEG ..102
 TIFF ...106
 Camera Raw ..106
Setting the Pixel Count (Resolution) ..108
Balancing Your Whites and Colors ...111
Tweaking Picture "Processing"...114

Chapter 6: Controlling Exposure and Focus117
Setting Light Sensitivity: ISO...118
Automatic Exposure: Making It Work120
 Choosing an autoexposure metering mode121
 Going semi-automatic ..123
 Applying exposure compensation (EV)............................125
Taking Flash Photos..128
 Fill flash (or force flash) ...128
 No flash ...129
 Flash with red-eye reduction ..129
 Slow sync flash ..130
 External flash ...130
Switching on Additional Lights ..131
Lighting Shiny Objects...133
Compensating for Backlighting ...134
Focus on Focus...136
 Working with fixed-focus cameras136
 Taking advantage of autofocus ..137
 Focusing manually..139
Shifting Depth of Field ..139
Taking Advantage of Scene Modes..140

Chapter 7: Take Your Best Shot143
Composition 101..143
A Parallax! A Parallax!...146
Composing for Compositing ...147
Zooming In without Losing Out...149
 Shooting with an optical (real) zoom149
 Using a digital zoom ..151
Catching a Moving Target ..151
Shooting Pieces of a Panoramic Quilt154
Avoiding the Digital Measles...157

Part III: From Camera to Computer and Beyond159

Chapter 8: Building Your Image Warehouse161
Downloading Your Images..162
A trio of downloading options ...162
Using a card reader or adapter...164
Cable transfer how-tos..166
Take the bullet TWAIN ...169
Camera as hard drive...170
Tips for trouble-free downloads ...170
Translating Camera Raw Files ...173
Converting Proprietary Camera Files ..176
Photo Organization Tools ..176

Chapter 9: Can I Get a Hard Copy, Please?181
Fast and Easy: Prints from a Lab ..182
Buying a Photo Printer ...184
Inkjet printers ..185
Laser printers ...186
Dye-sub (thermal dye) printers ...187
Thermo-Autochrome printers ..188
How Long Will They Last?..189
So Which Printer Should You Buy?..191
Comparison Shopping ..192
Does the Paper Really Matter? ..197
Setting Print Size and Resolution ...198
Sending Your Image to the Dance ..201
Getting better results from your printer202
These colors don't match!..203
Preparing a TIFF Copy for Publication205

Chapter 10: On-Screen, Mr. Sulu!209
Step into the Screening Room ..209
That's About the Size of It..213
Understanding monitor resolution and picture size..........213
Sizing images for the screen ..215
Sizing screen images in inches ...217
Nothing but Net: Photos on the Web..218
Basic rules for Web pictures ...218
JPEG: The photographer's friend ..221
Drop Me a Picture Sometime, Won't You?.................................224
Viewing Your Photos on a TV ...226

Part IV: Tricks of the Digital Trade229

Chapter 11: Making Your Image Look Presentable231

What Software Do You Need? ...232
Opening Your Photos...234
Editing Rules for All Seasons ..237
 Save now! Save often!..237
 Editing safety nets ..240
Straightening a Tilting Horizon ...242
Cream of the Crop ..244
Fixing Exposure and Contrast ...248
 Basic brightness/contrast controls...............................248
 Brightness adjustments at higher Levels251
 Using the Shadows/Highlights filter.............................253
Give Your Colors More Oomph ..255
Help for Unbalanced Colors...257
Focus Adjustments (Sharpen and Blur)259
 Applying sharpening filters...260
 Blur to sharpen? ..262
Out, Out, Darned Spots!..263

Chapter 12: Cut, Paste, and Cover Up267

Why (And When) Do I Select Stuff?..268
 What selection tools should I use?269
 Working with Elements tools ..270
 Brushing on a selection outline.....................................280
 Selecting (and deselecting) everything..........................281
 Reversing a selection outline..282
 Refining your selection outline.....................................283
Selection Moves, Copies, and Pastes.....................................285
 Cut, Copy, Paste: The old reliables286
 Adjusting a pasted object...287
Deleting Selected Areas..289
Pasting Good Pixels Over Bad ...289
Enlarging the Image Canvas...293

Chapter 13: Amazing Stuff Even You Can Do295

Giving Your Image a Paint Job ...296
 What's in your paint box?...297
 Setting the paint color ...299
 Exploring Brush and Pencil options303
 Painting away red-eye..306
 Painting large areas..309

Smudging Paint..312
Spinning Pixels around the Color Wheel......................314
Creating a Tinted or Grayscale Photo315
Uncovering Layers of Possibility317
 Working with Elements layers321
 Building a multilayered collage326
Turning Garbage into Art ..327

Part V: The Part of Tens329

Chapter 14: Ten Ways to Improve Your Digital Images331

Remember the Resolution!...332
Don't Overcompress Your Images333
Look for the Unexpected Angle......................................333
Turn Down the Noise..334
Press the Shutter Button Correctly334
Turn Off Digital Zoom ...335
Take Advantage of Your Photo Editor335
Print Your Images on Good Paper.................................335
Practice, Practice, Practice!..336
Read the Manual (Gasp!)..336

Chapter 15: Ten Great Uses for Digital Images339

Creating Online Photo Albums......................................339
Putting Together a Screen Saver340
Hanging Photo Wallpaper...343
Giving Photos an Artistic Twist....................................345
Putting Your Mug on a Mug ...346
Printing Photo Calendars and Cards346
Including Visual Information in Databases347
Putting a Name with the Face347
Exchanging a Picture for a Thousand Words...............347
Hanging a Masterpiece on Your Wall348

Chapter 16: Ten Great Online Resources
for Digital Photographers349

Digital Photography Review ..350
Imaging Resource ...350
Megapixel.net..350
PCPhoto Magazine ..351
PCPhotoREVIEW.com...351
Shutterbug ..351

Digital Photography Newsgroup ..351
Printing Newsgroup ...352
Manufacturer Web Sites ...352
This Book's Companion Site ..353

Glossary ...*355*

Index ...*363*

Introduction

*I*n the 1840s, William Henry Fox Talbot combined light, paper, a few chemicals, and a wooden box to produce a photographic print, laying the foundation for modern film photography. Over the years, the process that Talbot introduced was refined, and people everywhere discovered the joy of photography. They started trading pictures of horses and babies. They began displaying their handiwork on desks, mantels, and walls. And they finally figured out what to do with those little plastic sleeves inside their wallets.

Today, more than 160 years after Talbot's discovery, we've entered a new photographic age. The era of the digital camera has arrived, and with it comes a new and exciting way of thinking about photography. In fact, the advent of digital photography has spawned an entirely new art form — one so compelling that major museums now host exhibitions featuring the work of digital photographers.

With a digital camera, a computer, and some photo-editing software, you can explore unlimited creative opportunities. Even if you have minimal computer experience, you can easily bend and shape the image that comes out of your camera to suit your personal artistic vision. You can combine several pictures into a photographic collage, for example, and create special effects that are either impossible or difficult to achieve with film. You also can do your own photo retouching, handling tasks that once required a professional studio, such as cropping away excess background or sharpening focus.

More important, digital cameras make taking great pictures easier. Because digital cameras have a monitor on which you can instantly review your shots, you can see right away whether you have a keeper or need to try again. No more picking up a packet of prints at the photo lab and discovering that you didn't get a single good picture of that first birthday party, or that incredible ocean sunset, or whatever it was that you wanted to capture.

Digital photography also enables you to share visual information with people around the world instantaneously. Literally minutes after snapping a digital picture, you can put the photo in the hands of friends, colleagues, or strangers across the globe by attaching it to an e-mail message or posting it on the World Wide Web.

Blending the art of photography with the science of the computer age, digital cameras serve as both an outlet for creative expression and a serious communication tool. Just as important, digital cameras are *fun*. When was the last time you could say *that* about a piece of computer equipment?

Why a Book for Dummies?

Digital cameras have been around for several years, but at a price tag that few people could afford. Now, entry-level cameras sell for less than $100, which moves the technology out of the realm of exotic toy and into the hands of ordinary mortals like you and me. Which brings me to the point of this book (finally, you say).

Like any new technology, digital cameras can be a bit intimidating. Browse the digital camera aisle in your favorite store, and you come face to face with a slew of technical terms and acronyms — *CCD, megapixel, JPEG,* and the like. These high-tech buzzwords may make perfect sense to the high-tech folks who have been using digital cameras for a while. However, if you're an average consumer, hearing a camera salesperson utter a phrase like, "This model has a 6-megapixel CCD and can store 280 images on a 256MB CompactFlash card using maximum JPEG compression," is enough to make you run screaming back to the film counter.

Don't. Instead, arm yourself with *Digital Photography For Dummies,* 5th Edition. This book explains everything you need to know to become a successful digital photographer. And you don't need to be a computer or photography geek to understand what's going on. *Digital Photography For Dummies* speaks your language — plain English, that is — with a dash of humor thrown in to make things more enjoyable.

What's in This Book?

Digital Photography For Dummies covers all aspects of digital photography, from figuring out which camera you should buy to preparing your images for printing or for publishing on the Web.

Part of the book provides information that can help you select the right digital photography equipment and photo software. Other chapters focus on helping you use your camera to its best advantage. In addition, this book shows you how to perform certain photo-editing tasks, such as adjusting image brightness and contrast and creating photographic collages.

For some photo-editing techniques, I provide specific instructions for doing the job in a popular photo-editing program, Adobe Photoshop Elements 3.0. However, if you use another program (or another version of Elements), don't think that this book isn't for you. The basic editing tools that I discuss function similarly from program to program, and the general approach to editing is the same no matter what program you use. So you can refer to this book for the solid foundation you need to understand different editing functions and then easily adapt the specific steps to your own photo software.

Although this book is designed for beginning- and intermediate-level digital photographers, I do assume that you have a little bit of computer knowledge. For example, you should understand how to start programs, open and close files, and get around in the Windows or Macintosh environment, depending on which type of system you use. If you're brand-new to computers as well as to digital photography, you may want to get a copy of the appropriate *For Dummies* title for your operating system as an additional reference.

As a special note to my Macintosh friends, I want to emphasize that although most of the figures in this book were created on a Windows-based computer, this book is for Mac as well as Windows users. Whenever applicable, I provide instructions for both Macintosh and Windows systems.

Now that I've firmly established myself as neutral in the computer platform wars, here's a brief summary of the kind of information you can find in *Digital Photography For Dummies.*

Part 1: Peering through the Digital Viewfinder

This part of the book gets you started on your digital photography adventure. The first two chapters help you understand what digital cameras can and can't do and how they perform their photographic magic. Chapter 3 helps you track down the best camera for the type of pictures you want to take, while Chapter 4 introduces you to some of the camera add-ons and other accessories that make digital photography better, easier, or just more fun.

Part 11: Ready, Set, Shoot!

Are you photographically challenged? Are your pictures too dark, too light, too blurry, or just plain boring? Before you fling your camera across the room in frustration, check out this part of the book.

Chapter 5 gets you started, explaining which camera settings work best and walking you through the process of taking your first pictures. Chapter 6 reveals the secret to capturing well-exposed, perfectly focused photographs, and Chapter 7 presents tips to help you create more powerful, more exciting images. In addition, this part of the book shows you how to capture a series of photographs that you can stitch together into a panorama, how to deal with difficult lighting situations, and how to take advantage of the latest camera features, such as automatic shooting modes that make it easy for anyone to be a better photographer.

Part III: From Camera to Computer and Beyond

After you fill up your camera with photos, you need to get them off the camera and out into the world. Chapters in this part of the book show you how to do just that.

Chapter 8 explains the process of transferring pictures to your computer and also discusses ways to organize all those images. Chapter 9 gives you a thorough review of your printing options, including information about different types of photo printers. And Chapter 10 looks at ways to display and distribute images electronically — placing them on Web pages and attaching them to e-mail messages, for example.

Part IV: Tricks of the Digital Trade

In this part of the book, you get an introduction to photo editing. Chapter 11 discusses simple fixes for problem pictures. Of course, after reading the shooting tips in Part II, you shouldn't wind up with many bad photos. But for the occasional stinker, Chapter 11 comes to the rescue by showing you how to adjust exposure, sharpen focus, and crop away unwanted portions of the image.

Chapter 12 explains how to select a portion of your picture and then copy and paste the selection into another image. You also find out how to cover up flaws and unwanted photo elements. Chapter 13 presents some more-advanced tricks, including painting on your image, building photo collages, and applying special effects.

Keep in mind that coverage of photo editing in this book is intended just to spark your creative appetite and give you a solid background for exploring your photo software. If you want more details about using your software, you can find excellent *For Dummies* books about many photo-editing programs. In addition, one of my other books, *Photo Retouching and Restoration For Dummies,* may be of interest to photographers who want in-depth information about digital photo retouching.

Part V: The Part of Tens

Information in this part of the book is presented in easily digestible, bite-sized nuggets. Chapter 14 contains the top ten ways to improve your digital photographs; Chapter 15 offers ten ideas for using digital images; and Chapter 16 lists ten great online resources for times when you need help sorting out a technical problem or just want some creative inspiration. In other words, Part V is perfect for the reader who wants a quick, yet filling, mental snack.

Glossary

As you probably have already discovered, the digital photography world is very fond of jargon. I explain all the terms and acronyms you need to know throughout the book, but if you need a quick reminder of what a certain word means, head for the glossary at the back of the book, where you can find quick translations from geek-speak to everyday language.

Online extras

Throughout this book, I introduce you to lots of software that can make your digital photography life simpler and more enjoyable. In many cases, you can try out the featured programs for free by simply downloading trial or demo versions from the software vendor's Web site.

To make it easy for you to access this try-before-you-buy software, I've put together a Web page that contains links to the vendor sites. Just point your Web browser to the following address:

www.dummies.com/go/digitalphotofd5e

The Web page also includes low-resolution versions of some of the pictures used in this book. You may find it helpful to use these sample images as you try out the various projects featured throughout the book.

Icons Used in This Book

Like other books in the *For Dummies* series, this book uses icons to flag especially important information. Here's a quick guide to the icons used in *Digital Photography For Dummies*.

As mentioned earlier, I sometimes provide steps for accomplishing a photo-editing goal using Adobe Photoshop Elements 3.0. The Elements How To icon marks information specifically related to that program. But if you're using another program, you can adapt the general editing approach to your own software, so don't ignore paragraphs marked with the Elements How To icon.

This icon marks stuff that you should commit to memory. Doing so can make your life easier and less stressful.

Text marked with this icon breaks technical gobbledygook down into plain English. In many cases, you really don't need to know this stuff, but boy, will you sound impressive if you do.

The Tip icon points you to shortcuts that help you avoid doing more work than necessary. This icon also highlights ideas for creating better pictures and working around common digital photography problems.

When you see this icon, pay attention — danger is on the horizon. Read the text next to a Warning icon to keep yourself out of trouble and to find out how to fix things if you leaped before you looked.

Conventions Used in This Book

In addition to icons, *Digital Photography For Dummies* follows a few other conventions. When I want you to choose a command from a menu, you see the menu name, an arrow, and then the command name. For example, if I want you to choose the Cut command from the Edit menu, I write it this way: "Choose Edit⇨Cut."

Sometimes, you can choose a command more quickly by pressing two or more keys on your keyboard than by clicking your way through menus. I present these keyboard shortcuts like so: "Press Ctrl+A," which simply means to press and hold the Ctrl key, press the A key, and then let up on both keys. Usually, I provide the PC shortcut first, followed by the Mac shortcut, if it's different.

What Do I Read First?

The answer depends on you. You can start with Chapter 1 and read straight through to the Index, if you like. Or you can flip to whatever section of the book interests you most and start there.

Digital Photography For Dummies is designed so that you can grasp the content in any chapter without having to read all chapters that came before. So if you need information on a particular topic, you can get in and out as quickly as possible.

The one thing this book isn't designed to do, however, is to insert its contents magically into your head. You can't just put the book on your desk or under your pillow and expect to acquire the information inside by osmosis — you have to put eyes to page and do some actual reading.

With our hectic lives, finding the time and energy to read is always easier said than done. But I promise that if you spend just a few minutes a day with this book, you can increase your digital photography skills tenfold. Heck, maybe even elevenfold or twelvefold. Suffice it to say that you'll discover a whole new way to communicate, whether you're shooting for business, for pleasure, or for both.

The digital camera is the new Big Thing. And with *Digital Photography For Dummies,* you get the information you need in order to take advantage of this powerful new tool — quickly, easily, and with a few laughs along the way.

Part I

Peering through the
Digital Viewfinder

The 5th Wave By Rich Tennant

"If I'm not gaining weight, then why does
this digital image take up 3 MB more
memory than a comparable one taken
six months ago?"

In this part . . .

When I was in high school, the science teachers insisted that the only way to learn about different creatures was to cut them open and poke about their innards. In my opinion, dissecting dead things never accomplished anything other than giving the boys a chance to gross out the girls by pretending to swallow formaldehyde-laced body parts.

But even though I'm firmly against dissecting our fellow earthly beings, I am wholly in favor of dissecting new technology. It's my experience that if you want to make a machine work for you, you have to know what makes that machine tick. Only then can you fully exploit its capabilities.

To that end, this part of the book dissects the machine known as the digital camera. Chapter 1 looks at some of the pros and cons of digital photography, while Chapter 2 pries open the lid of a digital camera so that you can get a better understanding of how the thing performs its magic. Chapter 3 puts the magnifying glass to specific camera features, giving you the background you need to select the right camera for your photography needs. Chapter 4 provides the same kind of close inspection of camera accessories and digital imaging software.

All right, put on your goggles and prepare to dissect your digital specimens. And boys, no flinging camera parts around the room or sticking cables up your noses, okay? Hey, that means you, mister!

Filmless Fun, Facts, and Fiction

In This Chapter

▶ Understanding the differences between digital cameras and film cameras

▶ Discovering some great uses for digital cameras

▶ Comparing scanners and digital cameras

▶ Assessing the pros and cons of digital photography

▶ Calculating the impact on your wallet

1 love hanging out in computer stores. I'm not a major geek — not that there's anything *wrong* with that — I just enjoy seeing what new gadgets I may be able to justify as tax write-offs.

You can imagine my delight, then, when digital cameras began showing up on the store shelves at a price that even my meager budget could handle. Here was a device that not only offered time and energy savings for my business but, at the same time, was a really cool toy for entertaining friends, family, and any strangers I could corral on the street.

If you, too, have decided that the time is right to join the growing ranks of digital photographers, I'd like to offer a hearty "way to go!" — but also a little word of caution. Before you hand over your money, be sure that you understand how this new technology works — and don't rely on the salesperson in your local electronics or computer superstore to fill you in. From what I've observed, many salespeople don't fully understand digital photography. As a result, they may steer you toward a camera that may be perfect for someone else but doesn't meet your needs.

Nothing's worse than a new toy, er, *business investment* that doesn't live up to your expectations. Remember how you felt when the plastic action figure that flew around the room in the TV commercial just stood there doing nothing after you dug it out of the cereal box? To make sure that you don't experience

the same letdown with a digital camera, this chapter sorts out the facts from the fiction, explaining the pros and cons of digital imagery in general and digital cameras in particular.

Film? We Don't Need No Stinkin' Film!

As shown in Figure 1-1, digital cameras come in all shapes and sizes. (You can see additional cameras throughout the next several chapters.) But although designs and features differ from model to model, all digital cameras are created to accomplish the same goal: to simplify the process of creating digital images.

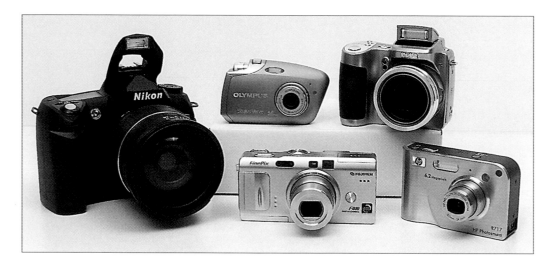

Figure 1-1: These models from Nikon, Olympus, Kodak, Fujifilm, and HP illustrate the variety of digital cameras.

When I speak of a *digital image,* I'm referring to a picture that you can view and edit on a computer. Digital images, like anything else you see on your computer screen, are nothing more than bits of electronic data. Your computer analyzes that data and displays the image on-screen. (For a detailed look at how digital images work, see Chapter 2.)

Digital images are nothing new — people have been creating and editing digital pictures using such programs as Adobe Photoshop for years. But until the advent of digital cameras, getting a stunning sunset scene or an endearing baby picture into digital form required some time and effort. After shooting

the picture with a film camera, you had to get the film developed and then have the photographic print or slide *digitized* (that is, converted to a computer image) using a piece of equipment known as a *scanner*. Assuming that you weren't well-off enough to have a darkroom and a scanner in the east wing of your mansion, this process could take several days and involve several middlemen and associated middleman costs.

Digital cameras provide an easier, more convenient option. While traditional cameras capture images on film, digital cameras record what they see using computer chips and digital storage devices, creating images that you can immediately access on your computer. No film, film processing, or scanning is involved — you press the shutter button, and voilà: You have a digital image. To use the image, you simply transfer it from your camera to the computer, which you can do in a variety of ways. With the latest digital cameras, you can send your pictures directly to a photo printer — you don't even need a computer!

Fine, but Why Do I Want Digital Images?

Going digital opens up a world of artistic and practical possibilities that you simply don't enjoy with film. Here are just a few advantages of working with digital images:

- **More creative control:** With traditional photos, you have no input into an image after it leaves your camera. Everything rests in the hands of the photofinisher. But with a digital photo, you can use your computer and photo-editing software to touch up and enhance your pictures.

 Figures 1-2 and 1-3 illustrate the point. Figure 1-2 shows an original digital photo that I shot while taking a walk with the three girls and their mothers. In addition to being slightly underexposed, the picture contains too much background, and the sidewalk at the top of the shot creates an unwanted distraction from the subjects. I opened the picture in my photo editor and took care of all these problems in a few minutes. You can see the much-improved picture in Figure 1-3.

 You could argue that I could have created the same image with a film camera by paying attention to the background, exposure, and framing before I took the picture. But sometimes, the situation doesn't allow that kind of preparation. Had I taken the time to make sure that everything was perfect before I pressed the shutter button, my opportunity to capture the interaction that was unfolding in front of me would have been long gone. And had I asked the girls to stop and wait for me to take their picture, they likely would have adopted a stiff pose that would be far less endearing than this candid moment. I'm not saying that you shouldn't strive to shoot the best pictures possible, but if something goes awry, you often can rescue marginal images in the editing stage.

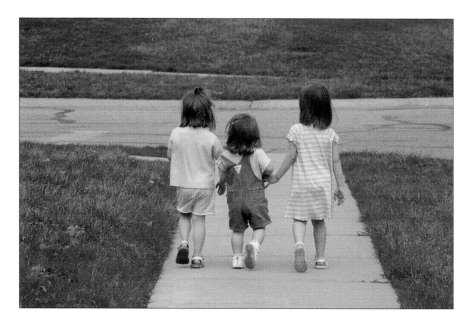

Figure 1-2: My original photo is underexposed and includes too much background.

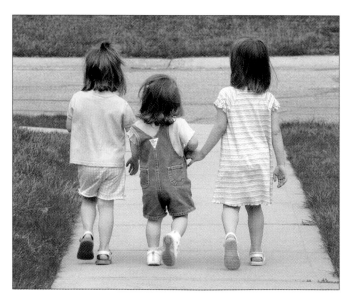

Figure 1-3: A little photo editing turns a so-so image into a compelling summer memory.

✔ **Instant, easy, photo sharing:** You can send an image instantaneously by attaching it to an e-mail message. Not only is electronic distribution of images quicker than regular mail or overnight delivery services, it's also more convenient. You don't have to address an envelope, find a stamp, or truck off to the post office or delivery drop box.

In addition to sending photos via e-mail, you can share photos with friends, family, and clients, no matter how far away, via a personal Web page or a photo-sharing site such as the Kodak EasyShare Gallery (formerly Ofoto, www.kodakgallery.com), featured in Figure 1-4. (Chapter 10 explains everything you need to do to prepare your images for online sharing or any type of on-screen display.)

Figure 1-4: Share your pictures through online photo albums.

✓ **More interesting presentations:** You can include pictures in business or educational presentations that you create with programs such as Microsoft PowerPoint. For more casual audiences, you can produce fun multimedia slide shows and burn them to a CD or DVD using programs such as PhotoShow Deluxe from Simple Star, shown in Figure 1-5.

✓ **More useful databases and household records:** You can include digital images in business and household databases. For example, if your company operates a telemarketing program, you can insert images into a product order database so that when sales reps pull up information about a product, they see a picture of the product and can describe it to customers. Or you may want to insert product shots into inventory spreadsheets, as I did in Figure 1-6.

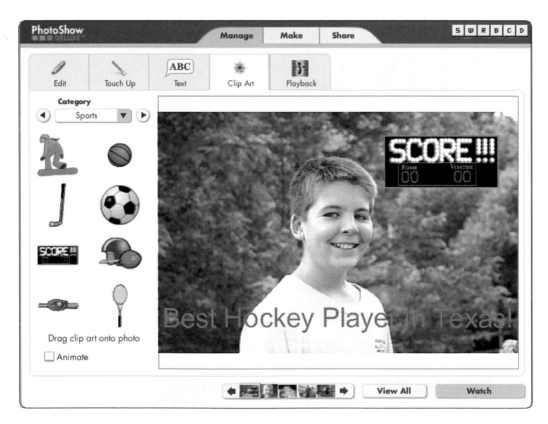

Figure 1-5: PhotoShow Deluxe and other beginner-friendly programs allow you to easily create digital slide shows.

✓ **More creative fun:** You can have a lot of fun exploring your artistic side. Using an image-editing program, you can apply wacky special effects, paint mustaches on your evil enemy, and otherwise distort reality.

You can also combine several images into a montage, such as the one featured in Chapter 13, and apply special-effects filters that give your photo the look of a painting, pencil sketch, or other traditional art medium, as shown in Figure 1-7.

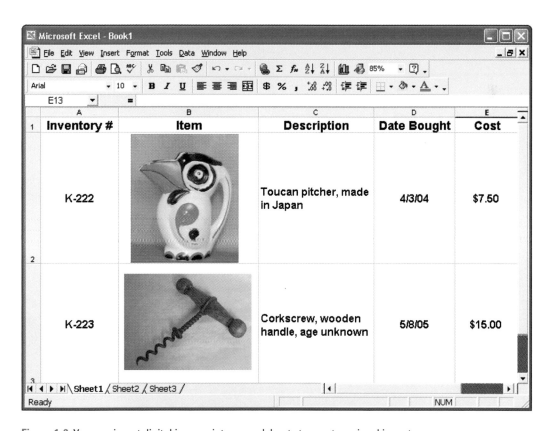

Figure 1-6: You can insert digital images into spreadsheets to create a visual inventory.

Figure 1-7: A special-effects filter gave this photo the look of a colored pencil sketch.

You can also create your own personalized stationery, business cards, calendars, mugs, t-shirts, postcards, and other goodies, as shown in Figure 1-8. The figure offers a look at Microsoft Digital Image Pro, an easy-to-use program that provides templates for creating such materials. You just select the design you want to use and insert your own photos into the template.

After you place your photos into the templates, you can print your artwork on a color printer using specialized print media sold by Kodak, Epson, HP, and other vendors. If you don't have access to a printer with this capability, you can get the job done at a local quick-copy shop or e-mail your image to one of the many vendors offering digital printing services via the Internet.

These are just some of the reasons digital imaging is catching on so quickly. For convenience, quality control, flexibility, and fun, digital does a slam-dunk on film.

Figure 1-8: Make a personal statement by creating your own invitations and greeting cards.

But Can't I Do All This with a Scanner?

The answer is, yes. You can do everything that I mentioned in the preceding section with any digital image, whether the picture comes from a scanner or a digital camera. However, digital cameras provide some benefits that you don't enjoy when you work with film prints and a scanner:

✔ **Print only the good ones:** If you're like most people, only a handful of pictures from every roll of film falls into the category of "that's a great picture" or even "that's an okay picture." Divide the cost of film and processing by the number of good photos per roll, and you'll discover that you're paying a lot more per picture than you thought.

With a digital camera, you can review your pictures on the camera's monitor and then print only those that are really special. If the picture isn't any good, you simply delete it. And because you're no longer wasting film, you can experiment freely with different camera settings and photo techniques.

✔ **Never miss important photo ops:** Instant, on-camera review of your pictures also means added peace of mind when you're photographing one-time events such as an anniversary party or business conference. You know right away whether you snapped a winner or need to try again. No more disappointing moments at the film lab when you discover that your packet of prints doesn't contain a single decent picture of the scene you wanted to capture.

✔ **Save time and effort:** If you shoot product pictures on a regular basis, digital cameras offer significant timesavings. You don't have to run off to the lab and wait for your pictures to be processed.

In addition, digital cameras free up time that you would otherwise spend scanning pictures into your computer. Even the best scanners are painfully slow when compared with the time it takes to generate an image with a digital camera.

In short, digital cameras save you time and money and, most important, make it easier to produce terrific pictures.

Now Tell Me the Downside

Thanks to design and manufacturing refinements, problems that kept people from moving to digital photography in the early days of the technology — high prices and questionable image quality being the most critical — have been solved. But a couple of downside issues remain, which I should bring up in the interest of fairness:

✔ Today's digital cameras can produce the same high quality prints as you've come to expect from your film camera. However, to enjoy that kind of picture quality, you need to start with a camera that offers moderate-to-high image resolution, which costs a minimum of $70. Images from lower-priced models just don't contain enough picture information to produce decent prints. Low-resolution cameras are fine for pictures that you want to use on a Web page or in a multimedia presentation, however. (See Chapter 2 for a complete explanation of resolution.)

✔ After you press the shutter button on a digital camera, the camera requires a few seconds to record the image to memory. During that time, you can't shoot another picture. With some cameras, you also experience a slight delay between the time you press the shutter button and the time the camera captures the image. These lag times can be a problem when you're trying to capture action-oriented events.

Generally speaking, the more expensive the camera, the less lag time you encounter. With some of the new, top-flight models, lag time isn't much more than you experience with a film camera using an automatic film advance.

Many digital cameras also offer a burst or continuous-capture mode that enables you to take a series of pictures with one press of the shutter button. This mode is helpful in some scenarios, although you're sometimes restricted to capturing images at a low resolution or without a flash. Chapter 7 provides more information.

✔ Becoming a digital photographer involves learning some new concepts and skills. If you're familiar with a computer, you shouldn't have much trouble getting up to speed with digital images. If you're a novice to both computers and digital cameras, expect to spend a fair amount of time making friends with your new machines. A digital camera may look and feel like your old film camera, but underneath the surface, it's a far cry from your father's Kodak Brownie. This book guides you through the process of becoming a digital photographer as painlessly as possible, but you need to invest the time to read the information it contains.

As manufacturers continue to refine digital-imaging technology, you can expect continued improvements in price and image-capture speed. I'm less hopeful that anything involving a computer will become easier to learn in the near future; my computer still forces me to "learn" something new every day — usually, the hard way. Of course, becoming proficient with film cameras requires some effort as well.

Whether or not digital will completely replace film as the foremost photographic medium remains to be seen. In all likelihood, the two mediums will each secure their niche in the image world. So make a place for your new digital camera in your camera bag, but don't stick your film camera in the back of the closet just yet. Digital photography and film photography each offer unique advantages and disadvantages, and choosing one option to the exclusion of the other limits your creative flexibility.

Just Tell Me Where to Send the Check. . . .

If you've been intrigued by the idea of digital photography but have so far been put off by the costs involved, I have great news. Prices for cameras, printers, and other necessary equipment have fallen dramatically over the past few years. Camera features that would have cost you $600 two years ago can now be had for under $100. (Don't you wish *everything* would keep coming down in price the way computer technology does?)

The following sections outline the various costs of going digital. As you read this information, keep in mind that digital photography offers some money-saving benefits to offset the expenses. As I mentioned earlier, you can experiment without worrying about the cost of film and processing. If you don't like a picture, you simply delete it. No harm, no foul. If you're a prolific photographer, this advantage alone adds up to significant savings over time. So even though the initial outlay for a digital camera may be more than you'd pay for a film camera, digital is cheaper over the long run.

Cameras

Today's digital cameras range from inexpensive point-and-shoot models for casual users to $1,500-and-up *pro-sumer* models that offer the high-end photography controls demanded by advanced photo enthusiasts and professional photographers.

You can get a bare-bones camera for less than $40. But models in this price range produce very low-resolution images, suitable for Web pictures and other on-screen uses only. They usually also lack some important convenience features, such as removable image storage and a monitor for reviewing pictures.

Expect to spend $70 and up for a camera that can generate quality prints and includes a flash, LCD monitor, removable storage, and other features that you'll want if you plan to use your camera on a regular basis. As you move up the price spectrum, you get higher resolution, which means that you can print larger pictures; you also typically get better quality optics, a zoom lens, and advanced features such as manual shutter speed and aperture control. Chapter 3 helps you figure out just how much camera you need.

Memory cards

Most digital cameras record pictures on removable memory cards, which are similar to the floppy disks that you may use with your computer. When you fill up the card with pictures, you have to delete some pictures or transfer them to your computer before you can continue shooting.

Memory cards used to be terribly expensive. In the first years of digital photography, you could spend as much as $20 per megabyte (MB) of memory. Thankfully, memory card prices have plummeted recently, and you now can buy a 256MB memory card for about $30.

How many pictures you can fit into that 256MB depends on camera resolution and image file format, two subjects that you can explore in the next two chapters.

Regardless, you can strike the cost of memory cards from your list of concerns. You won't spend any more than you would on film and processing to produce an equivalent number of traditional prints. And you can reuse memory cards as many times as you want, making them an even bigger bargain when compared to film.

Hardware, software, and other accessories

In addition to the camera itself, digital photography involves some peripheral hardware and software, not the least of which is a fairly powerful computer for viewing, storing, editing, and printing your images. You need a machine with a robust processor, at least 256MB of RAM, and a big hard drive with lots of empty storage space. The least you can expect to spend on such a system is about $400.

Getting your images from computer to paper requires an additional investment. If you have your pictures printed at a retail photofinishing lab, the cost per print is equal to or sometimes lower than what you pay for film prints. For do-it-yourself printing, printer costs range from about $80 to $700, but you don't need to buy at the high end of that spectrum to get good print quality. Most manufacturers use the same print engine in their low-priced photo printers as they do in their top-of-the-line products, so you can get really great results at a reasonable price. Higher-priced models offer faster output and additional features such as networking capabilities, the option to print directly from a camera memory card, a built-in monitor for previewing images, and the ability to output very large prints.

In addition, you need to factor in the cost of image-editing software, image storage and transfer devices, special paper for printing your photos, camera batteries, and other peripherals. If you're a real photography buff, you may also want to buy special lenses, lights, a tripod, and some other accessories.

Nope, a digital darkroom isn't cheap. Then again, neither is traditional film photography, if you're a serious photographer. And when you consider all the benefits of digital imagery, especially if you do business nationally or internationally, justifying the expense isn't all that difficult. But just in case you're getting queasy, look in Chapters 3, 4, and 9 for more details on the various components involved in digital photography — plus some tips on how to cut budgetary corners.

Mr. Science Explains It All

In This Chapter

▶ Understanding how digital cameras record images

▶ Visualizing how your eyes — and digital cameras — see color

▶ Perusing a perfectly painless primer on pixels

▶ Exploring the murky waters of resolution

▶ Analyzing the undying relationship between resolution and image size

▶ Looking at f-stops, shutter speeds, and other aspects of image exposure

▶ Exposing color models

▶ Diving into bit depth

*I*f discussions of a technical nature make you nauseated, keep a stomach-soothing potion handy while you read this chapter. The following pages are full of the kind of technical babble that makes science teachers drool but leaves us ordinary mortals feeling a little queasy.

Unfortunately, you can't be a successful digital photographer without getting acquainted with the science behind the art. But never fear: This chapter provides you with the ideal lab partner as you explore such important concepts as pixels, resolution, f-stops, bit depth, and more. Sorry, you don't dissect pond creatures or analyze the cell structure of your fingernails in this science class, but you do get to peel back the skin of a digital camera and examine the guts of a digital image. Neither exercise is for the faint of heart, but both are critical for understanding how to turn out quality images.

From Your Eyes to the Camera's Memory

A traditional camera creates an image by allowing light to pass through a lens onto film. The film is coated with light-sensitive chemicals, and wherever light hits the coating, a chemical reaction takes place, recording a latent image. During the film development stage, more chemicals transform the latent image into a printed photograph.

Digital cameras also use light to create images, but instead of film, digital cameras capture pictures using an *imaging array* or sensor, both of which are fancy ways of saying "light-sensitive computer chips." Currently, these chips come in two flavors: CCD, which stands for *charge-coupled device,* and CMOS, which is short for *complementary metal-oxide semiconductor.* (No, Billy, that information won't be on the test.) Figure 2-1 gives you a look at some sensors from Kodak.

Photo Courtesy Eastman Kodak Company

Figure 2-1: Imaging sensors do the work of film in digital cameras.

Although CCD and CMOS chips differ in some important ways, which you can read about in Chapter 3, both chips do essentially the same thing. When struck by light, they emit an electrical charge, which is analyzed and translated into digital image data by a processor inside the camera. The more light, the stronger the charge.

After the electrical impulses are converted to image data, the data is saved to the camera's memory, which may come in the form of an in-camera chip or a removable memory card or disk. To access the images that your camera records, you just transfer them from the camera memory to your computer. With some cameras, you can transfer pictures directly to a television monitor or printer, enabling you to view and print your photographs without ever turning on your computer.

Keep in mind that what you've just read is only a basic explanation of how digital cameras record images. I could write an entire chapter on CCD designs, for example, but you would only wind up with a big headache. Besides, the only time you need to think about this stuff is when deciding which camera to buy. To that end, Chapters 3, 4, and 8 explain the important aspects of imaging chips, memory, and image transfer so that you can make a sensible purchase decision.

The Secret to Living Color

Like film cameras, digital cameras create images by reading the light in a scene. But how does the camera translate that brightness information into the colors you see in the final photograph? As it turns out, a digital camera does the job pretty much the same way as the human eye.

To understand how digital cameras — and your eyes — perceive color, you first need to know that light can be broken into three color ranges: reds, greens, and blues. Inside your eyeball, you have three receptors corresponding to those color ranges. Each receptor measures the brightness of the light for its particular range. Your brain then combines the information from the three receptors into one multicolored image in your head.

Because most of us didn't grow up thinking about mixing red, green, and blue light to create color, this concept can be a little hard to grasp. Here's an analogy that may help. Imagine that you're standing in a darkened room and have one flashlight that emits red light, one that emits green light, and one that emits blue light. Now suppose that you point all the flashlights at the same spot on a white wall. Where the three lights overlap, you get white, as shown in Figure 2-2. Where no light falls, you get black.

Figure 2-2: RGB images are created by blending red, green, and blue light.

In the illustration, my flashlights emit full-intensity light with no fade over the spread of the beam, so mixing the three lights produces only three additional colors: magenta, cyan, yellow. But by varying the intensity of the beams, you can create every color that the human eye can see.

Just like your eyes, a digital camera analyzes the intensity — sometimes referred to as the *brightness value* — of the red, green, and blue light. Then it records the brightness values for each color in separate portions of the image file. Digital-imaging professionals refer to these vats of brightness information as *color channels*. After recording the brightness values, the camera mixes them together to create the full-color image.

Pictures created using these three main colors of light are known as *RGB images* — for red, green, and blue. Computer monitors, television sets, and scanners also create images by combining red, green, and blue light.

In sophisticated photo-editing programs such as Adobe Photoshop, you can view and edit the individual color channels in a digital image. Figure 2-3 shows a color image broken down into its red, green, and blue color channels. Notice that each channel contains nothing more than a grayscale image. That's because the camera records only light — or the absence of it — for each channel.

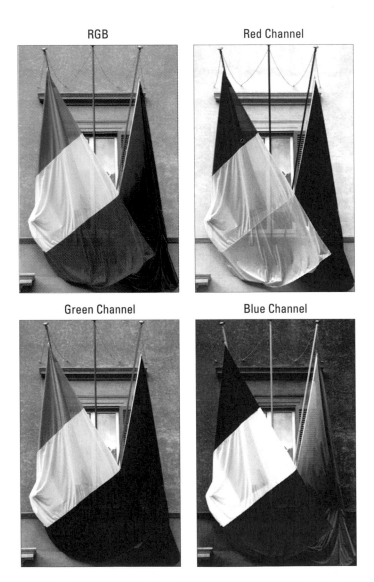

Figure 2-3: An RGB image has three color channels, one each for the red, green, and blue light values.

In any of the channel images, light areas indicate heavy amounts of that channel's color. For example, the red portion of the left flag appears nearly white in the red channel image, but nearly black in the green and blue channel images. Likewise, the blue flag poles appear very light in the blue channel images. And the white center portion of the left flag is bright in all three channel images; remember, strong amounts of red, green, and blue light produce white.

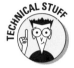

At the risk of confusing the issue, I should point out that not all digital images contain three channels. If you convert an RGB image to a grayscale (black-and-white) image inside a photo-editing program, for example, the brightness values for all three color channels are merged into one channel. And if you convert the image to the *CMYK color model* in preparation for professional printing, you end up with four color channels, one corresponding to each of the four primary colors of ink (cyan, magenta, yellow, and black). For more on this topic, see "RGB, CMYK, and Other Colorful Acronyms," later in this chapter.

Don't let this channel stuff intimidate you — until you become a seasoned photo editor, you don't need to give it another thought. I bring the topic up only so that when you see the term *RGB,* you have some idea what it means.

Resolution Rules!

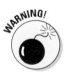

Without a doubt, the number one thing you can do to improve your digital photos is to understand the concept of *resolution.* Unless you make the right choices about resolution, your pictures will be a disappointment, no matter how captivating the subject. In other words, don't skip this section!

Pixels: Building blocks of digital photos

Have you ever seen the painting, *A Sunday Afternoon on the Island of La Grande Jatte,* by the French artist Georges Seurat? Seurat was a master of a technique known as *pointillism,* in which scenes are composed of millions of tiny dots of paint, created by dabbing the canvas with the tip of a paintbrush. When you stand across the room from a pointillist painting, the dots blend together, forming a seamless image. Only when you get up close to the canvas can you distinguish the individual dots.

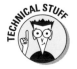

Digital images work something like pointillist paintings. Rather than being made up of dots of paint, however, digital images are composed of tiny squares of color known as *pixels.* The term *pixel* is short for *picture element.*

If you magnify an image on-screen, you can make out the individual pixels, as shown in Figure 2-4. Zoom out on the image, and the pixels seem to blend together, just as when you step back from a pointillist painting.

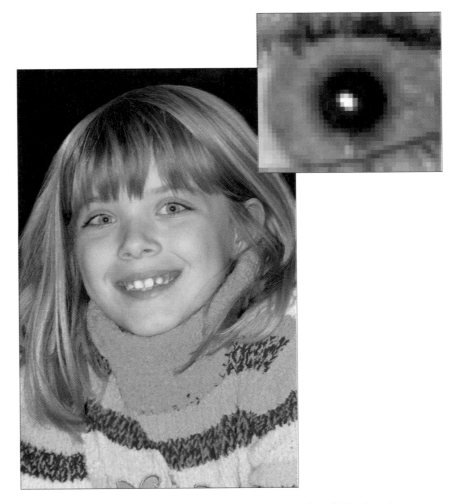

Figure 2-4: Zooming in on a digital photo enables you to see the individual pixels.

Every digital photograph is born with a set number of pixels, which you control by using the capture settings on your digital camera. (See Chapter 5 for details.) Most cameras today can record at least one million pixels, and higher-end models can capture six megapixels or more.

Some people use the term *pixel dimensions* to refer to the number of pixels in an image — number of pixels wide by number of pixels high. Others use the term *image size,* which can lead to confusion because that term is also used to refer to the physical dimensions of the picture when printed (inches wide by inches tall). For the record, I use *pixel dimensions* to refer specifically to the pixel count and *image size* or *print size* to mean the print dimensions.

As I detail in the next few sections, the number of pixels affects three important aspects of a digital photo:

✔ The maximum size at which you can produce good prints

✔ The display size of the picture when viewed on a computer monitor or television screen

✔ The size of the image file

Pixels and print quality

Before you print an image, you use a control in your photo editor to specify an *output resolution,* which determines the number of pixels per inch (ppi) in the print. Figure 2-5 shows the control as it appears in Adobe Photoshop Elements 3 (Chapter 9 provides specifics).

Output resolution, which many people refer to as *image resolution* or simply *resolution,* plays a big role in determining the quality of your printed digital photos. The more pixels per inch — the higher the ppi — the crisper the picture, as illustrated by Figures

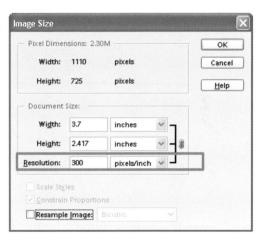

Figure 2-5: Output resolution (ppi) affects print quality.

2-6 through 2-8. The first image has resolution of 300 ppi; the second, 150 ppi; and the third, 75 ppi.

300 ppi

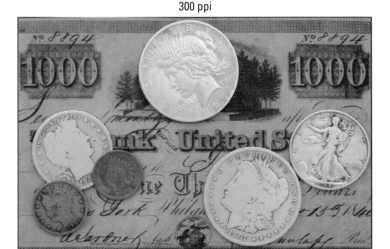

Figure 2-6: A photo with an output resolution of 300 ppi looks terrific.

150 ppi

Figure 2-7: At 150 ppi, the picture loses some sharpness and detail.

75 ppi

Figure 2-8: Reducing the resolution to 75 ppi causes significant image degradation.

Note that output resolution is measured in terms of pixels per *linear* inch, not square inch. So a resolution of 75 ppi means that you have 75 pixels horizontally and 75 pixels vertically, or 5625 pixels for each square inch of your printed image.

Why does the 75-ppi image in Figure 2-8 look so much worse than its higher-resolution counterparts? Because at 75 ppi, the pixels are bigger. After all, if you divide an inch into 75 squares, the squares are significantly larger than if you divide the inch into 150 squares or 300 squares. And the bigger the pixel, the more easily your eye can figure out that it's really just looking at a bunch of squares. Areas that contain diagonal and curved lines, such as the edges of the coins and the handwritten lettering in the figure, take on a stair-stepped appearance.

If you look closely at the black borders that surround Figures 2-6 through 2-8, you can get a clearer idea of how resolution affects pixel size. Each image sports a 2-pixel border. But the border in Figure 2-8 is twice as thick as the one in Figure 2-7 because a pixel at 75 ppi is twice as large as a pixel at 150 ppi. Similarly, the border around the 150-ppi image in Figure 2-7 is twice as wide as the border around the 300-ppi image in Figure 2-6.

Pixels and screen images

Although output resolution (ppi) has a dramatic effect on the quality of printed photos, it's a moot point for pictures displayed on-screen. A computer monitor (or other display device) cares only about the pixel dimensions, not pixels per inch, despite what you may have been told by some folks. The number of pixels does control the *size* at which the picture appears on the screen, however.

Like digital cameras, computer monitors (and other display devices) create everything you see on-screen out of pixels. You typically can choose from several monitor settings, each of which results in a different number of screen pixels. Standard settings include 640 x 480 pixels, 800 x 600 pixels, and 1024 x 768 pixels.

When you display a digital photo on your computer monitor, the monitor completely ignores any output resolution (ppi) setting you may have selected in your photo-editing program and simply devotes one screen pixel to every image pixel. For example, Figure 2-9 shows my 19-inch monitor as it appears when set to a screen resolution of 1024 x 768. The Pompeii photo inside the e-mail window contains 640 x 480 pixels — and therefore consumes 640 of the available 1024 horizontal screen pixels and 480 of the 768 vertical pixels.

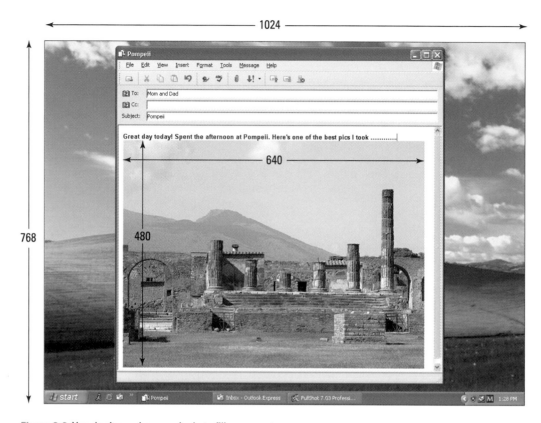

Figure 2-9: You don't need many pixels to fill a computer screen.

This fact is great news for digital photographers with low budgets, because even the most inexpensive digital camera captures enough pixels to cover a large expanse of on-screen real estate. And again, the pixel count doesn't alter the on-screen quality; all that varies is the display size of the photo.

For more specifics on sizing pictures for the screen, turn to Chapter 10.

Pixels and file size

Each pixel in a digital photo adds to the size of the image file. For a point of comparison, the high-resolution coin image in Figure 2-6 measures 1110 pixels wide and 725 pixels tall, for a total pixel count of 804,750. This file consumes roughly 2.3MB (megabytes) of storage space. By contrast, the 75-ppi image in Figure 2-8 measures 278 pixels wide by 181 pixels tall, for a total of 50,318 pixels. This image has a file size of just 153K (kilobytes).

In addition to eating up storage space on your computer's hard drive and on your camera memory cards, large image files make bigger demands on your computer's memory (RAM) when you edit them. And when placed on a Web page, huge image files are a major annoyance. Every kilobyte increases the time required to download the file.

To avoid straining your computer — and the patience of Web site visitors — keep your images lean and mean. You want the appropriate number of pixels to suit your final output device (screen or printer), but no more. You can find details on preparing images for print in Chapter 9 and read about designing pictures for screen use in Chapter 10.

Keep in mind, too, that color image files are larger than black-and-white pictures, or *grayscale photos,* as they're called in the biz. That's because of the aforementioned color channel issue; a color image requires three channels of data, while a grayscale photo requires only one. As an example, both photos in Figure 2-10 have the same pixel dimensions (750 x 940). But the grayscale image file size (714K) is about one-third the size of the full-color version (2.1MB).

2.1MB 714K

Figure 2-10: Grayscale photos have smaller file sizes than color pictures.

How many pixels are enough?

Because printers and screen devices think about pixels differently, your pixel needs vary depending on how you plan to use your picture.

- ✔ **Pixels for screen use:** If you want to use your picture on a Web page, a multimedia presentation, or for some other on-screen use, you need very few pixels. As I explain in the preceding section, you just match the pixel dimensions of the picture to the amount of the screen you want the image to fill. In most cases, 640 x 480 pixels is more than enough, and for many projects, you need half that many pixels or even fewer.

- ✔ **Pixels for prints:** If you plan to print your photo and want the best picture quality, you need enough pixels to enable you to set the output resolution in the neighborhood of 200 to 300 ppi. This number varies depending on the printer; sometimes you can get by with fewer pixels; some printers (certain Epson models, notably) ask for 360 pixels. Check your printer manual for resolution guidelines, and see Chapter 9 for additional printing information.

To determine how many pixels you need, just multiply the print size by the desired resolution. For example, if you want to create a 4 x 6-inch print at 300 ppi, you need at least 1200 x 1800 pixels. (For the math-haters in the group, Chapter 5 and the Cheat Sheet at the front of this book contain a handy reference chart to pixels and print sizes.)

Because I've hammered home the point that more pixels means better print quality, you may think that if 300 ppi delivers good print quality, 400 ppi or even higher produces even better quality. But this isn't the case. Printers are engineered to work with images set to a particular resolution, and when presented with an image file at a higher resolution, most printers simply ignore or eliminate the extra pixels.

Some cameras offer a setting that enables you to record two copies of each image, one appropriate for print and one for on-screen use. If your camera lacks this function and you're not sure how you're going to use your photos, set your camera to the setting that's suitable for print. If you later want to use a picture on a Web page or for some other on-screen use, you can delete extra pixels as necessary. But you can't add pixels after the fact with any degree of success. For more about this subject, see the next section.

Can't I add pixels later?

Many photo-editing programs enable you to add pixels to or delete pixels from an existing digital photo. This process is known as *resampling*. Adding pixels is sometimes called *upsampling;* dumping pixels, *downsampling*.

Upsampling sounds like a good idea — if you don't have enough pixels, you just go to the Pixel Mart and fill your basket, right? The problem is that when you add pixels, the photo-editing software simply makes its best guess as to what color and brightness to make the new pixels. And even high-end photo-editing programs don't do a very good job of pulling pixels out of thin air, as illustrated by Figure 2-11.

75 ppi upsampled to 300 ppi

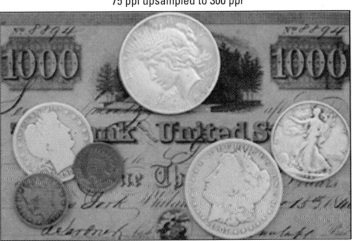

Figure 2-11: Here you see the result of upsampling the 75-ppi image in Figure 2-8 to 300 ppi.

To create this figure, I started with the 75-ppi image shown in Figure 2-8 and resampled the image to 300 ppi in Adobe Photoshop, one of the best photo-editing programs available. Compare this new image with the 300-ppi version in Figure 2-6, and you can see just how poorly the computer does at adding pixels.

With some images, you can get away with minimal upsampling — say, 10 to 15 percent — but with other images, you notice a quality loss with even slight pixel infusions. Images with large, flat areas of color tend to survive upsampling better than pictures with lots of intricate details. See Chapter 9 for information about how to make this adjustment during the printing process.

If your image contains too many pixels, which is often the case for pictures that you want to use on the Web, you can safely delete pixels (downsample). But keep in mind that every pixel you throw away contains image information, so too much pixel-dumping can degrade image quality. Try not to downsample by more than 25 percent, and always make a backup copy of your image in case you ever want those original pixels back.

For step-by-step instructions on how to alter your pixel count, see the section related to sizing images for print in Chapter 9 and the section about sizing photos for screen display in Chapter 10.

More mind-boggling resolution stuff

As if sorting out all the pixel, resampling, and resolution stuff discussed in the preceding sections isn't challenging enough, you also need to be aware that *resolution* doesn't always refer to output resolution. The term is also used to describe the capabilities of digital cameras, monitors, and printers. So when you hear the word *resolution,* keep the following distinctions in mind:

- ✔ **Camera resolution:** Digital camera manufacturers often use the term *resolution* to describe the number of pixels in the pictures produced by their cameras. A camera's stated resolution might be 640 x 480 pixels or 1.3 million pixels, for example. But those values refer to the pixel dimensions or total pixels a camera can produce, not the number of pixels per inch in your printed photos. *You* determine that value in your photo-editing software, as I discuss in Chapter 9. Of course, you can use the camera's pixel count to figure out the final resolution you can achieve from your images. See the earlier section, "How many pixels are enough?"

 Some vendors use the term *VGA resolution* to indicate a 640 x 480-pixel image, *XGA resolution* to indicate a 1024 x 768-pixel image, and *megapixel resolution* to indicate a total pixel count of 1 million or more.

- ✔ **Monitor resolution:** Manufacturers of computer monitors also use the word *resolution* to describe the number of pixels a monitor can display. As I mentioned a few sections ago, most monitors enable you to choose from display settings of 640 x 480 pixels (again, often referred to as VGA resolution), 800 x 600 pixels, or 1024 x 768 pixels (XGA). Some monitors can display even more pixels.

 See Chapter 10 to get more details about how screen resolution relates to image resolution.

- ✔ **Printer resolution:** Printer resolution is measured in *dots per inch,* or *dpi,* rather than pixels per inch. But the concept is similar: Printed images are made up of tiny dots of color, and dpi is a measurement of how many dots per inch the printer can produce. In general, the higher the dpi, the smaller the dots, and the better the printed image. But gauging a printer solely by dpi can be misleading. Different printers use different printing technologies, some of which result in better images than others. Some 300-dpi printers deliver better results than some 600-dpi printers.

Some people (including some printer manufacturers and software designers) mistakenly interchange dpi and ppi, which leads many users to think that they should set their image resolution to match their printer resolution. *But a printer dot is not the same thing as an image pixel.* Most printers use multiple printer dots to reproduce one image pixel. Every printer is geared to handle a specific image resolution, so you need to check your computer manual for the right image resolution for your model. See Chapter 9 for more information on printing and different types of printers.

What all this resolution stuff means to you

Head starting to hurt? Mine, too. So to help you sort out all the information you accumulated by reading the preceding sections, here's a brief summary of resolution matters that matter most:

- **Number of pixels across (or down) ÷ printed image width (or height) = output resolution (ppi).** For example, 600 pixels divided by 2 inches equals 300 ppi.

- **For good-quality prints, you typically need an output resolution of 200 to 300 ppi.** Chapter 9 provides in-depth information on this topic.

- **For on-screen display, think in terms of pixel dimensions, not output resolution.** See Chapter 10 for specifics.

- **Enlarging a print can reduce image quality.** When you enlarge an image, one of two things has to happen. Either the existing pixels must get larger to fit the new image boundaries, or the pixels stay the same size and the photo-editing software adds pixels to fill in the gaps (upsamples the image). Either way, your image quality can suffer.

- **To safely raise the output resolution of an existing image, reduce the print size.** Again, adding pixels to raise the output resolution rarely delivers good results. Instead, retain the existing number of pixels and reduce the print dimensions of the picture. Chapter 9 provides the complete scoop on resizing images in this manner.

- **Set your camera to capture a pixel count at or above what you need for your final picture output.** You can safely toss pixels if you want a lower image resolution later, but you can't add pixels without degrading your image. Also, you may need a low-resolution image today — for example, if you want to display a picture on the Web — but you may decide later that you want to print the image at a larger size, in which case you're going to need those extra pixels.

> ✔ **More pixels means a bigger image file.** And even if you have tons of file-storage space to hold all those huge images, bigger isn't always better, for two reasons:
>
> • Large images require a ton of RAM to edit and increase the time your photo software needs to process your edits.
>
> • On a Web page, large image files mean long download times.
>
> If your image has a higher resolution than you need, see Chapter 10 for information on how to dump the excess pixels.

Lights, Camera, Exposure!

Whether you're working with a digital camera or a traditional film camera, the brightness or darkness of the image is dependent on *exposure* — the amount of light that hits the film or image-sensor array. The more light, the brighter the image. Too much light results in a washed-out, or *overexposed,* image; too little light, and the image is dark, or *underexposed.*

Most low-priced digital cameras, like point-and-shoot film cameras, don't give you much control over exposure; everything is handled automatically for you. But many midrange cameras offer a choice of automatic exposure settings, and higher-end cameras typically provide manual exposure control in addition to automatic options.

Regardless of whether you're shooting with an automatic model or one that offers manual controls, you should be aware of the different factors that affect exposure — including shutter speed, aperture, and ISO — so that you can understand the limitations and possibilities of your camera.

Aperture, f-stops, and shutter speeds: The traditional way

Before taking a look at how digital cameras control exposure, it helps to understand how a film camera does the job. Even though digital cameras don't function in quite the same way as a film camera, manufacturers describe their exposure control mechanisms using traditional film terms, hoping to make the transition from film to digital easier for experienced photographers.

Figure 2-12 shows a simplified illustration of a film camera. Although the specific component design varies depending on the type of camera, all film cameras include some sort of shutter, which is placed between the film and the lens. When the camera isn't in use, the shutter is closed, preventing light

from reaching the film. When you take a picture, the shutter opens, and light hits the film. (Now you know why the little button you press to take a picture is called the *shutter button* and why people who take lots of pictures are called *shutterbugs*.)

You can control the amount of light that reaches the film in two ways: by adjusting the amount of time the shutter stays open (referred to as the *shutter speed*) and by changing the *aperture*. The aperture, labeled in Figure 2-12, is a hole in an adjustable diaphragm set between the lens and the shutter. Light coming through the lens is funneled through this hole to the shutter and then onto the film. So if you want more light to strike the film, you make the aperture bigger; if you want less light, you make the aperture smaller.

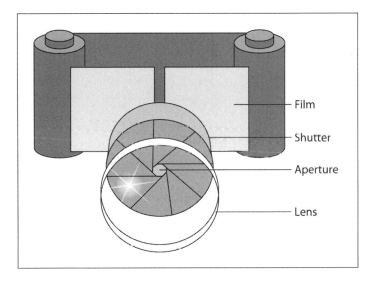

- Film
- Shutter
- Aperture
- Lens

Figure 2-12: A look at the shutter and aperture in a traditional film camera.

The size of the aperture opening is measured in f-numbers, more commonly referred to as *f-stops*. Standard aperture settings are f/1.4, f/2, f/2.8, f/4, f/5.6, f/8, f/11, f/16, and f/22.

Contrary to what you may expect, the larger the f-stop number, the smaller the aperture and the less light that enters the camera. Each f-stop setting lets in half as much light as the next smaller f-stop number. For example, the camera gets twice as much light at f/11 as it does at f/16. (And here you were complaining that computers were confusing!) See Figure 2-13 for an illustration that may help you get a grip on f-stops.

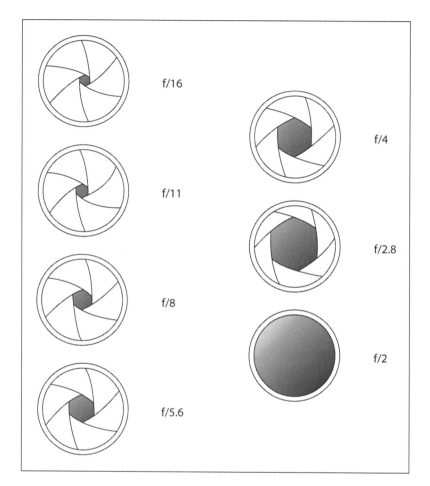

Figure 2-13: As the f-stop number decreases, the aperture size grows and more light enters the camera.

Shutter speeds are measured in more obvious terms: fractions of a second. A shutter speed of 1/8, for example, means that the shutter opens for one-eighth of a second. That may not sound like much time, but in camera years, it's in fact a very long period. Try to capture a moving object at that speed and you wind up with a big blur. You need a shutter speed of about 1/500 to capture action clearly.

On cameras that offer aperture and shutter speed control, you manipulate the two settings in tandem to capture just the right amount of light. For example, if you're capturing fast action on a bright, sunny day, you can combine a fast shutter speed with a small aperture (high f-stop number). To shoot the same picture at twilight, you need a wide-open aperture (small f-stop number) in order to use the same fast shutter speed.

Aperture, shutter speed, and f-stops: The digital way

As with a film camera, the exposure of a picture shot with a digital camera depends on the amount of light that the camera captures. But some digital cameras don't use a traditional shutter/aperture arrangement to control exposure. Instead, the chips in the image-sensor array simply turn on and off for different periods of time, thereby capturing more or less light. In some cameras, exposure is also varied — either automatically or by some control the user sets — by boosting or reducing the strength of the electrical charge that a chip emits in response to a certain amount of light.

Even on cameras that use this alternative approach to exposure control, the camera's capabilities are usually stated in traditional film-camera terms. For example, you may have a choice of two exposure settings, which may be labeled with icons that look like the aperture openings shown in Figure 2-13. The settings are engineered to deliver the *equivalent* exposure that you would get with a film camera using the same f-stop.

Aperture and shutter speeds aren't the only factors involved in image exposure, however. The sensitivity of the image-sensor array also plays a role, as the next section explains.

ISO ratings and chip sensitivity

Pick up a box of film, and you should see an *ISO number*. This number tells you how sensitive the film is to light and is also referred to as the *film speed*.

Film geared to the consumer market typically offers ratings of ISO 100, 200, or 400. The higher the number, the more sensitive the film, or, if you prefer photography lingo, the *faster* the film. And the faster the film, the less light you need to capture a decent image. The advantage of using a faster film is that you can use a faster shutter speed and shoot in dimmer lighting than you can with a low-speed film. On the downside, photos shot with fast film sometimes exhibit noticeable *grain* — that is, they have a slightly speckled appearance.

Most digital camera manufacturers also provide an ISO rating for their cameras. This number tells you the *equivalent* sensitivity of the chips on the image-sensor array. In other words, the value reflects the speed of film you'd be using if you were using a traditional camera rather than a digital camera. Typically, consumer-model digital cameras have an equivalency of about ISO 100.

I bring all this up because it explains why digital cameras need so much light to produce a decent image. If you were really shooting with ISO 100 film, you would need a wide-open aperture or a slow shutter speed to capture an image in low lighting — assuming that you weren't aiming for the ghostly-shapes-in-a-dimly-lit-cave effect on purpose. The same is true of digital cameras.

A bit about bit depth

If you own a high-end digital camera, it may enable you to choose between two *bit depth* settings. A *bit* is a chunk of computer data. Bit depth refers to how many bits are available to store color data. A higher bit depth allows more image colors.

Bit depth is stated either in terms of total bits or in bits per color channel. For example, a standard RGB image has 8 bits per channel, for a total of 24 bits (8 each for the red, green, and blue color channels). Images that contain more than 24 bits are known as *high-bit images.* High-bit RGB images contain as many as 16 bits per channel, or 48 bits total.

With 24 bits, you can capture about 16.7 million colors, which is typically more than enough. So what's the advantage to more bits? Those extra bits may be useful if you need to adjust exposure or color in your photo editor. If you apply heavy changes to a 24-bit image, you can sometimes introduce a defect called *banding* or *posterization,*

where abrupt color changes interrupt what should be a smooth transition of hues, as shown in the right image in the following figure. Theoretically, higher-bit images withstand more correction without breaking down because you have more original color data to manipulate.

However, going to 48 bits does not guarantee that this defect won't occur. And high-bit images have two important drawbacks: Files are significantly larger, and many photo-editing programs either can't open high-bit files or severely limit the number of tools that you can use on those files.

For my part, I stick with 24 bits unless I'm shooting in tricky light, in which case I might ramp up to 48 bits. In the photo-editing stage, I first make any necessary exposure or color adjustments and then convert the photo to a 24-bit image so that I can have full access to all my photo-editing tools. (To make this conversion in Adobe Photoshop Elements, choose Image➪Mode➪8 bits/channel.)

Some digital cameras enable you to choose from a few different ISO settings. Unfortunately, raising the ISO setting simply boosts the electronic signal that's produced when you snap a picture. Although this does permit a faster shutter speed, the extra signal power usually also results in electronic "noise" that leads to grainy pictures, just as you get with fast film. Most camera manuals suggest using the lowest ISO setting for best quality — as do I. However, if you're working with a newer model camera, especially a digital SLR, do some experimenting; some cameras exhibit remarkably little noise even at higher ISO settings. Chapter 6 discusses ISO and other exposure issues in more detail.

RGB, CMYK, and Other Colorful Acronyms

If you read "The Secret to Living Color," earlier in this chapter, you already know that cameras, scanners, monitors, and television sets are called RGB devices because they create images by mixing red, green, and blue light. When you edit digital photographs, you also mix red, green, and blue light to create the colors that you apply with your software's painting tools.

But RGB is just one of many color-related acronyms and terms you may encounter on your digital photography adventures. So that you aren't confused when you encounter these buzzwords, the following list offers a brief explanation:

Figure 2-14: The RGB color model is based on red, green, and blue light.

- ✔ **RGB:** Just to refresh your memory, RGB stands for red, green, and blue. RGB is the *color model* — that is, a method for defining colors — used by digital images, as well as any device that transmits or filters light. Figure 2-14 shows you how full-intensity red, green, and blue are mixed to create white, cyan, yellow, and magenta.

 Image-editing gurus also use the term *color space* when discussing a color model, something they do with surprising frequency.

- ✔ **sRGB:** A variation of the RGB color model, sRGB offers a smaller *gamut,* or range of colors, than RGB. One reason this color model was designed was to improve color matching between on-screen and printed images. Because RGB devices can produce more colors than printer inks can reproduce, limiting the range of available RGB colors helps increase the possibility that what you see on-screen is what you get on paper. The sRGB color model also aims to define standards for on-screen colors so that images on a Web page look the same on one viewer's monitor as they do on another.

 The sRGB color model is a topic of much debate right now. Many image-editing purists hate sRGB; others see it as a necessary solution to the color-matching problem. If your camera enables you to specify whether you want to shoot in RGB or sRGB, I suggest choosing RGB to capture the widest range of colors. For the same reason, also edit your photos in RGB, and not sRGB, if your photo software gives you the choice. You can always create an sRGB copy of your RGB original for Web use if you like. And if you have color-matching problems when printing your photos, see Chapter 9 for some possible fixes.

✔ **CMY/CMYK:** While light-based devices mix red, green, and blue light to create images, printers mix ink to emblazon a page with color. Instead of red, green, and blue, however, printers use cyan, magenta, and yellow as the primary color components, as illustrated in Figure 2-15. This color model is called the CMY model, for reasons I just know you can figure out.

Because inks are impure, producing a true black by mixing just cyan, magenta, and yellow is difficult. So high-end photo printers and commercial printing presses add black ink to the CMY mix. This model is called CMYK (the *K* is used to represent black because commercial printers refer to the black printing plate as the Key plate). Four-color images printed at a commercial printer may need to be converted to the CMYK color mode before printing. (See Chapter 9 for more information on CMYK printing.)

Figure 2-15: The print color model is based on cyan, magenta, and yellow ink.

One important note here: The colors you see in the RGB model in Figure 2-14 and the colors in the CMYK model in Figure 2-15 appear the same. But in reality, the RGB colors are much more vibrant; what you're seeing in Figure 2-14 is the RGB chart converted to the CMYK model for printing. You simply can't reproduce in print the most vivid hues in an RGB image, which is one reason why those colors you see on your monitor never exactly match what you see in your printed photos. For more on this issue, check out Chapter 9.

✔ **Grayscale:** A grayscale image is comprised solely of black, white, and shades of gray. Some people (and some photo-editing programs) refer to grayscale images as black-and-white images, but a true black-and-white image contains only black and white pixels, with no shades of gray in between. Graphics professionals often refer to black-and-white images as *line art.*

Many digital cameras enable you to capture grayscale images. But I suggest that you instead shoot in full color and then convert the color photo to grayscale in your photo-editing program. You can always go from color to grayscale after the fact, but you can't do the opposite. Check out Chapter 13 for the how-to's on creating a grayscale image and then adding a sepia tone to create the appearance of a hundred-year-old photograph.

✓ **CIE Lab, HSB, and HSL:** These acronyms refer to three other color models for digital images. Until you become an advanced digital-imaging guru, you don't need to worry about them. But just for the record, CIE Lab defines colors using three color channels. One channel stores luminosity (brightness) values, and the other two channels each store a separate range of colors. (The a and b are arbitrary names assigned to these two color channels.) HSB and HSL define colors based on hue (color), saturation (purity or intensity of color), and brightness (in the case of HSB) or lightness (in HSL).

About the only time you're likely to run into these color options is when mixing paint colors in an photo-editing program. Even then, the on-screen display in the color-mixing dialog boxes makes it easy to figure out how to create the color you want.

3

In Search of the Perfect Camera

In This Chapter

▶ Figuring out how many megapixels you need

▶ Understanding file formats, ISO, and other tech specs

▶ Determining which features you can live without

▶ Looking at lens and flash options

▶ Comparing SLRs and point-and-shoot models

▶ Asking other important questions before you hand over your cash

As soon as manufacturers figured out how to create digital cameras at prices the mass market could swallow, the rush was on to jump on the digital bandwagon. Today, everyone from icons of the photography world, such as Kodak, Olympus, Nikon, Canon, and Fujifilm, to powerhouse players in the consumer electronics market, such as Hewlett-Packard, Sony, and Casio, offers a digital photography line.

Having so many fingers in the digicam pie is both good and bad. More competition means better products, a wider array of choices, and lower prices. On the downside, you need to do more research to figure out which camera is right for you. Different manufacturers take different approaches to winning the consumer's heart, and sorting through the options can be confusing.

If you hate to make decisions, you may be hoping that I can tell you which camera to pick. Unfortunately, I can't. Buying a camera is a very personal decision, and no one camera suits every need. The camera that fits snugly into one person's hand may feel awkward in another's. You may enjoy a camera that has advanced photographic controls, while the guy next door prefers a simple, entry-level model.

But even though I can't guide you to a specific camera, I can help you determine which features you really need and which ones you can do without. I can also provide you with a list of questions to ask as you're evaluating different models. As you're about to find out, you need to consider a wide variety of factors before you plunk down your money.

Mac or Windows — Does It Matter?

Here's a relatively easy one. Most — not all, but most — digital cameras work with both Macintosh and Windows-based PCs. By "work with," I mean that you can transfer pictures to the computer by cabling the camera directly to the computer. Of course, if the camera stores pictures on removable memory cards, you can buy a card reader and eliminate the need to connect camera and computer altogether. (See the upcoming section "Memory Matters" for more about this option.)

Nor do you need to worry that your Mac friends will have trouble opening your digital photos if you work on a PC, or vice versa. Today's cameras store images in formats that are compatible with both platforms. And you can buy good photo-editing programs for both, too, although the choices for Macintosh software are more limited than on the Windows side. (Visit Chapter 4 for tips on choosing software.)

Be sure to check out the computer-system requirements on the camera box before you buy, however. You may need to upgrade to the latest operating system or install more memory (RAM) to run the camera software. I suggest that you have at least 256MB of RAM; the more, the merrier.

Picture Quality Options

As with a film camera, the sophistication of the lens, focusing, and exposure systems all play a role in digital picture quality. But three digital-only features also have an impact: resolution (pixel count), file format, and ISO setting.

The next two sections offer advice for finding a camera that offers the appropriate resolution and file format options for the type of photography you want to do. The section "Exposure Exposed," later in this chapter, talks about ISO options.

Note that on many cameras, you adjust resolution and file format via a single control, with settings that have generic names such as "Good, Better, Best" or "Fine, Basic, Normal." Cameras that offer separate controls for these two picture settings offer the most flexibility, of course, but most casual users won't miss having the independent controls.

You say you want a resolution

Chapter 2 provides the full story on resolution, but here's a quick recap: Camera resolution refers to the number of pixels that a camera can capture. Pixels are the square "tiles" of color that comprise all digital images.

Camera resolution is usually stated in terms of *megapixels. Megapixel* means 1 million pixels. A 2-megapixel camera offers 2 million pixels, a 3-megapixel camera offers 3 million pixels, and so on.

In years past, megapixels were the leading sales attraction. Thanks to advertising that emphasized this camera feature, consumers quickly learned that they should covet more pixels, even if they weren't quite sure why.

Megapixels *were* a critical consideration when resolution offerings varied from less than a megapixel to 3 megapixels. You need at least a 1-megapixel image to print good snapshots, more for 5-x-7-inch prints or larger. And until recently, you had to buy at the top of the camera line to get that higher resolution.

Today, however, most cameras offer at least 3 megapixels — even sub-$100 models. Because 3 megapixels are enough to generate 8-x-10-inch prints, the megapixel competition is much less heated than it used to be, although camera cost is still somewhat tied to the megapixel count.

Does that mean you're wasting your money if you pony up for more than 3 megapixels? Not necessarily. How many megapixels are appropriate depends on how you like to use your photos. The following list offers some guidance:

- **VGA resolution (640 x 480 pixels):** If all you want to do with your photos is share them via e-mail, post them on a Web page, or use them in a multimedia presentation, you can get by with a VGA-resolution camera. But as for print quality, you're going to be disappointed. Again, see Chapter 2 if you're not sure how resolution affects print quality.

- **One megapixel:** With a 1-megapixel model, you can print acceptable snapshots. You also get plenty of pixels for any on-screen picture use.

- **Two megapixels:** With 2 megapixels, you can produce very good 5 x 7-inch prints and acceptable 8 x 10s.

- **Three megapixels:** With this many pixels, you can generate good 8 x 10s.

- **Four megapixels and up:** If you like to produce prints that are larger than 8 x 10, go for 4 megapixels or more.

Additional pixels also give you the flexibility to crop your pictures and then print the remaining image at a decent size. For example, getting close-ups of zoo inhabitants is pretty tough unless you have a super-long zoom lens. The left image in Figure 3-1 shows the tightest shot I could manage of a resident at

our local zoo. Fortunately, my camera offered a resolution high enough to allow me to crop out the excess background in my photo software and produce the tighter composition you see on the right.

TIP

If you do go the mega-megapixel route, find out whether the camera also offers you the flexibility of shooting at a lower resolution. Why? Because more pixels increase the amount of storage space you need to hold your picture files. Also, the image capture time at a higher resolution setting can be longer because the camera needs more time to capture all those added pixels. The best cameras offer a choice of two or three resolution settings, so that you can vary the pixel count depending on your available memory and the pace at which you want to snap off shots.

Bottom line: Unless you're interested in making very large prints or doing a lot of close cropping, 4 megapixels is plenty, and you'll likely be happy with only 3. So instead of paying a premium for the highest megapixel count on the market, put your money into a longer zoom lens, a good photo printer, or other accessories.

Figure 3-1: When you start out with more megapixels (left), you can crop your photos and still have enough pixels left to produce a quality print (right).

The war between CCD and CMOS

Image-sensor chips — the chips that capture the image in digital cameras — fall into two main camps: *CCD,* or charge-coupled device, and *CMOS* (pronounced *see-moss*), which stands for complementary metal-oxide semiconductor.

The main argument in favor of CCD chips is that they're more sensitive than CMOS chips, so you can get better images in dim lighting. CCD chips also tend to deliver cleaner images than CMOS chips, which sometimes have a problem with *noise* — small defects in the image.

On the other hand, CMOS chips are less expensive to manufacture, and that cost savings translates into lower camera prices. In addition,

CMOS chips are less power-hungry than CCD chips, so you can shoot for longer periods of time before replacing the camera's batteries.

CMOS chips also perform better than CCD chips when capturing highlights, such as the sparkle of jewelry or the glint of sunlight reflecting across a lake. CCD chips can suffer from *blooming,* which means creating unwanted halos around very bright highlights, while CMOS sensors do not.

Currently, an overwhelming number of cameras use CCD technology. But camera manufacturers are working to refine CMOS technology, and when they do, you can expect to hear more about this type of camera.

File format flexibility

Pixel count is an important factor in digital photo quality. But the file format you use to record your pictures also plays a key role. *File format* refers to the way that computer data is stored within the file.

Scads of formats exist, with a dozen or so created expressly for handling digital imagery and graphics. Digital cameras, however, rely on a trio of formats: JPEG, TIFF, and Camera Raw, or *Raw,* for short.

Chapter 5 provides full coverage of these formats, but here's a brief introduction:

- **JPEG (*jay-peg*):** This format is the standard for digital-camera images. All Web browsers and e-mail programs can display JPEG photos, which means that you can go straight from the camera to the online world. JPEG has a disadvantage, though: When JPEG files are created, they're *compressed,* a process that throws away some image data in order to shrink file sizes.

 Smaller files are great, allowing you to fit more pictures on a camera memory card and reducing the time required to share images online. But although a small amount of compression does little noticeable damage, a high degree of compression seriously degrades picture quality.

✓ **TIFF (*tiff,* as in *argument*):** Unlike JPEG, this format retains all critical image data. That means the best possible image quality, but also files that are significantly larger than JPEG files. And you can't share TIFF files online without first opening them in a photo editor and converting them to JPEG.

✓ **Camera Raw (or just Raw):** When you shoot in the JPEG or TIFF format, the camera does some post-capture processing to refine color, contrast, and other picture qualities. In the Raw format, none of these changes are applied. You get uncooked, "raw" data right from the image sensor.

This format is designed for photographers who want to control whether and how any tweaking is done to the image-sensor data, in the same way that some film experts like to develop and print their own negatives. Because no compression is applied, Raw files are larger than JPEG files. More important, you must use a special piece of software called a *Raw converter* to tell your computer how to translate all the raw data into a digital picture.

Note that some manufacturers give Raw files a proprietary label. For example, Nikon Raw files are called NEF files.

To help you better understand the impact of format on picture quality, Figures 3-2 and 3-3 show you the difference between an uncompressed TIFF image, a lightly compressed JPEG (see Figure 3-2), and a highly compressed JPEG (see Figure 3-3). Differences between the uncompressed TIFF and lightly compressed JPEG are hard to spot, especially in the larger versions of the image. But the negative impact of excessive compression is clear — not only does the picture take on a blocky look, but also exhibits random color defects, known in the trade as *color artifacts* or *color fringing*.

Figure 3-2: Only upon close inspection can you see much visual difference between an uncompressed TIFF image (left) and a lightly compressed JPEG image (right).

If you've visited Chapters 2 or 5, you'll recognize the subject in Figures 3-2 and 3-3 as the same one used in those chapters to illustrate the impact of pixel count on a photo. For Figures 3-2 and 3-3, all three images contain the same number of pixels; the only difference is the file format. You can see that extensive compression is just as detrimental as having too few pixels. Combine low resolution with lots of compression, and the result is a picture that really stinks.

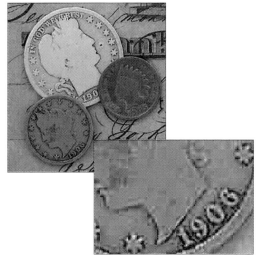

Cameras that enable you to choose from all three file formats offer the best of all worlds, of course. Even better, some cameras offer a JPEG+Raw or JPEG+TIFF option, which creates two

Figure 3-3: Heavy JPEG compression gives pictures a blocky look and causes random color defects.

versions of each picture: one in the JPEG format, for easy online sharing, and one in the TIFF or Raw format.

That said, unless you're a very demanding photographer and have the time and inclination to "process" your Raw files (a topic you can explore in Chapter 8), JPEG alone is just fine — add points for TIFF or Raw, but don't dismiss cameras that don't offer them. Just be sure that your camera offers a JPEG setting that applies minimum compression for times when picture quality is paramount.

In most cases, these compression settings go by vague names, such as Fine, Normal, and Basic. For example, Figure 3-4 shows the setting options on a Nikon camera that offers three JPEG quality options along with Raw and Raw+JPEG. In this case, the Fine, Normal, and Basic labels define compression, with Fine applying the least compression (for Fine picture quality).

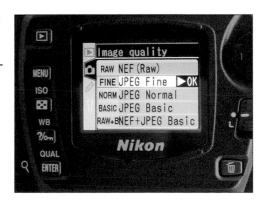

Figure 3-4: The file format options are often on the Image Quality menu.

Again, though, some manufacturers assign these same types of names to settings that either control the number of image pixels or control both resolution and file format together. So be sure that you know what option you're evaluating; check the camera manual for this information. Because analyzing image quality at all

the different settings is difficult to do just by looking at the camera monitor, reading the in-depth reviews published in print and online camera magazines pays off. (Chapter 16 points you toward some good online resources.)

Memory Matters

In a film camera, the film negative holds the picture information. In a digital camera, the picture data is stored in the camera *memory,* which you can think of as an electronic storage tank.

A few cameras have built-in memory (if you want to be hip, call it *on-board memory*). But most cameras now rely on removable memory cards or disks, sometimes referred to as *digital film.* You put a memory card or disk into a slot on the camera, as shown in Figure 3-5, just as you put a floppy disk into your computer or a videotape into your VCR.

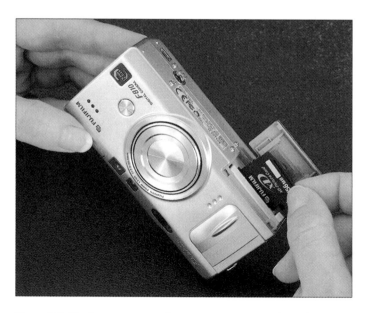

Figure 3-5: Most cameras store images on memory cards such as xD-Picture Card shown here.

For a look at some common types of removable camera memory, see Figure 3-6. I included the floppy disk primarily to give you an idea of the size of the other cards. With the advent of smaller, higher capacity options, floppy disks became dinosaurs in the memory game and only a few Sony cameras use them now.

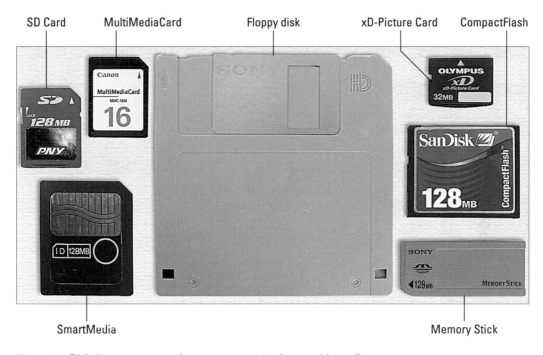

SD Card MultiMediaCard Floppy disk xD-Picture Card CompactFlash

SmartMedia Memory Stick

Figure 3-6: Digital cameras store pictures on a variety of removable media.

Again, almost all new cameras either provide a memory-card slot or give you the option of using on-board memory or removable media. But if you're considering a cardless model, keep these points in mind:

- ✔ When you fill up on-board memory, you have to stop shooting and either delete or download your photo files before you can take more pictures. After you fill up a memory card, though, you just take it out of the camera, insert another card, and keep shooting. Or you can buy a single, large-capacity card; most cameras accept cards that offer far more storage than is usually provided in on-board memory.

- ✔ When you download images to your computer, the transfer process is inconvenient if your camera offers only on-board storage. You have to cable together the camera and the computer, which often means crawling around the back of the computer looking for the right place to plug in the cable.

 With removable media, downloading images is painless. You can buy a card reader or adapter that enables your computer to see the memory card as simply another drive on your computer. When you want to download, you just take the card out of the camera, pop it into the reader or adapter, and move the files to the computer just as you move files from a floppy disk or CD.

✔ You can also print directly from media cards, either by using a printer that offers memory-card slots or taking your card into a photo lab for printing. Some printers do allow you to connect some cameras, via cable, for direct printing, but not all printer/camera combos offer this feature.

✔ Other electronics devices, such as some MP3 players, also store content on removable memory cards. So you may be able to get double duty from your memory cards.

As you can tell, I'm not a fan of cameras that offer only on-board memory. This is especially true if you're a parent buying a first camera for a young photographer who needs supervision to use the computer. Trust me, you don't want the hassle of firing up the computer, digging out the camera cable, and transferring pictures every half hour — which is about how long the average preteen takes to fill the typical amount of on-board storage. I empha-size this point because cameras marketed to this age group tend to be the ones that lack the removable memory option.

One last point about memory, whether on-board or removable: When com-paring cameras, look closely at the manufacturer's "maximum storage capac-ity" claims — the maximum number of images you can store in the available memory. The figure you see reflects the number of images you can store if you set the camera to capture the fewest number of pixels or apply the high-est level of JPEG compression, or both. So if Camera A can store more pic-tures than Camera B, and both cameras offer the same amount of memory, Camera A's images must either contain fewer pixels or be more highly com-pressed than Camera B's images. (See the JPEG information in the preceding section for more details about compression.)

Monitor, Viewfinder, or Both?

Most cameras have an LCD *(liquid-crystal display)* monitor to allow you to view the images stored in the camera, as shown in Figure 3-7. The LCD also displays menus that you use to change camera settings and delete images.

The ability to review and delete images right on the camera is one of the biggest benefits of digital photography. If an image doesn't come out the way you wanted, you erase it and try again. And of course, you enjoy the advan-tage of knowing that you captured the picture before you leave the scene or put away your camera.

On most cameras, the monitor can also provide a preview of your shot. In fact, some cameras lack a traditional *viewfinder* — the little window you look through to compose pictures when using a film camera — so you must frame your shots using the LCD monitor. Manufacturers omit the viewfinder either

to lower the cost of the camera or to allow a nontraditional camera design. I find it difficult to shoot pictures using only the monitor because you have to hold the camera a few inches away in order to see what you're shooting. If your hands aren't that steady, taking a picture without moving the camera can be tricky. When looking through the viewfinder, however, you can brace the camera against your face. Additionally, monitors tend to wash out in bright light, making it hard to see what you're shooting.

Viewfinder LCD monitor

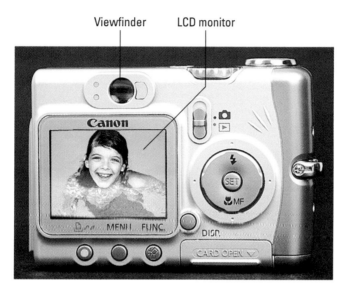

Figure 3-7: The LCD monitor enables you to review images immediately after you press the shutter button.

Clearly, though, many buyers are happy with having a monitor alone, or the camera makers wouldn't keep producing this style of camera. And I will say that monitors on the newest cameras are greatly improved, offering displays that are larger and better designed for bright-light viewing than in the past.

If you decide to go without a viewfinder, look for a camera that offers a feature designed to eliminate the blurring that can be caused by small camera movements. Depending on the manufacturer, this feature may be called *anti-shake, image stabilization,* or something similar. Also ask to try the camera outside in the sun to be sure that the picture on the monitor is easily viewable. Some cameras, like the Konica Minolta model shown in Figure 3-8, offer a monitor that swivels to allow for a better viewing angle; this feature is a definite plus.

On the other hand, if you decide that a viewfinder is critical, take a look at both traditional viewfinders — sometimes called *optical viewfinders* — and *electronic viewfinders*. Often referred to as an EVF, an *electronic viewfinder* is actually a tiny microdisplay, much like the monitor itself. The electronic viewfinder displays the same image that the camera lens sees, so you can shoot without worrying about parallax errors, a phenomenon that can occur with some optical viewfinders. (Chapter 7 has details.) However, some people (including me) don't like most electronic viewfinders because the display is less sharp than what you see through an optical viewfinder. Also, you usually can't see anything through the viewfinder until you turn the camera on, which means that you can't set up your shots without using up battery life.

Konica Minolta Photo Imaging, Inc.

Figure 3-8: Some monitors swivel to provide a choice of viewing angles.

SLR or Point-and-Shoot?

The majority of digital cameras are automatic, point-and-shoot models. They offer convenience and ease of use, providing autofocus, autoexposure, and auto just-about-everything else. But photographers who are used to working with a film SLR *(single-lens reflex)* camera or simply want to take more control over the picture-taking process may want to splurge on a digital SLR.

Most major names in film photography, including Nikon, Canon, Minolta, and Olympus, offer digital SLRs for the consumer market. Some models, like the Konica Minolta Maxxum 7D and Canon Digital Rebel XT, shown in the top row of Figure 3-9, look very much like their film counterparts; others, like the Olympus Evolt shown in the lower left part of the figure, take advantage of nontraditional design options made possible by digital technology. (To see Nikon's digital SLR, flip back to Figure 1-1, in Chapter 1.)

Digital SLRs provide the same range of features as film SLRs, including interchangeable lenses, manual focus and exposure controls, and connections for an external flash. And these cameras give you the best of two worlds: When you prefer to concentrate on picture composition, you can put the camera into fully automatic mode and let it handle exposure and focus decisions.

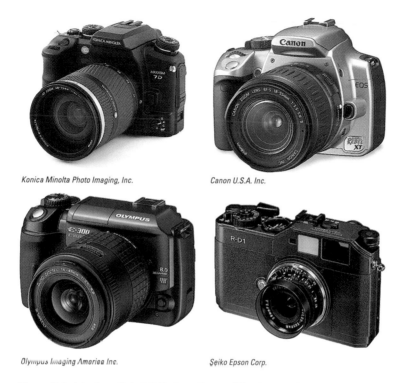

Konica Minolta Photo Imaging, Inc.

Canon U.S.A. Inc.

Olympus Imaging America Inc.

Seiko Epson Corp.

Figure 3-9: A look at digital SLRs from Canon, Minolta, and Olympus, plus a rangefinder model from Epson.

Of course, you pay more for this flexibility: The least expensive models start at about $700, and that buys just the camera body. You have to pony up more for the lens, just as when you invest in a film SLR.

Prefer rangefinder cameras to SLRs? You, too, can go digital, but expect to dig even deeper into your wallet. The Epson R-D1, shown in the lower-right corner of Figure 3-9, is priced at just under $3,000 — again, for the body only.

If you already have lenses, you may be able to use them with a digital body. But because of the differences between film and digital technology, a film lens produces a longer apparent focal length when used with a digital camera. The discrepancy varies from camera to camera; look for a spec called *multiplication factor* or *cropping factor* and then multiply that number by your lens focal length to find out how much increase to expect. For example, if the camera has a multiplication factor of 1.5, a 50mm lens on a film camera behaves like a 75mm lens on a digital camera. (For a detailed explanation of focal length, see the upcoming section "Fun facts about focal length.")

To make sure that you get expert advice in selecting a body and lens combination, I urge you to buy from a reputable camera store. I give this advice to people buying point-and-shoot cameras, too, but it's doubly important for SLR and rangefinder purchases because of the lens issues and larger financial investment.

Hybrid Cameras

As you shop, you'll encounter some devices that are part digital-still camera — that is, cameras that take still pictures, as opposed to movies — and part something else. Here's my take on the most common of these hybrids:

- **Webcams:** Sold for as little as $30, Webcams are simple video cameras designed for video conferencing and Internet telephony (making phone calls over the Internet). You sit in front of the camera, and the camera sends your image to your adoring online audience.

 Some Webcams can be untethered from the computer and used as a stand-alone camera. But most offer limited resolution — usually, 1 megapixel or less — and lack a monitor for reviewing your pictures. You may or may not be able to use removable memory. For these reasons, Webcams are best for people who have limited interest in or need for still photography.

- **Digital video cameras:** Show up with one of these devices and you'll be the envy of all the parents lugging traditional camcorders. However, when it comes to photos, don't expect the same quality that you get from a digital-still camera. In the same way, many digital-still cameras can record short movie clips but don't offer all the functions you expect from a video camera.

 Concord Camera Corp.
 Figure 3-10: This Concord hybrid records movies, takes still pictures, and plays digital music.

 That said, the convergence of the two technologies has gotten much better, so if you're as much interested in digital video as digital photography, do experiment with the combo models — you may find one that straddles both technologies well. You may also want to consider a product like the Concord DVx, shown in Figure 3-10. This model records MPEG-4 movies, can take 2 megapixel still pictures, and can even play MP3 music files.

 A good portion of this book applies to still pictures taken with a digital video camera, but for help with the video side of things, you may want to pick up a copy of *Digital Video For Dummies*, 3rd Edition, by Keith Underdahl (published by Wiley Publishing, Inc.).

✔ **Camera phones:** The newest addition to cellphone design is the built-in digital camera. After you snap a picture, you can attach it to an e-mail message that you send right from your phone. Or, if the recipient also has a camera phone, you can send the image to that phone. Depending on your service provider, you can also send the image from your phone to an online sharing site or printer. Some camera phones, including the Sanyo model shown in Figure 3-11, even have slots for removable memory cards.

Sending pictures via phone is fun and, perhaps more important, useful for communicating visual information quickly and conveniently. For example, a real-estate agent can snap and send an image of a hot new listing to a prospective client. But don't expect your phone to be a whole lot better at taking pictures than a camera is at making telephone calls. Even with phones that can take 1-megapixel stills, the picture quality is usually suspect; remember, a lot more goes into good images than pixels.

Sprint PCS Model by Sanyo
Figure 3-11: Camera phones are useful for instant sharing of visual information.

Flash Fundamentals

Film or digital, photography requires light. A flash is the most convenient way to provide the needed light for indoor or nighttime pictures. A flash can be handy when taking daytime pictures outdoors, too. You can use the flash to compensate for backlighting or to light a subject standing in the shade.

Most digital cameras now offer a built-in flash, but the array of flash-related options varies. The following list explains the most common flash features:

✔ **Basic flash controls:** Usually, you get at least three flash settings: *automatic* (the flash fires only when the camera thinks the light is too low); *fill flash* (the flash fires no matter what); and *no flash.* If the camera has an automatic flash, you definitely want the other two modes as well so that you, and not the camera, ultimately control whether the flash fires.

✔ **Red-eye reduction:** Most cameras also offer a *red-eye reduction mode,* which is designed to reduce the problem of a flash-induced red glint to subjects' eyes. I'm not too worried about this option because it usually doesn't work that well and you can always cover up red-eye in your photo software. See Chapter 13 for details.

✔ **Advanced flash features:** Higher-end cameras usually add *slow sync mode,* which produces brighter backgrounds in dim lighting than standard flash. Some cameras also enable you to raise or lower the intensity of the flash slightly, which can be helpful in tricky lighting situations. Give extra points to cameras offering these options.

✔ **External flash connection:** With
SLRs and some high-end point-and-
shoot models, you can add an exter-
nal flash unit, either via a *hot shoe*
connection (shown in Figure 3-12) or
a flash cable. These options are
attractive to professionals and
advanced hobbyists, but casual pho-
tographers can get by without them.
Note that if your camera doesn't
offer an external flash connection,
you can always use a *slave flash,*
which is a stand-alone flash that
fires when it "sees" your on-board
flash go off.

For tips on flash photography, see
Chapter 6.

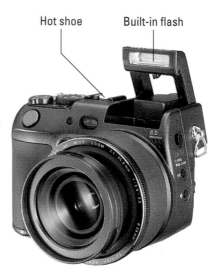

Hot shoe Built-in flash

Olympus Imaging America Inc.

Figure 3-12: A hot shoe enables you to
attach an external flash unit.

Through a Lens, Clearly

When shopping for a digital camera, many people get so caught up in the details
of resolution, compression, and other digital options that they forget to think
about some of the more basic, but just as essential, camera features. The lens
is one of those components that is often overlooked — and shouldn't be.

Serving as your camera's "eye," the lens determines what your camera can
see — and how well that view is transmitted to the CCD or CMOS chip for
recording. The following sections explain some of the lens details to consider
as you evaluate different cameras.

Fun facts about focal length

Different lenses have different *focal lengths.* On film cameras, focal length is
a measurement of the distance between the center of the lens and the film.
On a digital camera, focal length measures the distance between the lens
and the image sensor. For both types of cameras, focal length is measured in
millimeters.

Don't get bogged down in the scientific gobbledygook, though. Just focus —
yuk, yuk — on the following focal length facts:

✔ Focal length determines the lens's angle of view and the size at which your subject appears in the frame:

- **Wide-angle:** Lenses with short focal lengths are known as *wide-angle* lenses. A short focal length has the visual effect of "pushing" the subject away from you and making it appear smaller. As a result, you can fit more of the scene into the frame without moving back.

- **Telephoto:** Lenses with long focal lengths are called *telephoto* lenses. A long focal length seems to bring the subject closer to you and increases the subject's size in the frame.

- **"Normal":** On most point-and-shoot cameras, a focal length in the neighborhood of 35mm is considered a "normal" lens — that is, somewhere between a wide-angle and a telephoto. This focal length is appropriate for the kinds of snapshots most people take.

✔ Cameras that offer a zoom lens enable you to vary focal length. As you zoom in, the focal length increases; as you zoom out, it decreases.

✔ A few cameras offer dual lenses, which usually provide a standard, snapshot-oriented focal length plus a telephoto focal length. In addition, some cameras have *macro* modes, which permit close-up photography. Dual-lens cameras are different from zoom lens cameras, which offer the ability to shoot at any focal length along the zoom range. For example, a 38–110mm zoom can be placed at any focal length between its maximum and minimum settings: 38mm, 50mm, 70mm, and so on. A dual-lens 38mm/70mm camera has only the two focal-length settings.

✔ To get a visual perspective on focal length, take a look at Figure 3-13. Here, you see the same scene captured at four different focal lengths. As the focal length increases, the lens can capture less and less of the landscape.

✔ Note that the focal lengths I mention here aren't the true numbers for these cameras. Rather, they indicate the *equivalent* focal length provided by a lens on a 35mm-format film camera. Because of the way digital cameras are designed, the actual focal lengths don't really provide any useful information for the photographer. So manufacturers provide a "lens equivalency" number. Advertisements and spec sheets for cameras include lens statements such as "5mm lens, equivalent to 35mm lens on a 35mm-format camera."

This book takes the equivalency approach as well. So if I mention a lens focal length, I'm using the equivalent value.

24mm

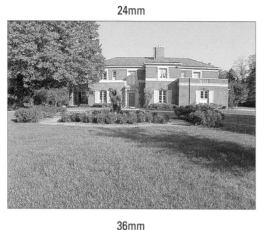

35mm

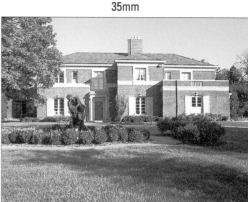

36mm

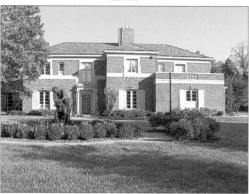

38mm

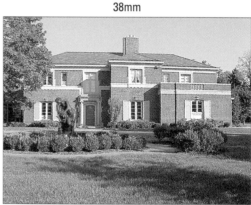

Figure 3-13: Focal length determines how much of a scene a lens can capture and how large subjects appear in the frame.

Now that you understand what those little lens numbers mean on the digital camera boxes, you can choose a camera that offers a lens appropriate for the kind of shooting you plan to do. Again, a standard, 35mm (equivalent) lens is good for taking ordinary snapshots. If you want to do a lot of landscape shooting, you may want to look for a slightly shorter focal length because that enables you to capture a larger field of view. A wide-angle lens is also helpful for shooting in small rooms; with a standard 35mm, you may not be able to get far enough away from your subject to fit it in the frame.

Some wide-angle lenses cause a problem known as *convergence,* a distortion that makes vertical structures appear to lean toward the center of the frame. If you plan to do a lot of wide-angle shooting, be sure to take some test pictures to check for this issue before buying a camera.

Optical versus digital zoom

As the preceding section explains, zoom lenses give you a closer view of far-away subjects. A zoom lens is especially great for travel photography and is also good for portraits or still-life shots in which you want to shoot a subject without including a large amount of background. (Chapter 7 illustrates this technique.)

If a zoom lens is important to you, be sure that the camera you buy has an *optical zoom.* An optical zoom is a true zoom lens. Some cameras instead offer a *digital zoom,* which is nothing more than some in-camera image processing. When you use a digital zoom, the camera enlarges the image area at the center of the frame and trims away the outside edges of the picture. The result is the same as when you open an image in your photo-editing program, crop away the edges of the picture, and then enlarge the remaining portion of the photo. Enlarging the "zoomed" area reduces the image resolution and the image quality.

For a better understanding of resolution, see Chapter 2; for more information about digital and optical zooms, see Chapter 7.

Focusing aids

Some cameras have *fixed-focus* lenses, which means that the point of focus is unchangeable. Usually, this type of lens is engineered so that images appear in sharp focus from a few feet in front of the camera to infinity.

Many cameras enable you to adjust the focus point for three different distances. Among the settings are *macro mode* for extreme close-ups, *portrait mode* for subjects a dozen feet from the camera, and *landscape mode* for distant subjects.

Different cameras offer different focus ranges, which is probably most important in the area of close-up photography. Some cameras enable you to get very near your subject, but other cameras are a bit limiting in this regard. If you want to do a lot of close-up work, check the minimum subject-to-camera distance of a camera before you buy. Also note that because of the short focal lengths of their lenses, digital cameras typically offer extreme *depth of field,* which means that the zones of sharp focus are far greater than with a film camera.

Cameras with *autofocus* automatically adjust the focus depending on the distance of the subject from the lens. Most cameras with autofocus abilities offer a very useful feature called *focus lock.* You can use this feature to specify exactly which object you want the camera to focus on, regardless of the object's position in the frame. Usually, you center the subject in the viewfinder, press the shutter button halfway down to lock the focus, reframe, and then snap the picture.

Digital SLRs and a few high-end point-and-shoot models offer the option to switch from automatic to manual focusing, giving you complete control over the focus range. On SLRs, you adjust focus by twisting a manual focus ring on the lens barrel, just as with a film SLR. On the point-and-shoot models, you usually set the focus point a specific distance from the camera — 12 inches, 3 feet, and so on — via a menu that's displayed on the LCD monitor.

However you implement it, manual focus is a desirable option even for those whose photographic interests aren't advanced enough to demand it. Sometimes, autofocusing mechanisms have trouble getting the focus right when you're shooting a complex scene. If you're taking a picture of a tiger in a cage, for example, the autofocus may lock onto the cage instead of the tiger. Setting the focus yourself may be the only way to make sure that the subject is in sharp focus.

For more insights about focus, see Chapter 6.

Lens adaptability

Digital SLRs allow you the same lens flexibility you get with film SLRs. You also can add color and effects filters, just as you can with film models.

If you're a serious photography buff but not ready to invest in a digital SLR, you may want to buy a point-and-shoot model that accepts lens adapters and filters. Many cameras now sport lens designs that enable you to screw on wide-angle, fish-eye, or close-up lens adapters. Several third-party companies also offer adapters and filters for popular cameras.

 You also can attach color filters, such as a warming or cooling filter, to some point-and-shoot lenses. However, such filters may be unnecessary because you can create some of the effects that they produce by changing the *white balance* setting. (See Chapter 5 for details.) You also can mimic the look of many traditional filters by applying special effects in a photo editor. About the only filter effect you can't reliably re-create in a photo editor is the glare-reduction properties of a polarizing filter.

Exposure Exposed

As Chapter 2 explains, image exposure is affected by shutter speed, aperture, and ISO. Chapter 6 provides a thorough explanation of how to manipulate exposure, but how much flexibility you have in that department depends on your camera's exposure controls. So here's a quick rundown of what to make of the exposure-control specs you may encounter when you shop for cameras:

- **Programmed autoexposure** is fully automatic exposure. The camera selects both the proper aperture and shutter speed for you.

- **Aperture-priority autoexposure** means that you select the aperture, and the camera sets the appropriate shutter speed. The most common use for this setting is to shift depth of field (the zone of sharp focus). On low-priced cameras, you typically get only two aperture settings: one for dim light and another for bright light. Higher-end cameras offer a larger range of apertures.

- **Shutter-priority autoexposure** means that you select the shutter speed, and the camera chooses the aperture. This feature is helpful for capturing moving subjects; the shutter speed selected by the programmed autoexposure may not be quick enough to "stop the action."

- **Manual exposure** allows you to set both shutter speed and aperture. The range of shutter speeds and aperture settings depends on the camera.

- **EV compensation** enables you to increase or decrease the exposure setting chosen by the automatic exposure mechanism. This control is very helpful and, thankfully, provided on most cameras.

- **Automatic bracketing** captures a series of shots, each at a different exposure, with one press of the shutter button. For example, I shot the images in Figure 3-14 using this feature. Many photographers routinely shoot the same scene at different exposures — called *bracketing the shot* — to make sure that they get a least one image with an exposure that's correct. Some people also combine the darkest exposure and lightest exposure in a photo editor to achieve an image that has better detail in both the shadows and highlights than you can get from a single exposure.

Figure 3-14: Automatic bracketing records multiple images, each using different exposure settings, with one press of the shutter button.

- **Metering modes** determine how the camera evaluates the available light when determining the correct exposure:

 - **Spot metering** sets the exposure based on the center of the frame only.

 - **Center-weighted metering** reads the light in the entire frame but gives more importance to the center of the frame.

 - **Matrix or multizone metering** reads the light throughout the entire frame and chooses an exposure that does the best job of capturing both the brightest and darkest regions of the picture.

 Lower-priced cameras typically provide only the last metering mode, which works well for everyday pictures. More advanced cameras add the first two modes, which are helpful for shooting in tricky light.

- **Scene modes** are special shooting modes that automatically select an aperture and shutter speed that's appropriate for specific shooting conditions. For example, portrait mode is designed for taking people shots, while sports mode is geared to action photography. This feature is great for photographers who want creative flexibility without spending more money for a camera that offers manual exposure controls.

- **ISO** affects the camera's sensitivity to light. Newer digital cameras may offer a wide range of ISO settings. The higher the ISO, the less light is required to capture the image. But a higher ISO also usually results in a grainy or "noisy" image. This problem is hard to detect when looking at the camera monitor; you need to read reviews to find out how the camera you're considering performs at each of its available ISO settings. Until you know that you can produce good images at the highest settings, don't pay more for that extended ISO range.

Discount-store bargains — really a good buy?

You're cruising through the aisles of your neighborhood discount store. Just past the table of slightly imperfect waterbed sheets and the rack of 24-roll, megasaver toilet-paper packages, you spot a display of digital cameras. Wow! Digital cameras at deep discounts? Is this your lucky day? Or are you looking at a deal that's too good to be true? Maybe . . . maybe not.

Although you *can* get a good buy at deep-discount stores, you need to shop armed with plenty of data to be sure that you get a real bargain. Off-price stores and even major electronics chains often feature last year's cameras. Although these cameras may be just fine from a quality and performance standpoint, they don't usually represent the best price/feature ratio, even when they're sold at a huge discount to the original retail prices.

Each year, manufacturers refine production processes to develop better, cheaper digital cameras. Most vendors also manufacture digital cameras in greater quantities now than in past years, which has lowered the per-unit cost even further. As a result, you may get more features for the same or less money if you opt for the manufacturer's newest model.

Still More Features to Consider

The preceding sections cover the major features to evaluate when you're camera shopping. Explore the rest of this chapter to discover some additional options that may also be important to you, depending upon the kind of photography you want to do.

Now playing, on your big-screen TV

Many cameras offer *video-out* capabilities. Translated into plain English, this means that you can connect your camera to your television and display your pictures on the TV screen, as shown in Figure 3-15, or record the images on your VCR.

Figure 3-15: You can connect some cameras to a TV for picture playback.

When might you use such a feature? One scenario is when you want to show your pictures to a group of people — such as at a seminar or family gathering. Let's face it, most people aren't going to put up with crowding around your 15-inch computer monitor for very long, no matter how terrific your images are.

You may sometimes hear video-out called *NTSC output*. NTSC, which stands for National Television Standards Committee, refers to the standard format used to generate TV pictures in North America. Europe and some other parts of the world go by a different standard, known as *PAL*, an acronym for *phase alteration line-rate*. You can't display NTSC images on a PAL system.

Keep in mind that while video output is a cool feature, you can also buy stand-alone playback devices for viewing pictures from a memory card. Chapter 10 offers a look at one such product. Some DVD players even sport memory-card slots.

In addition to video input/output options, some cameras enable you to record audio clips along with your images. So when you play back your image, you can actually hear your subjects shouting "Cheese!" as their happy mugs appear on-screen.

Self-timer and remote control

Many cameras offer a *self-timer* mechanism. Just in case you haven't had experience with this particular option, a self-timer enables the photographer to be part of the picture. You press the shutter button, run into the camera's field of view, and after a few seconds, the picture is snapped automatically.

A few cameras take the self-timer concept one step further and provide a remote control unit that you can use to trigger the shutter button while standing a few feet away from the camera.

There's a computer in that camera!

All digital cameras include some computer-like components — chips that enable them to capture and store images, for example. But some of the newer models have bigger "brains" that enable them to perform some interesting functions that otherwise require a full-fledged computer. Here are some features you can find on such cameras, which some pundits have described as *camputers:*

- **Time-lapse photography:** Some cameras provide a time-lapse shooting option that tells the camera to take a picture automatically at specified intervals. If you need to take pictures of events that occur over a long period of time — a flower opening and closing its blooms, for example — look for this feature.

- **On-board image correction:** Many cameras enable you to perform basic image correction without ever downloading pictures to your computer. You can apply sharpening and color correction, for example. Usually, you select the correction options before you snap the picture, and the corrections are applied as the image is saved to memory. Some cameras also offer red-eye removal, which you can apply after reviewing a picture.

 I'm not a big fan of this feature because you don't get the same kind of control over the correction as you do when fixing images yourself using even a basic image editor. But on-board editing can come in handy if you

use a printer that can print directly from your camera or removable memory card. The on-board processing can improve print quality in this scenario. And some of the in-camera red-eye removal filters that I've seen do work pretty well, although you should test this feature for yourself. Sometimes, these filters can be pretty clumsy.

✓ **PictBridge:** This technology enables digital cameras and photo printers to communicate. If your camera offers this technology, you can connect it to any PictBridge-enabled printer, even if the camera and printer are from different manufacturers. Then you can print your pictures without using a computer as a middleman.

✓ **DPOF:** Another printing-related specification, DPOF *(dee-poff),* indicates that you can set up a print job through the camera's menus and also tag images for later printing. Cameras that offer DPOF technology don't always include PictBridge, however.

As an alternative to connecting your camera to your printer, you can buy a printer that can print from memory cards. You also can simply take your memory cards to most any retail photo lab or even your corner drugstore for printing. Chapter 9 discusses printing options in more detail.

Action-oriented options

Shooting action with digital cameras can be difficult because most cameras need a few seconds between shots to process an image and store it in memory. Some newer cameras have been engineered to enable more rapid shooting, however. If action photography is important to you, I recommend visiting the manufacturer Web sites to find out which of their models are geared to fast shooting.

Some cameras also offer a *continuous-capture mode,* often referred to as *burst* mode. With this feature, you can record a series of images with one press of the shutter button. The camera waits until after you release the shutter button to perform most of the image-processing and storage functions, so lag time is reduced.

Note that I said *reduced,* not *eliminated.* You can usually shoot a maximum of two or three frames per second. That's a fast capture rate, but it's still not quick enough to catch every moving target. See Chapter 7 for more information.

As an alternative action-shot feature, some cameras enable you to record a "mini movie" in a digital video format, such as MPEG. You can capture images and sounds for a short period of time and then play the moving images on your TV or on any computer that has software for opening and playing the movie files.

Little things that mean a lot

When you're shopping for digital cameras, you can sometimes focus so much on the big picture (no pun intended) that you overlook the details. The following list presents some features that may not seem like a big deal in the store, but can really frustrate you after you get the camera home:

- **Batteries:** Thinking about batteries may seem like a trivial matter, but trust me, this issue becomes more and more important as you shoot more and more pictures. On some cameras, you can suck the life out of a set of batteries in less than an hour of shooting, even quicker if you keep the LCD monitor turned on.

 Some cameras can accept AA lithium batteries, which have about three times the life of a standard AA alkaline battery — and cost twice as much. Other cameras use rechargeable NiCad or NiMH batteries or 3-volt lithium batteries, and others can accept only regular AA alkaline batteries.

 Be sure to ask which types of batteries the camera can use and how many pictures you can expect to shoot on a set of batteries. Then factor that battery cost into the overall cost of camera ownership. Some cameras come with a battery charger and batteries, which adds up to major savings over time.

- **AC adapters:** Many cameras offer an AC adapter that enables you to run the camera off AC power instead of batteries. Some manufacturers include the adapter as part of the standard camera package; others charge extra.

- **Ease of use:** Have the salesperson demonstrate how you operate the various camera controls, and try those controls yourself. How easily can you delete a picture, for example, or change the resolution? Are the controls clearly labeled and easy to manipulate? If not, the camera may ultimately frustrate you.

- **Tripod mount:** As with a film camera, if you move a digital camera during the time the camera is capturing the image, you get a blurry picture. And holding a camera steady for the length of time it needs to capture the exposure can be difficult, especially when you're using the LCD as a viewfinder or when you're shooting in low light (the lower the light, the longer the exposure time). For that reason, using a tripod can greatly improve your pictures.

Tripod socket

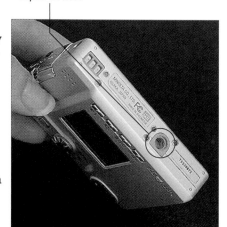

Figure 3-16: The screw socket on the bottom of the camera is for attaching a tripod.

In order for you to use a tripod, though, your camera must have a tripod mount — that is, a socket into which the tripod can be screwed, as shown in Figure 3-16.

✏ **Physical fit:** Don't forget to evaluate the personal side of the camera: Does it fit into your hands well? Can you reach the shutter button easily? Can you hold the camera steady as you press the shutter button? Do you find your fingers getting in the way of the lens, or does your nose bump up against the LCD when you look through the viewfinder? Is the viewfinder large enough that you can see through it easily? Don't just run out and buy whatever camera a friend or magazine reviewer recommends — make sure that the model you select is a good fit for you.

✏ **Durability:** Does the camera seem well built, or is it a little flimsy? For example, when you open the battery compartment, does the little door or cover seem durable enough to withstand lots of opening and closing, or does it look like it might fall off after 50 or 60 uses?

✏ **Computer and camera hookups:** Today's cameras connect via a USB port (*Universal Serial Bus*), found on all later model computers. (You can buy a USB hub to add more ports to your system if needed.) If you're buying a used or discontinued camera, it may connect via a serial port. Some models also offer a wireless connection through technologies including IrDA and Bluetooth.

Some novice-oriented cameras offer a "one-button transfer" feature. After connecting the camera to the computer, you press a button to automatically launch the camera's image-transfer software and move your pictures from camera to computer. You can even send images to friends and family via the Web through a similar automated process.

Whether you need such handholding or not, make sure that the connection provided by the camera works with your system — or that you can buy whatever adapters may be needed to bring the two devices together. Some cameras require that you buy an accessory "docking station" in order to enjoy the automatic transfer function. Other models ship with the dock, which sometimes also serves as a battery charger, printer, or both.

If you're buying a camera that records pictures on removable media, of course, you can always transfer images through a card reader instead of hooking the camera directly to the computer. But just as a backup, you should be able to connect your camera "the old-fashioned way" if necessary. You also may need to connect the camera to the computer to download and install updates to the camera's *firmware* — the internal software that runs the camera.

✏ **Software:** Every camera comes with software for downloading images. But many also come with basic photo-editing software. Because the programs included with cameras typically retail for under $50, having an image editor included with the camera isn't a huge deal. Then again, 50 bucks is 50 bucks, so if all other things are equal, software is something to consider.

> ✏ **Warranty, restocking fee, exchange policy:** As you would with any
> major investment, find out about the camera's warranty and the return
> policy of the store. Be aware that some major electronics stores and
> mail-order companies charge a *restocking fee,* which means that unless
> the camera is defective, you're charged a fee for the privilege of return-
> ing or exchanging the camera. Some sellers charge restocking fees of 10
> to 20 percent of the camera's price.

Sources for More Shopping Guidance

If you read this chapter, you should have a solid understanding of the fea-
tures you do and don't want in your digital camera. But I urge you to do some
more in-depth research so that you can find out the details on specific makes
and models.

First, look in digital photography magazines as well as in traditional photog-
raphy magazines such as *Shutterbug* for reviews on individual digital cameras
and peripherals. Some of the reviews may be too high-tech for your taste or
complete understanding, but if you first digest the information in this chapter
as well as Chapter 2, you should be able to get the gist of things.

If you have Internet access, you can also find good information on several
Web sites dedicated to digital photography. See Chapter 16 for suggestions
on a few Web sites worth visiting.

Computer magazines and Web sites routinely review digital cameras, too, but I
find their commentary less helpful than what's available from sources whose
main concern is photography. For example, I've seen reviews in a leading
computer magazine that award the publication's highest rating to a camera
even though the reviewer calls the image quality only "fair." Call me crazy
(many do), but I think that a camera isn't deserving of a good rating, let alone
the highest possible marks, if it can't produce excellent images!

Extra Goodies for Extra Fun

In This Chapter

▶ Buying and using removable storage media

▶ Transferring images to your computer the easy way

▶ Choosing a digital closet (storage solutions)

▶ Seeking out the best imaging software

▶ Stabilizing and lighting your shots

▶ Protecting your camera from death and destruction

▶ Pushing the cursor around with a pen

Do you remember your first Barbie doll or — if you're a guy who refuses to admit playing with a girl's toy — your first G.I. Joe? In and of themselves, the dolls were entertaining enough, especially if the adult who ruled your household didn't get too upset when you tried stuff like shaving Barbie's head and seeing whether G.I. Joe was tough enough to withstand a spin in the garbage disposal. But Barbie and Joe were even more fun if you could talk someone into buying you some of the many doll accessories on the toy-store shelves. With a few changes of clothing, a plastic convertible or tank, and loyal doll friends like Midge and Ken, Dollworld was a much more interesting place.

Similarly, you can enhance your digital photography experience by adding a few hardware and software accessories. Digital camera accessories don't bring quite the same rush as a Barbie penthouse or a G.I. Joe surface-to-air missile, but they greatly expand your creative options and make some aspects of digital photography easier.

This chapter introduces you to some of the best camera accessories, from adapters that speed the process of downloading images, to software that enables you to retouch and otherwise manipulate your photographs. If you begin buttering up your loved ones now, I just know that one of them will cave and buy you one of these goodies soon.

Note that all the prices I quote in this chapter and elsewhere are "street prices" — what you can expect to pay in retail or online stores. Because prices for many digital imaging products seem to drop daily, you may be able to get even more for your money than at the time this book was printed.

Memory Cards and Other Camera Media

If your camera stores pictures on removable storage media, you may have received one memory card or disc with your camera. At minimum, cameras that include removable media in the box typically provide at least 16MB of storage capacity.

In the days when digital cameras produced only low-resolution images, 16MB was more storage space than most people needed on a regular basis. But because today's models can capture many more pixels than cameras even a few years old, 16MB now represents just a starting point for most digital photographers.

The good news is that most types of removable camera memory are now very affordable. You can buy a 256MB card for about $30, less if you watch the sale ads.

How many pictures can a memory card hold? That depends on what resolution and file format you use when you shoot those images. Resolution and file format both contribute to the size of the image file, and, therefore, how much memory it consumes. (See Chapter 3 for a full explanation of this issue.)

As an example, Table 4-1 shows approximately how many pictures can fit in various amounts of memory. The table assumes that the picture is taken using the JPEG file format with a minor amount of compression — a setting that translates to good picture quality. If you prefer to shoot in the Raw or TIFF format, your files are substantially larger. On the other hand, if you use a lower-quality JPEG setting, file sizes are much smaller.

Your camera manual should provide a table that lists the file sizes of pictures taken at each of the resolution and format settings the camera offers. Use these numbers as a guide to how many megabytes of storage you need. Keep in mind that the more memory you can carry with you, the less often you need to stop shooting and download pictures to your computer.

Table 4-1	How Many Pictures Can a Memory Card Hold?			
Resolution	*16MB*	*32MB*	*64MB*	*128MB*
1 megapixel	17	34	68	136
2 megapixels	12	24	48	96
3 megapixels	9	18	36	72
4 megapixels	6	12	24	48

Approximate storage capacity based on high-quality JPEG images (minimum compression).

Memory shopping tips

Here are a few other pointers on buying camera memory:

✔ Most cameras can use only one type of memory, so check your manual for specifics. (For a look at the most popular types of removable memory, see Chapter 3.) You don't have to buy any particular brand, though; it's the type of card that's important — CompactFlash, Memory Stick, and so on.

✔ Some cards are designated as high-speed cards. These cards can record picture data more quickly than standard cards — a benefit that's especially important to people who take lots of action shots. However, high-speed cards cost more, and the extra expense may not be worthwhile. First, your camera must be engineered to take advantage of the higher-speed cards (most point-and-shoot models are not). Second, you probably won't notice a difference unless you're shooting at high resolutions — say, 5 megapixels or more. So check your manual or the manufacturer's Web site for recommendations before you shell out additional cash for a high-speed card.

✔ As with other commodities, you pay less per megabyte when you buy "in bulk." A 256MB card costs less per megabyte than a 32MB card, for example.

✔ One last tip for owners of cameras that use SmartMedia cards: Most manufacturers have abandoned SmartMedia as a storage option, which means that these cards are becoming hard to find at a decent price. You may want to shop eBay or a similar outlet if you're in the market for SmartMedia cards. The cards come in two different voltages, 3.3 volts and 5 volts, so be sure that you buy the right type. Also note that some cameras can't use the highest-capacity SmartMedia cards. Check your camera manual for specifics on the type and capacity of card to buy.

Care and feeding of memory cards

To protect your memory cards — as well as the images they hold — pay attention to the following care and maintenance tips:

- ✓ When you insert a card into your camera for the first time, you may need to format the card so that it's prepared to accept your digital images. Look in your camera manual for information on how to do this formatting.

 Be careful *not* to format a card that already contains pictures, however. Formatting erases all the data on a card.

- ✓ Never remove the card while the camera is still recording or accessing the data on the card. (Most cameras display a little light or indicator to let you know when the card is in use.)

- ✓ Don't shut off the camera while it's accessing the card.

- ✓ Avoid touching the contact areas of the card. On a CompactFlash card, for example, keep your mitts off the connector on the bottom of the card; on a Secure Digital card, the little gold strips are the no-touch zone. (Most cards ship with a little flyer that alerts you to the sensitive spots on a card.)

- ✓ If your card gets dirty, wipe it clean with a soft, dry cloth. Dirt and grime can affect the performance of memory cards.

- ✓ Try not to expose memory cards to excessive heat or cold, humidity, static electricity, and strong electrical noise. You don't need to be overly paranoid, but use some common sense.

- ✓ Ignore rumors about airport security scanners destroying data on memory cards. Although scanners can damage film, they do no harm to digital media.

- ✓ To keep your cards safe while not in use, store them in their original plastic sleeves or boxes. For a handy way to store and carry multiple cards, invest in a memory card wallet. The Lowepro version shown in Figure 4-1 has compartments for batteries as well as memory cards (www.lowepro.com).

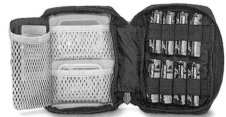

Lowepro USA

Figure 4-1: A memory-card wallet provides safe storage for spare cards.

Download Devices

In years past, most digital cameras came with a serial cable for connecting the camera to the computer. To download images, you plugged the cable into both devices and used special image-transfer software to move the pictures from camera to computer. This method of file transfer was excruciatingly slow — transferring a dozen pictures could easily take 20 minutes or more.

Thankfully, manufacturers have now switched to USB technology for camera-to-computer connections. (In case you're wondering, USB stands for *Universal Serial Bus.*)

With USB, images flow from camera to computer much more quickly. But you still have to track down that camera cable every time you want to transfer pictures to the computer. And you must keep the camera turned on during the transfer process, so unless your camera came with an AC adapter, you waste battery power.

For a better solution, consider the following products:

✓ **Memory card reader:** A card reader is a device that enables you to transfer images directly from a memory card. You can buy an internal reader that installs into an empty expansion slot on your computer or an external reader that connects via USB. Either way, your computer "sees" the reader as just another drive on the system. You insert a memory card into the reader and then drag and drop the files from the reader to your hard drive, just as you would copy files from a CD-ROM or floppy disk.

You can buy card readers that accept a single type of memory card for about $10, but for added flexibility and long-term functionality, you may want to invest a little more and get a multi-format reader such as the SanDisk model shown in Figure 4-2, which accepts 12 different types of cards. If you buy a camera down the road and the camera uses different media than your old one, you won't need to buy a new reader. You also can download images taken by visitors whose cameras use different media than yours.

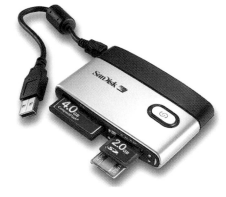

SanDisk Corporation

Figure 4-2: A memory card reader simplifies the picture-download process.

If your computer is relatively new, you may already have a card reader. Many manufacturers now offer built-in readers for the most popular types of memory.

✔ **PC Card adapter:** Laptop computers often have a slot for connecting PCMCIA devices (such as modems and external hard drives), commonly known as PC Card devices. You can buy adapters that enable various types of memory cards to fit those slots. Figure 4-3 offers a glimpse of an adapter for a CompactFlash card. After putting the memory card in the adapter, as shown in the figure, you insert the whole she-bang into the PC Card slot. The PC Card shows up as a drive on your computer, and you drag and drop image files from the card to your hard drive. The cost of a PC Card adapter varies depending on the type; expect to pay between $10 and $50.

MediaGear

Figure 4-3: This adapter from MediaGear (www.mymediagear.com) makes CompactFlash cards compatible with a laptop's PC Card slot.

✔ **Docking stations:** For some cameras, you can buy accessory *camera docks* that also simplify the image-transfer process. A dock is a small base unit that you leave permanently connected to your computer, usually via a USB cable. To download pictures, you place the camera into the dock, press a button or two, and the dock, camera, and computer work together to automatically start the transfer process.

Most docks also serve as the camera's battery charger, and some offer features that simplify e-mailing and printing pictures. You can even buy docks that have a built-in snapshot printer, such as the Kodak model shown in Figure 4-4.

A few cameras ship with a docking station; sold alone, docks usually run in the $50 to $150 range, depending on whether they incorporate a printer. Check your camera manufacturer's Web site to see what types of docks may be available, if any, for your camera.

✔ **Photo printer with memory card slots:** If you have a photo printer that can print directly from your camera's memory card, you may be able to transfer images to the computer by way of the printer instead of investing in a separate card reader. This option may not work well — or at all — with some printers, especially those that connect via a parallel port, which doesn't offer very fast data-transfer speeds. But if you already own a printer that has memory card slots (or are in the market for a new printer), check the manual to find out whether this transfer option is available to you.

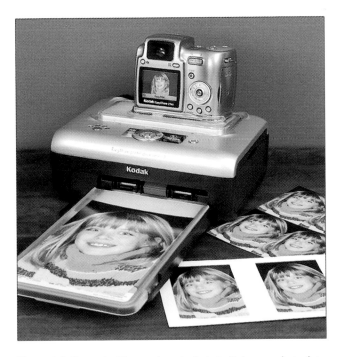

Figure 4-1: Some docking stations include built-in snapshot printers.

Storing Your Picture Files

In the professional digital-imaging world, the hot new topic is *digital asset management.* Digital asset management — which, incredibly, is often referred to by its initials — simply refers to the storing and cataloging of image files. Professional graphic artists and digital photographers accumulate huge collections of images and are always striving for better ways to save and inventory their assets.

Your image collection may not be as large as that of a professional photographer's, but at some point, you, too, need to think about where to keep all those photos you take. You may be at that point now if you shoot high-resolution pictures and your computer's hard drive — the thing that stores all your data files — is already cramped for space.

Additional storage options are plentiful. Provided that you have the cash, you can add as many digital closets and shoe boxes to your system as you want. For starters, you can add an additional hard drive to your computer. An 80GB external drive costs about $70.

Although adding a second hard drive may temporarily solve your picture storage concerns, you also should invest in a storage device that stores data on removable media. Because hard drives do fail on occasion, making backup copies on removable media is a necessity. In addition, this option enables you to give copies of your picture files to other people, something you can't do if you have only a hard drive for image storage.

The following list offers my take at the three most popular removable media devices for home and small-office users (Chapter 8 introduces you to some cataloging programs that can help you keep track of all your images after you stow them away):

- **Floppy disk:** For many years, the most common removable storage option was the floppy disk. But because they can hold less than 1.5MB of data — a capacity that makes them unsuitable for storing today's large media files — floppies have fallen out of favor. In fact, most computer manufacturers either don't provide floppy drives anymore or charge extra for the feature. If your system does have a floppy drive, you can use floppies to store only very low-resolution or highly compressed picture files. On the positive side, the disks are incredibly cheap: You can get a floppy for less than a quarter if you watch the sale ads.

- **Super floppy:** Several companies offer removable storage devices commonly known as *super floppies.* These drives save data on disks that are just a little larger than a floppy but that can hold much more data. The best-known option in this category is the Iomega Zip drive, available in 100MB, 250MB, and 750MB versions. Some computer vendors now include Zip drives as standard equipment on desktop and even laptop systems. If not, you can buy an external Zip drive; expect to pay about $80 for the smallest-capacity drive and $170 for the largest. Disk prices range from $10 to $15, depending on capacity.

- **CD-ROM:** The most affordable and convenient option for long-term storage is to copy your files to a CD-ROM, using a CD recorder, or *burner,* in tech talk. If your computer is new, you likely have a built-in CD burner. If not, you can add an external model to your system for under $100. The CDs themselves, which can store as much as 650MB of data, cost from $0.50 to $2, depending on which type you buy. (See the sidebar "CD-R or CD-RW?" for more on different types of CDs.)

Just a few years ago, I would have told you to avoid CD burners because they were a little too finicky and the recording software too complicated for anyone who didn't care to spend hours learning a slew of new technical languages and sorting out hardware conflicts. But most of the problems previously associated with this technology have been resolved, making the process of burning your own CDs much easier and much more reliable. Most recorders ship with wizards that walk you through the process of copying your images to a CD, so you no longer have to be a technical guru to make things work.

That said, recording your own CDs is by no means as carefree a prospect as copying files to a floppy or Zip disk:

- Some compatibility issues exist that make it impossible for some types of homemade CDs to be read by some older computers.

- Even with the software wizards to guide you, you still must deal with plenty of new and confusing technical terminology when choosing recording options.

So if techno-babble intimidates you and the occasional unexplained glitch tempts you to put your fist through your computer monitor, you may prefer to let the professionals do your CD burning. Most retail photo labs can burn CDs from camera memory cards.

✔ **DVD:** A close cousin to the CD burner, DVD burners enable you to record your photos onto a DVD (digital video disc). What's the difference between CDs and DVDs? Capacity, mostly. A standard single-layer DVD stores 4.7GB of data, while a CD holds about 650MB.

Although DVD is poised to overtake the CD as the most popular archival storage option in the next few years, it's too new for me to recommend it as a solution for the average photographer just yet. The industry doesn't seem to have settled firmly on a DVD format, which means that DVDs that you burn today may not be readable by tomorrow's DVD players. And of course, you can't share a DVD with people whose computers have only the more common CD-ROM drive.

As with any computer data, digital-image data degrades over time. How soon you begin to lose data depends on the storage media you choose. With devices that use magnetic media, which includes hard drives, Zip disks, and floppies, image deterioration starts to become noticeable after about ten years. In other words, don't rely on magnetic media for long-term archiving of images.

CD-ROM storage offers better security. Some manufacturers say that their CD-Rs have life expectancies of as much as 100 years, while CD-RWs are said to survive about 30 years. However, those claims are the subject of some pretty hot debate right now — and if you ask around, you're sure to hear horror stories of CDs going bad. Whether or not the problem stems from the CD itself or mishandling by the user is the question. But just to be safe, always make two copies of your image CDs.

For the ultimate in archiving safety, always print your pictures, too. That way, if something does go wrong with the digital file, you can scan the print and create a new digital copy. You can make prints easily and cheaply at any retail lab if you don't care to do it yourself. See Chapter 9 for help with printing.

CD-R or CD-RW?

CD recorders enable you to *burn* your own CDs — that is, copy image files or other data onto a compact disc (CD). Two types of recordable CDs exist: CD-R and CD-RW. The *R* stands for *recordable; RW* stands for *rewriteable*. Most CD burners can do either dance.

With CD-R, you can record data until the disc is full. But you can't delete files to make room for new ones — after you fill the disc once, you're done. On the plus side, your images can never be accidentally erased. CD-Rs are cheap, too, selling for about $0.50 each or even less if you happen upon a special store promotion. (However, because quality can vary from brand to brand, I recommend that you stay away from no-name, ultra-cheap CD-Rs and stick with high-quality discs from a respected manufacturer.)

With CD-RW, your CD works just like any other storage medium. You can get rid of files you no longer want and store new files in their place. Although CD-RWs cost more than CD-Rs — about $2 each — they can be less expensive over the long run because you can reuse them as you do a floppy or Zip disk. However, you shouldn't rely on CD-RWs for archiving purposes. For one thing, you can accidentally overwrite or erase an important image file. For another, data on CD-RWs starts to degrade after about 30 years, while CD-Rs can last as long as 100 years. (See my earlier note on this issue.)

One other important factor distinguishes CD-R from CD-RW: compatibility with existing CD-ROM drives. If you're creating CDs to share images with other people, you should know that those people need *multiread* CD drives to access files on a CD-RW. This type of CD drive is being implemented in new computer systems, but most older systems do not have multiread drives. Older computers can usually read CD-Rs without problems, however. (Depending on the recording software you use, you may need to format and record the disc using special options that ensure compatibility with older CD drives.)

On-the-Go Storage and Viewing

Even if you carry several large-capacity memory cards, you can fill them up quickly if you're shooting with a high-resolution camera or shooting Raw files. For times when you can't easily download pictures from your cards, several manufactures offer large-capacity, portable drives. You can download pictures to one of these units, erase the card, and start shooting again.

Some units, including the Epson P-2000 shown in Figure 4-5, provide a screen on which you can review your pictures, too. This feature is especially great for photographers who work with clients in the field; you can show your work this way rather than pass your camera around after every shot.

Prices vary from about $150 to $500, depending on the storage capacity, whether a viewing screen is provided, and other features. Many units can also serve as digital music players, for example, or offer connections to certain photo printers. You can also connect some storage units to a TV so that you can view your pictures on a larger screen. The Epson model shown in the figure can hold 40GB (gigabytes) of data and costs $500.

Seiko Epson Corp.
Figure 4-5: This portable storage unit from Epson has a large screen for viewing your pictures.

Software Solution

Flashy and sleek, digital cameras are the natural stars of the digital-imaging world. But without the software that enables you to access and manipulate your images, your digital camera would be nothing more than an overpriced paperweight. Because I know that you have plenty of other had-to-have-it, never-use-it devices that can serve as paperweights, the following sections introduce you to some software products that help you get the most from your digital camera.

Image-editing software

Image-editing software enables you to alter your digital photos in just about any way you see fit. You can correct problems with brightness, contrast, color balance, and the like. You can crop out excess background and get rid of unwanted image elements. You can also apply special effects, combine pictures into a collage, and explore countless other artistic notions. Part IV of this book provides you with a brief introduction to photo editing to get you started on your creative journey.

Today's computer stores, mail-order catalogs, and online shopping sites are stocked with an enormous array of photo-editing products. But all these programs can be loosely grouped into two categories: entry-level and advanced. The following sections help you determine which type fits your needs.

Programs for first-timers

Several companies offer programs geared to the photo-editing novice. Popular choices include ArcSoft PhotoImpression (www.arcsoft.com), Paint Shop Photo Album (www.corel.com), and Microsoft Picture It! Premium (www.microsoft.com), all available for under $50.

These programs provide a basic set of image-correction tools plus plenty of on-screen hand-holding. *Wizards* (step-by-step on-screen guides) walk you through different editing tasks, and project templates simplify the process of adding your photo to a business card, calendar, e-mail postcard, or greeting card. In Figure 4-6, I'm creating a calendar using Paint Shop Photo Album.

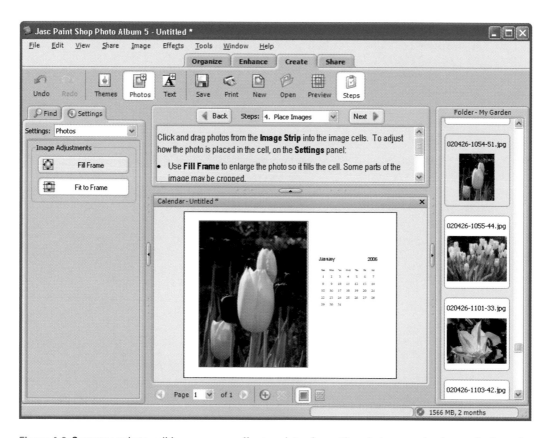

Figure 4-6: Consumer photo-editing programs offer templates for putting photos on calendars and other print materials.

Within this category, the range of editing and effects tools provided varies widely, so read product reviews to make sure that the program you get enables you to do the photographic projects you have in mind. See Chapter 16 for the names of some Web sites where you can find this kind of information.

Programs with more power

Although the entry-level programs I discuss in the preceding section provide enough tools to keep most casual users happy, people who edit pictures on a daily basis or just want a little more control over their images may want to move up the software ladder a notch. Advanced photo-editing programs provide you with more flexible, more powerful, and, often, more convenient photo-editing tools than entry-level offerings.

What kind of additional features do you get for your money? Here's just one example to illustrate the differences between beginner and advanced programs. Say that you want to retouch an image that's overexposed. In an entry-level program, you typically are limited to adjusting the exposure for all colors in the image by the same degree. But in an advanced program, you can adjust the highlights, shadows, and midtones (areas of medium brightness) independently — so that you can make a businessman's white shirt even whiter without also giving his dark brown hair and beige suit a bleach job.

Additionally, using tools known as *dodge* and *burn tools,* you can "brush on" lightness and darkness as if you were painting with a paintbrush. In some programs, you can even apply exposure adjustments in a way that preserves all the original image data in case you decide later that you don't like the results of your changes. And that's but a sampling of your many options — all just for adjusting exposure.

Advanced programs also include tools that enable power-users to accomplish complicated tasks more quickly. Some programs enable you to record a series of editing steps and then play the editing routine back to apply those same edits to a batch of images, for example.

The downside to advanced programs is that they can be intimidating to new users and also require a high learning curve. You usually don't get much on-screen assistance or any of the templates and wizards provided in beginner-level programs. Figure 4-7, for example, offers a look at Adobe Photoshop (www.adobe.com), the leading professional photo editor. Not exactly what you'd call intuitive. So expect to spend plenty of time with the program manual or a third-party book to become proficient at using the software tools. Photoshop is also expensive, selling for just under $600.

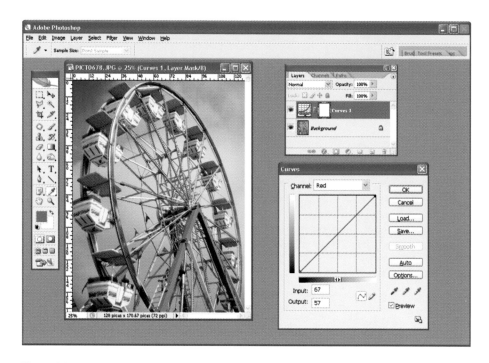

Figure 4-7: Adobe Photoshop is a top choice for serious imaging enthusiasts.

Fortunately, several good, less-expensive alternatives exist for users who don't need the ultra-high-end power of Photoshop. Perhaps the best known program is Adobe Photoshop Elements, which sells for about $100 and is the software featured in Part IV of this book. Elements includes Photoshop's basic power tools but also provides some of the same type of help features provided in consumer-level programs. Other good choices in the same price range are Corel Paint Shop Pro (www.corel.com), Ulead PhotoImpact (www.ulead.com), and Microsoft Digital Image Suite (www.microsoft.com). Note that Corel Paint Shop Pro was formerly known as Jasc Paint Shop Pro; Corel acquired Jasc Software and its very popular Paint Shop Pro product.

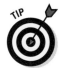

Before you invest in any imaging program, no matter how expensive, you're smart to give the program a whirl on your computer, using your images. Many software vendors make free trial versions available on their Web sites. For a quick way to explore your options, visit the Web page for this book, www.dummies.com/go/digitalphotofd5e. The page offers links to sites where you can find out more about all the software I mention.

Specialty software

In addition to programs designed specifically for photo editing, you can find great programs geared to special digital photography needs and interests. The following list discusses some of my favorites:

✔ **Image-cataloging programs** assist you in keeping track of all your images. As mentioned earlier, some industry gurus refer to these programs as digital asset management (DAM) tools. But you can just call them cataloging programs and get along fine with me. I don't think you want to walk into a computer store and ask to see all the DAM programs, anyway. Figure 4-8 offers a look at one such program, ThumbsPlus ($50, www.cerious.com), and Chapter 8 provides more information about this kind of software.

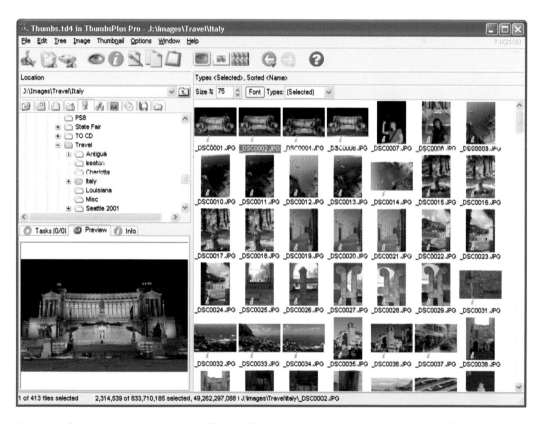

Figure 4-8: Cataloging programs such as ThumbsPlus make it easier to organize your photo files.

✐ **Slide-show programs** make it easy to produce multimedia presentations featuring your photos. See Chapter 1 for a look at one program in this category, SimpleStar PhotoShow Deluxe (www.simplestar.com).

✐ **Special-effects plug-ins** can add to the functionality of your photo editor. One of my favorite programs of this type is nik Color Efex Pro (www. nikmultimedia.com), featured in Figure 4-9. This plug-in package enables you to create effects similar to those produced by traditional camera filters as well as cool special effects. It works with many popular photo editors, including Photoshop Elements. Pricing ranges from $80 to $300, depending on which effects collection you buy.

✐ **Digital painting programs** enable you to create original artwork or use your photos to create images that have the look of traditional art media. Chapter 13 gives you a look at a leading program in this category, Corel Painter.

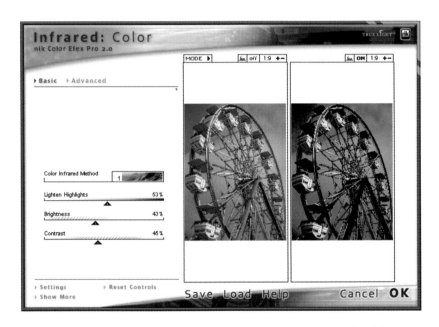

Figure 4-9: Special-effects plug-ins such as this one from nik multimedia add more creative options to your photo-editing software.

Finally, you can find several programs that fall into the "pure fun" category, such as BrainsBreaker, shown in Figure 4-10. With this $20 program (www.brainsbreaker.com), you can turn any photo into a digital jigsaw puzzle. You put the puzzle together by dragging pieces into place with your mouse — an endeavor that I find enormously addictive, I should add.

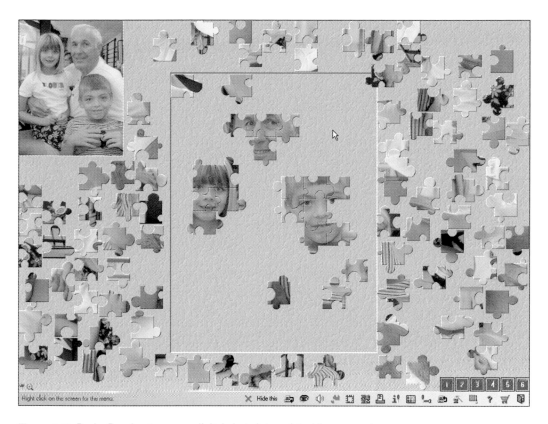

Figure 4-10: BrainsBreaker turns any digital photo into a virtual jigsaw puzzle.

Camera Accessories

So far, I've focused on accessories to make your life easier and more fun after you shoot your digital pictures. But the items in the following list are even more essential because they help you capture great pictures in the first place:

✔ **Special lens adapter and lenses:** If your camera can accept other lenses, you can expand your range of creativity by investing in a wide-angle, close-up, or telephoto lens (telephoto lenses are designed for making faraway objects appear closer). With some cameras, you can add supplementary wide-angle and telephoto elements that slip over the normal camera lens. The price range of these accessories varies depending on the quality and type and whether or not you need a separate adapter to fit the lens to your camera.

✔ **Tripod:** If your pictures continually suffer from soft focus, camera shake is one possible cause — and using a tripod is a good cure. You can spend a little or a lot on a tripod, with models available for anywhere from $20 to several hundred dollars. I can tell you that I've been quite happy with my $20 model, though. And at that price, I don't worry about tossing the thing into the trunk when I travel. Just be sure that the tripod you buy is sturdy enough to handle the weight of your camera. You may want to take your camera with you when you shop so that you can see how well the tripod works with your camera.

Alfred DeBat, technical editor for this book, suggests this method for testing a tripod's sturdiness: Set the tripod at its maximum height, push down on the top camera platform, and try turning the tripod head as though it were a doorknob. If the tripod twists easily, look for a different model.

✔ **LCD hoods:** If you have difficulty viewing images on your camera's LCD monitor in bright light, you may want to invest in an LCD hood. Hoods wrap around the monitor to create a four-sided awning that reduces glare on the screen. Several companies, including Hoodman (www.hoodmanusa.com) make custom-tailored hoods for a variety of digital cameras.

✔ **Light dome or box:** If you take product shots of shiny or sparkly objects, such as glass or jewelry, you may find it almost impossible to avoid getting reflections or glare from your flash or other light source. You can solve this problem by using a light dome or tent, which serves as a diffusion screen between the objects and the light source. Chapter 6 shows examples.

✔ **Camera case:** Digital cameras are sensitive pieces of electronic equipment, and if you want them to perform well, you need to protect them from hazards of daily life. No camera is likely to take great pictures after being dropped on the sidewalk, being banged around inside a briefcase, or suffering other physical abuse on a regular basis. So whenever you're not using the camera, you should stow it in a well-padded camera case.

You can pick up a decent, padded case for about $10 at a discount store. Or if you want to spend a little more, head for a camera store, where you can buy a full-fledged digital camera bag that has room for all your batteries and other gear. Some digital cameras do come with their own cases, but most of these cases are pretty flimsy and not up to the job of keeping your camera safe from harm. You're spending lots of money on a camera, so do yourself a favor and invest a little more on a proper protective case.

Mouse Replacement Therapy: The Drawing Tablet

To wrap up this chapter, I want to introduce you to one more accessory that doesn't fit nicely into any of the other categories: a digital drawing tablet.

A drawing tablet enables you to do your photo editing using a pen stylus instead of a mouse. If you do a good deal of intricate touch-up work on your pictures or you enjoy digital painting or drawing, you'll wonder what you ever did without a tablet after you try one.

Professional drawing tablets run as high as $700, but you don't need to spend anywhere near that much to enjoy the benefits of a decent tablet. Wacom, the industry leader in the tablet arena, offers a consumer-oriented model called the Graphire (www.wacom.com). The model shown in Figure 4-11 has an active drawing area of about 6 x 8 inches and sells for about $200, but a smaller, 4 x 5-inch model is available for under $100. (For the record, I've been using a 4 x 5 tablet for years and never longed for more drawing space.) The Graphire comes with both a stylus and cordless mouse so that you can switch back and forth easily between the two devices.

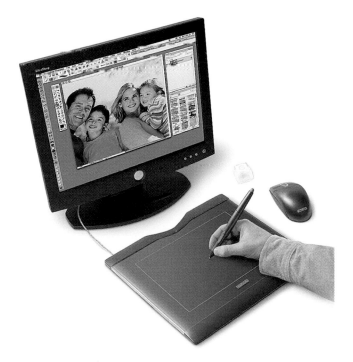

Wacom Technology

Figure 4-11: Intricate photo-editing tasks become easier when you set aside the mouse in favor of a drawing tablet and stylus like this Wacom Graphire.

I never metadata I didn't like

Most digital cameras, especially those at the mid- to high end of the consumer price range, store *metadata* along with picture data when recording an image to memory. Metadata is a fancy name for information that gets stored in a special area of the image file. Digital cameras record such information as the aperture, shutter speed, exposure compensation, and other camera settings as metadata.

To capture and retain metadata, digital cameras typically store images using a variation of the JPEG file format known as EXIF, which stands for *exchangeable image format*. This flavor of JPEG is often stated in camera literature as JPEG (EXIF).

You can view metadata in many photo-editing and cataloging programs, such as Corel Paint Shop Photo Album, shown in the following figure. The image-transfer software that ships with your camera may also offer this feature.

By reviewing the metadata for each image, you can get a better grasp on how the various settings on your camera affect your images. It's like having a personal assistant trailing around after you, making a record of your photographic choices each time you press the shutter button — only you don't have to feed this assistant lunch or provide health insurance.

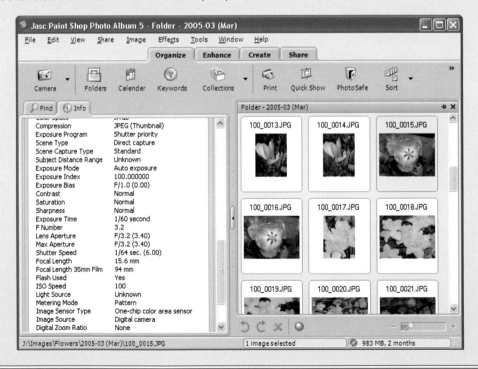

Part II
Ready, Set, Shoot!

In this part . . .

Most digital cameras are categorized as "point-and-shoot" cameras. That is, you're supposed to be able to simply point the camera at your subject and shoot the picture.

But as is the case with point-and-shoot film cameras, picture-taking with a digital camera isn't quite as automatic as the camera manufacturers would like you to believe. Before you aim that lens and press the shutter button, you need to consider quite a few factors if you want to come away with a good picture, as this part of the book reveals.

Chapter 5 walks you through the initial camera setup process, explaining which options to use in which shooting scenarios. Chapter 6 tells you everything you need to know about two primary components of a great photograph: exposure and focus. Chapter 7 builds on those fundamentals by offering tips on composing photos, capturing action, working with a zoom lens, and more.

By abandoning the point-and-shoot approach and adopting the think-point-and-shoot strategies outlined in this part, you, too, can turn out impressive digital photographs. At the very least, you will no longer wind up with pictures in which the top of your subject's head is cut off or the focus is so far gone that people ask why you took pictures on such a foggy day.

Choosing the Right Camera Settings

In This Chapter

▷ Making initial setup decisions

▷ Selecting a file format

▷ Understanding quality and picture size settings

▷ Taking a look at JPEG compression

▷ Reviewing white balance options

▷ Choosing picture enhancement settings

*D*igital camera manufacturers work hard to create a good "out of box" experience — that is, to make your first encounter with your camera fun, easy, and rewarding. To that end, cameras leave the factory in automatic picture-taking mode, using default settings that are likely to produce a good picture the first time you press the shutter button.

Your camera's default settings can't deliver the best images in every situation, however. Capturing a properly exposed photo at a nighttime ballgame, for example, requires different settings than you need on a sunny afternoon.

So after the initial excitement of taking your first few pictures wears off, grab your camera and manual and spend an hour or so going through all the controls available to you. To help you sort through which options to use when, this chapter explains the basics of digital image capture, discussing controls such as file format, resolution (pixel count), and white balance. Chapter 6 continues the discussion with a thorough explanation of exposure and focus options.

Getting Started: Basic Camera Settings

Somewhere on the back of your camera, you should find a button that displays a setup menu in the camera's LCD monitor, as shown in Figure 5-1. In addition to standard photographic options such as exposure and flash, many cameras offer the following basic operational settings:

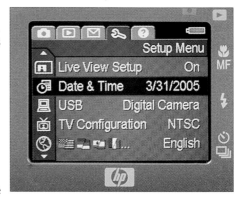

Figure 5-1: Scroll through camera menus to discover what options are available.

- **Date/Time:** This setting is perhaps the most critical of the basic operation controls. Your camera records the current date and time in the image file, along with details about what other camera settings were in force when you shot the picture. In many photo editors and image browsers, you can view this information, known as *EXIF metadata*.

 Having the correct date and time in the image file enables you to have a permanent record of when each picture was taken. More importantly, in many photo programs, you can search for all the pictures taken on a particular date. Figure 5-2 shows one program with this feature, ACDSee (www.acdsystems.com).

- **Auto shut-off:** To conserve battery power, many cameras turn off automatically after a few minutes of inactivity. The drawback is that you can miss fleeting photographic opportunities; by the time you restart the camera, your subject may be gone.

 If your camera doesn't allow you to disable this feature, you can prevent shut-down by pressing the shutter button down halfway to activate the autofocus/autoexposure mechanism. (The next chapter explains both.) On cameras with a zoom lens, you also can zoom in or out a little.

- **Instant review:** After you take a picture, your camera may display it automatically for a few seconds. You may want to turn this function off when you're trying to capture fast-paced subjects because the camera won't take another picture until the review period is passed. And because monitors consume power, also turn off instant review if you're worried about running out of battery juice.

- **Monitor brightness:** Adjusting the monitor brightness can make pictures easier to view in bright light. But be careful: The monitor may then give you a false impression of your image exposure. Before you put your camera away, double-check your pictures in a setting where you can use the default brightness level.

- **Auto-rotate:** This feature automatically rotates pictures that you take with a vertical orientation so that they display properly in the camera

monitor. Hmm. I usually can find the downside of anything, but I'll be darned if I can think of one for this option.

✔ **TV/video format (NTSC, PAL, or SECAM):** If your camera has a video-out feature, which enables you to hook your camera to a TV, VCR, or DVD player, you may get the choice of these three video-signal formats. Most North American countries go with NTSC, as does Japan. In Europe, PAL is the standard. You can find the proper format for other countries by doing a quick Web search.

✔ **Sound effects:** Digital cameras are big on sounds: Some play a little ditty when the camera is turned on. Some beep to let you know that the camera's autofocus or autoexposure mechanism has done its thing, and others emit a little "shutter" sound as you take the picture. I even worked with one model that said "Goodbye" in this odd little digitized voice when you turned the camera off. Before heading to a wedding or any other event where your camera's bells and whistles won't be appreciated, check your camera menu to see whether you can silence them or at least turn down the volume.

Some cameras offer "museum mode." When you choose this setting, the camera automatically stifles its vocal chords and also disables the flash (because flash photography isn't permitted in most museums).

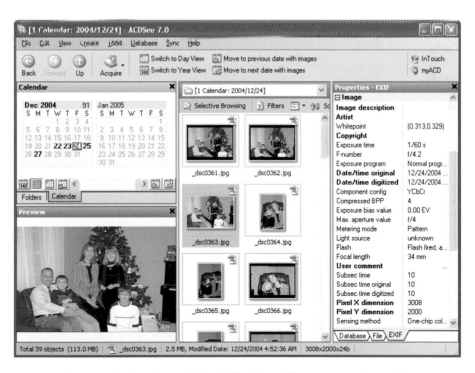

Figure 5-2: Because the date is recorded with the picture file, you can easily track down pictures taken during a certain period.

Selecting a File Format

Your camera may offer a choice of file types, or *formats,* in digital lingo. The format determines how the camera records and stores all bits of data that comprise a digital photo. This setting affects file size, picture quality, and what types of computer programs you need to view and edit the photo.

Although many formats have been developed for digital images, camera manufacturers have settled — at least for now — on just three: JPEG, TIFF, and Camera Raw. Each of these formats has its pros and cons, and which one is best depends on your picture-taking needs. The next three sections tell you what you need to know to make a file-format decision.

Keep in mind that some cameras don't offer a separate file format control but instead give you a choice of resolution (pixel count) and format combinations. You need to open that manual to find out how your model approaches these options.

Also, be careful not to confuse your camera's *file format* control with the one that *formats* your camera memory card. The latter erases all data on your card. Don't freak out about this possibility: When you choose the card format option, your camera displays a warning to let you know that you're about to dump data. You get no such message for the file format control.

JPEG

Pronounced *jay-peg,* this format is standard on every camera. JPEG stands for *Joint Photographic Experts Group,* the organization that developed the format.

JPEG is the leading camera format for two important reasons:

- **Web-friendly photos:** All Web browsers and e-mail programs can display JPEG images, which means that you can share your pictures online seconds after you shoot them.

- **Small file sizes:** JPEG files are smaller than those captured in other formats, so you can store more pictures in your camera's memory. Smaller files also take less time to transmit over the Web.

The drawback to JPEG is that you may trade off picture quality for the smaller file size and online convenience. In order to trim file size, JPEG applies *lossy compression,* a process that eliminates some original image data. (Many digital imaging experts refer to this process as simply JPEG compression.)

Compare the uncompressed portrait in Figure 5-3 with its highly compressed cousin in Figure 5-4. Excessive compression gives the image a tiled look and often causes a defect known as *color artifacting*. Notice the bluish tinges around the eyelashes and near the jaw line in Figure 5-4? That's artifacting.

Now for the good news: Most cameras offer a JPEG setting that applies only a little bit of compression, which significantly reduces file size without producing noticeable damage. At a minimum compression setting, JPEG is the right format choice for all but the most demanding photographers.

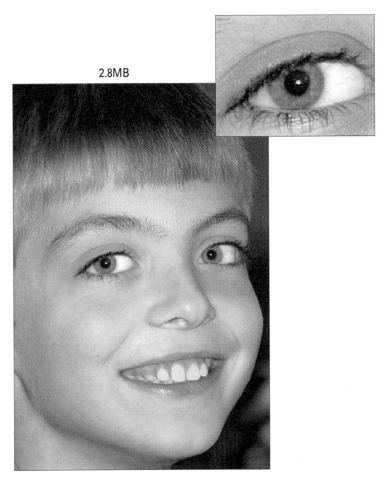

2.8MB

Figure 5-3: No compression means top photo quality, but large file sizes.

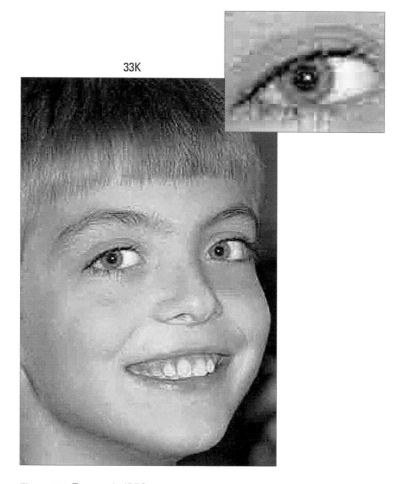

33K

Figure 5-4: Too much JPEG compression destroys picture quality.

As an example, Figure 5-5 shows a lightly compressed version of the portrait. The file size is reduced from 2.8MB to 400K, and you have to look hard to see any loss of image detail.

Figuring out what JPEG options are available to you requires a look at the camera manual. Typically, compression settings are given vague monikers: Good/Better/Best or High/Normal/Basic, for example.

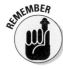

These names refer not to the amount of compression being applied, but to the resulting image quality. If you set your camera to the Best setting, for example, the image is compressed less than if you choose the Good setting. Of course, the less you compress the image, the larger its file size, and the fewer images you can fit in the available camera memory.

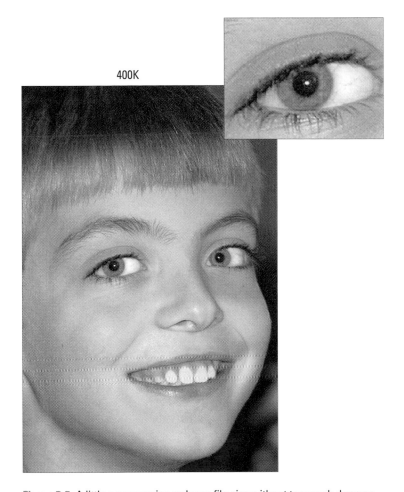

400K

Figure 5-5: A little compression reduces file size without too much damage.

You should find a chart in your manual that indicates how many images you can fit into a certain amount of memory at different compression settings. But you need to experiment to find out exactly how each setting affects picture quality. Shoot the same image at all the different settings to get an idea of how much damage you do if you opt for a higher degree of compression.

If your camera offers several resolution settings, do the compression test for each resolution setting; remember, resolution and compression work together to determine image quality. You usually get away with more compression at a higher resolution. Low resolution combined with heavy compression yields results even a mother couldn't love.

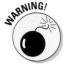

When you edit your images in a photo editor, you can save your altered file in the JPEG format. At that point, you have the option of applying another round of compression. Because each pass through the compression machine does further damage, you should instead save works-in-progress in a format such as TIFF (see the next section), which does a much better job of preserving picture quality. See Chapter 11 for a primer on saving your edited photos and refer to Chapter 10 for details on saving in the JPEG format.

TIFF

TIFF stands for *Tagged Image File Format,* in case you care, which you really shouldn't. TIFF — say it *tiff* — is designed for folks who don't care for the data loss that occurs with JPEG compression.

Whether or not you notice a significant quality difference between a TIFF image and a lightly compressed JPEG depends on the camera, however. I created the uncompressed picture in Figure 5-3 in the TIFF format, for example, and even I can't discern a huge difference between it and the lightly compressed JPEG version in Figure 5-5.

In addition, TIFF files are much larger than JPEG files, and Web browsers and e-mail programs can't display TIFF photos. You need to open TIFF pictures in a photo editor and convert them to JPEG before you can share them online. (Chapter 10 tells you how.)

For these reasons, JPEG is a better choice unless your number one concern is optimum picture quality, you have no worries about running out of space on your camera memory card, and you don't mind the extra step of converting to JPEG for online use.

Camera Raw

When you shoot in the JPEG or TIFF format, your camera takes the data collected by the image sensor and then applies certain enhancements — exposure correction, color adjustments, sharpening, and so on — before recording the final image. These changes are based on the picture characteristics that the manufacturer believes its customers prefer.

The Camera Raw format, sometimes called simply *Raw,* was developed for photo purists who don't want the camera manufacturer to make those decisions. Camera Raw records data straight from the sensor, without applying any post-capture processes. You get "uncooked" data, if you will.

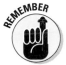

Unlike JPEG and TIFF, Camera Raw is not a standardized format. Each manufacturer uses different data specifications and names for its Raw format. Nikon Raw files are called NEF files, for example, while Canon's version go by the name CRW.

Raw files are uncompressed, which means that they are larger than JPEG files. In addition, after transferring your pictures to your computer, you must use a special software tool called a *Raw converter* to convert your photos to TIFF or JPEG before you can do much of anything with them. Figure 5-6 shows you the converter from Adobe Photoshop Elements; Chapter 8 details the conversion process.

Because of the added complication of working with Raw files, I recommend that you stick with JPEG or TIFF if you're a photo-editing novice. Frankly, the in-camera processing that occurs with those two formats is likely to produce results that are at least as good as, if not better, than what you can do in your photo editor.

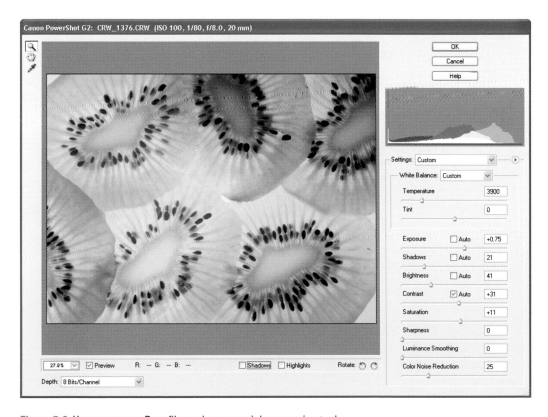

Figure 5-6: You must open Raw files using a special conversion tool.

DNG: Format of the future?

Adobe Systems recently introduced another digital-camera file format, DNG. Short for *Digital Negative Format,* DNG was created in response to growing concerns about the fact that every camera manufacturer uses its own, specially engineered flavor of Camera Raw. This Tower of Picture Babel makes it difficult for software designers to create programs that can open every type of Raw file, which in turn makes it difficult for people to share Raw files. That issue isn't a huge problem for the average consumer, but it's a pain for professionals who must work with Raw images from many photographers. In addition, the possibility exists that future software may not support earlier generations of Raw files, leaving people with images they can no longer open (think Betamax videotapes and 8-track audio recordings).

The goal of DNG is to create a standard raw-data format that all camera manufacturers can embrace. That hasn't happened yet, but if you want to translate your current Raw files to DNG, the Adobe Web site (www.adobe.com) offers a free converter that can handle files from most current digital cameras. Of course, there's no guarantee that DNG will be around 100 years from now, either, and most photo software can't yet open DNG files. But with Adobe backing the format, my guess is that DNG will one day be as common as JPEG or TIFF.

For my part, I simply find Raw too much trouble for day-to-day picture taking. The only time I use Raw is when I can't get the results I want from TIFF or JPEG. When shooting the image in Figure 5-6, for example, I had the kiwi slices on top of a light box so that they were lit from below. (Don't ask — it was one of those 3 a.m. ideas that never works out as well as you hope.) No matter what camera settings I tried, I couldn't arrive at the balance of color, exposure, and contrast that I wanted with JPEG or TIFF. So I switched to Raw so that I could better control those qualities.

Some cameras offer a setting called JPEG+Raw. With this option, the camera creates both a Raw file and a JPEG file that's appropriately sized for online sharing. Of course, you consume even more camera memory with this option because you're creating two files.

Setting the Pixel Count (Resolution)

Depending on your camera, you may be able to select from two or more image resolution settings. This option determines how many total pixels the image will contain, not pixels per inch (ppi). You set this second value in your photo editor before you print your pictures. (See Chapter 2 for the complete story.)

The resolution option is presented in different ways, depending on the camera. You may be given a choice of pixel dimensions, as shown in the top image in Figure 5-7, or total pixel count, as shown in the bottom example. (MP stands for *megapixel,* or 1 million pixels.) Some cameras take another approach, using vague options such as Basic, Fine, and Superfine, which often control pixel population, file format, and compression amount together. Your camera manual should spell out exactly how you go about changing the resolution and how many pixels you get with each setting.

When setting capture resolution, consider the final output of the image. For Web pictures, you can get by with 640 x 480 pixels or even 320 x 240 pixels. But if you want to print your picture, choose the capture setting that comes closest to giving you the output resolution — pixels per inch, or *ppi* — that your printer manual recommends.

Again, Chapter 2 explains all this in more detail and provides illustrations to show you the impact of pixel count on picture quality. But for quick reference, Table 5-1 shows you the *minimum* pixel count you need to produce acceptable prints at standard sizes; I'm assuming an output resolution of 200 ppi. (You may be able to generate a good print with fewer pixels, however, so experiment with your own camera and print.) Figure 5-8 shows portions of the low, medium, and high-resolution examples from Chapter 2 to remind you of just how crummy a picture looks if you don't snag enough pixels.

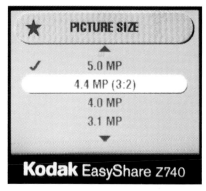

Figure 5-7: The initial pixel count determines how large you can print your pictures.

Table 5-1	How Many Pixels for Good Prints?	
Print Size	*Pixels for 200 ppi*	*Megapixels (approx.)*
4 x 6	800 x 1200	1 mp
5 x 7	1000 x 1400	1.5 mp
8 x 10	1600 x 2000	3 mp
11 x 14	2200 x 2800	6 mp

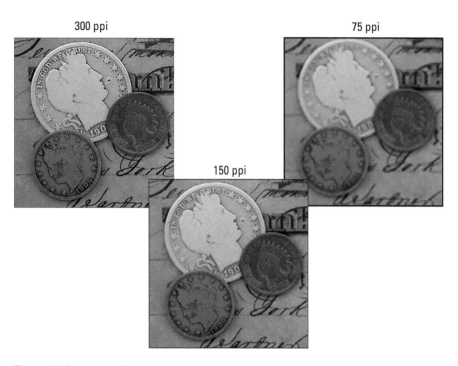

Figure 5-8: Low resolution means low-quality prints.

Keep these additional pixel pointers in mind:

✔ The more pixels, the bigger the picture file and the more memory your image consumes. So if your camera has limited memory and you're shooting at a location where you can't download images, you may want to choose a lower resolution setting so that you can fit more pictures into the available memory. Alternatively, you may be able to reduce file size by changing the file format or applying more JPEG compression, as I discuss earlier in this chapter.

✔ Some cameras provide a dual-capture option: Your picture is recorded twice, once at the highest-resolution setting you specify and once at a smaller size that's suitable for Web or e-mail use.

✔ The pixel-capture settings on your digital camera likely won't match up exactly with the numbers you see in Table 5-1 because digital camera images have a different *aspect ratio* than traditional print sizes, which are based on the proportions of 35mm film. A digital camera image has an aspect ratio of 4:3, which means it is four units wide by three units tall (just like a traditional computer monitor). A 35mm film negative has an aspect ratio of 3:2, which is why the 4 x 6 print emerged as a standard snapshot size. When figuring your necessary pixel count, just get as close as you can (or higher than) the numbers you see in Table 5-1.

However, some cameras offer a special resolution setting that produces an image with the traditional 3:2 aspect ratio. This setting is highlighted on the Kodak model shown in Figure 5-7. A few new cameras even offer the option of capturing images that conform to the 16:9 proportions used by wide-screen televisions.

✔ The numbers in the table assume that you're printing the *entire* photo. If you crop the photo, you need more original pixels because you're getting rid of a portion of the image.

✔ On some cameras, capture resolution is lowered automatically when you use certain features. For example, many cameras provide a burst mode that enables you to record a series of images with one press of the shutter button (see Chapter 7 for information). When you use this mode, some cameras reduce the resolution to 640 x 480 pixels or lower.

Balancing Your Whites and Colors

Different light sources have varying *color temperatures,* which is a fancy way of saying that they contain different amounts of red, green, and blue light.

Color temperature is measured on the Kelvin scale, illustrated in Figure 5-9. The midday sun has a color temperature of about 5500 Kelvin, which is often abbreviated as 5500K — not to be confused with 5500 kilobytes, abbreviated as 5500K. When two worlds as full of technical lingo as photography and computers collide, havoc ensues. If you're ever unsure as to which *K* is being discussed, just nod your head thoughtfully and say, "Yes, I see your point."

2000	3000	5000	8000

Candlelight | Incandescent bulbs | Tungsten lights | Fluorescent bulbs | Bright sunshine | Flash | Overcast skies | Snow, water, shade

Figure 5-9: Each light source emits its own color cast.

Anyway, what's important about color temperature is that it affects how a camera — video, digital, or film — perceives the colors of the objects being photographed. If you've taken pictures in fluorescent lighting, you may have noticed a slight green tint to your photographs. The tint comes from the color of fluorescent light.

Film photographers use special films or lens filters designed to compensate for different light sources. But digital cameras, like video cameras, get around the color-temperature problem using a process known as *white balancing*. White balancing simply tells the camera what combination of red, green, and blue light it should perceive as pure white, given the current lighting conditions. With that information as a baseline, the camera can then accurately reproduce the other colors in the scene.

On most digital cameras, white balancing is handled automatically. But many models provide manual white-balance controls as well. Why would you want to make manual white-balance adjustments? Because sometimes, automatic white balancing doesn't go quite far enough in removing unwanted color casts. If you notice that your whites aren't really white or that the image has an unnatural tint, you can sometimes correct the problem by choosing a different white-balance setting. Table 5-2 shows some common manual settings.

Table 5-2	Manual White-Balance Settings
Setting	*Use*
Daylight or Sunny	Shooting outdoors in bright light
Cloudy	Shooting outdoors in overcast skies
Fluorescent	Taking pictures in fluorescent lights, such as those in office buildings
Incandescent	Shooting under incandescent lights (standard household lights)
Flash	Shooting with the camera's on-board flash

Figure 5-10 gives you an idea of how image colors are affected by white-balance settings. I took these pictures with a Nikon digital camera. Normally, the automatic white-balance feature on this camera, as on other cameras, works pretty well. But this shooting location threw the camera a curve ball because the subject is lit by three different light sources. Like most office buildings, the one in which this picture was taken has fluorescent lights, which light the subject from above. To the subject's left (the right side of the picture), bright daylight was shining through a large picture window. And just to make things even more complicated, I switched on the camera's flash.

Auto

Sunny

Incandescent

Fluorescent

Flash

Cloudy

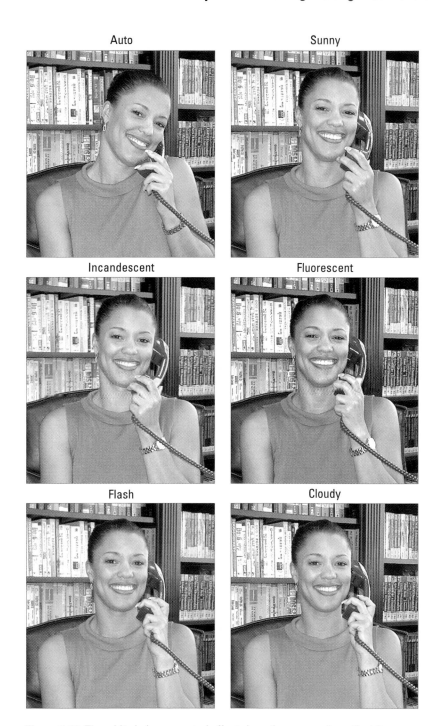

Figure 5-10: The white balance control affects how the camera "sees" white.

The image has a slightly yellowish cast at the Automatic setting. That's because in the Automatic mode, the camera I was using selects the Flash white-balance setting when the flash is turned on (which is why the results of the Flash mode and the Automatic mode are the same in the figure). But the Flash mode balances colors for the temperature of the flash only and doesn't account for the two other light sources hitting the subject. In my shooting scenario, the Fluorescent setting achieved the most accurate color balance, with the Sunny option coming in a close second.

Although white-balance controls are designed to improve color accuracy, some digital photographers use them to mimic the effects produced by traditional color filters, such as a warming filter. As illustrated by Figure 5-10, you can get a variety of takes on the same scene simply by varying the white-balance setting. How each setting affects your image colors depends on lighting conditions.

If your camera doesn't offer white-balance adjustment or you just forget to think about this issue when you're shooting, you can remove unwanted color casts or give your picture a warmer or cooler tone in the photo-editing stage. Chapter 11 gives you information on color adjustments.

Tweaking Picture "Processing"

As you scroll through your camera's menus, you're likely to find a few options that enable you to tweak color saturation, contrast, and other aspects of your picture. With a film camera, these enhancements are done during the film processing and printing; with a digital camera, they're applied right in the camera (assuming that you're not shooting in the Camera Raw format, which I discuss earlier in this chapter).

Because every camera applies these changes differently, you need to experiment with your model to see whether you want to deviate from the default settings. On the whole, I prefer to make these kinds of changes in my photo-editing software because you get more control and because the camera monitor doesn't always reflect the most accurate view of your pictures.

One post-capture option that can be dangerous is *sharpening,* a process that boosts contrast to create the illusion of sharper focus. You can easily add more sharpening in a photo editor, but fixing an overly sharpened picture — which has a rough, grainy look — is difficult.

In addition, many cameras offer an option that creates a grayscale or sepia-toned photo, as shown in Figure 5-11. These options are fine, but keep in mind that you can't go back after the fact and add the original colors back to the image. So when in doubt, shoot in normal color; as with sharpening, creating a grayscale or sepia version of a color image in a photo editor is a breeze. Most photo editing programs offer one-click filters that do the job.

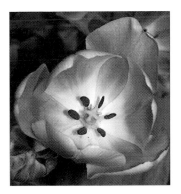 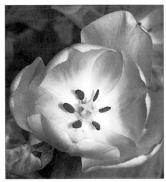 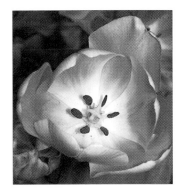

Figure 5-11: Many cameras can produce grayscale or sepia-toned photos.

6

Controlling Exposure and Focus

In This Chapter

▶ Boosting light sensitivity with ISO

▶ Getting the best autoexposure results

▶ Understanding shutter-priority and aperture-priority autoexposure

▶ Tweaking exposure through metering modes

▶ Discovering EV compensation

▶ Using flash in new ways

▶ Lighting shiny objects

▶ Manipulating focus

▶ Taking advantage of scene modes

*G*etting a grip on the digital characteristics of your camera — resolution, white balance, and so on — is critical. But don't get so involved in these new picture-taking issues that you overlook the traditional fundamentals of exposure and focus. All the megapixels in the world can't save a too dark, too light, or blurry picture.

Chapter 2 covers the basics of exposure, detailing the interaction between shutter speed, aperture, and ISO, while Chapter 3 introduces you to focusing basics. This chapter provides tips and techniques to help you better manipulate exposure and focus. In addition to showing you how to get good results from your camera's automatic exposure and focusing features, the pages to come explain controls that allow you to become more creative in how you harness the power of light and lens.

Setting Light Sensitivity: ISO

As you know if you've read Chapter 2, the size of the lens aperture and the shutter speed work together to control how much light enters the camera when you take a picture. The amount of light you need to produce a proper exposure depends on the sensitivity of the camera's recording medium — the negative, in a film camera, or the imaging sensor, in a digital camera.

Film is assigned an ISO number to indicate light sensitivity. The higher the number, the "faster" the film — meaning that it reacts more quickly to light, enabling you to shoot in dim lighting without a flash or to use a faster shutter speed or smaller aperture.

Many digital cameras also offer a choice of ISO settings, which theoretically gives you the same flexibility as working with different speeds of film. I say "theoretically" because raising the ISO can have a downside that outweighs the potential advantage. Pictures shot at a higher ISO sometimes suffer from *noise,* which is a fancy way of referring to a speckled, grainy texture. Faster film also produces grainier pictures than slower film, but the quality difference seems to be greater when you shoot digitally.

Figure 6-1 illustrates the impact of ISO on quality. I took all four images in programmed autoexposure mode but used different ISO settings for each shot: 200, 400, 800, and 1600. As I doubled the ISO, the camera increased the shutter speed or reduced the aperture — or both — to produce the same exposure as at the lower ISO. But each shift up in ISO meant a step down in image quality.

When you print pictures at a small size, noise may not be apparent to the eye; instead, the image may have a slightly blurry look, as in Figure 6-1. Figure 6-2 shows close-up views of each image so that you can more easily compare the loss of detail and increase in noise.

For some shooting scenarios, you may be forced to use a higher ISO. Had I waited for the sun to recede a little farther when taking my twilight shots, for example, the camera wouldn't have been able to produce a properly exposed photo at all at the lower ISO settings. And if you're trying to capture a moving subject, you may need to raise the ISO in order to use the fast shutter speed necessary to freeze the action.

The bottom line is this: Experiment with ISO settings if your camera offers them, and by all means, go with a higher ISO if the alternative is not getting the shot at all. But for best picture quality, keep the ISO at its lowest or next-to-lowest setting. (How far up you can go depends on the camera, so take some test shots to evaluate quality at each setting.)

ISO 200

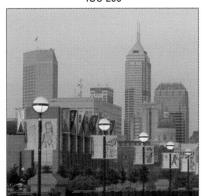

ISO 400

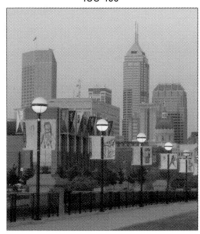

ISO 800

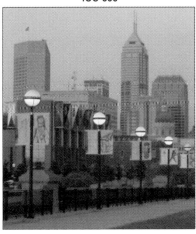

ISO 1600

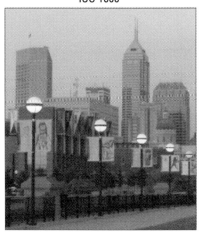

Figure 6-1: Raising the ISO setting increases light sensitivity, but also can produce a defect known as *noise*.

I do recommend, however, that you avoid automatic ISO adjustment, a feature that tells the camera to set the ISO based on the available light. The camera may ramp up the ISO to a point that produces more noise than is acceptable to you. Better to control this aspect of your picture-taking yourself.

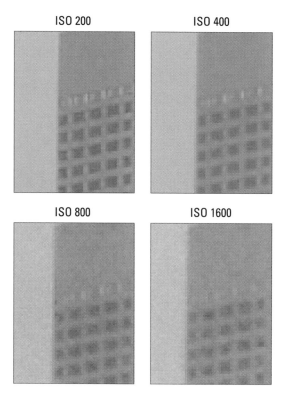

Figure 6-2: Noise becomes more apparent when you enlarge images.

Automatic Exposure: Making It Work

Most digital cameras, from the most basic to high-priced D-SLR (digital SLR) models, offer *autoexposure mode,* sometimes known as *programmed autoexposure.* This feature does just what its name implies: The camera reads the light in the scene and then sets the exposure automatically.

Today's autoexposure mechanisms are incredibly capable. But in order for the feature to work correctly, you need to take this three-step approach to shooting pictures:

 1. Frame your subject in the viewfinder or monitor.

2. **Press the shutter button halfway and hold it there.**

 The camera analyzes the scene and sets the exposure. If you're working in autofocus mode (which I discuss later in "Taking advantage of autofocus") focus is set at the same time. After the camera makes its decisions, it signals you in some fashion — usually with a light near the viewfinder or with a beep.

3. **Press the shutter button the rest of the way to take the picture.**

On lower-end cameras, you typically get a choice of two autoexposure settings — one appropriate for shooting in very bright light and another for average lighting. Many cameras display a warning light or refuse to capture the image if you choose an autoexposure setting that will result in a badly overexposed or underexposed picture. Higher-priced cameras give you more control over autoexposure; see the next few sections for more information..

Choosing an autoexposure metering mode

Many cameras offer a choice of autoexposure *metering modes.* (Check your manual to find out what buttons or menu commands to use to access the different modes.) In plain English, *metering mode* refers to the way in which the camera's autoexposure mechanism *meters* — measures — the light in the scene while calculating the proper exposure for your photograph. The typical options are as follows:

- **Matrix metering:** Sometimes known as *multizone metering* or *pattern metering,* this mode divides the frame into a grid (matrix) and analyzes the light at many different points on the grid. The camera then chooses an exposure that best captures both shadowed and brightly lit portions of the scene. This mode is typically the default setting and works well in most situations.

- **Center-weighted metering:** When set to this mode, the camera measures the light in the entire frame but assigns a greater importance — weight — to the center of the frame. Use this mode when you're more concerned about how stuff in the center of your picture looks than stuff around the edges. (How's that for technical advice?)

- **Spot metering:** In this mode, the camera measures the light only at the center of the frame.

Spot and center-weighted metering are especially helpful when the background is much brighter or darker than the subject. In matrix metering mode, your subject may be under- or overexposed because the camera adjusts the exposure to account for the brightness of the background.

Figure 6-3 offers an example. In the left image, I shot the picture using matrix metering. Because the camera saw so much darkness in the frame, it used an exposure that left the white rose very overexposed — almost no detail remains in the petals.

Matrix metering Spot metering Center-weighted metering

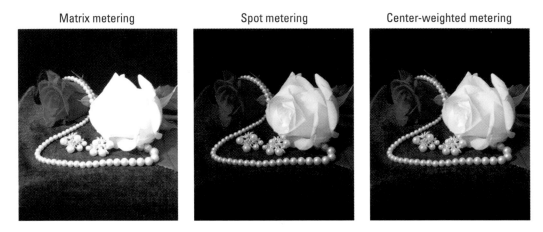

Figure 6-3: Try center-weighted or spot metering when your subject is much darker or lighter than the background.

Changing to spot metering corrected the white rose, but left the red rose too dark, as shown in the middle image. For this scene, center-weighted metering produced the best exposure balance. However, if that red rose were out of the picture, I would prefer the spot-metering exposure because it adds more depth to the white rose.

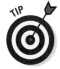

You can take advantage of spot or center-weighted metering even if you don't want your subject to appear at the center of the picture, by the way. First, frame the shot with the subject at the center. Press the shutter button halfway to lock in the exposure and then reframe the picture. As long as you keep the shutter button halfway down, the camera retains the initial exposure setting.

Of course, when you switch to spot or center-weighted metering, your background may become too dark or too bright. For other possible solutions, see the section "Compensating for Backlighting," later in this chapter.

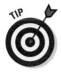

Keep in mind, too, that you can correct minor lighting and exposure problems in the photo-editing stage. Generally speaking, making a too-dark image brighter is easier than correcting an overexposed (too bright) image. So if you can't seem to get the exposure just right, opt for a slightly underexposed image rather than an overexposed one.

Going semi-automatic

In addition to regular autoexposure mode, where the camera sets both aperture and shutter speed, your camera may offer *aperture-priority* autoexposure or *shutter-priority* autoexposure. These options offer more control while still giving you the benefit of the camera's exposure brain. Here's how they work:

- **Aperture-priority autoexposure:** This mode gives you control over the aperture. After setting the aperture, you frame your shot and then press the shutter button halfway to set the focus and exposure, as you do when using programmed autoexposure mode. But this time, the camera checks to see what aperture you chose and then selects the shutter speed necessary to correctly expose the image at that aperture.

 By altering the aperture, you change depth of field — the range of sharp focus. The section "Shifting Depth of Field," near the end of this chapter, explores this relationship between aperture and depth of field.

- **Shutter-priority autoexposure:** In shutter-priority mode, you choose the shutter speed, and the camera selects the correct aperture.

Theoretically, you should wind up with the same exposure no matter what aperture or shutter speed you choose, because as you adjust one value, the camera makes a corresponding change to the other value, right? Well, yes, sort of. Remember that you're working with a limited range of shutter speeds and apertures (your camera manual provides information on available settings). So depending on the lighting conditions, the camera may not be able to properly compensate for the shutter speed or aperture that you choose.

Suppose that you're shooting outside on a bright, sunny day. You take your first picture at an aperture of f/11, and the picture looks great. Then you shoot a second picture, this time choosing an aperture of f/4. The camera may not be able to set the shutter speed high enough to accommodate the larger aperture, which means an overexposed picture. (Again, if you're not sure what the terms *shutter speed* and *aperture* mean, check out Chapter 2.)

Here's another example: Say that you're trying to catch a tennis player in the act of smashing a ball during a gray, overcast day. You know that you need a high shutter speed to capture action, so you switch to shutter-priority mode and set the shutter speed to 1/500 second. But given the dim lighting, the camera can't capture enough light even at the largest aperture setting. So your picture turns out too dark.

As long as you keep the camera's shutter speed and aperture range in mind, however, switching to shutter-priority or aperture-priority mode can come in handy in the following scenarios:

✓ **You're trying to capture an action scene, and the shutter speed the camera selects in programmed autoexposure mode is too slow.** In Figure 6-4, for example, a shutter speed of 1/60 second left my jumping friends blurry. Switching to shutter-priority mode and setting the shutter speed to 1/300 second caught them cleanly in mid-jump. (Note that the speed you need to stop action depends on how fast your subject is moving.)

1/60 second | 1/300 second

Figure 6-4: At a slow shutter speed, moving objects appear blurry (left); a faster shutter catches action cleanly (right).

- ✐ **You *want* moving objects to be blurred so that you convey a sense of motion.** When shooting fountains and waterfalls, for example, you can give the water a misty look by slowing down the shutter, as shown in Figure 6-5. The shutter speed for the left image was 1/200 second; the right image, 1/20 second.

- ✐ **You want to use aperture to control depth of field.** Again, see the last section in this chapter for details on this possibility. (A quick preview: The larger the aperture, the blurrier the background.)

Any time you use a slow shutter speed, be careful to hold the camera still. Otherwise, stationary objects and moving objects alike may appear blurry.

Applying exposure compensation (EV)

Whether you're working in fully automatic mode or using shutter- or aperture-priority mode, you may be able to tweak the exposure by using *exposure compensation,* also referred to as EV *(exposure value)* adjustment. This control bumps the exposure up or down a few notches from what the camera's autoexposure computer thinks is appropriate.

1/200 second 1/20 second

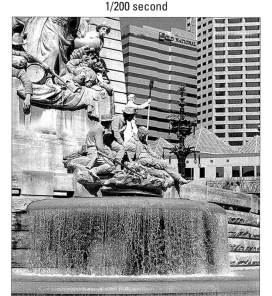
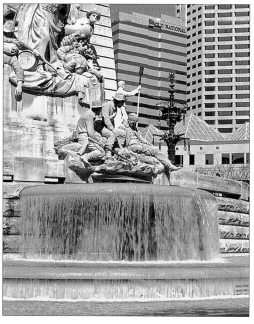

Figure 6-5: A slow shutter speed gives the water a softer, mistier look.

How you get to the exposure compensation settings varies from camera to camera. But you typically choose from settings such as +0.7, +0.3, 0.0, –0.3, –0.7, and so on, with the 0.0 representing the default autoexposure setting.

Regardless of how you access the EV control, the adjustment works the same way:

- ✐ To produce a brighter image, raise the EV value.

- ✐ To produce a darker picture, lower the EV value.

Different cameras provide you with different ranges of EV options, and the extent to which an increase or decrease in the value affects your image also varies from camera to camera. But Figures 6-6 through 6-8 give you an idea of the impact you can make with EV compensation.

EV 0.0

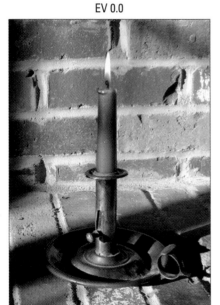

The image in Figure 6-6 shows the exposure that the camera created when I set the EV value to 0.0. The two images In Figure 6-7 show the same shot when I reduced the exposure by using a negative EV value. Figure 6-8 shows what happened when I used positive EV values.

The candle scene points up the benefits of exposure compensation. I wanted an exposure dark enough to allow the candle flame to create a soft glow and to capture the contrast between the shadowed background areas and the bands of strong afternoon sunshine, which were coming in through the slats of a wooden blind. The nonadjusted exposure

Figure 6-6: The original autoexposure setting produced an image that is a little too bright for my liking.

(labeled EV 0.0) was just a bit brighter than I had in mind. So I just played with the EV values until I came up with a mix of shadows and highlights that suited the subject. For my purposes, I liked the result I obtained with an EV setting of –0.3.

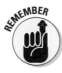

Don't forget that if your camera offers a choice of metering modes, you may want to experiment with changing the metering mode as well as using EV adjustment. Adjusting the metering mode changes the area of the frame that the camera considers when making its exposure decision. For the candle image, I used matrix metering mode, which bases exposure on the entire frame.

EV −0.3 EV −1.0

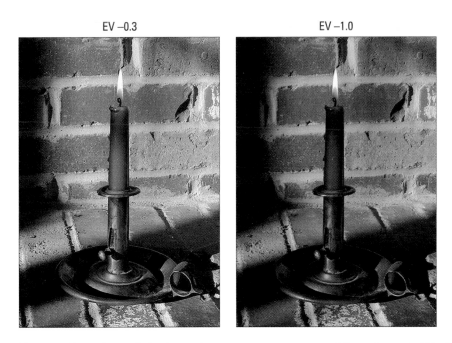

Figure 6-7: To produce a darker image than the autoexposure meter delivers, lower the EV value.

EV +0.3 EV +1.0

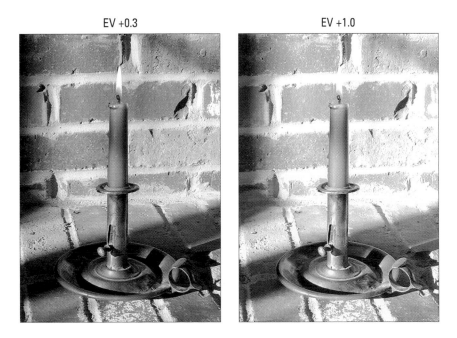

Figure 6-8: For a brighter image, raise the EV value.

Taking Flash Photos

If the techniques in preceding sections don't deliver a bright enough exposure, you simply have to find a way to bring more light onto your subject. The obvious choice, of course, is to use a flash.

Most cameras have a built-in flash that operates in several modes. In addition to automatic mode, in which the camera gauges the available light and fires the flash if needed, you typically get the following options: fill flash, no flash, red-eye reduction, and night-time flash (also called *slow-sync flash*). Higher-end cameras may allow you to add an external flash unit as well.

The next several sections explain these additional flash options.

Fill flash (or force flash)

This mode triggers the flash regardless of the light in the scene. Fill-flash mode is especially helpful for outdoor shots, such as the one in Figure 6-9. I shot the image on the left using auto-flash mode. Because the picture was taken on a sunny day, the camera didn't see the need for a flash. But I did because the shadow from the hat obscured the subject's eyes. Switching to fill-flash mode and forcing the flash to fire threw some additional light on her face, bringing her eyes into visible range.

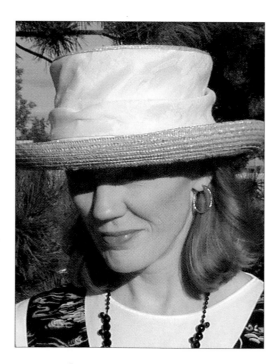

Figure 6-9: Adding flash light brings the eyes out from the shadows created by the hat.

No flash

Choose this setting when you don't want to use the flash, no way, no how. For example, you may want to use this mode when you're shooting highly reflective objects, such as glass or metal, because the flash can cause blown highlights (areas that are completely white, with no tonal detail). The upcoming section "Lighting Shiny Objects" offers more help with this problem.

You may also want to turn off the flash simply because the quality of the existing light is part of what makes the scene compelling, as is the case in the candle image in Figure 6-6. The interplay of shadows and light is the interesting aspect of the scene. Turn on the flash, and you have nothing more than a boring shot of a candle on a hearth.

When you turn off the flash, the camera may reduce the shutter speed to compensate for the dim lighting. That means that you need to hold the camera steady for a longer period of time to avoid blurry images. Use a tripod or otherwise brace the camera for best results.

Flash with red-eye reduction

Anyone who's taken people pictures with a point-and-shoot camera — digital or film — is familiar with the so-called red-eye problem. The flash reflects in the subject's eyes, and the result is a demonic red glint in the eye. Red-eye reduction mode aims to thwart this phenomenon by firing a low-power flash before the "real" flash goes off or by lighting a little lamp for a second or two prior to capturing the image. The idea is that the prelight, if you will, causes the iris of the eye to shut down a little, thereby lessening the chances of a reflection when the final flash goes off.

Unfortunately, red-eye reduction on digital cameras doesn't work much better than it does on film cameras. Often, you still wind up with fire in the eyes — hey, the manufacturer only promised to *reduce* red eye, not eliminate it, right? Worse, your subjects sometimes think the preflash or light is the real flash and start walking away just when the picture is actually being captured. So if you shoot with red-eye mode turned on, be sure to explain to your subjects what's going to happen.

The good news is that, because you're shooting digitally, you can repair red eyes easily. Some cameras have an in-camera red-eye remover that you can apply after you take a picture. If not, the fix is easy to make in a photo-editing program. Chapter 13 shows you how.

Slow-sync flash

Slow-sync flash, which sometimes also goes by the name *nighttime flash,* increases the exposure time beyond what the camera normally sets for flash pictures.

With a normal flash, your main subject is illuminated, but background elements beyond the reach of the flash are dark, as in the top example in Figure 6-10. The longer exposure time provided by slow-sync flash allows more ambient light to enter the camera, resulting in a lighter background. I used this setting for the lower example in Figure 6-10.

Whether a brighter background is desirable depends upon the subject and your artistic mood. However, remember that the slower shutter speed required for slow-sync flash can easily result in a blurred image; both camera and subject must remain absolutely still during the entire exposure to avoid that problem. As a point of reference, the exposure time for the normal flash example in Figure 6-10 was 1/60 second, while the slow-sync exposure time was a full five seconds. In addition, colors in slow-sync pictures may appear slightly warmer because of the white-balance issues that Chapter 5 discusses.

External flash

Higher-end digital models may enable you to use a separate flash unit with your digital camera. In this mode, the camera's on-board flash is disabled, and you must set the correct exposure to work with

Figure 6-10: Slow-sync flash produces a brighter background than normal flash mode.

your flash. This option is great for professionals and advanced photo hobbyists who have the expertise and equipment to use it; check your camera manual to find out what type of external flash works with your camera and how to connect the flash.

If your camera doesn't offer an accessory off-camera flash connection, you can get the benefits of an external flash by using so-called "slave" flash units. These small, self-contained, battery-operated flash units have built-in photo eyes that trigger the supplemental flash when the camera's flash goes off. If you're trying to photograph an event in a room that's dimly lit, you can put several slave units in different places. All the units fire when you take a picture anywhere in the room.

But it looked good in the LCD!

Your camera's monitor gives you a good idea of whether your image is properly exposed. But don't rely entirely on the monitor, because it doesn't provide an absolutely accurate rendition of your image. Your actual image may be brighter or darker than it appears on the monitor, especially if your camera enables you to adjust the brightness of the monitor display.

To make sure that you get at least one correctly exposed image, *bracket* your shots if your camera offers exposure-adjustment controls. Bracketing means to record the same scene at several different exposure settings. Some cameras even offer an automatic bracketing feature that records multiple images, each at a different exposure, with one press of the shutter button.

Switching on Additional Lights

Although your camera's flash offers one alternative for lighting your scene, flash photography isn't problem-free. When you're shooting your subject at close range, a flash can leave some portions of the image overexposed or even cause blown highlights — areas that are so overexposed that they are completely white, without any detail. A flash can also lead to red-eyed people, as all of us know too well.

Some digital cameras can accept an auxiliary flash unit, which helps reduce blown highlights and red eye because you can move the flash farther away from the subject. But if your camera doesn't offer this option, you usually get better results if you turn off the flash and use another light source to illuminate the scene.

If you're a well-equipped film photographer and you have studio lights, go dig them up. Or you may want to invest in some inexpensive photoflood lights — these are the same kind of lights used with video camcorders and are sometimes called "hot" lights because they "burn" continuously.

But you really don't need to go out and spend a fortune on lighting equipment. If you get creative, you can probably figure out a lighting solution using stuff you already have around the house. For example, when shooting small objects, I sometimes clear off a shelf on the white bookcase in my office. A nearby window offers a perfect natural light source.

For shots where I need a little more space, I sometimes use the setup shown in Figure 6-11. The white background is nothing more than a cardboard presentation easel purchased at an art and education supply store — teachers use these things to create classroom displays. I placed another white board on the table surface.

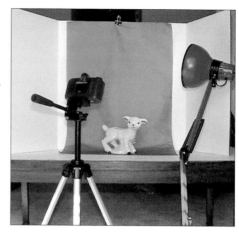

Figure 6-11: You can create a makeshift studio using nothing more than a white presentation easel, a tripod, and household lamp.

The easel and board brighten the subject because they reflect light onto it. If I need still more light, I switch on a regular old desk lamp or a small clip-on shop light (the kind you buy in hardware stores). And if I want a colored background instead of a white one, I clip a piece of colored tissue paper, also bought at that education supply store, to the easel. Fabric remnants from your local sewing store provide another source of inexpensive backdrops.

Okay, so professional photographers and serious amateurs may turn up their noses at these cheap little setups. But I say, whatever works, works. Besides, you've already spent a good sum of money on your camera, so why not save a few bucks where you can?

When using an artificial light source, whether it's a true-blue photography light or a makeshift solution like a desk lamp, you get better results if you don't aim the light directly at the object you're photographing. Instead, aim the light at the background and let the light bounce off that surface onto your subject. For example, when using a setup like the one in Figure 6-11, you might aim the light at one of the side panels. This kind of lighting is called *bounce lighting,* in case you're curious.

If your lighting setup is near a window, keep in mind that sunlight and artificial lights have different color temperatures, which can fluster your camera's white balancing sensor. Do a few test shots, and if your pictures exhibit an unwanted colorcast, try changing your camera's white-balance setting. Alternatively, you can buy some daylight photo flood bulbs to get the color temperature of your artificial lights more in sync with the daylight shining through the window. For more details about white balance and color temperature, check out Chapter 5.

Lighting Shiny Objects

When you shoot shiny objects such as jewelry, glass, chrome, and porcelain, lighting presents a real dilemma. Any light source that shines directly on the object can bounce off the surface and cause blown highlights, as shown in the left image in Figure 6-12. In addition, the light source or other objects in the room may be reflected in the surface of the object you want to shoot. For the jewelry shot, the reflections in the crystal earrings also distorted color.

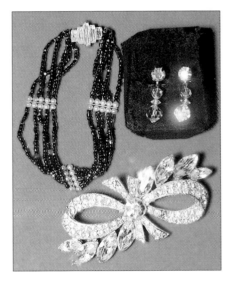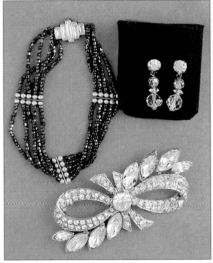

Figure 6-12: Direct lighting creates blown highlights (left); working with a diffused light source solves the problem (right).

Professional photographers invest in expensive lighting setups to avoid these problems when shooting product shots like the one in Figure 6-12. If you're not in the professional category — or just don't have a huge budget for outfitting a studio — try these tricks to get decent pictures of shiny stuff:

- **Turn off your camera's built-in flash and find another way to light the object.** A built-in flash creates a strong, focused light source that's bound to create problems. See earlier sections in this chapter to find out how various digital camera features may enable you to get a good exposure without using a flash.

- **Find a way to diffuse the lighting.** Placing a white curtain or sheet between the light source and the object not only softens the light and helps prevent blown highlights, but also prevents unwanted reflections.

✔ **If you regularly need to photograph reflective objects, you may want to invest in a product like the Cloud Dome.** (See the left photo in Figure 6-13.) You put the objects you want to shoot under the dome and then attach your camera to a special mount, centering the camera lens over a hole in the top of the dome. The dome diffuses the light sources and eliminates reflections. In addition, the mount stabilizes the camera, eliminating camera shake that can cause a blurred image.

Cloud Domes start at $200 (www.clouddome.com); you can buy extenders that allow for shooting taller or wider objects. The price may seem a little steep at first, but if you do a lot of this type of photography, the amount of time and frustration it can save is well worth your investment. Another option is to buy a light tent, which is a little bit like a teepee made of white cloth. You put your subject inside and then shoot through a hole in the tent, as shown in the right photo in Figure 6-13. Light tents come in a wide variety of sizes and prices. The 20-inch diameter tent in Figure 6-13 is from Lastolite (www.lastolite.com) and costs about $65.

Photos courtesy Cloud Dome, Inc. and Lastolite Limited

Figure 6-13: Devices like the Cloud Dome (left) and Lastolite light tent (right) make shooting reflective objects easier.

Compensating for Backlighting

A *backlit* picture is one in which the sun or light source is behind the subject. With autoexposure cameras, strong backlighting often results in too-dark subjects because the camera sets the exposure based on the light in the overall scene, not just on the light falling on the subject. The first image in Figure 6-14 is a classic example of a backlighting problem. I shot this picture at mid-morning, when the sun was almost directly behind the statue (you can see the bright light reflected off her shoulders).

TIP

Excuse me, can you turn down the sun?

Adding more light to a scene is considerably easier than reducing the light. If you're shooting outdoors, you can't exactly hit the dimmer switch on the sun. If the light is too strong, you really have only a few options. You can move the subject into the shade (in which case you can use a fill flash to light the subject), or, on some cameras, reduce the exposure by lowering the EV value.

If you can't find a suitable shady backdrop, you can create one with a piece of cardboard. Just have a friend hold the cardboard between the sun and the subject. Voilà — instant shade. By moving the cardboard around, you can vary the amount of light that hits the subject.

Figure 6-14: Backlighting can lead to underexposed subjects (left). Try switching the metering mode (middle), raising the EV value, adding a flash, or all three (right).

To remedy the situation, you have several options:

- ✔ **Reposition the subject so that the sun is behind the camera instead of behind the subject.** Unfortunately, this is not an option for immovable objects like the statue in Figure 6-14.

- ✔ **Reposition yourself so that you're shooting from a different angle.** Hmm, again, this is not a solution for this example, assuming you want to capture the front of the statue.

✔ **If your camera offers a choice of metering modes, switch to spot metering or center-weighted metering.** (Check out "Choosing a metering mode," earlier in this chapter, for information about metering modes.) For the middle example in Figure 6-14, I set the camera to spot metering mode. The image is improved, but the statue is still a little underexposed.

✔ **On cameras that don't offer spot or center-weighted metering, meaning that the camera considers the light throughout the frame when setting the exposure, try to "fool" the autoexposure meter.** Fill the frame with a dark object, press the shutter button halfway to lock in the exposure, reframe the subject, and press the shutter button the rest of the way to take the picture.

If you're working in autofocus mode, the focus is also set when you press the shutter button halfway. So be sure that the dark object you use to set the exposure is the same distance from the camera as your real subject. Otherwise, the focus of the picture will be off.

✔ **Raise the EV value.** See the section "Applying exposure compensation (EV)," earlier in this chapter, for information about this technique.

✔ **Use a flash.** Adding the flash can bring subjects out of the shadows. However, because the working range of the flash on most consumer digital cameras is relatively small, your subject must be fairly close to the camera for the flash to do any good.

To produce the well-exposed statue image on the right in Figure 6-14, I switched to spot metering, bumped the EV value up to +0.3, and added a flash. Note that on a bright day, the flash may also add a warmer tone to your scene, as here, due to the white-balancing issue explained in Chapter 5. The camera sets the white balance to compensate for the color of flash light, which is cooler (bluer) than sunny light.

Focus on Focus

Like point-and-shoot film cameras, digital cameras for the consumer market provide focusing aids to help you capture sharp images with ease. The following sections describe the different types of focusing schemes available and how you can make the most of them.

Working with fixed-focus cameras

Fixed-focus cameras are just that — the focus is set at the factory and can't be changed. The camera is designed to capture sharply any subject within a certain distance from the lens. Subjects outside that range appear blurry.

Fixed-focus cameras sometimes are called *focus-free* cameras because you're free of the chore of setting the focus before you shoot. But this term is a misnomer, because even though you can't adjust the focus, you have to remember to keep the subject within the camera's focusing range. There is no such thing as a (focus) free lunch.

Be sure to check your camera manual to find out how much distance to put between your camera and your subject. With fixed-focus cameras, blurry images usually result from having your subject too close to the camera. (Most fixed-focus cameras are engineered to focus sharply from a few feet away from the camera to infinity.)

Taking advantage of autofocus

Most digital cameras offer autofocus, which means that the camera automatically adjusts the focus after measuring the distance between lens and subject. But "autofocusing" isn't totally automatic. For autofocus to work, you need to *lock in* the focus before you shoot the picture, as follows:

1. **Frame the picture.**

2. **Press the shutter button halfway and hold it there.**

 Your camera analyzes the picture and sets the focus. If your camera offers autoexposure — as most do — the exposure is set at the same time. After locking in exposure and focus, the camera lets you know that you can proceed with the picture. Usually, a little light blinks near the viewfinder or the camera makes a beeping noise.

3. **Press the shutter button the rest of the way to take the picture.**

Although autofocus is a great photography tool, you need to understand a few things about how your camera goes about its focusing work in order to take full advantage of this feature. Here's the condensed version of the autofocusing manual:

- Autofocus mechanisms fall into one of two main categories:

 - **Single-spot focus:** With this type of autofocus, the camera reads the distance of the element that's at the center of the frame in order to set the focus.

 - **Multi-spot focus:** The camera measures the distance at several spots around the frame and sets focus relative to the nearest object.

 You need to know how your camera adjusts focus so that when you lock in the focus (using the press-and-hold method just described), you place the subject within the area that the autofocus mechanism reads. If the camera uses single-spot focusing, for example, you should place your subject in the center of the frame when locking the focus. Some cameras enable you to choose which type of focusing you want to use for a particular shot; check your camera manual for details.

- If your camera offers single-spot focus, you may see little framing marks in the viewfinder that indicate the focus point. Check your camera manual to see what the different viewfinder marks mean. On some cameras, the marks are provided to help you frame the picture rather than as a focusing indicator. (See the section "A Parallax! A Parallax!," in the next chapter, for more information.)

- After you lock in the focus, you can reframe your picture if you want. As long as you keep the shutter button halfway down, the focus remains locked. Be careful that the distance between the camera and the subject doesn't change, or your focus will be off.

- Some cameras that offer autofocus also provide you with one or two manual-focus adjustments. Your camera may offer a *macro mode* for close-up shooting and an *infinity lock* or *landscape focusing mode* for shooting subjects at a distance, for example. When you switch to these modes, autofocusing may be turned off, so you need to make sure that your subject falls within the focusing range of the selected mode. Check your camera's manual to find out the proper camera-to-subject distance.

Hold that thing still!

A blurry image isn't always the result of poor focusing; you can also get fuzzy shots if you move the camera during the time the image is being captured.

Holding the camera still is essential in any shooting situation, but it becomes especially important when the light is dim because a longer exposure time is needed. That means that you have to keep the camera steady longer than you do when shooting in bright light.

To help keep the camera still, try these tricks:

- Press your elbows against your sides as you snap the picture.

- Squeeze, don't jab, the shutter button. Use a soft touch to minimize the chance of moving the camera when you press the shutter button.

- Place the camera on a countertop, table, or other still surface. Better yet, use a tripod. You can pick up an inexpensive tripod for about $20.

- If your camera offers a self-timer feature, you can opt for hands-free shooting to eliminate any possibility of camera shake. Place the camera on a tripod (or other still surface), set the camera to self-timer mode, and then press the shutter button (or do whatever your manual says to activate the self-timer mechanism). Then move away from the camera. After a few seconds, the camera snaps the picture for you automatically.

Of course, if you're lucky enough to own a camera that offers remote-control shooting, you can take advantage of that feature instead of the self-timer mode.

Focusing manually

On most consumer digital cameras, you get either no manual-focusing options or just one or two options in addition to autofocus. You may be able to choose a special focus setting for close-up shooting and one for faraway subjects.

But a few high-end cameras offer more extensive manual focusing controls. Although some models offer a traditional focusing mechanism where you twist the lens barrel to set the focus, most cameras require you to use menu controls to select the distance at which you want the camera to focus.

The ability to set the focus at a specific distance from the camera comes in handy when you want to shoot several pictures of one, nonmoving subject. By setting the focus manually, you don't have to go to the trouble of locking in the autofocus for each shot. Just be sure that you've accurately gauged the distance between camera and subject when setting the manual-focus distance.

If you're using manual focus for close-up shooting, get out a ruler and make sure that you have the correct camera-to-subject distance. You can't get a good idea of whether the focus is dead-on from the viewfinder or LCD, and being just an inch off in your focus judgment can mean a blurry picture.

Shifting Depth of Field

If you're an experienced photographer, you probably know that one aspect of focus — *depth of field* — is controlled in part by the aperture setting. Depth of field refers to how much of an image is in sharp focus. The larger the depth of field, the greater the zone of sharp focus. (Note that zooming in on a subject also changes the depth of field; for more about this issue, see Chapter 7.)

Figure 6-15 shows an example of how aperture affects depth of field. For both pictures, I used the camera's macro focusing mode. But I shot the left image with an aperture setting of f/3.4 and the right image with an aperture of f/11.

In the left image, only objects very close to the front tulip are sharply focused — in other words, the picture has a short depth of field. Reducing the aperture increased the depth of field, bringing more surrounding flowers into focus. (Remember, a higher f-stop number means a smaller aperture.)

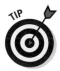

If your digital camera doesn't offer aperture control or a zoom lens, you can use your photo editor's blur filters to create the effect of a short depth of field in an existing picture. Chapter 11 shows you how. You may also have access to scene modes, explained next, which automatically vary the aperture.

f/3.4 f/11

Figure 6-15: An aperture setting of f/3.4 (left) results in a blurrier background than a setting of f/11 (right).

Taking Advantage of Scene Modes

When you're first getting into photography, remembering all the rules about ISO, shutter speed, aperture, and focus can be a pain at best — and nigh on impossible at worst. That's why many cameras now offer *scene modes.* These special picture-taking modes are designed to automatically flip all the available focus and exposure controls to settings that are appropriate for different types of subject matter.

For example, your camera may offer a Portrait scene mode. Because most people prefer the backgrounds in portraits to be slightly out of focus, Portrait mode automatically dials in a larger aperture, which reduces depth of field. (See the preceding section for more about depth of field.)

Table 6-1 lists the four standard scene modes and gives you an idea of how each one affects your picture. Check your manual to find out whether your camera offers these features; chances are, you may even have additional modes to make other types of picture-taking easier.

Table 6-1	Automatic Scene Modes
Mode	**What It Does**
Portrait	Uses the largest aperture, which shortens depth of field and creates a blurrier background. The camera may choose a faster shutter speed to compensate for the larger aperture.
Landscape	Selects the smallest possible aperture to ensure the greatest depth of field. Use this mode when you want as much of the scene as possible to be in sharp focus. The camera may choose a slower shutter speed to compensate, requiring you to hold the camera steady longer. This mode may also set the focusing mechanism to landscape mode.
Action	Selects a fast shutter speed to capture moving objects without blurring. The camera may open the aperture wider to compensate for the faster shutter, decreasing depth of field.
Nighttime	Use flash in combination with a slow shutter so that picture backgrounds are brighter. Don't use this mode if you want the background to be dark.

7

Take Your Best Shot

In This Chapter

▷ Composing your image for maximum impact

▷ Preventing parallax errors

▷ Working with a zoom lens

▷ Capturing action

▷ Shooting panoramas

▷ Turning down camera noise

Chapters 5 and 6 emphasize the science of digital photography, explaining technical issues such as resolution, aperture, shutter speed, and so on. But photography is as much art as it is science. After all, a boring image is a boring image, no matter how technically perfect.

This chapter offers some suggestions that can help you take more memorable, captivating photographs. Whether you're snapping pics of your children or shooting product images for your company's sales brochure, experiment with these techniques. As you'll discover, a little planning and creativity is all you need to evolve from a so-so picture taker to a creative, knock-their-socks-off photographer.

Composition 101

Consider the image in Figure 7-1. Exposure, focus, and the other technical aspects of the picture are fine. And the subject, a statue at the base of the Soldiers and Sailors Monument in Indianapolis, is interesting enough. But overall, the picture is . . . well, dull as dishwater. In fact, with all the new scented dishwashing liquids out there, I think dishwater might even be more intriguing.

Now look at Figure 7-2, which shows two additional images of the same subject, but with more powerful results. What makes the difference? In a word, *composition*. Simply framing the statue differently, zooming in for a closer view, and changing the camera angle create more captivating images.

Not everyone agrees on the "best" ways to compose an image — art being in the eye of the beholder and all that. For every composition rule, you can find an incredible image that proves the exception. That said, the following list offers some suggestions that can help you create images that rise above the ho-hum mark on the visual interest meter:

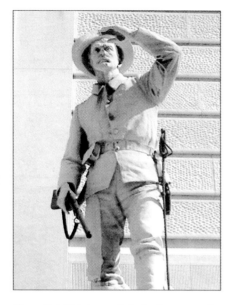

Figure 7-1: This image falls flat because of its uninspired framing and angle of view.

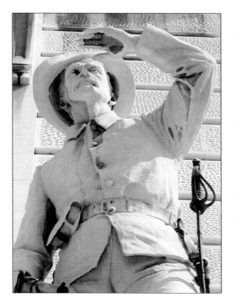

Figure 7-2: Getting closer to the subject and shooting from less-obvious angles result in more-interesting pictures.

✔ **Remember the rule of thirds.**
For maximum impact, don't place your subject smack in the center of the frame, as I did in Figure 7-1. Instead, mentally divide the image area into thirds, as illustrated in Figure 7-3. Then position the main subject elements at spots where the dividing lines intersect. In the sample image, the point of interest, the deer's eye and nose, fall at that placement.

This deer, fortunately, was so engrossed in nibbling the foliage that I had time to frame the shot well. But if you don't have that luxury, frame the shot loosely, including a good margin of background around the subject. Then you can crop the image to a better composition in your photo editor. Chapter 11 shows you how.

Figure 7-3: One rule of composition is to divide the frame into thirds and position the main subject at one of the intersection points.

✔ **Shoot from unexpected angles.**
Again, refer to Figure 7-1. This image accurately represents the statue. But the picture is hardly as captivating as the images in Figure 7-2, which show the same subject from more unusual angles.

✔ **Draw the eye across the frame.**
To add life to your images, compose the scene so that the viewer's eye is naturally led from one edge of the frame to the other, as in Figure 7-4. The figure in the image, also part of the Soldiers and Sailors Monument, appears ready to fly off into the big, blue yonder. You can almost feel the breeze blowing the torch's flame and the figure's cape.

Figure 7-4: To add life to your pictures, frame the scene so that the eye is naturally drawn from one edge of the image to the other.

✔ **Get close to your subject.** Often, the most interesting shot is the one that reveals the small details, such as the laugh lines in a grandfather's face or the raindrop on the rose petal. Don't be afraid to fill the frame with your subject, either. The old rule about "head room" — providing a nice margin of space above and to the sides of a subject's head — is a rule meant to be broken on occasion.

✔ **Pay attention to the background.** Before taking a picture, do a quick scan of the background, looking for distracting background elements such as the flower and computer monitor in Figure 7-5.

Figure 7-5: A beautiful subject set against a horrendous background.

Here's a trick for capturing children against a noninvasive backdrop: Photograph them while they're lying down on the floor and looking up at the camera, as in Figure 7-6. Rooms full of children also tend to be full of toys, sippy cups, and other kid paraphernalia, which can make getting an uncluttered shot difficult. So I simply shove everything off a small area of carpet and have the kids get down on the floor and pose.

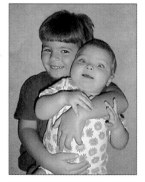

✔ **Try to capture the subject's personality.** The most boring people shots are those in which the subjects stand in front of the camera and say "cheese" on the photographer's cue. If you really want to reveal something about your subjects, catch them in the act of enjoying a favorite hobby or using the tools of their trade. This tactic is especially helpful with subjects who are camera-shy; focusing their attention on a familiar activity helps put them at ease and replace that stiff, I'd-rather-be-anywhere-but-here look with a more natural expression.

Figure 7-6: To avoid clutter, have kids lie on an empty swatch of carpet.

A Parallax! A Parallax!

You compose your photo perfectly. The light is fine, the focus is fine, and all other photographic planets appear to be in alignment. But after you snap your picture and view the image on the camera monitor, the framing is off, as though your subject repositioned itself while you weren't looking.

TECHNICAL STUFF

You're not the victim of some cruel digital hoax — just a photographic phenomenon known as a *parallax error*.

On many digital cameras, as on most point-and-shoot film cameras, the viewfinder looks out on the world through a separate window from the camera lens. Because the viewfinder is located an inch or so above or to the side of the lens, it sees your subject from a slightly different angle than the lens. But the image is captured from the point of view of the lens, not the viewfinder.

When you look through your viewfinder, you may see some lines near the corners of the frame. The lines indicate the boundaries of the frame as seen by the camera lens. Pay attention to these framing cues, or you may wind up with pictures that appear to have been lopped off along one edge, as in Figure 7-7.

Figure 7 7: My pal Bernie loses his ears as the result of a parallax error.

The closer you are to your subject, the bigger the parallax problem becomes, whether you use a zoom lens or simply position the camera lens nearer to your subject. Some cameras provide a second set of framing marks in the viewfinder to indicate the framing boundaries that apply when you're shooting close-up shots. Check your camera manual to determine which framing marks mean what. (Some markings have to do with focusing, not framing.)

TIP

If your camera has an LCD monitor, you have an additional aid for avoiding parallax problems. Because the monitor reflects the image as seen by the lens, you can simply use the monitor instead of the viewfinder to frame your image. On some cameras, the LCD monitor turns on automatically when you switch to macro mode for close-up shooting.

Composing for Compositing

REMEMBER

For the most part, the rules of digital image composition are the same rules that film photographers have followed for years. But when you're creating digital images, you need to consider an additional factor: how you want to use the image. If you want to lift part of your picture out of its background — for example, in order to paste the subject into another image — pay special attention to the background and framing of the image.

Digital-imaging gurus refer to the process of combining two images as *compositing.*

Suppose that you're creating a product brochure and you want to create a photo montage that combines images of four products. To make life easier in the photo-editing stage, shoot each product against a plain background. That way, you can easily separate the product from the background when you're ready to cut and paste the product image into your montage.

As I explain in Chapter 12, you must *select* an element in your photo editor before you can lift it out of its background and paste it into another picture. Selecting simply draws an outline around the element so that the computer knows which pixels to cut and paste. So why does shooting your subject against a plain background make the job easier? Because most photo editors offer a tool that enables you to click a color in your image to automatically select surrounding areas that are similarly colored. If you shoot your subject against a red backdrop, for example, you can select the background by clicking a red background pixel. You then can invert (reverse) the selection to easily select the subject.

Figures 7-8 and 7-9 offer an example. The vintage fabric used as a background in Figure 7-8 makes artistic sense, given that the subject is a vintage camera. But because little contrast exists between the edges of the camera and the background, you lose the automatic selection option. Instead, you have to draw your selection outline manually by tracing around the camera.

Figure 7-8: Avoid busy backgrounds such as this one when shooting objects that you plan to use in a photo collage.

Again, you can find complete details about selecting in Chapter 12 and read about building a collage in Chapter 13. For now, just remember that if you want to separate an object from its background in the editing stage, shoot the object against a plain background, as in Figure 7-9. Make sure that the background color is distinct from the colors around the *perimeter* of the subject, not the interior, if you have a multicolor subject, such as the camera.

Another important rule of shooting images for compositing is to fill as much of the frame as possible with your subject, as I did in Figure 7-9. That way, you devote the maximum number of pixels to your subject, rather than wasting them on a background that you're going to trim away. The more pixels you have, the larger the prints you can make. (See Chapter 2 for more information on this law of digital imaging.)

Figure 7-9: Shoot elements against a plain background and fill as much of the frame as possible.

Zooming In without Losing Out

Many digital cameras offer zoom lenses that enable you to get a close-up perspective on your subject without going to the bother of actually moving toward the subject.

Some cameras provide an *optical zoom*, which is a true zoom lens, just like the one you may have on your film camera. Other cameras offer a *digital zoom*, which isn't a zoom lens at all but a bit of pixel sleight of hand. The next two sections offer some guidelines for working with both types of zooms.

Shooting with an optical (real) zoom

If your camera has an optical zoom, keep these tips in mind before you trigger that zoom button or switch:

- The closer you get to your subject, the greater the chance of a parallax error, discussed earlier in this chapter.
- When you zoom in on a subject, you can fit less of the background into the frame than if you zoom out and get your close-up shot by moving nearer to the subject, as illustrated by Figure 7-10. This choice is entirely subjective, by the way. If you want more background in the frame, zoom out and walk closer to your subject; if not, walk away and zoom in. For this portrait example, zooming was the right thing to do because it eliminates the distracting background elements you see in the right photo.

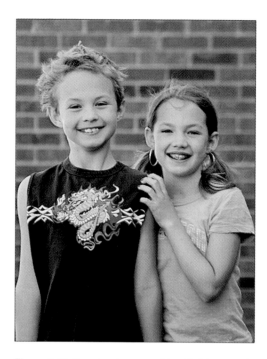 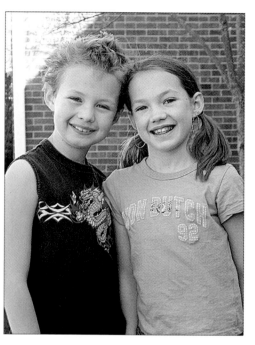

Figure 7-10: Zooming in on a subject (left) means less background in the frame than zooming out and moving closer to the subject (right).

✔ Zooming to a telephoto setting also tends to make the background blurrier than if you shoot close to the subject. This happens because the *depth of field* changes when you zoom. Introduced in Chapter 6, depth of field simply refers to the zone of sharp focus in your photo. With a short depth of field — which is what you get when you're zoomed in — elements that are close to the camera are sharply focused, but distant background elements are not. When you zoom to a wide-angle lens setting, you have a greater depth of field, so faraway objects may be as sharply focused as your main subject. Notice that the bricks in the zoom example in Figure 7-10 are much less sharply focused than those in the right image.

Keep in mind that varying the camera's aperture setting also affects depth of field. See the last section in Chapter 6 for details. For Figure 7-10, the aperture was the same for both shots so that the change in depth of field occurred only as a result of zooming.

Using a digital zoom

Some cameras put a new twist on zooming, providing a *digital zoom* rather than an optical zoom. With digital zoom, the camera enlarges the elements at the center of the frame to create the *appearance* that you've zoomed in.

Say that you want to take a picture of a boat that's bobbing in the middle of a lake. You decide to zoom in on the boat and lose the watery surroundings. The camera crops out the lake pixels and magnifies the boat pixels to fill the frame. The end result is no different than if you had captured both boat and lake, cropped the lake away in your photo software, and then enlarged the remaining boat image. Any time you enlarge a photo significantly, you run the risk of reducing picture quality. (See Chapter 2 to find out why.) In addition, a digital zoom doesn't produce the same change in depth of field as an optical zoom.

For the most part, this feature is more marketing gimmick than anything else. However, digital zoom — which is really in-camera cropping — may come in handy if you want to print directly from your camera memory card and won't have the opportunity (or desire) to do the cropping yourself on your computer.

Catching a Moving Target

Capturing action with most point-and-shoot cameras, digital or film, isn't an easy proposition. If your subject is moving very rapidly, your camera may not offer shutter speeds high enough to "stop" action — that is, to record a non-blurry image of a moving target. (See Chapter 6 for help with manipulating shutter speeds.)

Compounding the problem, the camera needs a few seconds to establish the autofocus and autoexposure settings before you shoot, plus a few seconds after you shoot to process and store the image in memory. If you're shooting with a flash, you also must give the flash a few seconds to recycle between pictures.

Some cameras offer a rapid-fire option, usually known as *burst mode* or *continuous capture mode,* that enables you to shoot a series of images with one press of the shutter button. The camera takes pictures at timed intervals as long as you keep the shutter button pressed. This feature eliminates some of the lag time that occurs from the moment you press the shutter button until the time you can take another picture. I used burst mode to record the series of images in Figure 7-11.

Figure 7-11: Burst mode enables you to shoot a moving target. Here, a capture setting of three frames per second broke a golfer's swing into five stages.

If your camera offers burst-mode shooting, check to find out whether you can adjust the settings to capture more or fewer images within a set period of time. To capture the images in Figure 7-11, for example, I set the camera to its fastest burst mode, three frames per second.

Keep in mind that most cameras can shoot only low- or medium-resolution pictures in burst mode (high-resolution pictures would require a longer storage time). And the flash is typically disabled for this capture mode. More importantly, though, timing the shots so that you catch the height of the action is difficult. Notice that in Figure 7-11, I didn't capture the most important moment in the swing — the point at which the club makes contact with the ball! If you're interested in recording just one particular moment, you may be better off using a regular shooting mode so that you have better control over when each picture is taken.

When you're shooting action shots "the normal way" — that is, without the help of burst mode — use these tricks to do a better job of stopping a moving subject in its tracks:

- **Lock in focus and exposure in advance.** Press the shutter button halfway to initiate the autofocus and autoexposure process (if your camera offers these features) well ahead of the time when you want to capture the image. That way, when the action happens, you don't have to wait for the focus and exposure to be set. When locking in the focus and exposure, aim the camera at an object or person approximately the same distance away and in the same lighting conditions as your final subject will be. See Chapter 6 for more information about locking in focus and exposure.

- **Anticipate the shot.** With just about any camera, a slight delay occurs between the time you press the shutter button and the time the camera actually records the image. So the trick to catching action is to press the shutter button just a split second *before* the action occurs. Practice shooting with your camera until you have a feel for how far in advance you need to press that shutter button.

- **Turn on the flash.** Even if it's daylight, turning on the flash sometimes causes the camera to select a higher shutter speed, thereby freezing action better. To make sure that the flash is activated, use the fill-flash mode (check out Chapter 6), rather than auto-flash mode. Remember, though, that the flash may need time to recycle between shots. So for taking a series of action shots, you may want to turn the flash off.

- **Switch to shutter-priority autoexposure mode (if available).** Then select the highest shutter speed the camera provides and take a test shot. If the picture is too dark, lower the shutter speed a notch and retest. Remember, in shutter-priority mode, the camera reads the light in the scene and then sets the aperture as needed to properly expose the image at the shutter speed you select. So if the lighting isn't great, you may not be able to set the shutter speed high enough to stop action. For more about this issue, see Chapter 6.

If your camera doesn't offer shutter-priority autoexposure (or manual shutter and aperture control), it may provide a sports or action scene mode that increases shutter speed. Check your manual for information.

✔ **Use a lower capture resolution.** The lower the capture resolution, the smaller the image file, and the less time the camera needs to record the image to memory. That means that you can take a second shot sooner than if you captured a high-resolution image.

✔ **Turn off automatic playback.** If your camera offers an "instant review" feature that automatically displays a picture on the LCD monitor for a few seconds after you shoot the image, turn off the feature. When it's on, the camera likely won't let you take another picture during the review period.

✔ **Make sure that your camera batteries are fresh.** Weak batteries can sometimes make your camera behave sluggishly.

✔ **Keep the camera turned on.** Because digital cameras suck up battery juice like nobody's business, the natural tendency is to turn off your camera between shots. But most cameras take a few seconds to warm up after you turn them on — during which time, whatever it was that you were trying to record may have come and gone. Do turn the LCD monitor off, though, to conserve battery power.

Shooting Pieces of a Panoramic Quilt

You're standing at the edge of the Grand Canyon, awestruck by the colors, light, and majestic rock formations. "If only I could capture all this in a photograph!" you think. But when you view the scene through your camera's viewfinder, you quickly realize that you can't possibly do justice to such a magnificent landscape with one ordinary picture.

Wait — don't put down that camera and head for the souvenir shack just yet. When you're shooting digitally, you don't have to try to squeeze the entire canyon — or whatever other subject inspires you — into one frame. You can shoot several frames, each featuring a different part of the scene, and then stitch them together just as you would sew together pieces of a patchwork quilt. Figure 7-12 shows two images of a historic farmhouse that I stitched together into the panorama shown in Figure 7-13.

Although you could conceivably combine photos into a panorama using your photo-editor's regular cut-and-paste editing tools, a dedicated stitching tool makes the job easier. You simply pull up the images you want to join, and the program assists you in stitching the digital "seam."

Figure 7-12: I stitched together these two images to create the panorama in Figure 7-13.

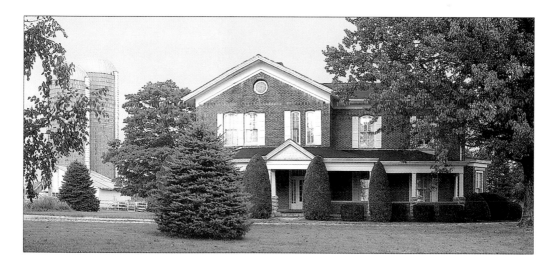

Figure 7-13: The resulting panorama provides a larger perspective on the farmhouse scene.

Some camera manufacturers provide proprietary stitching tools as part of the camera's software bundle. In addition, many photo-editing programs offer a stitching tool; Figure 7-14 shows the version provided in Photoshop Elements. You also can buy stand-alone stitching programs such as ArcSoft Panorama Maker ($40, www.arcsoft.com).

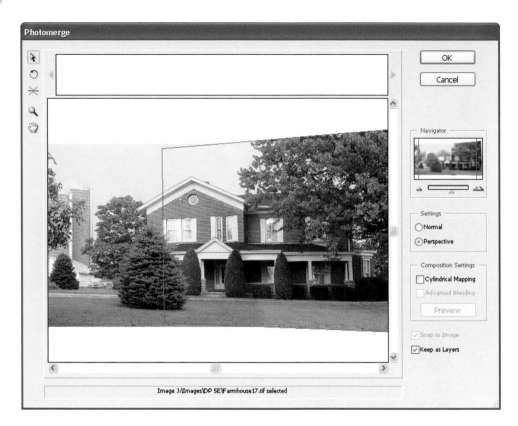

Figure 7-14: Photoshop Elements offers a panorama tool that helps you stitch images together.

The stitching process is easy if you shoot the original images correctly. If you don't, you wind up with something that looks more like a crazy quilt than a seamless photographic panorama. Here's what you need to know:

✔ **Capture each picture using the same camera-to-subject distance and camera height.** If you're shooting a wide building, don't get closer to the building at one end than you do at another, for example, or raise the camera for one shot in the series.

✔ **Overlap each shot by at least 30 percent.** Say that you're shooting a line of ten cars. If image one includes the first three cars in the line, image two should include the third car as well as cars four and five. Some cameras provide a panorama mode that displays a portion of the previous shot in the monitor so that you can see where to align the next shot in the series. If your camera doesn't offer this feature, you need to make a mental note of where each picture ends so that you know where the next picture should begin.

- **Maintain the right axis of rotation.** As you pan the camera to capture the different shots in the panorama, imagine that the camera is perched atop a short flagpole, with the camera's lens aligned with the pole. Be sure to use that same alignment as you take each shot. If you don't, you can't successfully join the images later. For best results, use a tripod.

- **Keep the camera level.** Some tripods include little bubble levels that help you keep the camera on an even keel. If you don't have this kind of tripod, you may want to buy a little stick-on level at the hardware store and put it on top of your camera.

- **Use a consistent focusing approach.** If you lock the focus on the foreground in one shot, don't focus on the background in the next shot.

- **Check your camera manual to find out whether your camera offers an exposure lock function.** This feature retains a consistent exposure throughout the series of panorama shots, which is important for seamless image stitching.

If your camera doesn't provide a way to override autoexposure, you may need to fool the camera into using a consistent exposure. Say that one half of a scene is in the shadows and the other is in the sunlight. With autoexposure enabled, the camera increases the exposure for the shadowed area and decreases the exposure for the sunny area. That sounds like a good thing, but what it really does is create a noticeable color shift between the two halves of the picture. To prevent this problem, lock in the focus and exposure on the same point for each shot. Choose a point of medium brightness for best results.

- **Avoid including moving objects in the shot.** If possible, wait for bypassers to get out of the frame before you take each picture. If someone is walking across the landscape as you shoot, you may wind up with the same strolling figure appearing at several spots in the stitched panorama. Ditto for cars, bicycles, and other moving objects.

If you really enjoy creating panorama images or need to do so regularly for business purposes, you can make your life a little easier by investing in a special panoramic tripod head, which helps you make sure that each shot is perfectly set up to create a seamless panorama. Manufacturers of these specialty tripods include Manfrotto (www.manfrotto.com) and Kaidan (www.kaidan.com). Expect to pay several hundred dollars for these specialty devices.

Avoiding the Digital Measles

Are your images coming out of your camera looking a little blotchy or dotted with colored speckles, like those you see in Figure 7-15? Or do some parts of the image have a jagged appearance?

Figure 7-15: Low lighting can result in grainy images.

If your images suffer from these defects, try these remedies:

- **Use a lower JPEG compression setting.** Jaggedy or blotchy images are often the result of too much JPEG compression, a topic that you can explore in Chapter 5. Check your camera manual to find out how to choose a lower compression setting.

- **Raise the resolution.** Too few pixels can mean blocky-looking — or *pixelated* — images. The larger you print the photo, the worse the problem becomes. (See Chapter 2 for information on why low resolution translates to poor print quality.)

- **Increase the lighting.** Photos shot in very low light often take on a grainy appearance, like the one in Figure 7-15. Unfortunately, you can't really throw a spotlight on a skyline scene like this one, but if you're shooting smaller, closer subjects, adding flash or other light sources is a good notion.

- **Lower the camera's ISO setting (if possible).** Typically, the higher the ISO, the grainier the image. For more on this issue, check out Chapter 6.

Part III

From Camera to Computer and Beyond

In this part . . .

One major advantage of digital photography is how quickly you can go from camera to final output. In minutes, you can print or electronically distribute your images, while your film-based friends are cooling their heels, waiting for their pictures to be developed at the one-hour photo lab.

The chapters in this part of the book contain everything you need to know to get your pictures out of your camera and into the hands of friends, relatives, clients, or anyone else. Chapter 8 explains the process of transferring images to your computer and also discusses ways to organize image files. Chapter 9 describes all your printing options and provides suggestions for which types of printers work best for different printing needs. And Chapter 10 explores electronic distribution of images — placing them on the World Wide Web, sharing them via e-mail, and the like — and offers ideas for additional on-screen uses for your images.

In other words, you find out how to coax all the pretty pixels inside your camera to come out of hiding and reveal your photographic genius to the world.

Building Your Image Warehouse

In This Chapter

▶ Downloading photos from a card reader or adapter

▶ Transferring files via a camera-to-computer connection

▶ Converting Camera Raw files

▶ Working with proprietary camera files

▶ Organizing your picture files

For most people, the picture-taking part of digital photography isn't all that perplexing — the process is pretty much the same as shooting with a film camera, after all. Where the confusion arises is the step of getting pictures from the camera to the computer, especially for people who don't have much computer experience.

This chapter sorts out the mysteries of this part of the digital photography routine, showing you the fastest and easiest ways to transfer pictures to your computer. Look here, too, for details on how to work with pictures taken in the Camera Raw format and for tips on how to organize your picture files. (Chapter 4 discusses the best ways to archive your files once they're on your computer.)

If you *are* a computer novice, I encourage you to also pick up a copy of the appropriate *For Dummies* book for your Windows or Mac operating system. Although I try to provide enough information to get you started, this book doesn't have enough room to cover all the nuts and bolts of working with various operating systems. And without a good grip on computer basics, your digital photography experience will be more frustrating and less enjoyable than it should be.

Downloading Your Images

You have a camera full of pictures. Now what? You transfer them to your computer, that's what. The following sections introduce you to several methods of doing so.

Some digital photography aficionados refer to the process of moving photos from the camera to the computer as *downloading*.

A trio of downloading options

Digital camera manufacturers have developed several ways for users to transfer pictures from camera to computer. You may or may not be able to use all these options, depending on your camera. The following list offers a brief overview of the various transfer methods, beginning with the fastest and easiest choice:

- **Memory card transfer:** If you own a Sony digital camera that stores images on a floppy disk, just pop the disk out of your camera and insert it into the floppy drive on your computer (assuming that your computer has said drive). Then copy the images to your hard drive as you do regular data files on a floppy disk.

 If your camera uses some other type of removable storage media, you can also enjoy the convenience of transferring images directly from that media, provided you have a matching card reader or adapter. See Chapter 4 for more information on these gadgets.

- **Cable transfer:** You can also connect your computer directly to your camera using the cable that came in your camera box. If your camera is an older model, the connection may be via a serial cable, which transfers data at a speed roughly equivalent to a turtle pulling a 2-ton pickup. Okay, so maybe the speed isn't quite that slow — it just seems that way. Fortunately, newer cameras connect to the computer via a USB port, which makes the transfer process faster.

- **Wireless transfer:** A few cameras offer wireless transfer, taking advantage of the same technologies employed by wireless Internet connections, television remote controls, and other wireless devices. In order to take advantage of this feature, both your camera and computer must have the right wireless equipment.

You can find more details on memory-card transfer and camera-to-computer transfer in the next several sections. Because setting up wireless transfer varies depending on the specific wireless technology, camera, and computer,

I must refer you to your camera manual for help with that process. Note that the speed at which your image files travel through the air depends on the type of wireless connection; you may find that one of the other two transfer options gets the job done more quickly.

The software provided with some cameras and card readers includes an automated feature that's designed to help you with the transfer process. As soon as you put a card in the reader slot or connect the camera, a screen may pop up with instructions that guide you through the steps of moving or copying files to your computer. Some photo-editing software also launches automatically whenever it detects a camera or card. For example, Figure 8-1 shows the window you see whenever Photoshop Elements notices that image files are knocking at your computer's door.

These utilities all work differently, so consult the reader or software manual to see what's what. If you don't want the utility to launch automatically, you should be able to turn that feature off via the program's options or preferences menu. You can then follow the steps I outline in the upcoming sections to transfer your files from the camera or card.

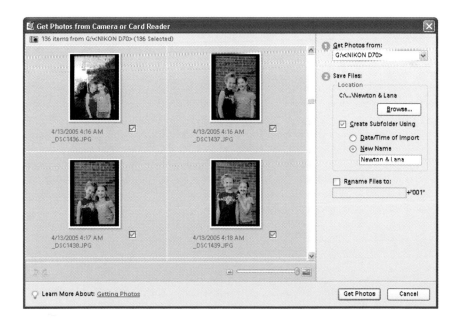

Figure 8-1: Elements automatically launches this transfer utility whenever it detects the presence of a camera or memory card.

Using a card reader or adapter

Before you can transfer photos using a card reader, you must first hook up the reader to your computer and install any software that shipped with the reader. Pay close attention to the installation instructions; it's important to make the connection and install the software in the exact order the manufacturer specifies.

After installing the card reader, just put your memory card into the appropriate slot on the reader, as shown in Figure 8-2. The computer should then recognize the card, and you can access the picture files it contains as you would any files already on your hard drive.

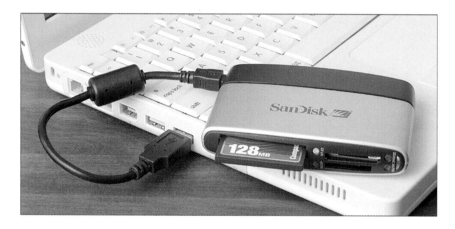

Figure 8-2: Just push the memory card into the matching slot on the card reader.

As an example, Figure 8-3 shows how a card reader I use shows up in Windows Explorer. This reader has four slots, so Explorer lists four drives, each with its own drive letter. In the figure, Drive I is the one that currently holds a memory card. As shown in the figure, you have to open a folder or two to get to the actual image files — they're typically housed inside a folder named DCIM (for *digital camera images*).

On a Mac, the card should appear as a drive on the desktop, similar to what happens when you put a CD into the CD drive. Double-click the drive icon to access the card contents. (The upcoming Figure 8-8 offers an illustration.)

Card reader drives

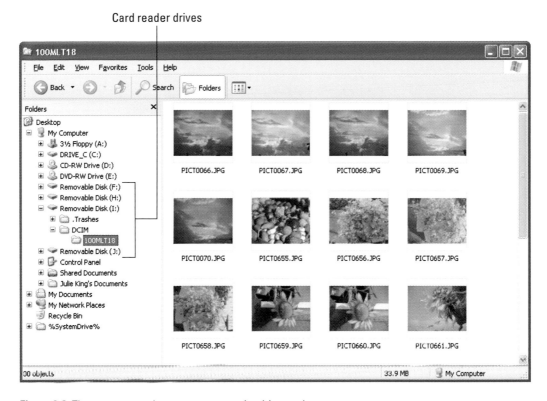

Figure 8-3: The memory card appears as a regular drive on the computer.

After opening the folder that contains the images, select the ones you want to transfer and then just drag them to the folder on your hard drive (or other location) where you want to store them, as shown in Figure 8-4. The little plus sign next to your cursor indicates that you're placing a *copy* of the files on the memory card into the new storage bin; your originals remain on the card. When you're sure that the files made it to their new home, you can put the card back into the camera to erase the originals.

This same process works whether you're moving files from a dedicated card reader or from memory-card slots provided on a printer, by the way. And you use the same technique if you're using a memory-card adapter instead of a card reader.

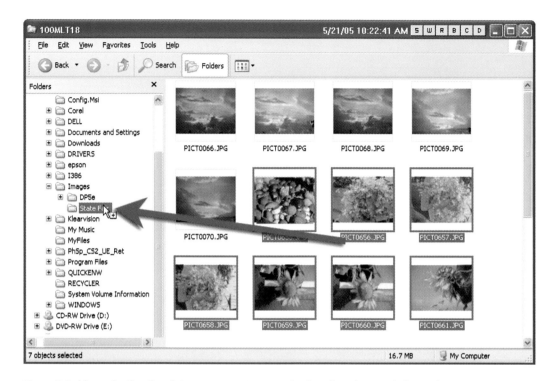

Figure 8-4: After selecting the pictures you want to transfer, just drag them to their new home.

 Also, you don't necessarily need to use Windows Explorer or the Mac Finder as the gateway for accessing your files. You typically can download files from within your photo-cataloging or photo-editing program, too.

Cable transfer how-to's

Before you connect your camera to the computer for the first time, you may need to install some software that came with the camera. The software varies, so dig out that camera manual for specifics.

With the proper software installed, the transfer process works like so:

1. **If you're connecting via serial cable, turn off your computer and camera. Then skip to Step 3.**

 This step is *essential;* most cameras don't support *hot swapping* — connecting via serial cable while the devices are turned on. If you connect the camera to the computer while either machine is powered up, you risk damaging the camera.

2. If you're connecting via USB, check your camera manual.

You probably do not have to shut down your computer before hooking up the camera. But please, check your camera and computer manuals to be certain. You may or may not need to turn the camera off.

3. Connect the camera to your computer.

Plug one end of the connection cable into your camera and the other into your computer. If you're going the serial-cable route and you use a Macintosh computer, you typically plug the camera cable into the printer or modem port, as shown in the top half of Figure 8-5. On a PC, the serial cable usually connects to a COM port (often used for connecting external modems to the computer), as shown in the bottom half of Figure 8-5.

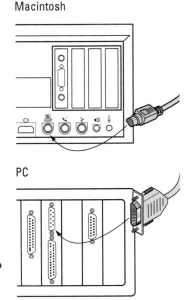

The setup is the same for cameras that come with a USB cable. Plug one end of the cable into the camera and the other into your computer's USB port, as illustrated in Figure 8-6. That little three pronged symbol you see between the two ports in the figure is the universal USB marking.

Note that if you use Windows 95, your computer may refuse to recognize the presence of the camera, even if you install the Windows 95 update that is supposed

Figure 8-5: Plug the serial cable into the printer or modem port on a Mac or a COM port on a PC.

to enable USB. So if you want to avoid hassles, either upgrade to a later version of Windows or use some method of image transfer other than USB.

4. Turn the computer and camera back on, if you turned them off before connecting.

5. Set the camera to the appropriate mode for image transfer.

On some cameras, you put the camera in playback mode; other cameras have a PC setting. Check your manual to find out the right setting for your model.

USB plug USB ports

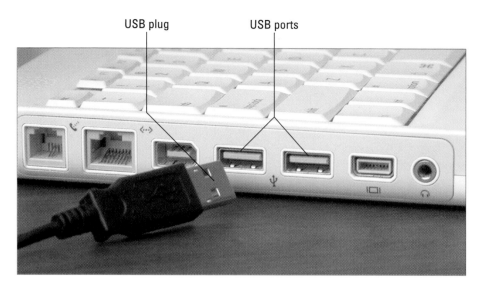

Figure 8-6: Most new cameras connect via a USB cable.

6. **Start the image-transfer software.**

When your computer detects the presence of the camera, a transfer program may launch itself. For example, if you've set up Elements to act as the transfer program, it appears automatically (refer to Figure 8-1 for a look at the transfer window). Your camera also likely shipped with some transfer software, and if you installed that software, it may jump to life without any input from you. Figure 8-7 offers a look at the software for a Fujifilm camera, for example. After the software launches, you need to specify the folder where you want to house the pictures.

7. **Download away.**

From here on out, the commands and steps needed to get those pictures from your camera onto your computer vary, depending on the camera and what software you're using. Sorry, but again I must point you toward those all-important camera and software manuals for specifics. After you start the transfer, you should see a progress bar or window letting you know that the files are working their way to the computer, as shown in the bottom half of Figure 8-7.

Most transfer software offers an option that deletes the original files from the memory card after downloading. Turn this option off so that if something goes awry during downloading, your originals are still on the memory card.

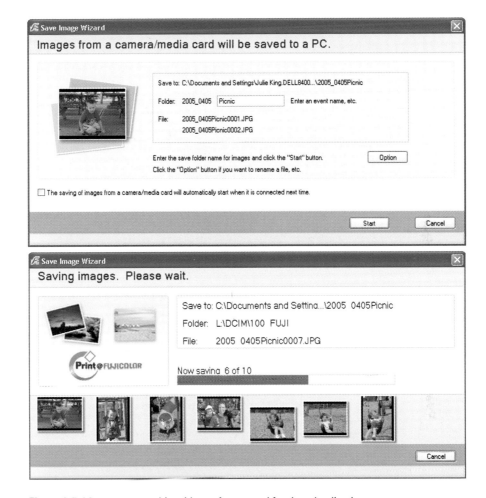

Figure 8-7: Most cameras ship with a software tool for downloading images.

Take the bullet TWAIN

Chances are good that your camera comes with a CD that enables you to install something called a *TWAIN driver* on your computer. TWAIN is a special *protocol* (language) than enables your photo-editing or catalog program to communicate directly with a digital camera or scanner. (The name TWAIN is an homage to the Kipling poem that made famous the phrase "never the twain shall meet," although the more popular legend has long been that TWAIN stands for Technology Without An Interesting Name.)

After you install the TWAIN driver, you can access picture files that are on the camera through your photo-editing or cataloging program. Of course, your camera still needs to be cabled to the computer. And your photo-editing or cataloging program must be *TWAIN compliant,* meaning that it understands the TWAIN language.

The command you use to open camera images varies from program to program, but typically, the command is on the File menu. In some programs, you can access your camera files as you would any files on your hard drive, using the regular File⇨Open command. In other programs, the command name may be Acquire or Import. (In some programs, you first have to select the *TWAIN source* — that is, specify which piece of hardware you want to access. This command is also usually on the File menu.)

Camera as hard drive

With some digital cameras, the manufacturer provides software that, when installed on your computer, makes your computer think that the camera is just another hard drive. In this case, you can follow the same process for transferring files as outlined in the earlier section "Using a card reader or adapter."

When you connect the camera to a Windows-based PC, for example, the camera gets its own little drive icon in Windows Explorer. On a Macintosh, the Finder displays the icon. The earlier section featured an Explorer example, so Figure 8-8 offers up a Mac illustration. In this figure, the drive with the label No Name is the camera. (Sometimes, the name of the camera appears in the label.)

Whatever the operating system, you can access the files in the camera just as you do files on your other drives. Then you can drag and drop files from the camera to a location on your hard drive, an option that's typically quicker than downloading the individual images through the camera's transfer software.

As discussed in the preceding section, you may also be able to get at your camera files directly through your photo-editing or cataloging software.

Tips for trouble-free downloads

For whatever reason, the download process is one of the more complicated aspects of digital photography. The introduction of card readers and USB connections have made things much easier, but not all users have access to this method. So don't feel badly if you run into problems — I do this stuff on a daily basis, and I still sometimes have trouble getting the download process to run smoothly when I work with a new camera.

Images folder Camera icon

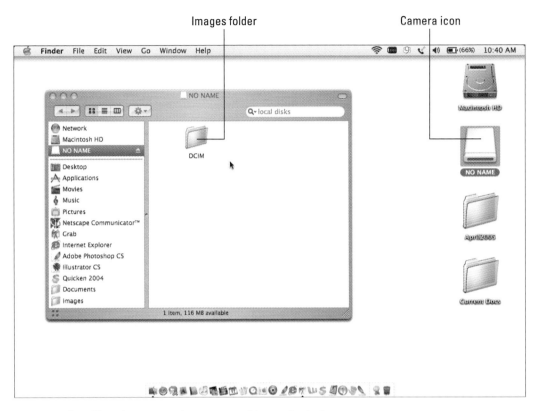

Figure 8-8: On a Mac, the camera shows up as a drive on the desktop.

Here are some troubleshooting tips I've picked up during my struggles with image transfer:

- If you get a message saying that the software can't communicate with the camera, check to make sure that the camera is turned on and set to the right mode (playback, PC mode, and so on).

- On a Macintosh, you may need to turn off AppleTalk, Express Modem, and/or GlobalFax, which can conflict with the transfer software. Check the camera manual for possible problem areas.

- On a PC, check the COM port setting in the transfer software if you have trouble getting the camera and computer to talk to each other via a serial cable connection. Make sure that the port selected in the download program is the one into which you plugged the camera.

✔ If you're connecting via a USB port, make sure that the USB port is enabled in your system. Some manufacturers ship their computers with the port disabled. To find out how to turn the thing on, check your computer manual. Also see my earlier comments about USB and Windows 95 in the section "Cable transfer how-to's."

✔ Check your camera manufacturer's Web site for troubleshooting information. Manufacturers often post updated software drivers on their Web sites to address downloading problems. Log on to the Web sites for your brand of computer and image software, too, because problems may be related to that end of the download process rather than to your camera.

✔ Some transfer programs give you the option of choosing an image file format and compression setting for your transferred images. Unless you want to lose some image data — which results in lower image quality — choose the no-compression setting. (If that last sentence sounded like complete gibberish, check out the section on file formats in Chapter 5.)

✔ Digital cameras typically assign your picture files meaningless names such as DCS008.jpg and DCS009.jpg (for PC files) or Image 1, Image 2, and the like (for Mac files). If you previously downloaded images and haven't renamed them, files by the same names as the ones you're downloading may already exist on your hard drive.

When you attempt to transfer files, the computer should alert you to this fact and ask whether you want to replace the existing images with the new images. But just in case, you may want to create a new folder to hold the new batch of images before you download. That way, you avoid any chance of overwriting existing images.

✔ If your camera has an AC adapter, use it when downloading images via cable. The process can take quite a while, and you need to conserve all the battery power you can for your photography outings.

✔ I mentioned this earlier, but it bears repeating: When you initiate the transfer process, you may be able to select an option that automatically deletes all images from the camera's memory after downloading. At the risk of sounding paranoid, I *never* select this option. After you transfer images, always review them on your computer monitor *before* you delete any images from your camera. Glitches can happen, so make sure that you really have that image on your computer before you wipe it off your camera. As an extra precaution, make a backup copy of the image on removable media (CD, Zip, or the like).

Oh no, I erased my pictures!

It happens to everyone sooner or later: You accidentally erase an important picture — or worse, an entire folder full of images. Don't panic yet — you may be able to get those pictures back.

The first step: *Stop shooting.* If you take another picture, you may not be able to rescue the deleted files.

For pictures that you erased using the camera's delete function, go online or to your local computer store to buy a file-recovery program such as MediaRECOVER ($30, www.mediarecover.com) or RescuePRO ($40, www.lc-tech.com). For these programs to work, your computer must be able to access the camera's memory card as if the card were a regular drive on the system. So if your camera doesn't show up as a drive when you connect it to the computer, you may need to buy a card reader or adapter as well.

If you erased pictures on the computer, you may not need any special software. In Windows Explorer, deleted files go to the Recycle Bin and stay there until you empty the Bin. Assuming that you haven't taken that step, just open the Bin, click an erased file, and then choose File⇨ Restore to "un-erase" the picture. On a Mac, deleted files linger in the Trash folder until you choose the Empty Trash command. Until you do, you can open the Trash folder and move the deleted file to another folder on your hard drive.

Already emptied the Recycle Bin or Trash? You also can buy programs to recover files that were dumped in the process; start your software search at the two aforementioned Web sites.

Translating Camera Raw Files

Many new, high-end digital cameras can capture images in the Camera Raw file format — Raw, for short. As discussed in Chapter 5, this format stores raw picture data from the image sensor, without applying any of the usual post-processing that occurs when you shoot using the other two common formats, JPEG and TIFF.

Although you can transfer Raw files to your computer using the same processes outlined in the first part of this chapter, you can't open them without running them through a *Raw converter.* With this little piece of software, you specify how you want the raw data translated into an actual picture.

Cameras that offer Raw as a file format usually ship with a converter utility. But you may not need to use that utility; many photo-editing programs, including Photoshop Elements, have a built-in converter. These converters aren't compatible with all cameras, though, so you need to see whether your model is supported.

The following steps walk you through the process of converting Raw files in Elements. The steps are pretty much the same no matter what converter you use, although the controls you get for adjusting the Raw image vary.

1. **Follow your normal process for transferring files to your computer.**

 Again, the first part of this chapter shows you the transfer process.

2. **Choose File⇨Open to launch the Open dialog box.**

3. **Track down the file and click Open.**

 For more ways to open an image file, see Chapter 11.

 Elements recognizes that the file is in the Raw format and launches the Camera Raw window, shown in Figure 8-9. Be sure that the Preview check box underneath the image window is turned on; if not, click it. Now you can see the results of any changes you make.

Clipped highlights

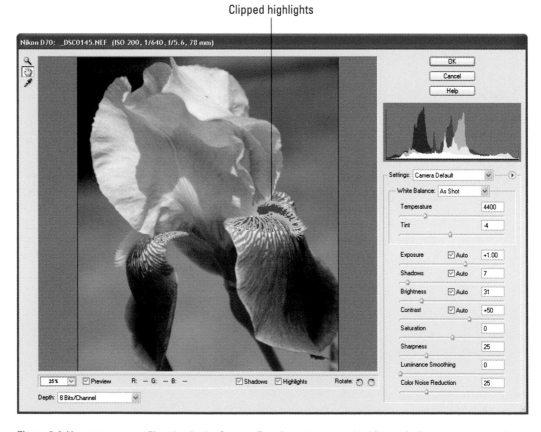

Figure 8-9: You must convert files shot in the Camera Raw format to a standard format before you can open them.

4. **Use the controls on the right side of the window to tweak the image appearance if necessary.**

 The upcoming list offers a few details about some of the more complex controls.

5. **Click OK to finish opening the file.**

6. **Choose File⇨Save As to open the Save As dialog box.**

7. **Save the file in a standard image format.**

 Saving in your photo editor's native format is best — in Elements, that's the PSD format. Another good option is the TIFF format. Chapter 11 offers more specifics about saving files. Chapter 9 explains the options you encounter when you save in the TIFF format.

 Don't skip this step — the converted file is only temporary until you save it.

Now for those Elements converter details I promised in Step 4:

- **Depth:** The Depth drop-down list in the lower-left corner of the converter window controls the image bit depth. You can specify whether you want an 8-bit file or a 16-bit file. This option is applicable only if your camera is capable of shooting 16-bit files, however. See Chapter 2 for an explanation of bit depth.

- **Settings:** Start out with the Settings drop-down list set to Camera Default, as shown in Figure 8-9. The controls underneath that list then automatically shift to settings that Elements considers appropriate for your camera. When you tweak any of those controls, the Settings option changes to Custom.

- **Luminance Smoothing and Color Noise Reduction:** These sliders, in the bottom-right corner of the dialog box, are designed to remove *noise,* the defect that makes your image look as though it was dusted with colored sand. Keep a close eye on your photo as you drag these sliders; both options soften focus as they tone down noise. (For more about removing noise, see Chapter 11.)

- **Shadows and Highlights:** If you turn on the Shadows and Highlights controls underneath the image preview, Elements indicates shadows and highlights that are *clipped* at the current settings. Clipping means that pixels that were formerly different colors have shifted either to all black — which destroys shadow detail — or all white, which eliminates highlight detail. Clipped highlights are indicated by a red overlay; clipped shadows, a blue overlay. In Figure 8-9, for example, the red splotches on the iris petal indicate that the current settings result in highlight clipping. If you see a lot of clipping, use the controls on the right side of the dialog box to try to correct it.

✔ **Other adjustments:** Unless you notice lots of clipping, I recommend that you make changes to exposure, color, and sharpness *after* you open the file rather than in the Camera Raw dialog box. You can then apply those changes selectively, as outlined in Chapter 12, rather than applying them to the entire image, as is required in the dialog box.

Don't throw away your original Raw files. First, when you save the converted file, some or all of the original EXIF metadata may be lost. (Chapter 4 explains metadata.) Second, you may someday want to convert the file using different settings.

Converting Proprietary Camera Files

Most digital cameras today store images in one of three standard formats: JPEG, TIFF, or Camera Raw. But if you're working with an older camera, it may record images using a *proprietary format.* That means simply that the format is used only by the type of camera you're using. (Proprietary formats are sometimes also referred to as *native* formats.)

If you want to edit photos stored in a proprietary format, you must use the software provided with the camera to convert the files to a format that other programs can open, just as you have to convert Camera Raw files.

After converting the files, you're asked to specify the new format you want to use to save them. To retain the most original image data and ensure the widest compatibility with other programs, choose TIFF. Chapter 9 explains the options that you may encounter when you save to the TIFF format.

If you need to share the file on the Internet, either via e-mail or on a Web page, make a copy of that new TIFF file and save the copy in the JPEG format. Chapter 10 explains the options you encounter in that case. Remember, JPEG eliminates some image data, so don't use it to store your original files.

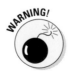

As when working with Raw files, you should retain a copy of the original, proprietary files even after you make your TIFF or JPEG copies. Saving to another format usually wipes out any EXIF metadata that was recorded in the file, and you may want to access that information one day.

Photo Organization Tools

After you move all those picture files from your camera to your hard drive, a CD, or other image warehouse, you need to organize them so that you can easily find a particular photo.

If you're a no-frills type of person, you can simply organize your picture files into folders, as you do your word-processing files, spreadsheets, and other documents. You may keep all pictures shot during a particular year or month in one folder, with images segregated into subfolders by subject. For example, your main folder may be named Photos, and your subfolders may be named Family, Sunsets, Holidays, Work, and so on.

Many photo-editing programs include a utility that enables you to browse through your image files and view thumbnails of each photo. Figure 8-10 shows the organizer utility included for the Windows version of Photoshop Elements 3.0, for example. Such utilities make it easy to track down a particular image if you can't quite remember what you named the thing. (If you're running Elements 3.0 on the Mac, you can organize via the program's File Browser, introduced in Chapter 11.)

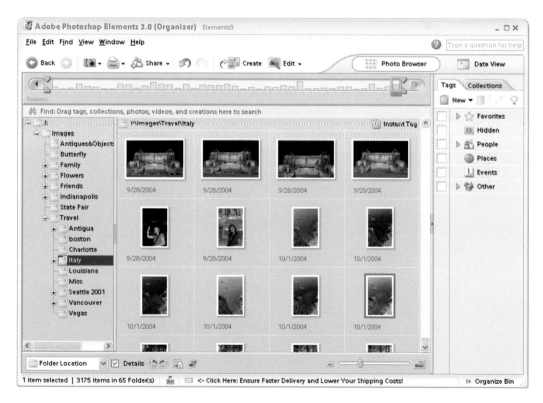

Figure 8-10: Photoshop Elements provides a built-in photo organizer; here, you see the Windows version.

Depending on your computer's operating system, it also may offer tools for browsing through thumbnails of your digital photo files. Recent versions of Windows, for example, enable you to view thumbnails in Windows Explorer. If you work on a Macintosh computer running OS X 10.1.2 or later, you can download a free copy of a browser called iPhoto at the Apple Web site. Figure 8-11 offers a look at iPhoto. (This software may look different depending on what version of the operating system and iPhoto you use.)

You may find that your operating system or photo-editing program together offer all the image-viewing and management tools that you need. But if you find those tools too slow, too limited, or both, consider investing in a third-party image-management program. Chapter 4 introduces you to one such program, ThumbsPlus ($50, www.cerious.com); Figure 8-12 shows another of my favorites, ACDSee, ($50, www.acdsystems.com). Another good option is Extensis Portfolio (about $200, www.extensis.com).

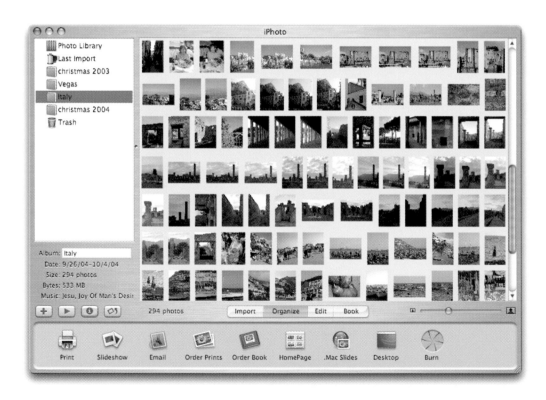

Figure 8-11: Mac users can browse images using iPhoto.

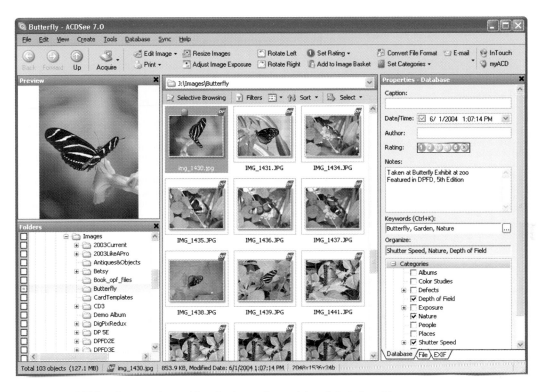

Figure 8-12: ACDSee is a popular tool for viewing and organizing digital photo files.

In all these programs, you can browse and manage your images in several different layouts, including one that mimics the Windows Explorer format, as shown in Figure 8-12. You also can inspect all the EXIF metadata that your camera may store in the image file.

But the real power of these products lies in their database features, which you can use to assign keywords to images and then search for files using those keywords. For example, if you have an image of a Labrador retriever, you might assign the keywords "dog," "retriever," and "pet" to the picture's catalog information. When you later run a search, entering any of those keywords as search criteria brings up the image.

Geared to more casual use, programs such as FlipAlbum Suite ($70, www. flipalbum.com) feature a traditional photo-album motif. Figure 8-13 offers a look at this program. You drag images from a browser onto album pages, where you can then label the images and record information, such as the date and place the image was shot.

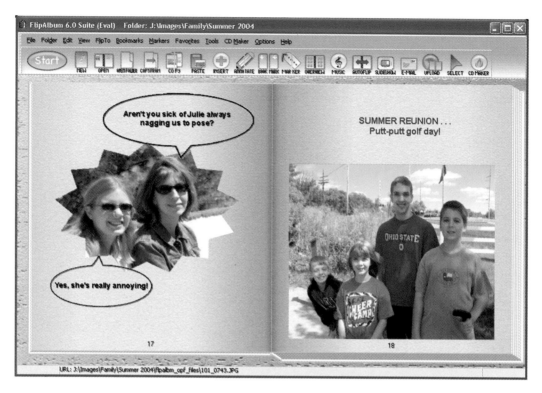

Figure 8-13: You can use programs such as FlipAlbum Suite to create digital photo albums.

Photo-album programs are great for those times when you want to leisurely review your images or show them to others, much as you would enjoy a traditional photo album. And creating a digital photo album can be a fun project to enjoy with your kids — they'll love picking out frames for images and adding other special effects. In addition, some album programs, including FlipAlbum Suite, offer tools to help you create and share CDs containing your digital photo albums.

For simply tracking down a specific image or organizing images into folders, however, I prefer the folder-type approach like the one used by the aforementioned organizer programs. I find that design quicker and easier to use than flipping through the pages of a digital photo album.

Again, your photo editor may offer some of the same features as you find in third-party organizers and album programs. Elements and Photoshop both offer pretty capable organizers, for example. So be sure to explore those tools before you invest in an unneeded extra program. And remember that you can find free trials of most programs at the vendor's Web site. To access those sites easily, head for the Web page for this book, www.dummies.com/go/digital photofd5e, which contains links to the products I cover.

9

Can I Get a Hard Copy, Please?

In This Chapter

▷ Taking the fast track to great prints

▷ Choosing a photo printer

▷ Making your prints last

▷ Understanding CMYK

▷ Choosing the right paper for the job

▷ Printing your own photos

▷ Getting better monitor-to-printer color matching

▷ Saving a TIFF copy for use in a publication

*G*etting a grip on all there is to know about digital photography can be a little overwhelming — I know, I've been there. So if you're feeling like your head is already about to pop from all the new terms and techniques you've stuffed into it, I have great news for you: You only need to read the first section of this chapter to find out how to get terrific prints of your digital photos.

Those first paragraphs introduce you to retail photo-printing services that make getting digital prints as easy as having a roll of film developed. In fact, digital printing can be even *more* convenient than film printing. If you like, you can handle the whole thing via the Internet, without ever leaving home.

When you're ready for do-it-yourself printing — and that process, too, has been greatly simplified recently — the rest of the chapter offers tips on buying a photo printer and getting the best results from it. You can also find out how to set the print size and resolution (ppi), save a TIFF copy of your picture for use in a publication, and get better color matching between printer and monitor.

Fast and Easy: Prints from a Lab

In the first years of digital photography, the only option for people who didn't want to print their own photos was to find a professional photo lab that could handle digital files. Unless you lived in a major city, you probably didn't have access to such a lab, and if you did, you paid big bucks to get your prints.

Now, any outlet that offers film developing, from your local drugstore to big-box retailers such as Wal-Mart, also offers quick and easy digital camera "developing." You just take your memory card (or a CD full of images) to the store and specify the print size and quantity, just as you do when dropping off a roll of film.

The cost of retail printing has come way down, too. Depending on the number of prints you make, you can get 4 x 6-inch prints for as little as 19 cents apiece. If that sounds high compared with what you pay for a roll of film prints, keep in mind that with digital, you're printing only the pictures you really love. With film, you pay to develop and print everything on the roll, even the badly exposed and out-of-focus clunkers that you wind up throwing away. If you stop and do the math, you'll discover that digital prints usually end up being cheaper than film prints.

What's more, you now have a variety of options for getting your digital prints:

- **One-hour printing:** Drop your memory card or CD off at the lab, fill out the order form, and then go run other errands or do your shopping. Come back to the lab in an hour, and pick up your prints.

- **Do-it-yourself kiosks:** In a hurry? You don't even need to wait an hour for those prints. Many stores offer self-service kiosks like the one shown in Figure 9-1. Again, you just put your memory card or CD into the appropriate kiosk slot, push a few buttons, and out come your prints. You can even do some retouching, such as cropping and eliminating red-eye, right at the kiosk.

- **Order online, print locally:** Here's one of my favorite options. You can send your image files via the Internet to the store where you want your prints made. Then pick up the prints at your convenience.

Eastman Kodak Company

Figure 9-1: At self-service kiosks, you can output your own prints in minutes.

This option also makes it easy to get prints to faraway friends and relatives. Instead of having the prints made at your local lab and then mailing them off, you can simply upload your files to a lab near the people who want the prints. They can then pick up the prints at that

lab. You can either prepay with a credit card or have the person getting the prints pay upon picking them up.

For help finding a lab that's conveniently located, check out these two Web sites:

- www.digitalcameradeveloping.com

- www.prints-are-memories.com

At both sites, you can enter a zip code and get a list of printers, along with a description of the services they offer, as shown in Figure 9-2.

✔ **Order online, get prints by mail:** Several Web-based print services offer yet another option. You can upload your photo files for printing and then receive the prints in the mail. Some sites to try include Kodak EasyShare Gallery (formerly Ofoto, www.kodakgallery.com), shown in Figure 9-3, Snapfish (www.snapfish.com), and Shutterfly (www.shutterfly.com). These sites are also picture-sharing sites, and you can read more about them in Chapter 10.

Don't limit yourself to 4 x 6 prints, either. Most places that can print your digital files also can produce calendars, t-shirts, mugs, and other items featuring your favorite photos. Most can also copy your images to a CD, saving you the step of archiving the files to CD yourself.

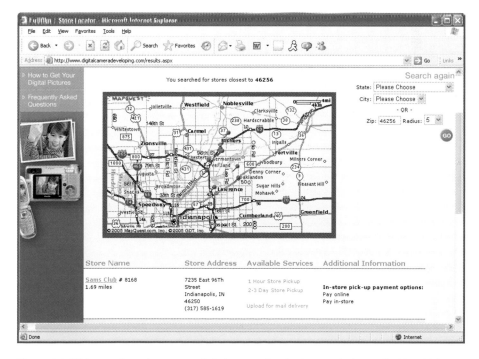

Figure 9-2: Web portals such as www.digitalcameradeveloping.com help you find local labs that can print your digital photos.

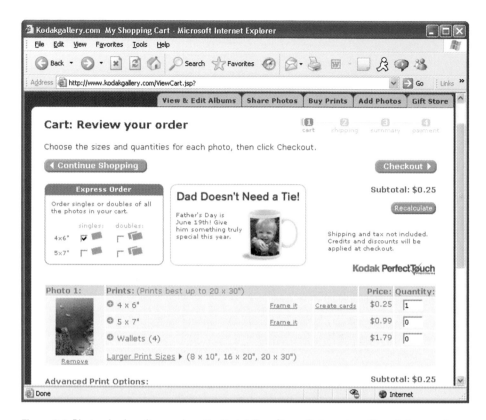

Figure 9-3: Photo-sharing sites such as the Kodak EasyShare Gallery also offer printing services.

Buying a Photo Printer

Even if you have most of your prints made at a retail lab, adding a photo printer to your digital-photography system is still a good investment. First, when you need only a print or two, it's more convenient to do the job yourself than to send the pictures to a lab. Second, for times when you're feeling artistic, you can print on special media, such as canvas-textured paper. With a model such as the $500 HP Photosmart 8750, shown in Figure 9-4, you can even output borderless prints in sizes up to 13 x 19 inches. And of course, doing your own printing gives you complete control over the output, which is important to many photo enthusiasts, especially those who exhibit or sell their work.

Today's photo printers can produce excellent results, too. In fact, most people can't tell the difference between the prints I make at home and the ones I have output at my local lab.

HP
Figure 9-4: With this HP printer, you can output borderless prints up to 13 x 19 inches.

When you go printer shopping, you'll encounter several types of printers. Each offers advantages and disadvantages, and the technology you choose depends on your budget, your printing needs, and your print-quality expectations. To help you make sense of things, the following sections discuss the main categories of consumer and small-office printers.

Inkjet printers

Inkjet printers work by forcing little drops of ink through nozzles onto the paper. Inkjet printers designed for the home office or small business cost anywhere from $50 to $800. Typically, print quality peaks as you reach the $200 price range, though. Higher-priced inkjets offer speedier printing and extra features, such as the ability to output on wider paper, produce borderless prints, hook up to an office network, or print directly from a camera or memory card.

Most inkjet printers enable you to print on plain paper or thicker (and more expensive) photographic stock, either with a glossy or matte finish. That flexibility is great because you can print rough drafts and everyday work on plain paper and save the more costly photographic stock for final prints and important projects. As for cost per print, that number varies widely depending on the paper and the printer; about the least you can expect to pay is $0.20 for a 4 x 6-inch print. See the upcoming section "Comparison Shopping" for some additional information on this issue.

Inkjets fall into two basic categories:

- General-purpose models, which are engineered to do a decent job on both text and pictures.

- Photo printers, sometimes referred to as *photocentric* printers, which are geared solely toward printing images. Photocentric printers produce better-quality photographic output than all-purpose printers, but they're sometimes not well suited to everyday text printing because the print speed can be slower than on a general-purpose machine.

That's not to say that you should expect lightning-fast prints from a general-purpose inkjet, though. Even on the fastest inkjet, outputting a color image can take several minutes if you use the highest-quality print settings.

In addition, the wet ink can cause the paper to warp slightly, and the ink can smear easily until the print dries. (Remember when you were a kid and painted with watercolors in a coloring book? The effect is similar with inkjets, although not as pronounced.) You can lessen both of these effects by using paper especially made for inkjets.

Despite these flaws, inkjets remain a good, economical solution for many users. Newer inkjet models incorporate refined technology that produces much higher image quality, less color bleeding, and less page warping than models in years past. Images printed on glossy photo stock from the latest photocentric inkjets rival those from a professional imaging lab. For the record, I've been especially impressed with output from Epson, HP, and Canon photocentric models.

Laser printers

Laser printers use a technology similar to that used in photocopiers. I doubt that you want to know the details, so let me just say that the process involves a laser beam, which produces electric charges on a drum, which rolls toner — the ink, if you will — onto the paper. Heat is applied to the page to permanently affix the toner to the page (which is why pages come out of a laser printer warm).

Color lasers can produce near-photographic quality images as well as excellent text. They're faster than inkjets, and you don't need to use any special paper (although you get better results if you use a high-grade laser paper as opposed to cheap copier paper).

The downside to color lasers? Price. Although they've become much more affordable over the past two years, color lasers still run $200 and up. And these printers tend to be big in stature as well as price — this isn't a machine that you want to use in a small home office that's tucked into a corner of your kitchen.

As for photo quality, it varies from machine to machine, so be sure to read reviews carefully. To my eye, laser-printed photos aren't quite as impressive as those from the best inkjets, but that's a personal preference. Many people can't tell the difference between an inkjet and laser print.

If you have the need for high-volume color output, a color laser printer can make sense. Although you may pay more up front than for an inkjet, you should save money over time because the price of *consumables* (toner or ink, plus paper) is usually lower for laser printing than inkjet printing. Many color lasers also offer networked printing, making them attractive to offices where several people share the same printer. Figure 9-5 offers a look at a color laser from Konica Minolta.

Konica Minolta Photo Imaging

Figure 9-5: Color lasers are now very affordable and can produce good photo prints.

Dye-sub (thermal dye) printers

Dye-sub is short for *dye-sublimation,* which is worth remembering only for the purpose of one-upping the science-fair winner who lives down the street. Dye-sub printers transfer images to paper using a plastic film or ribbon that's coated with colored dyes. During the printing process, heating elements move across the film, causing the dye to fuse to the paper.

Dye-sub printers are also called *thermal-dye* printers — heated (thermal) dye . . . get it?

Some popular snapshot printers, including certain models from Kodak, use this technology. Dye-sub printers fall within the same price range as quality inkjets, and most produce good-looking prints.

However, dye-sub machines present a few disadvantages that may make them less appropriate for your home or office than an inkjet:

✔ Most dye-sub printers can output only snapshot size prints, although a few new models, such as the $500 Olympus P-440 shown in Figure 9-6, can produce 8 x 10-inch prints.

✔ You have to use special stock designed to work expressly with dye-sub printers. That means that dye-sub printing isn't appropriate for general-purpose documents; these machines are purely photographic tools.

The cost per print depends on the size of the paper, as with any printer. With the Olympus P-440, the cost of an 8 x 10-inch print is just under $2.

Olympus Imaging America Inc.

Figure 9-6: The Olympus P-440 can output 8 x 10-inch dye-sub prints.

Thermo-Autochrome printers

A handful of printers use Thermo-Autochrome technology. With these printers, you don't have any ink cartridges, sticks of wax, or ribbons of dye. Instead, the image is created using light-sensitive paper — the technology is similar to that found in fax machines that print on thermal paper.

You can find Thermo-Autochrome printers within the same general price range as dye-sub printers. But as with dye-sub machines, most Thermo-Autochrome printers can output only snapshot-size prints and can't print on plain paper. More important, examples that I've seen from consumer printers that employ this technology don't match dye-sub or good inkjet output, although I will say that the latest crop of Thermo-Autochrome printers does a much better job than earlier models.

How Long Will They Last?

In addition to the issues presented in the preceding discussion of printer types, another important factor to consider when deciding on a printer is print stability — that is, how long can you expect the prints to last?

All photographs are subject to fading and color shifts over time. Researchers say that a standard film print has a life expectancy of anywhere from 10 to 60 years, depending on the photographic paper, the printing process, and exposure to ultraviolet light and airborne pollutants, such as ozone. Those same criteria affect the stability of photos that you output on your home or office printer.

Unfortunately, the two technologies capable of delivering image quality equal to a traditional photograph — dye-sub and inkjet printing — produce prints that can degrade rapidly, especially when displayed in very bright light. Hang a print in front of a sunny window, and you may notice some fading or a change in colors in as little as a few months.

Manufacturers have been scrambling to address this issue, and several possible solutions have been introduced recently. A few years ago, Epson introduced an inkjet printer that used longer-lasting, pigment-based inks, as opposed to the standard dye-based inks. Figure 9-7 shows the latest version of this printer, the $850 R2400. Epson estimates that color prints made with these inks, on Epson's archival paper, should resist fading for up to 108 years.

Seiko Epson Corp.

Figure 9-7: Some printers feature pigment-based inks instead of dye-based inks.

The downside to pigment-based inks — you knew there had to be one, didn't you — is that they can reproduce a smaller range of colors than dye-based inks. Will you notice the difference? Hard to tell, because it depends on the color range you're capturing with your camera. I can tell you that many professional photographers (including me) rely on pigment-based printers to produce the prints they sell and exhibit.

Epson and several other vendors also make inks and papers that you can use with dye-based inkjet printers and are engineered to provide a print life of 25 years or more. You may or may not be able to take advantage of these products, depending on your printer. (Note that when you use inks not specifically provided by the printer's manufacturer, you may not get the best print quality and you may void the printer's warranty.)

Some dye-sub printers, such as the Olympus P-440 featured in Figure 9-6, add a special protective coating to prints to help extend print life. The folks at Olympus say that photos from this printer have about the same life expectancy as a traditional photograph.

The truth is, though, that no one really knows just how long a print from any of these new printers — inkjet or dye-sub — will last because they just haven't been around that long. The estimates given by manufacturers are based on lab tests that try to simulate the effect of years of exposure to light and atmospheric contaminants. But the research results are pretty varied, and the anticipated photo life you can expect from any printing system depends on whose numbers you use.

If your photography requires archival printing, you can dig a little deeper into the subject at the Web site of Wilhelm Imaging Research (www.wilhelm-research.com), a respected source of print life studies. The company posts details about specific papers, inks, and dyes at its site.

Protecting your prints

No matter what the type of print, you can help keep its colors bright and true by adhering to the following storage and display guidelines:

- If you're framing the photo, mount it behind a matte to prevent the print from touching the glass. Be sure to use acid-free, archival matte board and UV-protective glass.

- Display the picture in a location where it isn't exposed to strong sunlight or fluorescent light for long periods of time.

- In photo albums, slip pictures inside acid-free, archival sleeves.

- Don't adhere prints to a matte board or other surface using masking tape, scotch tape, or other household products. Instead, use acid-free mounting materials, sold in art-supply stores and some craft stores.

- Limit exposure to humidity, wide temperature swings, cigarette smoke, and other airborne pollutants, as these can also contribute to image degradation.

- Although the refrigerator door is a popular spot to hang favorite photos, it's probably the worst location in terms of print longevity. Unless protected by a frame, the photo paper soaks up all the grease and dirt from your kitchen, not to mention jelly-smudged fingerprints and other telltale signs left when people open and close the door.

- For the ultimate protection, always keep a copy of the image file on a CD-ROM or other storage medium so that you can output a new print if the original one deteriorates. See Chapter 4 for advice on archiving your digital files.

So Which Printer Should You Buy?

The answer to that question depends on your printing needs and your printing budget. Here's my take on which of the printing technologies works best for which situation:

✒ If you want the closest thing to traditional photographic prints, go for a photo inkjet or dye-sub model. If you go dye-sub, though, remember that you can't print on plain paper.

✒ If you're buying a printer for use in an office and you want a machine that can handle high-volume printing, look into color lasers.

✒ For home or small-office printing of both text and photos, opt for a general-purpose inkjet model. You can produce good-looking color and grayscale images, although you need to use high-grade paper and the printer's highest quality settings to get the best results. You can print on glossy photographic paper as well.

A brief warning about general-purpose inkjets: Some of the inkjets I've tried have been so slow and had such page-warping problems that I would never consider using them on a daily basis. Others do a really good job, delivering sharp, clean images in a reasonable amount of time, with little evidence of the problems normally associated with this printing technology. The point is, all inkjets are not created equal, so shop carefully.

✒ If you're using your digital camera for business and frequently need prints on the road, consider adding a portable printer to your equipment roster. Several manufacturers sell small, lightweight, snapshot printers that can print directly from a camera or memory card.

✒ In the past, multipurpose printers — those that combine a color printer, copy machine, and scanner in one unit — didn't produce the kind of output that would satisfy most photo enthusiasts. Today, however, some all-in-one printers use the same print technology as in the company's photo printers and so really can deliver good photographic prints. If you need a new scanner as well as a printer, these models are worth considering, especially if you have limited desktop space. The Canon model shown in Figure 9-8, for example, is a digital-imaging workhorse: You can print new images from a memory card or camera, scan and copy old prints, and even scan slides and negatives.

Figure 9-8: This all-in-one from Canon can print from a memory card or camera and also can scan prints, slides, and negatives.

REMEMBER

Keep in mind that most photocentric printers aren't engineered with text printing as the primary goal, so your text may not look as sharp as it would on a low-cost black-and-white laser or inkjet printer. Also, your text printing costs may be higher than on a black-and-white printer because of ink costs.

Comparison Shopping

After you determine which type of printer is best for your needs, you can get down to the nitty-gritty and compare models and brands. Print quality and other features can vary widely from model to model, so do plenty of research.

The easiest feature to compare is the size of print that the machine can produce. You have three basic options:

- ✔ **Standard printers** can print on paper as large as 8.5 x 11 inches, or what we commonly refer to as letter-size paper. However, some printers can't print all the way to the edge of the paper — in other words, can't produce borderless photo prints.

- ✔ **Wide-format printers** — such as the models pictured in Figure 9-4 and 9-7 — can handle larger paper. The maximum size print varies from model to model. In addition, some wide-format printers can print borderless prints.

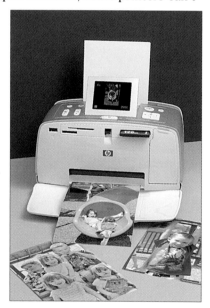

- ✔ **Snapshot printers** are limited to printing pictures at sizes of 4 x 6 inches or smaller. Figure 9-9 shows one snapshot printer from HP. Most snapshot printers, including this one, can print directly from camera memory cards. If the printer and camera both offer PictBridge technology, you can also connect the printer right to the camera. The HP model even has a small monitor that enables you to view your pictures before printing.

Figure 9-9: Many snapshot printers print from the camera or a memory card.

After you get past print size, sorting through the remaining printer features can get a little murky. The information you see on the printer boxes or marketing brochures can be a little misleading. So here's a translation of the most critical printer data to study when you're shopping:

↳ **Dpi:** Dpi stands for *dots per inch* and refers to the number of dots of color the printer can create per linear inch. You can find consumer-level color printers with resolutions from 300 dpi up to 2400 dpi.

A higher dpi means a smaller printer dot, and the smaller the dot, the harder it is for the human eye to notice that the image is made up of dots. So in theory, a higher dpi should mean better-looking images. But because different types of printers create images differently, an image output at 300 dpi on one printer may look considerably better than an image output at the same or even higher dpi on another printer. For example, a 300-dpi dye-sub printer may produce prints that look better than those from a 600-dpi inkjet. So although printer manufacturers make a big deal about their printers' resolutions, dpi isn't always a reliable measure of print quality. For more information about resolution and dpi, take a cab to Chapter 2.

↳ **Quality options:** Many printers give you the option of printing at several different quality settings. You can choose a lower quality for printing rough drafts of your images and then bump up the quality for final output. Typically, the higher the quality setting, the longer the print time and, on inkjet printers, the more ink required.

Ask to see a sample image printed at each of the printer's quality settings and determine whether those settings are appropriate for your needs. For example, is the draft quality so poor that you would need to use the highest quality setting even for printing proofs? If so, you may want to choose another printer if you print a lot of drafts.

Also, if you need to print many grayscale images as well as color images, find out whether you're limited to the printer's lowest-quality setting for grayscale printing. Some printers offer different options for color and grayscale images.

↳ **Inkjet colors:** Most inkjets print using four colors: cyan, magenta, yellow, and black. This ink combination is known as CMYK (see the sidebar "The separate world of CMYK," later in this chapter). Some lower-end inkjets eliminate the black ink and just combine cyan, magenta, and yellow to approximate black. "Approximate" is the key word — you don't get good, solid blacks without that black ink, so for best color quality, avoid three-color printers.

Some photocentric inkjets feature six or more ink colors, adding lighter shades of the primary colors or several shades of gray to the standard CMYK mix. The extra inks expand the range of colors that the printer can manufacture, resulting in more accurate color rendition, but add to the print cost.

If you enjoy making black-and-white prints — *grayscale* prints, in official digital-imaging lingo — look for a printer that adds the extra gray cartridges. Some printers that use only one black cartridge have a difficult time outputting truly neutral grays — prints often have a slight color tint. Browse magazines that cover black-and-white photography for leads on the best machines for this type of printing.

✔ **Print speed:** If you use your printer for business purposes and you print a lot of images, be sure that the printer you pick can output images at a decent speed. And be sure to find out the per-page print speed for printing at the printer's *highest* quality setting. Most manufacturers list print speeds for the lowest-quality or draft-mode printing. When you see claims like "Prints at speeds *up to* . . . ," you know you're seeing the speed for the lowest-quality print setting.

✔ **Cost per print:** To understand the true cost of a printer, you need to think about how much you'll pay for consumables each time you print a picture. This is pretty easy for a dye-sub printer because you buy the paper and dye ribbon together, with each packet producing a specific number of prints.

For inkjets and laser printers, things are less clear. The paper part is easy, of course; just find out what kind of paper the manufacturer recommends and then go to any computer store or office-supply outlet and check prices for that paper. Calculating your ink or laser toner costs is pretty difficult, however. Manufacturers usually state costs in terms of *x* percentage of coverage per page — for example, "three cents per page at 15 percent coverage." In other words, if your image covers 15 percent of an 8.5 x 11-inch sheet of paper, you spend three cents on toner or ink. The problem is that no single standard for calculating this data exists, so you really can't compare apples to apples. One manufacturer may specify per-print costs based on one size image and one print-quality setting, while another uses an entirely different print scenario.

My advice? Don't discount cost-per-print data entirely, but don't take it as gospel, either. This information is most useful for deciding between different print technologies — inkjet, laser, and so on. But when you compare models within a category, don't drive yourself nuts trying to find the model that claims to shave a percentage of a penny off your print costs. Remember, the numbers you see are approximations at best and are calculated in a fashion designed to make the use costs appear as low as possible. As they say in the car ads, your actual mileage may vary.

That said, if you're buying an inkjet printer, you *can* lower your ink costs somewhat by choosing a printer that uses a separate ink cartridge for each ink color or at least uses a separate cartridge for the black ink. On models that have just one cartridge for all inks, you usually end up throwing away some ink because one color often becomes depleted before the others.

Also remember that some printers require special cartridges for printing in photographic-quality mode. In some cases, these cartridges lay down a clear overcoat over the printed image. The overcoat gives the image a glossy appearance when printed on plain paper and also helps protect the ink from smearing and fading. In other cases, you put in a cartridge that enables you to print with more colors than usual — for example, if the printer usually prints using four inks, you may insert a special photo cartridge that enables you to print using six inks. These special photographic inks and overlay cartridges are normally more expensive than standard inks. So when you compare output from different printers, find out whether the images were printed with the standard ink setup or with more expensive photographic inks.

✏ **Computer-free printing:** Some printers can print directly from camera memory cards — no computer required. You insert your memory card, use the printer's control panel to set up the print job, and press the Print button.

Many printers also can print directly from the camera itself. In years past, this option worked only if the printer and camera were from the same manufacturer. But now, you can hook up any camera that offers PictBridge connectivity to any PictBridge-enabled printer. Manufacturers are also starting to introduce printers and cameras that can communicate wirelessly; expect to see more of these devices in the future.

Also look for something called *DPOF* (say it *dee-poff*), which stands for *digital print order format.* DPOF enables you to select the images you want to print through your camera's user interface. The camera records your instructions and passes them onto the printer when you transfer the images between the two devices.

Of course, direct printing takes away your chance to edit your pictures; you may be able to use camera or printer settings to make minor changes, such as rotating the image, making the picture brighter, or applying a prefab frame design, but that's all. Direct printing is great on occasions where print immediacy is more important than image perfection, however. For example, a real-estate agent taking a client for a site visit can shoot pictures of the house and output prints in a flash so that the client can take pictures home that day.

✏ **PostScript printing:** If you want to be able to print graphics created in illustration programs such as Adobe Illustrator and saved in the EPS (Encapsulated PostScript) file format, you need a printer that offers PostScript printing functions. Some photo-editing programs enable you to save in EPS as well. Some printers have PostScript support built in, while others can be made PostScript-compatible with add-on software.

The separate world of CMYK

As you know if you read Chapter 2, on-screen images are *RGB* images. RGB images are created by combining red, green, and blue light. Your digital camera and scanner also produce RGB images. Professional printing presses and most, but not all, consumer printers, on the other hand, create images by mixing four colors of ink — cyan, magenta, yellow, and black. Pictures created using these four colors are called *CMYK* images. (The *K* is used instead of *B* because black is called the *key* color in CMYK printing.)

You may be wondering why four primary colors are needed to produce colors in a printed image, while only three are needed for RGB images. (Okay, I know you're probably not wondering that at all, but indulge me.) The answer is that unlike light, inks are impure. Black is needed to help ensure that black portions of an image are truly black, not some muddy gray, as well as to account for slight color variations between inks produced by different vendors.

What does all this CMYK stuff mean to you? First, if you're shopping for an inkjet printer, be aware that some models print using only three inks, leaving out the black. Color rendition is usually worse on models that omit the black ink.

Second, if you're sending your image to a service bureau for printing, you may need to convert your image to the CMYK color mode and create *color separations*. If you read "The Secret to Living Color" in Chapter 2, you may recall that CMYK images comprise four color channels — one each for the cyan, magenta, yellow, and black image information. Color separations are nothing more than grayscale printouts of each color channel. During the printing process, your printer combines the separations to create the full-color image. If you're not comfortable doing the CMYK conversion and color separations yourself or your image-editing software doesn't offer this capability, your service bureau or printer can do the job for you. (Be sure to ask the service rep whether you should provide RGB or CMYK images, because some printers require RGB.)

Don't convert your images to CMYK for printing on your own printer, because consumer printers are engineered to work with RGB image data. And no matter whether you're printing your own images or having them commercially reproduced, remember that CMYK has a smaller *gamut* than RGB, which is a fancy way of saying that you can't reproduce with inks all the colors you can create with RGB. CMYK can't handle the really vibrant, neon colors you see on your computer monitor, for example, which is why images tend to look a little duller after conversion to CMYK and why your printed images don't always match your on-screen images.

One more note about CMYK: If you're shopping for a new inkjet printer, you may see a few models described as CcMmYK or CcMmYKk printers. Those lowercase letters indicate that the printer offers a light cyan, magenta, or black ink, respectively, in addition to the traditional cyan, magenta, and black cartridges. As I mentioned earlier, the added inksets are provided to expand the range of colors that the printer can produce.

For more information about RGB and CMYK, hightail it to Chapter 2.

Although the preceding specifications should give you a better idea of which printer you want, also search through computer and photography magazines for reviews of any printer you're considering. In addition, you can get customer feedback on different models by logging onto one of the digital photography or printing newsgroups on the Internet. See Chapter 16 for leads on two newsgroups as well as a list of other sources for finding the information you need.

Just as with any other major purchase, you should also investigate the printer's warranty — one year is typical, but some printers offer longer warranties. And be sure to find out whether the retail or mail-order company selling the printer charges a *restocking fee* if you return the printer. Many sellers charge as much as 15 percent of the purchase price in restocking fees. (In my city, all the major computer stores charge restocking fees, but the office supply stores don't — yet.)

I resent the heck out of restocking fees, especially when it comes to costly equipment like printers, and I never buy at outfits that charge these fees. Yes, I understand that after you open the ink cartridges and try out the printer, the store can't sell that printer as new (at least, not without putting in replacement ink cartridges). But no matter how many reviews you read or how many questions you ask, you simply can't tell for certain that a particular printer can do the job you need it to do without taking the printer home and testing it with your computer and with your own images.

Few stores have printers hooked up to computers, so you can't test-print your own images in the store. Some printers can output samples using the manufacturer's own images, but those images are carefully designed to show the printer at its best and mask any problem areas. So either find a store where you can do your own pre-purchase testing, or make sure that you're not going to pay a hefty fee for the privilege of returning the printer.

Does the Paper Really Matter?

Sorry, the answer is yes. With paper, as with most things in life, you get what you pay for. The better the paper, the more your images will look like traditional print photographs. In fact, if you want to upgrade the quality of your images, simply changing the paper stock can do wonders.

If your printer can accept different stocks, print drafts of your images on the cheaper stocks, and reserve the good stuff for final output. By "good stuff," I mean paper from a well-known manufacturer, not the cheap store brands. Start with paper from the manufacturer of your printer because that paper is specifically engineered to work with your printer's inks. The prints you make with that paper can give you a baseline from which you can compare results on other brands.

TIP

Don't limit yourself to printing images on standard photo paper, though. You can buy special paper kits that enable you to put images on calendars, stickers, greeting cards, transparencies (for use in overhead projectors), and all sorts of other stuff. Some printers even offer accessory kits for printing your photos on coffee mugs and t-shirts. And if you use an inkjet printer, try out some of the new textured papers, which have surfaces that mimic traditional watercolor paper, canvas, and the like.

Setting Print Size and Resolution

As mentioned several times earlier in this chapter, many printers enable you to output prints right from a memory card or from the camera. If you're going that route, just follow the instructions in your printer manual. There's really not much to do in advance of printing except specify the size of the print and the number of copies, which you do either via your camera menus or buttons on the printer.

Many photo-editing programs also offer simplified printing, providing wizards that ask you to set only print size and other basics. If you like the results you get from these automated printing utilities, great. But keep in mind that when you set the print size this way, you let the printer software or your imaging software make the all-important resolution decision for you.

WARNING!

Chapter 2 explains this issue fully, but here's a quick recap:

- ✔ Resolution — pixels per inch — has a major impact on print quality. To do their best work, most printers need 200 to 300 pixels per inch. If you're having your picture output at a professional lab, you may be required to submit the file at a specific resolution.

- ✔ When you enlarge an image, one of two things happens: The resolution goes down and the pixel size increases, or the software adds new pixels to fill the enlarged image area (a process called *upsampling*). Both options can result in a loss of image quality.

- ✔ Similarly, when you reduce print size, you can retain the current pixel count, in which case the resolution goes up and the pixel size shrinks. Or you can retain the current resolution, in which case the image-editing software *downsamples* the image (dumps excess pixels). Because dumping too many pixels can also harm your image, avoid downsampling by more than 25 percent. With some photos, you may not notice any quality loss even if you downsample by a greater degree, however.

REMEMBER

- ✔ To figure out the maximum size at which you can print your image at a desired resolution, divide the horizontal pixel count (the number of pixels across) by the desired resolution. The result gives you the maximum print width (in inches). To determine the maximum print height, divide the vertical pixel count by the desired resolution.

✔ What if you don't have enough pixels to get both the print size and resolution you want? Well, you have to choose which is more important. If you absolutely need a certain print size, you just have to sacrifice some image quality and accept a lower resolution. And if you absolutely need a certain resolution, you have to live with a smaller image. Hey, life's full of compromises, right?

Again, if you're happy with the prints you get when you go the automatic route, that's terrific. Some print utilities offer guidance as to how large you can print your picture without losing quality; pay attention to those on-screen messages, and you'll be fine.

But if you *do* want to take control over output resolution, you must set the print size and resolution *before* you send the image to the printer. Here's how to do the job in Elements:

1. **Choose Image⇨Resize⇨Image Size.**

 The Image Size dialog box shown in Figure 9-10 appears.

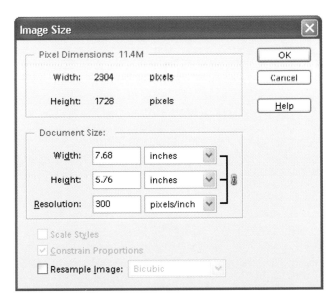

Figure 9-10: Set print size and output resolution (ppi) in the Image Size dialog box.

2. **Turn off the Resample Image check box.**

 This option controls whether the program can add or delete pixels as you change the print dimensions. When the option is turned off, the number of pixels can't be altered.

Click the box to toggle the option on and off. An empty box means that the option is turned off, which is what you want in this case.

3. **Enter the print dimensions or resolution.**

Enter the print dimensions in the Width or Height boxes; as you change one value, the other changes automatically to retain the original proportions of the picture. Likewise, as you change the dimensions, the Resolution value changes automatically. If you prefer, you can change the Resolution value, in which case the program alters the Width and Height values accordingly.

4. **Click OK or press Enter.**

If you did things correctly — that is, deselected the Resample Image check box in Step 2 — you shouldn't see any change in your image on-screen, because you still have the same number of pixels to display. However, if you choose View⇨Rulers, which displays rulers along the top and left side of your image, you can see that the image will, in fact, print at the dimensions you specified.

5. **If you want to retain the current settings after you close the image, save the file.**

If you want to resample the image in order to achieve a certain print resolution, select the Resample Image check box. (Click the box so that a check mark appears inside.) Turn on the Constrain Proportions box and the Scale Styles box, if it's available. Then set your desired Width, Height, and Resolution values.

When the Resample Image option is enabled, a second set of Width and Height boxes becomes available at the top of the dialog box. Use these options if you want to set your photo dimensions using pixels or percent (of the original dimensions) as the unit of measure.

After resampling, be sure to *save your image with a new name.* You may want the image at the original pixel count some day.

If you're using another photo editor, be sure to consult the program's Help system or manual for information on resizing options available to you. Advanced photo-editing programs such as Elements offer you the option of controlling resolution as you resize, but some entry-level programs don't. Instead, these programs automatically resample the image any time you resize it, so be careful.

How can you tell if a program is resampling images upon resizing? Check the "before" and "after" size of the image file. If the file size changes when you resize the image, the program is resampling the photo. (Adding or deleting pixels increases or reduces the file size.)

Sending Your Image to the Dance

Printing from your photo-editing or cataloging software is similar to printing a file in any computer program. Here's the general overview:

1. **Open the photo file.**

 Chapter 11 offers help with this step if you need it.

2. **Set the image size and resolution as discussed in the preceding section.**

3. **Choose the Print command.**

 In almost every program on the planet, the Print command resides on the File menu. Choosing the command results in a dialog box through which you can change the print settings, including the printer resolution or print quality and the number of copies you want to print. You can also specify whether you want to print in *portrait mode,* which prints your image in its normal, upright position, or *landscape mode,* which prints your image sideways on the page. Figure 9-11 shows the dialog box that appears when you choose the Print command in Elements.

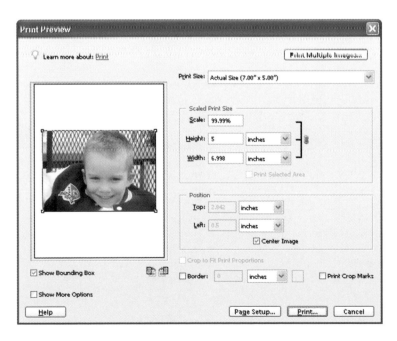

Figure 9-11: The Elements Print Preview dialog box offers a variety of print settings.

4. **Specify the print options you want to use.**

 The available options — and the manner in which you access those options — vary widely depending on the type of printer you're using and whether you're working on a PC or a Mac. In some cases, you can access settings via the Print dialog box; in other cases, you may need to go to the Page Setup dialog box, which opens when you choose the Page Setup command, generally found on the File menu, not too far from the Print command. (In Elements, as in some other programs, you can access the Page Setup dialog box by clicking the Page Setup button inside the Print dialog box, too.)

 I'd love to explain and illustrate all kazillion variations of Print and Page Setup dialog box options, but I have neither the time, space, nor psychotherapy budget that task would require. So please read your printer's manual for information on what settings to use in what scenarios, and, for heaven's sake, follow the instructions. Otherwise, you aren't going to get the best possible images your printer can deliver.

 Also, if you have more than one printer, make sure that you have the right printer selected before you go setting all the printer options.

 Stay away from any options inside the Print dialog box that adjust the picture size or resolution, or you undo the work you did in Step 2. In Elements, leave the Print Size option set to Actual Size, and keep your paws off the Print Scale options.

5. **Send that puppy to the printer.**

 Look in the dialog box for an OK or Print button and click the button to send your image scurrying for the printer.

Getting better results from your printer

With the general printing info under your belt — and with your own printer manual close at hand — you're ready for some more specific tips about making hard copies of your images. So here are a few tips that can help you get the best output from any printer:

- ✓ **Better paper equals better prints.** For those special pictures, invest in glossy photographic stock or some other high-grade option.

- ✓ **When setting up the print job, be sure to choose the right paper settings.** If the printer is set to print on matte paper, for example, and you instead feed it glossy stock, you're going to have a smeary mess on your hands.

- ✓ **Do a test print using different printer-resolution or print-quality settings.** This process enables you to determine which settings work best for which types of images and which types of paper. The default settings selected by the printer's software may not be the best choices for the

types of images you print. Be sure to note the appropriate settings so that you can refer to them later. Also, some printer software enables you to save custom settings so that you don't have to reset all the controls each time you print. Check your printer manual to find out whether your printer offers this option.

✔ **Don't forget to install the printer *driver* (software) on your computer.** Follow the installation instructions closely so that the driver is installed in the right folder in your system. Otherwise, your computer can't communicate with your printer.

✔ **Use the right printer cable.** If your printer didn't ship with a cable to connect the printer and computer — most don't — make sure that you buy the correct type of cable. For parallel-port connections, most printers require bidirectional, IEEE 1284–compliant cables. Don't worry about what that means — just look for the words on the cable package. And don't cheap out and buy less-expensive cables that don't meet this specification, or you won't get optimum performance from your system.

✔ **Some printers don't perform well when connected to the computer through a pass-through device.** For example, if you have a CD recorder connected to your computer's printer port and then plug your printer into a printer port on the CD recorder, you may experience printing hang-ups. Do a test print after connecting your printer to any new pass-through devices.

✔ **Don't ignore your printer manual's instructions regarding routine printer maintenance.** Print heads can become dirty, inkjet nozzles can become clogged, and all sorts of other gremlins can gunk up the works. When testing an inkjet model for this book, for example, I almost wrote the printer off as a piece of junk because I was getting horrendous printouts. Then I followed the troubleshooting advice in the manual and cleaned the print heads. The difference was like night and day. Suddenly, I was getting beautiful, rich images, just like the printer's advertisements promised.

As for the number-one printing complaint — printed colors that look different from on-screen colors — move to the next section.

These colors don't match!

You may notice a significant color shift between your on-screen and printed images. This color shift is due in part to the fact that you simply can't reproduce all RGB colors using printer inks, a problem explained in the sidebar "The separate world of CMYK," earlier in this chapter. In addition, the brightness of the paper, the purity of the ink, and the lighting conditions in which you view the image can all lead to colors that look different on paper than they do on-screen.

Although perfect color matching is impossible, you can take a few steps to bring your printer and monitor colors closer together, as follows:

- On an inkjet printer, check your ink status. An empty or clogged ink cartridge is very often the culprit when colors are seriously off.

- Changing your paper stock sometimes affects color rendition. In my experience, the better the paper, the truer the color matching.

- The software provided with most color printers includes color-matching controls that are designed to get your screen and image colors to jibe. Check your printer manual for information on how to access these controls.

- If playing with the color-matching options doesn't work, the printer software may offer controls that enable you to adjust the image's color balance. When you adjust the color balance using the printer software, you don't make any permanent changes to your image. Again, you need to consult your printer manual for information on specific controls and how to access and use them.

- Don't convert your images to the CMYK color model for printing on a consumer printer. These printers are designed to work with RGB images, so you get better color matching if you work in the RGB mode.

- Many image-editing programs also include utilities that are designed to assist in the color-matching process as well. Some of these are very user-friendly; after printing a sample image, you let the program know which sample most closely matches what you see on-screen. The program then calibrates itself automatically using this information.

 Photoshop Elements, Photoshop, and other advanced programs offer more sophisticated color-management options. If you're new to the game, I suggest you leave these settings in their default positions, as the whole topic is a little mind-boggling and you can just as easily make things worse as improve them. Many of the color settings aren't designed to improve matching between your printer and monitor, anyway, but to ensure color consistency through a production workflow — that is, between different technicians passing an image file along from creation to printing.

- If your photography work demands more accurate color-matching controls than your printer or photo-editing software delivers, you can invest in a *color-management* system, or CMS, for short. Incorporating special software and hardware tools, a CMS enables you to calibrate all the different components of your image-processing system — scanner, monitor, and printer — so that colors stay true from machine to machine. Among companies offering color-management products for consumers are Colorvision (www.colorvision.com), X-Rite (www.xrite.com), and GretagMacbeth (www.i1color.com).

Remember, too, that even the best color-matching system can't deliver 100-percent accuracy because of the inherent difference between creating colors with light and reproducing them with ink.

These same comments apply to the color-management systems that may be included free with your operating-system software, such as ColorSync on the Mac.

⌐ If your monitor enables you to adjust the screen display, try this procedure to get your printer and monitor more in sync. Print a color image and then hold the image up next to the monitor. Compare the printed picture with the one on-screen and then adjust the monitor settings until the two fall more in line. But remember that this process is a little backwards in that it calibrates the monitor to the printer rather than the other way around. So if you print your image on another printer, your colors may shift dramatically from what you see on the monitor.

⌐ Finally, remember that the colors you see both on-screen and on paper vary depending on the light in which you view them.

Preparing a TIFF Copy for Publication

In order to submit your photo to a newsletter or other print publication, you may need to provide the file in the TIFF format. You may also need to convert the file to TIFF to use it in some page-layout and publishing programs.

To create a TIFF copy of an original file, open the image in your photo editor and choose File⇨Save As to make your copy.

In Elements, the exact steps are as follows. If you're using another program, the options discussed in Steps 4 and 6 should be the same, although the order in which they appear may differ:

1. **If you have made any changes to the file since the last time you saved, save those changes.**

 In Elements, for example, save the file in the PSD format, making sure to select the Layers check box to preserve layers, if your image contains them. (Chapter 13 explains layers.)

2. **Choose File⇨Save As.**

 Be sure to choose Save As, not just File⇨Save; otherwise, your program simply resaves the file at its current settings.

3. **In the Save As dialog box, give the file a name and choose the storage location, as usual.**

4. **Choose TIFF as the file format.**

5. **This time, if your file contains layers, select the option that merges all those layers into one.**

 Many programs can't open layered TIFF files, so it's best to merge all the layers in your TIFF copy. In Elements, turn off the Layers check box. Assuming that you saved the original image as instructed in Step 1, the layers in your original are unaffected by this step. (Not all programs allow you to keep layers independent when you save to the TIFF format, so if you don't see this option, don't worry about it. In some programs, you may not get access to the option until the next step.)

6. **Click Save.**

 When you do, you're presented with some additional options. These vary depending on the program, but in most cases, they include the options shown in Figure 9-12. This is the TIFF Options dialog box from Photoshop Elements.

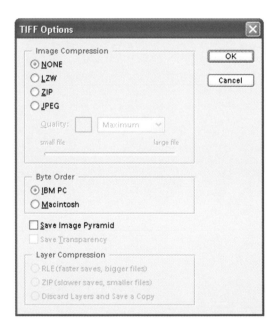

Figure 9-12: For the widest compatibility with other programs, use these TIFF options when saving your file.

7. **Set the format options as follows:**

 • **Image Compression:** Choose None. The LZW option is also safe in terms of preserving all your image data, but some programs can't open files saved with LZW.

 • **Byte Order:** Choose IBM PC if you know you'll be using the file on a Windows-based system; choose Macintosh for a Mac system. But don't stress too much about this one — most programs can open either type of file.

 • **Save Image Pyramid:** Give this one a pass, too. When enabled, it creates a file that some programs won't open.

 • **Layer Compression:** If you forgot to disable the Layers box in Step 5, choose Discard Layers and Save a Copy. If you did already disable layers (or your image doesn't contain multiple layers) all the Layer Compression options are dimmed and unavailable.

8. **Click OK to complete the process.**

 Your original file closes, and your TIFF copy appears on-screen. Unless you want to make further changes, just close the image.

On-Screen, Mr. Sulu!

In This Chapter

▶ Creating pictures for screen display

▶ Preparing photos for use on a Web page

▶ Trimming your file size for faster image downloading

▶ Saving a JPEG file

▶ Attaching a photo to an e-mail message

▶ Viewing pictures on your television

igital cameras are ideal for creating pictures for on-screen display. Even the most inexpensive, entry-level cameras can deliver enough pixels to create good images for Web pages, online photo albums, multimedia presentations, and other on-screen uses.

The process of preparing your pictures for the screen can be a little confusing, however — in part because so many people don't understand the correct approach and keep passing along bad advice to newcomers.

This chapter shows you how to do things the right way. You find out how to set the display size of on-screen photos, save the resized photo in the JPEG file format, send a picture along with an e-mail message, and more.

Step into the Screening Room

With a printed picture, your display options are fairly limited. You can pop the thing into a frame or photo album. You can stick it to a refrigerator with one of those annoyingly cute refrigerator magnets. Or you can slip it into your wallet so that you're prepared when an acquaintance inquires after you and yours.

In their digital state, however, you can display photos in all sorts of new and creative ways, including the following:

✔ **On a Web page:** If your company has a Web site, add interest by posting product pictures, employee photos, and images of your corporate head-quarters. Many folks these days even have personal Web pages devoted not to selling products but to sharing information about themselves. (Your Internet provider may provide you with a free page just for this purpose.)

You can even create an online photo gallery — and you don't need to be an experienced Web designer, either, because many photo-editing programs provide a wizard that practically automates the process. Figure 10-1 shows the wizard provided in Photoshop Elements, for example. Figure 10-2 offers a look at the finished Web page. See "Nothing but Net: Photos on the Web," later in this chapter, for details on preparing a digital photo for use on a Web page.

Figure 10-1: Putting together a simple Web gallery is easy, thanks to step-by-step wizards provided in many photo-editing and cataloging programs.

Figure 10-2: Visitors to your gallery can click a thumbnail to display the image at a larger size.

✔ **Via e-mail:** E-mail a picture to friends, clients, or relatives, who then can view the image on their computer screens, save the image file, and even edit and print the photo if they like. Check out "Drop Me a Picture Sometime, Won't You?" later in this chapter for information on how to attach a picture to your next e-mail missive.

✔ **On a photo-sharing site:** When you have more than a few pictures to share, forego e-mail and instead take advantage of photo-sharing sites such as Kodak EasyShare Gallery (www.kodakgallery.com), Snapfish (www.snapfish.com), or Shutterfly (www.shutterfly.com). Figure 10-3 offers a look at an online album that I created at the Snapfish Web site. After uploading pictures, you can invite people to view your album and to buy prints of their favorite photos. You generally can create and share albums at no charge; the Web sites make a profit through their photo printing services.

Do *not* rely on photo-sharing sites for archival picture storage, however. Many sites delete your pictures if you don't buy prints within a certain amount of time. And some sites that have had glorious beginnings went through a bad spell and shut down, taking all their customers' photos with them. See Chapter 4 for information on how to properly archive your digital files.

✔ **In a multimedia presentation:** Import the picture into a multimedia presentation program such as Microsoft PowerPoint or Corel Presentations. The right images, displayed at the right time, can add excitement and emotional impact to your presentations and also clarify your ideas. Check your presentation program's manual for specifics on how to add a digital photo to your next show.

✔ **As a screen saver:** Create a personalized screen saver featuring your favorite images or pick a single image to use as your desktop wallpaper, as I did for Figure 10-4, in the next section. Chapter 15 provides the step-by-step instructions for both projects.

Figure 10-3: Online album sites such as Snapfish offer a convenient way to share photos with far-flung friends and relatives.

✔ **As a slide show:** Put together a digital slide show using a specialty program such as PhotoShow, introduced in Chapter 1. You can burn the show to CD for playback on any computer and on some DVD players. Many photo-editing and cataloging programs also offer a tool for making slide shows, although they're usually more limited than what you get in a stand-alone program.

✔ **On TV:** With many digital cameras, you can download images to your TV, DVD player, or VCR. You can then show your pictures to a living room full of guests and even record your images to videotape. For information, see the last section of this chapter.

That's About the Size of It

Preparing pictures for on-screen display requires a different approach than you use to get them ready for the printer. The following sections tell all.

Understanding monitor resolution and picture size

As you prepare pictures for on-screen use, remember that monitors display images using one screen pixel for every image pixel. (If you need a primer on pixels, flip back to Chapter 2.) The exception is when you're working in a photo-editing program or other application that enables you to zoom in on a picture, thereby devoting several screen pixels to each image pixel.

Most monitors can be set to a choice of displays, each of which results in a different number of screen pixels, or, in common lingo, a different *monitor resolution.* Standard monitor resolution settings include 640 x 480 pixels, 800 x 600 pixels, 1024 x 768 pixels, and 1280 x 1024 pixels. The first number always indicates the number of horizontal pixels.

To size a screen picture, you simply match the pixel dimensions of the photo to the amount of screen real estate that you want the picture to consume. If your photo is 800 x 600 pixels, for example, it consumes the entire screen when the monitor resolution is set to 800 x 600. Raise the monitor resolution, and the same photo no longer fills the screen.

For a clearer idea of how monitor resolution affects the size at which your photo appears on-screen, see Figures 10-4 and 10-5. Both examples show an 800 x 600-pixel digital photo as it appears on a 19-inch monitor. I used the Windows Desktop Properties control to display the photo as my Windows desktop background, or *wallpaper,* in geek speak. (See Chapter 15 for how-to's.) In Figure 10-4, I set the monitor resolution to 800 x 600. The image fills the entire screen (although the Windows taskbar hides a portion of the image at the bottom of the frame). In Figure 10-5, I displayed the same picture but switched the monitor resolution to 1600 x 1200. The image now eats up one-fourth of the screen. A higher screen resolution means smaller screen pixels, so everything appears smaller — including your photo.

Figure 10-4: An 800 x 600-pixel digital photo fills the screen when the monitor resolution is set to 800 x 600.

Unfortunately, you often don't have any way to know or control what monitor resolution will be in force when your audience views your pictures. Someone viewing your Web page in one part of the world may be working on a 21-inch monitor set at a resolution of 1280 x 1024, while another someone may be working on a 13-inch monitor set at a resolution of 640 x 480. So you just have to strike some sort of compromise.

For Web and e-mail images, I recommend sizing your photos assuming a 640 x 480 monitor resolution — the least common denominator, if you will. If you create an image larger than 640 x 480, people who use a monitor resolution of 640 x 480 have to scroll the display back and forth to see the entire photo. Of course, if you're preparing images for a multimedia presentation and you know what monitor resolution you'll be using, work with that display in mind. For online use, also keep in mind that the Web browser or e-mail window itself takes up some of the available screen space.

Figure 10-5: At a monitor resolution of 1600 x 1200, an 800 x 600-pixel photo consumes one-quarter of the screen.

Sizing images for the screen

Some digital cameras offer an option that automatically creates two copies of each image: one with lots of pixels for making prints, and another that has the appropriate number of pixels for e-mail or Web use. But if your camera doesn't offer this feature, you can easily make a resized copy of a photo for online sharing.

Here's how to do the job in Photoshop Elements:

1. **Save a backup copy of your picture.**

 In all likelihood, you're going to trim pixels from your photo for on-screen display. You may want those original pixels back someday, so save a copy of the picture with a different name before you go any further.

2. **Choose Image⇨Resize⇨Image Size to display the Image Size dialog box.**

3. Select the Resample Image check box, as shown in Figure 10-6.

This option, when turned on, enables you to *resample* the picture — that is, to add or delete pixels. After you select the option (by clicking the check box), the Pixel Dimensions area at the top of the dialog box offers a set of Width and Height controls, as shown in the figure. You use these controls to add or delete pixels in Step 6.

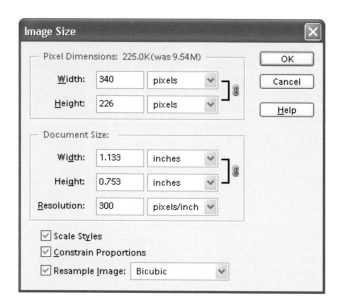

Figure 10-6: To add or delete pixels in Photoshop Elements, select the Resample Image check box.

4. Select Bicubic from the drop-down list next to the Resample Image option.

The options in this list affect the method the program uses when adding and deleting pixels. Bicubic, the default setting, produces the best results when you're trimming pixels. If you're adding pixels, use Bicubic Smoother.

5. Select the Constrain Proportions check box, as shown in the figure.

This option makes sure that the original proportions of your picture are maintained when you change the pixel count.

6. Select the Scale Styles box, if it's available.

7. **Using the top set of Width and Height boxes, enter the new pixel dimensions for your photo.**

 Remember, *pixel dimensions* is just a nerdy way of saying "number of pixels across by number of pixels down."

 Before setting the new pixel count, select Pixels as the unit of measurement from the drop-down list next to the Width or Height box. Because the Constrain Proportions option is turned on, the Height value automatically changes when you adjust the Width value, and vice versa.

8. **Click OK or press Enter.**

 To view your photo at the size it will display on-screen, choose View➪ Actual Pixels. Keep in mind that this view setting displays the photo according to your current monitor resolution; if displayed on a monitor using a different resolution, the photo size will change. For more on this sticky bit of business, refer to the preceding section.

9. **Save the resized photo in the JPEG format.**

 The upcoming section "JPEG: The photographer's friend," offers specifics on this step. If your original image was in the JPEG format, be sure to give the resized copy a new name so that you don't overwrite the original file.

The steps for resizing a photo in other programs should be very similar. For specifics, check your software's Help system for information about how to resample pictures. Your software may even offer a wizard that automates the process of downsampling a picture and sending it via e-mail.

Whatever program you use to resample your photos, remember that if you *add* pixels, the software has to make up — *interpolate* — the new pixels, and your picture quality can suffer. Check out the information on resampling and resolution in Chapter 2 for more details on this subject.

Also, the more pixels you have, the larger the image file. If you're preparing photos for the Web, file size is a special consideration because larger files take longer to download than smaller files. See "Nothing but Net: Photos on the Web" for more information about preparing images for use on Web pages.

Sizing screen images in inches

Newcomers to digital photography often have trouble sizing images in terms of pixels and prefer to rely on inches as the unit of measurement. And some photo-editing programs don't offer pixels as a unit of measurement in their image-size dialog boxes.

If you can't resize your picture using pixels as the unit of measurement or you prefer to work in inches, set the image width and height as usual and then set the output resolution to somewhere between 72 and 96 ppi. In Photoshop Elements, follow the same steps as outlined in the preceding section, but set the picture size and output resolution using the Width, Height, and Resolution boxes in the Document Size section of the Image Size dialog box.

Where does this 72 to 96 ppi figure come from? It's based on default monitor resolution settings on Macintosh and PC monitors. Mac monitors usually leave the factory with a monitor resolution that results in about 72 screen pixels per linear inch of the viewable area of the screen. PC monitors are set to a resolution that results in about 96 pixels for each linear inch of screen. So if you have a 1 x 1-inch picture and set the output resolution to 72 ppi, for example, you wind up with enough pixels to fill an area that's one-inch square on a Macintosh monitor.

Note that this approach is pretty unreliable because of the wide range of monitor sizes and available monitor resolution settings — the latter of which the user can change at any time, thereby blowing the 72/96 ppi guideline out of the water. For more precise on-screen sizing, the method described in the preceding section is the way to go.

Nothing but Net: Photos on the Web

If your company operates a Web site or you maintain a personal Web site, you can easily place pictures from your digital camera onto your Web pages.

Because I don't know which Web-page creation program you're using, I can't give you specifics on the commands and tools you use to add photos to your pages. But I can offer some advice on a general artistic and technical level, which is just what happens in the next few sections.

Basic rules for Web pictures

If you want your Web site to be one that people love to visit, take care when adding photos (and other graphics, for that matter). Too many images or images that are too big quickly turn off viewers, especially viewers with slow dialup connections. Every second that people have to wait for a picture to download brings them a second closer to giving up and moving on from your site.

To make sure that you attract, not irritate, visitors to your Web site, keep these nuggets of information in mind:

✔ **For business Web sites, make sure that every image you add is *necessary*.** Don't junk up your page with lots of pretty pictures that do nothing to convey the message of your Web page — in other words, images that are pure decoration. These kinds of images waste the viewer's time and cause people to click away from your site in frustration.

✔ **If you use a picture as a hyperlink, also provide a text-based link.** (A *hyperlink,* in case you're new to the Internet, is a graphic or bit of text that you click to travel to another Web page.) This suggestion applies whether you use a single image as a link or combine several images into a multi-link graphic, or *image map.* Why the need for both image and text links? Because many people with slow Internet connections set their browsers so that images do not automatically download. Images appear as tiny icons that the viewer can click to display the entire image. This setup reduces the time required for a Web page to load. But without those text links, people can't navigate your site unless they take the time to load each image.

✔ **Save Web-bound photos in the JPEG file format.** This format produces the best-looking on-screen pictures, and all Web browsers can display JPEG files. Two other photo formats, PNG (pronounced *ping*) and JPEG 2000, are in development, but not fully supported by either browsers or Web-page creation programs yet.

✔ **Don't save photos in the GIF format.** If you're familiar with Web design, you may be wondering about using the GIF format for your online photos. GIF, which stands for *Graphics Interchange Format,* is a great format for small graphics, such as logos. But it's not good for photos because a GIF image can contain only 256 colors. As a result, photos can turn splotchy when saved to this format, as illustrated by Figure 10-7.

People argue about whether to say *jiff,* as in *jiffy,* or *gif,* with a hard *g.* I go with *jiff* because my research turned up evidence that the creators of the format intended that pronunciation. But I don't care how you say GIF as long as you remember not to use it for your Web photos.

✔ **Understand how pixel count affects display size.** Set the display size of your photos following the guidelines discussed earlier in "Sizing images for the screen." To accommodate the widest range of viewers, size your images with respect to a screen display of 640 x 480 pixels. Don't forget that the Web browser or e-mail program needs part of the available screen space. For e-mail pictures, I suggest a maximum image width of 300 pixels and a maximum height of 250 pixels.

Note that with this low pixel count, people can't make a decent print from your pictures. Consider using a photo-sharing Web site instead of e-mail if you want people to have the option of printing your photos.

✔ **File size determines how long it takes other people to download your pictures.** It also determines how long you sit and wait for pictures to make it from your computer to the Web.

✔ **Pixel count, not ppi, determines file size.** File size is determined by the total number of pixels in the image, not the output resolution (pixels per inch, or ppi). The file size of a 640 x 480-pixel image is the same at 72 ppi as it is at 300 ppi. Check out Chapter 2 for a more detailed explanation of all this file-size, pixel-count, and output resolution stuff.

✔ **Increasing the amount of JPEG compression is another way to reduce file size.** The next section explains this option.

✔ **If you want to control the use of your photos, think twice about posting them online.** Remember, anyone who visits your page can download, save, edit, print, and distribute your image — without your knowledge or approval. To prevent unauthorized use of your pictures, you may want to investigate digital watermarking and copyright protection services. To start learning about such products, visit the Web site of one of the leading providers, Digimarc (www.digimarc.com). The Web site operated by the organization Professional Photographers of America (www.ppa.com) provides good background information on copyright issues in general.

Figure 10-7: For better-looking Web photos, use the JPEG file format (top). GIF images can contain only 256 colors, which can leave photos looking splotchy (bottom).

Would you like that picture all at once, or bit by bit?

When you save a picture in the JPEG format inside a photo editor, you usually encounter an option that enables you to specify whether you want to create a *progressive* image. This feature determines how the picture loads on a Web page.

With a progressive JPEG, a faint representation of your image appears as soon as the initial image data makes its way through the viewer's modem. As more and more image data is received, the picture details are filled in bit by bit. With *nonprogressive* images, no part of your image appears until all image data is received.

Progressive images create the *perception* that the image is being loaded faster because the viewer has something to look at sooner. This type of photo also enables Web-site visitors to decide more quickly whether the image is of interest to them and, if not, to move on before the image download is complete.

However, progressive images take longer to download fully, and some Web browsers don't handle them well. In addition, progressive JPEGs require more RAM (system memory) to view. For these reasons, most Web design experts recommend that you don't use progressive images on your Web pages.

If you decide to go with the GIF format instead of JPEG, by the way, you encounter an option called *interlacing,* which has the same result as a progressive JPEG. For reasons illustrated earlier in this chapter (refer to Figure 10-7), I don't recommend using GIF for photos, but if you do, don't create interlaced files.

JPEG: The photographer's friend

JPEG (*jay-peg*) is the standard format used by digital cameras to store picture files. If you don't need to resize your JPEG originals, you can share them via e-mail or post them on a Web page immediately. All Web browsers and e-mail programs can display JPEG photos.

Chances are, though, that your originals are too large for on-screen use, which means that you need to dump some pixels, following the instructions earlier in this chapter. After you take that step — or do any other photo editing — you must resave the file in the JPEG format before sharing it online.

When you save a file in the JPEG format, the picture undergoes *lossy compression.* This feature creates smaller file sizes by dumping some image data, which can reduce picture quality. (Chapter 5 offers an illustration.) So before you save an image in the JPEG format, create a backup copy using a file format that doesn't use lossy compression — TIFF, for example, or the Photoshop Elements format (PSD), if you use that program.

As an alternative, you can simply resave the file in the JPEG format, but using a new filename. Don't take that route if your file contains layers, however; saving to JPEG merges layers. (For an explanation of layers, see Chapter 13.)

The following steps show you how to use the Photoshop Elements Save for Web utility, introduced earlier in this chapter, to save your picture in the JPEG format. Using this feature enables you to see how much damage your picture will suffer at various levels of JPEG compression. If you're using another image editor, check the Help system for the exact commands to use to save to JPEG. The available JPEG options should be much the same as described here, although you may or may not be able to preview the compression effects on your picture.

1. **Choose File⇨Save for Web to display the Save for Web dialog box, shown in Figure 10-8.**

 The preview on the left side of the dialog box shows your original picture; the right-side preview shows how your photo will look when saved at the current settings.

2. **Select JPEG from the Format drop-down list, labeled in Figure 10-8.**

 After you select JPEG, you see the other save options shown in the figure.

3. **Set the compression amount by using the Quality controls labeled in the figure.**

 A higher Quality setting results in less compression and a larger file.

 The Quality drop-down list offers five general settings: Maximum, Very High, High, Medium, and Low. Maximum provides the best picture quality/least compression; Low provides the least quality/most compression. If you want to get a little more specific, use the Quality slider on the right. You can specify any Quality value from 0 to 100, with 0 giving you the lowest image quality (maximum compression) and 100 the best image quality (least compression).

 As you adjust either control, the right preview in the dialog box updates to show you the impact on your photo. Beneath the preview, the program displays the approximate file size and download time at a specific modem speed. To specify the modem speed, open the Preview menu, labeled in Figure 10-8.

4. **Turn off the Progressive and ICC Profile check boxes.**

 If you see a check mark in a box, click the box to remove the check mark and turn off the option. For reasons discussed in the earlier sidebar, "Would you like that picture all at once, or bit by bit?" progressive JPEG files aren't a good idea. The ICC Profile option has to do with some color management issues that professional imaging folks may want to investigate, but us ordinary mortals don't need to worry about. In addition, the option adds to the file size.

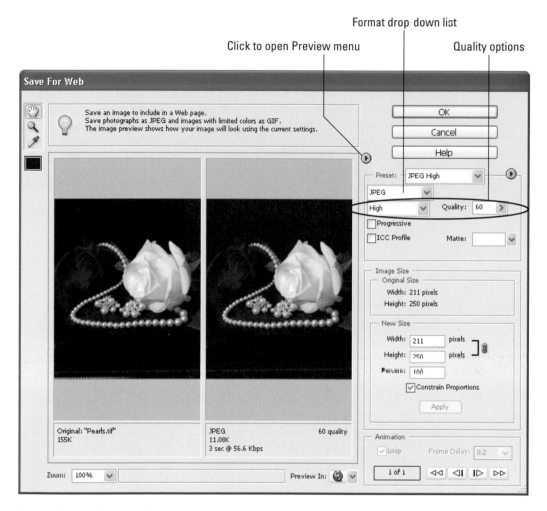

Figure 10-8: The Quality settings determine how much compression is applied.

5. If your picture contains transparent areas, choose a Matte color.

This feature comes into play only if the *bottom* layer of your picture contains transparent areas. (See Chapter 13 for the scoop on layers and layer transparency.) JPEG files can't preserve transparency, so transparent areas are filled with the color you choose from the Matte drop-down list — white, if you don't select another color.

If you're placing the photo on a Web page that has a solid-colored background, you can make the transparent parts of a JPEG photo *appear* to retain their transparency, however. Just match the Matte color to the color of your Web page background. The viewer's eye then can't tell where the image stops and the Web page begins.

6. Click OK.

The Save for Web dialog box disappears, and the Save Optimized As dialog box comes to life. This dialog box works like any file-saving dialog box. Just give your picture a filename and specify where you want to store the file. The correct file format is already selected for you.

7. Click Save or press Enter.

The program saves the JPEG copy of your picture. Your original photo remains open and on-screen. If you want to see the new JPEG version, you have to open that file.

Drop Me a Picture Sometime, Won't You?

Being able to send digital photos to friends and family around the world via e-mail is one of the most enjoyable aspects of owning a digital camera. With a few clicks of your mouse, you can send an image to anyone who has an e-mail account.

Although attaching a digital photo to an e-mail message is really simple, the process sometimes breaks down due to differences in e-mail programs and how files are handled on the Mac versus the PC. Also, newcomers to the world of electronic mail often get confused about how to view and send images — which isn't surprising, given that e-mail software often makes the process less than intuitive.

One way to help make sure that your image arrives intact is to prepare it properly before sending. First, size your image according to the guidelines discussed earlier in this chapter in "That's About the Size of It." Also, save your resized image in the JPEG format, as explained in the preceding section.

Note that these instructions don't apply to pictures that you're sending to someone who needs to use the image for some professional graphics purpose — for example, if you created an image for a client who plans to put it in a company newsletter. In that case, save the image file in whatever format the client needs, and use the output resolution appropriate for the final output, as explained in Chapter 2. If you want the recipient of your e-mail to produce a decent print, you can still use the JPEG format, but you can't reduce the pixel count as you do for only on-screen viewing. Either way, you're going to be sending a large file and should expect long download times unless you have a high-speed Internet connection. With a dialup connection, putting the image on a Zip disk, CD, or some other removable storage medium and sending it off via overnight mail may be a better option than e-mail transmission.

That said, the following steps explain how to attach an image file to an e-mail message in Microsoft Outlook Express Version 6.0. (If you're using another version or some other e-mail program, the process is probably very similar, but check your program's Help system for specific instructions.)

1. **Connect to the Internet and fire up Outlook Express.**

2. **Choose File⇨New⇨Mail Message.**

 You're presented with a blank mail window.

3. **Enter the recipient's name, e-mail address, and subject information as you normally do.**

4. **Choose Insert⇨File Attachment or click the Attach File button on the toolbar, labeled in Figure 10-9.**

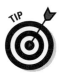

 Most programs provide such a toolbar button — look for a button that has a paper clip icon on it. The paper clip has become the standard icon to represent the attachment feature.

 You then see a dialog box that looks much like the one you normally use to locate and open a file. Track down the image file that you want to attach, select it, and click Attach. You're then returned to the message composition window.

5. **Choose File⇨Send Message or click the Send button (labeled in Figure 10-9) to launch that image into cyberspace.**

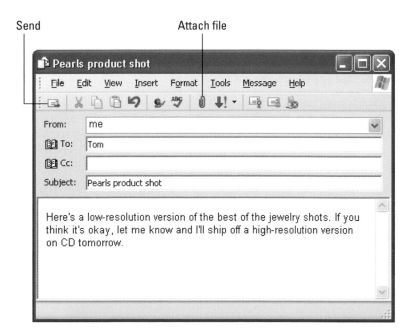

Figure 10-9: Click the paper clip button to attach a picture file to your e-mail message.

If everything goes right, your e-mail recipient should receive the image in no time. In Outlook Express, the image either appears as an *inline graphic* — that is, it is displayed right in the e-mail window as in Figure 10-10 — or as a text link that the user clicks to display the image.

But as mentioned earlier, several technical issues can throw a monkey wrench into the process. If the image doesn't arrive as expected or can't be viewed, the first thing to do is call the tech support line for the recipient's e-mail program or service. Find out whether you need to follow any special procedures when sending images and verify that the recipient's software is set up correctly. If everything seems okay on that end, contact your own e-mail provider or software tech support. Chances are, some e-mail setting needs to be tweaked, and the tech support personnel should be able to help you resolve the problem quickly.

Figure 10-10: Use a maximum height of 250 pixels and a maximum width of 300 pixels when e-mailing pictures.

Viewing Your Photos on a TV

If you've shopped for a DVD player recently, you may have spotted an interesting new feature on a few models: a slot that accepts some types of digital camera media. You can pop a memory card out of your camera, into the DVD player, and view all the pictures on the card on your television set.

For those without the latest in home electronics technology, many cameras come with a *video-out* port and video connection cable. Translated into English, that means that you can connect the camera itself to a DVD player or regular old TV to display your digital photos. You can even connect the camera to a VCR and record your images on videotape.

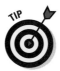

Why would you want to display your images on a TV? Here are a couple reasons:

- ✓ You can show your pictures to a group of people in your living room or office conference room instead of having them huddle around your computer monitor.

- ✓ You can review your images more closely than you can on your camera's LCD monitor. Small defects that may not be noticeable on the camera monitor become readily apparent when viewed on a 27-inch television screen.

As with connecting the camera to a computer, consult your camera's manual for specific instructions on how to hook your camera to the DVD player, TV, or VCR. Typically, you plug one end of an AV cable (supplied with the camera) into the camera's video- or AV-out port and then plug the other end into the video-in port on your TV, DVD player, or VCR, as shown in Figure 10-11. If your camera has audio-recording capabilities, the cable has a separate AV plug for the audio signal. That plug goes into the audio-in port. If your playback device supports stereo sound, you typically plug the camera's audio plug into the mono-input port.

Figure 10-11: Many cameras enable you to send video signals from the camera to your TV, VCR, or DVD player for playback.

To display your pictures on the TV, you generally use the same procedure as when reviewing your pictures on the camera's LCD monitor, but again, check your manual. You may need to set your TV's input signal to the auxiliary input mode; look in your TV manual to find out how to do this.

To record the images on videotape, just put the VCR in record mode, turn on the camera, and display each image for the length of time you want to record it. You may need to select a different input source for the VCR — for example, to switch the VCR from its standard antenna or cable input setting to its auxiliary input setting.

Most digital cameras sold in North America output video in NTSC format, which is the format used by televisions in North America. You can't display NTSC images on televisions in Europe and other countries that use the PAL format instead of NTSC. So if you're an international business mogul needing to display your images abroad, you may not be able to do it using your camera's video-out feature. Some newer cameras do provide you with the choice of NTSC or PAL formats.

You can view your photos on TV even if your camera doesn't offer a video-out feature or your DVD player doesn't offer memory-card slots, by the way. Several companies sell image-viewing devices designed just for this purpose. Figure 10-12 shows one such product, the SanDisk Photo Album ($50, www.sandisk.com). Some camera docking stations also offer video-out ports; see Chapter 4 for more information on docking stations.

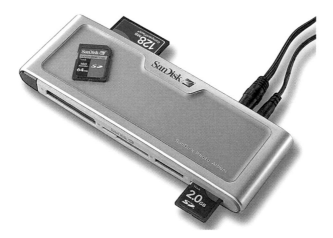

SanDisk Corporation

Figure 10-12: You can buy stand-alone devices that enable you to view images from memory cards on your TV.

Part IV
Tricks of the Digital Trade

The 5th Wave — By Rich Tennant

"I've got some new image editing software, so I took the liberty of erasing some of the smudges that kept showing up around the clouds. No need to thank me."

In this part . . .

*I*f you watch many spy movies, you may have noticed that image editing has worked its way into just about every plot line lately. Typically, the story goes like this: A Mel Gibson-type hero snags a photograph of the bad guys. But the photograph is taken from too far away to clearly identify the villains. So Mel takes the picture to a buddy who works as a digital-imaging specialist in a top-secret government lab. Miraculously, the buddy is able to enhance the picture enough to give Mel a crystal-clear image of his prey, and soon all is well for Earth's citizens. Except for the buddy, that is, who invariably gets killed by the villains just moments after Mel leaves the lab.

I'm sorry to say that, in real life, image editing doesn't work that way. Maybe top-secret government-types have software that can perform the tricks you see in movies — hey, for all I know, our agents really have ray guns and secret decoder rings, too. But the image editors available to you and me simply can't create photographic details out of nothing.

That doesn't mean that you can't perform some pretty amazing feats, though, as this part of the book illustrates. Chapter 11 shows you how to do minor touch-up work, such as cropping your image and correcting color balance. Chapter 12 explains how to apply edits to just part of your image by creating selections, how to cut and paste two or more images together, and how to cover up minor image flaws and unwanted background elements. Chapter 13 gives you a taste of some advanced editing techniques, such as painting on your image, creating photographic montages, and applying special-effects filters.

11

Making Your Image Look Presentable

In This Chapter

▶ Opening and saving pictures

▶ Cropping out unwanted elements

▶ Tweaking exposure

▶ Increasing color saturation

▶ Adjusting color balance

▶ Sharpening "focus"

▶ Blurring backgrounds

▶ Removing noise and jaggies

*O*ne of the great things about digital photography is that you're never limited to the image that comes out of the camera, as you are with traditional photography. With film, a lousy picture stays lousy forever. Sure, you can get one of those little pens to cover up red-eye problems, and if you're really good with scissors, you can crop out unwanted portions of the picture. But that's about the extent of the corrections you can do without a full-blown film lab at your disposal.

With a digital image and a basic photo-editing program, however, you can do amazing things to your pictures with surprisingly little effort. In addition to cropping, color balancing, and adjusting brightness and contrast, you can cover up distracting background elements, bring back washed-out colors, paste two or more images together, and apply all sorts of special effects.

Chapter 12 explains how to cover up image blemishes and how to paste photos together, while Chapter 13 explores painting tools, special-effects filters, and other advanced photo-editing techniques. This chapter explains the basics: simple tricks you can use to correct minor defects in your pictures.

What Software Do You Need?

In this chapter, and in others that describe specific photo-editing tools, I show you how to get the job done using Adobe Photoshop Elements. I chose this software for two reasons. First, it costs less than $100, yet offers many of the same features found in the more sophisticated (and more expensive) Adobe Photoshop, the leading professional-level photo editor. In addition, Elements is available for both Windows-based and Macintosh computers, which is a rarity in today's Windows-centric computing world.

A few additional notes about the photo-editing instructions in this book:

- ✔ Steps and illustrations feature Elements 3.0. However, if you're using another version of the program, the core components are much the same, although Version 3.0 introduced a few new tools.

- ✔ Text marked with an Elements How-To icon relates specifically to Elements. This book is just intended to help you get your feet wet with Elements, however. If you want to dig deeper into the program, many excellent books are available, and the built-in Help system is quite good as well. (Choose Help➪Photoshop Elements Help.)

- ✔ In figures, the Elements toolbox appears as a one-column affair, as shown in Figure 11-1, while yours may occupy two columns. The arrangement depends on the size of the program window; if the window is small, the toolbox shrinks itself in height so that you can see the entire toolbox at all times.

- ✔ In addition, I hid the Palette Bin and Photo Bin to leave more room for the image itself. You can hide and display these components via the Window menu. On a Mac, you also can hide the toolbox and options bar, labeled in Figure 11-1, but while working with this book, display those two features.

- ✔ Finally, my instructions assume that you're working in Standard Edit mode; click the Standard Edit button at the right end of the toolbar to make it so.

Toolbox

Toolbar

Options bar

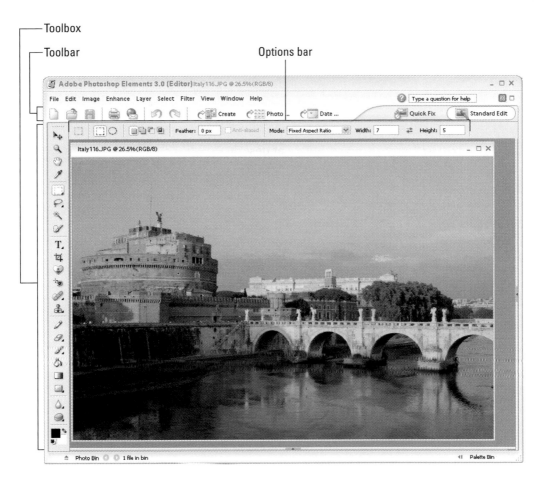

Figure 11-1: Hiding the Palette Bin and Photo Bin allows more room for your photos.

Readers who own Adobe Photoshop will find that many of that program's tools work exactly as they do in Elements, although Photoshop sometimes offers a broader array of tool options than Elements. If you use a photo editor other than Elements or Photoshop, be assured that you can easily adapt the information provided in this book to your software. Most photo-editing programs provide similar tools to the ones I discuss here. And the basic photo-retouching concepts and photographic ideas are the same no matter what photo software you prefer.

So use this book as a guide for understanding the general approach you should take when editing your digital pictures, and consult your software's manual or online Help system for the specifics of applying certain techniques.

If you don't have any photo-editing software or you're shopping for a new program, you can find demo versions of several good products online. The Web page for this book (www.dummies.com/go/digitalphotofd5E) provides links to those products, and I've also posted some sample photos in case you want to work along with the project steps.

Opening Your Photos

Before you can work on a digital photo, you have to open it inside your photo-editing program. In just about every program on the planet, you can use the following techniques to crack open a picture file:

- Choose File⇨Open.

- Use the universal keyboard shortcut for the Open command: In Windows, press Ctrl+O; on a Mac, press ⌘+O.

 - Click the Open button on the toolbar. The universal symbol for this button is a file folder being opened. The Photoshop Elements version of the button appears in the margin.

Whichever method you choose, the program displays the same dialog box you see when you open files in any program. Figure 11-2 shows both the Windows XP and Mac OS X versions of the dialog box. Click the name of the picture file and then click the Open button.

Why is my photo software so sluggish?

Photo editing requires a substantial amount of free RAM (system memory). If your computer slows to a crawl when you try to open a picture, try shutting down all programs, restarting your computer, and then starting your photo software only. (Be sure to disable any startup routines that launch programs automatically in the background when you fire up your system.) Now you're working with the maximum RAM your system has available. If your computer continues to complain about a memory shortage, consider adding more memory — memory is relatively cheap right now, fortunately.

Understand, too, that your photo software uses your computer's hard drive space as well as RAM when processing images. In Elements, you see a message saying that your *scratch disk* is full when you run out of drive space; other programs may use different terminology. In any case, you can solve the problem by deleting unneeded files to free up some room on the hard drive. Another option is to buy an external hard drive and move your less-used files to that drive.

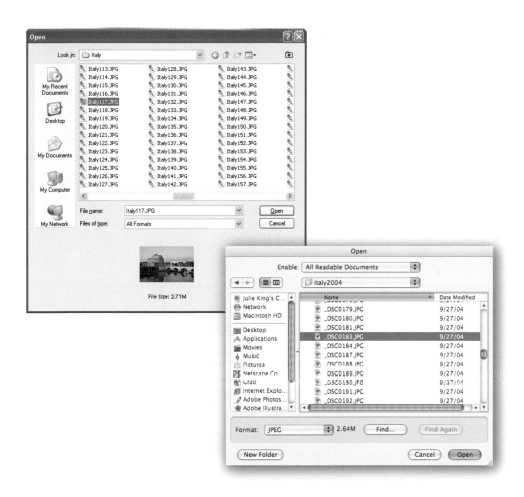

Figure 11-2: The Open dialog box for Windows XP (top) and Mac OS X (bottom).

Here are a few other bits of gossip related to opening images:

✔ Some programs, including Elements, offer a built-in file browser that you can use to preview thumbnails of your picture files before you open them. Figure 11-3 presents the Elements File Browser, which you display by choosing Window➪File Browser. You can double-click a thumbnail to open the picture file.

Note that in the Windows version of Elements 3, you also can view and open pictures from the Organizer, a beefed up cousin of the File Browser. Starting with Version 4, the File Browser is gone, and you must use the Organizer to view picture thumbnails.

✔ All the aforementioned techniques work for accessing picture files that live on your computer's hard drive, a CD, or other storage device. But depending on your photo software, camera, and computer operating system, you may be able to open images directly from your camera (while the camera is connected to the computer). Check the program and camera manuals to find out how to make your software and hardware talk to each other. If you've invested in a memory card reader, you also should be able to access files directly from the card. Chapter 8 offers more help with both scenarios.

✔ Most photo editors can't handle the proprietary file formats that some older digital cameras use to store images. Many programs also choke on Camera Raw files. If your program refuses to open a file because of format, check your camera manual for information about the photo-transfer software provided with your camera. You should be able to use the software to convert your images to a standard file format. See Chapter 8 for help with opening Camera Raw files in Elements.

✔ If your picture opens on its side, use your software's Rotate commands to set things right. In Elements, the commands reside on the Image➪ Rotate submenu.

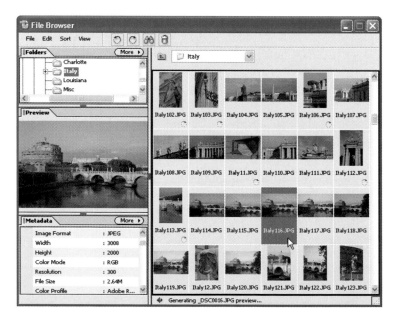

Figure 11-3: Choose Window➪File Browser to browse thumbnails of your pictures in Elements 3.0.

Editing Rules for All Seasons

Before you begin editing your digital photos, review these basic rules of success:

- ✔ **Save a backup of your original picture file.** Then you can experiment freely, safe in the knowledge that if you really botch things, you can return to the original version at any time.

- ✔ **Save at regular intervals as you work on the photo.** See the next section to find out why and how.

- ✔ **Edit on a separate layer.** If your software offers layers, copy the area that you want to alter to a new layer before tackling a significant edit. Then apply the edit to the duplicate. Don't like what you see? Just delete the layer and start over. (Chapter 13 explains what I mean by *layer,* in case you're not familiar with this term.)

- ✔ **Discover selective editing.** Most photo editors enable you to *select* a portion of your image and then apply changes to just the selected area. For example, if the sky in your photo is very bright but the landscape is very dark, you can select the landscape and then increase the brightness of just that area. To find out more about selecting, read Chapter 12.

- ✔ **Bypass automated filters.** As you explore your photo software, you will no doubt find some "instant fix" filters. Elements, for example, offers automatic filters that promise to correct problems with contrast, exposure, and color with one click. Feel free to try these tools — who am I to discourage you from seeking instant gratification? But understand that automatic correction filters often produce less-than-satisfactory results, either under- or overcompensating for problems. For this reason, most programs also include "manual" tools that enable you to control the type and amount of correction applied to your image.

 Correcting your photo manually may take a few more seconds than using automatic filters, but you'll be rewarded for your efforts. Figure 11-4, for example, shows you the result of an "automatic fix" versus what I accomplished with manual tools. In this book, I concentrate on manual correction tools for most projects.

Save now! Save often!

Chapter 4 discusses options for preserving your original photo files. You also need to take precautions to preserve any changes you make to your pictures in your photo editor.

Original Auto Fix Custom correction

Figure 11-4: As is the case for many images, a one-click-fix automated filter (middle) didn't do the job as well as "manual" correction tools (right).

Until you save the edited picture, all your work is vulnerable. If your system crashes, the power goes out, or some other cruel twist of fate occurs, everything you did since the last time you saved the picture is lost forever. So commit the following image-safety rules to memory:

- **Saving for the first time:** To save an edited picture for the first time, choose File⇨Save As. You're presented with a dialog box in which you can enter a name for the file and choose a storage location on disk, just as you do when saving any other type of document.

 Figure 11-5 shows the Windows and Macintosh versions of this dialog box as it appears in Elements. Along with the standard file-saving options, you get a few controls related to Elements features. Because of space limitations, I must refer you to the Elements Help system for the lowdown on these options. Chapter 13 tells you more about the Layers box, however.

 If you don't want to overwrite your original photo file, be sure to give the picture a new name, choose a different file format, or store it in a separate folder from the original.

- **Saving works in progress:** As you work on a photo, resave the file periodically. You can usually simply press Ctrl+S (⌘+S on a Mac) to resave the image without messing with a dialog box. Or click the Save button on the toolbar, which looks like a floppy disk (also shown in the margin). Do *not* use this tactic to save an altered file for the first time, or you overwrite the original image file.

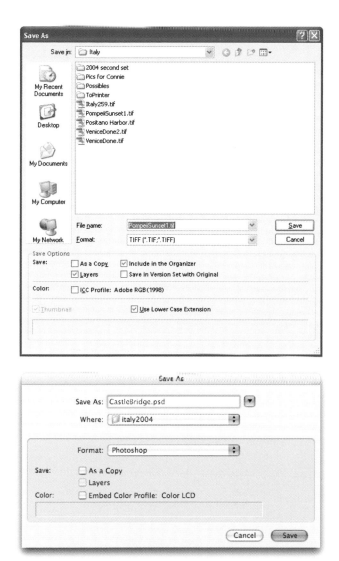

Figure 11-5: Give your edited file a new name, format, or location to avoid overriding the original image file.

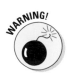

In most programs, you can specify a file format when you choose the Save As command. Always save photos-in-progress in your photo editor's *native format* — that is, the program's own file format — if one is available. In Elements and Photoshop, the native format is PSD.

Why stick with the native format? Because it's designed to enable the program to process your edits more quickly. In addition, generic file formats, such as JPEG, GIF, and TIFF, may not be able to save some of the photo features, such as image layers. (Chapter 13 explains layers.)

Save your image in another format only when you're completely done editing. And before you save a file in the JPEG format, which destroys some picture data, be sure to save a backup copy of the original in a nondestructive format, such as TIFF or, again, your photo-editor's native format. Chapter 10 provides specific instructions for saving JPEG files; Chapter 9 explains file-saving options for TIFF, which you may need to use if preparing a picture for use in a print publishing program.

Editing safety nets

As you make your way through the merry land of photo editing, you're bound to take a wrong turn every now and then. Perhaps you clicked when you should have dragged. Cut when you meant to copy. Or painted a mustache on your boss's face when all you intended to do was cover up a blemish.

Fortunately, most mistakes can be easily undone by using the safety nets explored in the next several sections.

Undo

The Undo command, usually on the Edit menu, takes you one step back in time. In many programs, you can choose Undo quickly by pressing Ctrl+Z in Windows or ⌘+Z on a Mac. The program may also offer an Undo button; the Elements version appears in the margin.

Undo can't bail you out of all messy situations, though. If you forget to save a picture before you close it, you can't use Undo to restore the work you did before closing. Nor can Undo reverse the Save command.

Most photo programs enable you to undo a whole series of edits rather than just one. Say that you crop your image, resize it, adjust the colors, and tweak exposure. Later, you decide that you prefer the original size. You can go back to the point at which you changed the size, and reverse your decision. Any edits applied after the one you undo are also eliminated, however. If you undo that resizing step, for example, your color and exposure adjustments are also wiped out.

To undo a series of edits in Elements, keep clicking the Undo button on the toolbar, choosing Edit⇨Undo, or pressing Ctrl+Z (⌘+Z on the Mac).

If your image editor does not offer multiple Undo, choose Undo *immediately* after you perform the edit you want to reverse. If you use another tool or choose another command, you lose your opportunity to undo.

Redo

Change your mind about that Undo? Look for a Redo command, usually found right next to the Undo command (try the Edit menu). Redo puts things back to the way they were before you chose Undo.

As with Undo, some programs enable you to redo a whole series of Undo actions, while others can reverse only the most recent application of the Undo command. Check your software manual or Help system to find out how much Undo/Redo flexibility you have.

 If your program offers an Undo button, it no doubt provides a Redo button as well. In Elements, you also can redo a batch of undo's by choosing Edit⇨Redo or pressing Ctrl+Y (⌘+Y) repeatedly.

Undo History palette

Some photo editors offer a palette or window that lists your most recent changes. You can use this tool to more easily undo a batch of edits.

In Elements, this feature is called the Undo History palette, shown in Figure 11-6. Display the palette by choosing Window⇨Undo History. In the palette, click the change directly above the one that you want to undo. All changes after the one you click are undone and appear dimmed in the palette. For example, in Figure 11-6, I undid two edits. To reverse your decision, click the dimmed edit that you want to restore. All edits before that change are also restored.

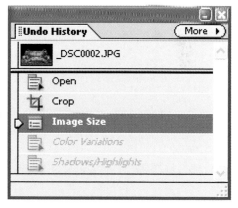

Figure 11-6: In Elements, the History palette tracks your recent changes.

 By default, the History palette tracks your last 50 actions. If you want to change that number, visit the General panel of the Preferences dialog box and enter a new value in the History States box. (In Windows, choose Edit⇨Preferences⇨General; on a Mac, choose Photoshop Elements⇨Preferences⇨General.) The higher the value, though, the more the program taxes your computer system's resources. In fact, if Elements is running too slowly for your liking, try reducing the History States value to 20 or lower.

Revert to Saved

Elements offers the Edit➪Revert to Saved command, which restores your image to the way it appeared the last time you saved it. This command is helpful when you totally make a mess of your image and you just want to get back to square one.

If your software doesn't offer this command, you can accomplish the same thing by closing your image without saving it and then reopening the image.

Straightening a Tilting Horizon

Figure 11-7 shows a common problem: a horizon line that appears to be tipping to one side. In Elements, the fix comes via the Image➪Transform command. Most photo editors offer a similar command, although it may go by some other name, such as Custom Rotation. The idea is the same no matter what the name.

If you also want to crop your photo, fix the horizon line first. You lose a portion of your picture when you straighten it, so you want to start with as much original image area as possible.

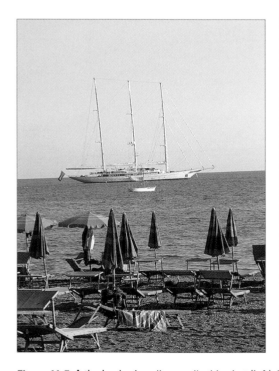
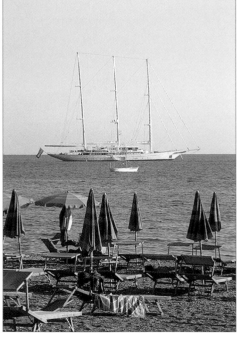

Figure 11-7: A tipping horizon line spoils this shot (left), but is easily fixed (right).

Follow these steps to straighten your photo:

1. **Choose Select⇨All to select the entire image.**

2. **Select the Move tool (labeled in Figure 11-8 and shown in the margin).**

 Actually, you can use any tool except the Cookie Cutter or the Custom Shape tool for this step.

3. **Choose Image⇨Transform⇨Free Transform.**

 A box with square handles appears around the image, as shown in Figure 11-8.

4. **Move your cursor outside a corner handle to display a curved, two-headed arrow cursor.**

 Labeled in Figure 11-8, this is the Elements rotate cursor.

5. **Drag up or down to rotate the image.**

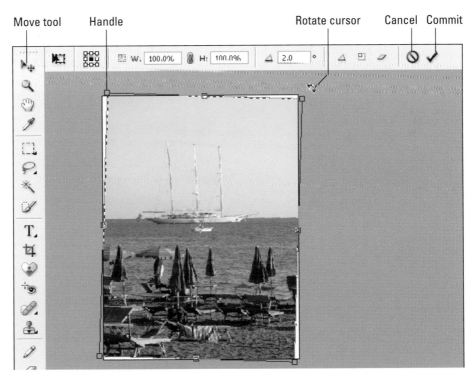

Figure 11-8: Drag outside a corner handle to rotate the photo until the horizon is level.

6. **Press Enter or click the Commit check mark to apply the rotation.**

 Should you want to cancel out of the change, click the Cancel button or just press Esc. Figure 11-8 labels the Commit and Cancel buttons.

 As you can see from Figure 11-8, the rotation clips away part of your photo. The empty area takes on the background paint color, which is white in the example. (See Chapter 13 for details about paint colors.)

7. **Crop away the empty areas of the image.**

 The next section explains this step.

Cream of the Crop

Chapter 7 offers tips on photo composition. But if you're not happy with the composition you created when you took a picture, you may be able to improve it by cropping.

Figure 11-9 offers an example. In this photo, my lovely nieces get lost in all that pool water. The older one encouraged me to walk into the pool for a tighter shot, but somehow that didn't seem like a good idea, given that I was using an $800 camera that wasn't mine! Instead, I stayed put and later cropped the picture to produce the more pleasing image in Figure 11-10.

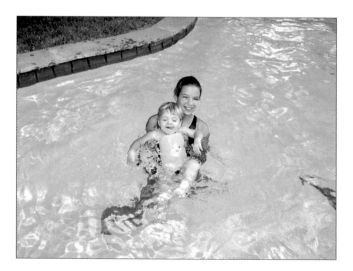

Figure 11-9: Suffering from an excess of boring background, this image begs for some cropping.

The following steps explain how to give your image a haircut using the Elements Crop tool. Every photo program offers a comparable tool, most of which work similarly to the Elements version.

Figure 11-10: A tight cropping job restores emphasis to the subjects.

1. **Pick up the Crop tool.**

 Click the Crop tool icon in the toolbox, labeled in Figure 11-11, and shown in the margin. Make sure that the Width, Height, and Resolution boxes on the options bar are empty, as shown in the figure. If not, click the Clear button.

2. **Drag to create a crop boundary around the area you want to keep.**

 Drag from one corner of the area you want to keep to the other corner, as shown in Figure 11-11.

Crop tool

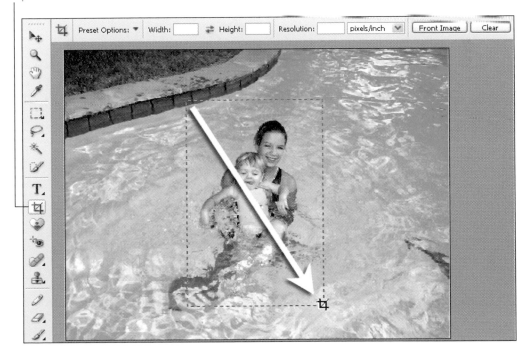

Figure 11-11: Drag to create the initial crop boundary.

After you complete your drag, you see a square handle at each corner of the crop boundary, as in Figure 11-12, and the area outside the crop boundary becomes shaded.

Handle Commit

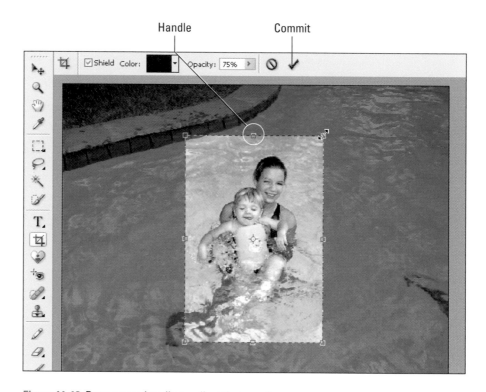

Figure 11-12: Drag a crop handle to adjust the boundary.

3. **Drag the crop handles to adjust the crop boundary as needed.**

 To move the entire boundary, drag anywhere inside the outline.

4. **Click the Commit check mark (labeled in Figure 11-12) or press Enter.**

If you want to crop a picture to fit a particular frame size in Elements, bypass the Crop tool and instead use this technique:

1. **Choose the Rectangular Marquee tool, labeled in Figure 11-13.**

 If the Elliptical Marquee appears in the toolbox instead of the Rectangular Marquee, press and hold on the triangle on the tool icon to display a flyout menu. Then click the Rectangular Marquee icon on the flyout.

2. **Choose Fixed Aspect Ratio from the Mode drop-down list on the options bar.**

3. **Enter the desired proportions in the Width and Height boxes on the options bar.**

 For example, to create a picture for a 4 x 6-inch frame, enter 4 and 6 into the boxes, as shown in Figure 11-13. Set the other options bar controls as shown in the figure.

4. **Drag to enclose the portion of the photo you want to keep in a dotted outline, as shown in Figure 11-13.**

 That outline is the *selection outline,* which I explain more in the next chapter. Elements restricts the outline so that it matches the proportions you entered in the Width and Height boxes. You can reposition the outline by dragging inside it.

5. **Choose Image⇨Crop.**

 Everything outside the selection outline is cropped away.

 Whether you use this method or work with the Crop tool, keep image resolution in mind. You want enough pixels remaining to produce a good print. How much of the original image you need to keep depends on the initial pixel count. For help with this issue, see Chapter 2.

Rectangular Marquee · Selection outline

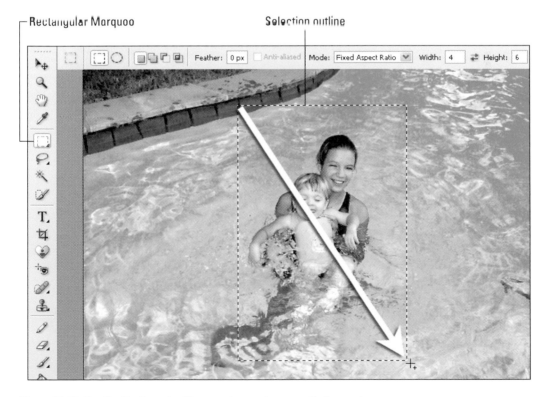

Figure 11-13: Use the Rectangular Marquee to crop to a specific frame size.

Fixing Exposure and Contrast

At first glance, the underexposed picture on the left side of Figure 11-14 appears to be a throwaway. But don't give up on images like this, because you may be able to rescue that too-dark image, as I did here. The next three sections explain how to use a variety of exposure-repair tools.

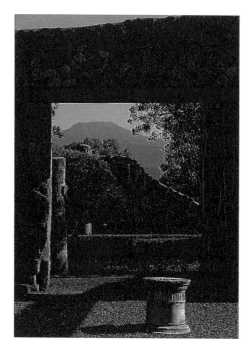 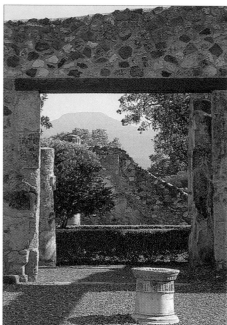

Figure 11-14: An underexposed image (left) sees new light (right).

Basic brightness/contrast controls

Many photo-editing programs offer one-shot brightness/contrast filters that adjust your image automatically. As mentioned earlier, these automatic correction tools tend to do too much or too little and, depending on the image, can even alter image colors dramatically.

Fortunately, most programs also provide exposure controls that enable you to specify the extent of the correction. These controls are easy to use and almost always produce better results than the automatic variety.

The most basic exposure and contrast tools work like the Elements Brightness/Contrast filter, found on the Enhance⊏>Adjust Lighting menu and shown in Figure 11-15. You just drag the sliders to adjust brightness or contrast.

Although the Brightness/Contrast filter is easy to use, it's not always a terrific solution because it adjusts all pixels by the same amount. That's fine for some pictures, but often, you don't need to make wholesale exposure changes. For example, in the too-dark image shown in Figure 11-14, the shadows are where they need to be, exposure-wise. Only the highlights and *midtones* — areas of medium brightness — need lightening.

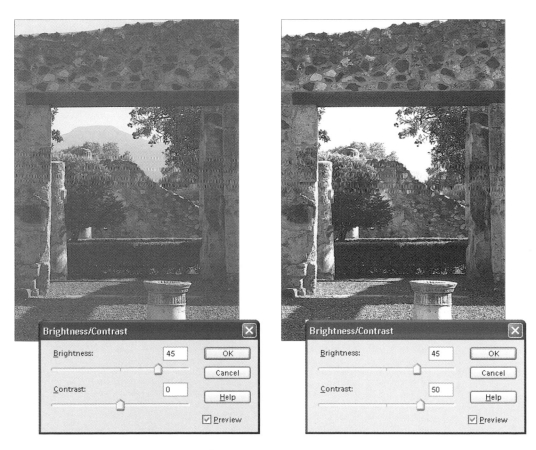

Figure 11-15: Raising the Brightness and Contrast values brought midtones into an acceptable range, but also blew out all color in the sky.

What's an adjustment layer?

Some photo-editing programs, including Photoshop Elements, offer *adjustment layers.* Adjustment layers enable you to apply exposure and color-correction filters to a photo in a way that doesn't permanently alter the picture. You can go back at any time and easily change the filter settings or even remove the filter. In addition, you can use layer blending features to soften the impact of a filter. You also can easily expand the image area affected by the filter or remove the filter entirely from just a portion of the picture.

I don't have room in this book to cover adjustment layers, but I urge you to get acquainted with them if your photo software provides this feature. Using adjustment layers may seem a little complicated at first, but after you get the hang of using them, you'll appreciate the added flexibility and convenience they offer. For an explanation of layers in general, see Chapter 13.

In the left image in Figure 11-15, I raised the Brightness value enough to get the midtones to the right level. Pixels that were formerly very light become white, and pixels that used to be black jump up the brightness scale to dark gray. The result is a decrease in contrast and a loss of detail in the highlights and shadows. Raising the Contrast value only made the situation worse, as shown in the right image in the figure. The contrast shift amped up the highlights way too much, blew out detail in the sky, and caused the distant mountaintop to virtually disappear.

When pictures need selective exposure adjustments, you have a couple of options:

- If your photo editor offers a Brightness/Contrast filter only, use the techniques outlined in Chapter 12 to select the area that you want to alter before applying the filter. That way, your changes affect the selected pixels only.

- If you use Elements, Photoshop, or some other advanced photo editor, check out the next two sections, which introduce you to two more sophisticated tools, the Levels filter and the Shadows/Highlights filter.

- You may have access to several additional tools to wield against under- or overexposed images. For example, Elements offers *Dodge* and *Burn* tools, which enable you to "paint" lightness or darkness onto your image by dragging over it with your mouse. Check your software manual for information about using these exposure tools.

Brightness adjustments at higher Levels

Advanced photo-editing programs provide a Levels filter, which enables you to darken shadows, brighten highlights, and adjust midtones (areas of medium brightness) independently. Depending on your software, the Levels filter may go by another name; check the manual or online help system to find out whether you have a Levels-like function. In Elements, choose Enhance⇨ Adjust Lighting⇨Levels to access the filter.

When you apply this filter, you typically see a dialog box that's full of strange-sounding options, graphs, and such. Figure 11-16 shows the Levels dialog box from Elements, along with the original too-dark image from the preceding section. Don't be intimidated — after you know what's what, the controls are easy to use.

The chart-like thing in the middle of the dialog box is a *histogram*. A histogram maps out all brightness values in the image, with the darkest pixels plotted on the left side of the graph and the brightest pixels on the right. The histogram in Figure 11-16 reveals a heavy concentration of pixels at the dark end of the exposure range and a limited pixel population in the middle and high end.

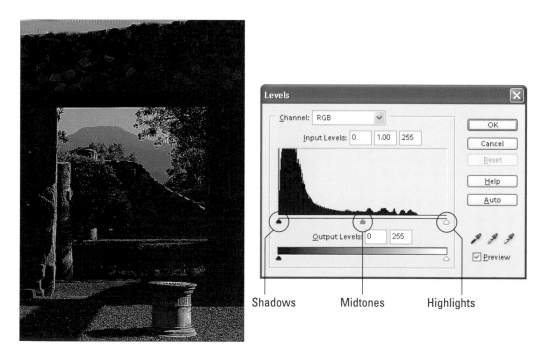

Shadows Midtones Highlights

Figure 11-16: Drag the sliders under the histogram to adjust shadows, midtones, and highlights independently.

Being able to read a histogram is a fun parlor game, but the real goal is to adjust those brightness values to create a better-looking picture. Here's what you need to know:

- ✔ **Levels dialog boxes offer separate controls for adjusting shadows, highlights, and midtones.** Often, these three controls are labeled Input Levels.

 In Elements, you can adjust the Input Levels values by entering numbers in the boxes above the histogram or dragging the sliders beneath the histogram.

 - **Shadows:** Adjust shadows by changing the value in the leftmost Input Levels option box or dragging the corresponding slider, labeled in Figure 11-16. Drag the slider to the right or raise the value to darken shadows. Some programs refer to this control as the *Low Point control.*

 - **Midtones:** Tweak midtones using the middle box or slider, labeled *Midtones* in Figure 11-16. Drag the slider left or raise the value to brighten midtones; drag right or lower the value to darken them. This control sometimes goes by the name *Gamma* or *Midpoint control.*

 - **Highlights:** Manipulate the lightest pixels in the photo by changing the value in the rightmost box or dragging its slider, labeled *Highlights* in the figure. To make the lightest pixels lighter, drag the slider to the left or lower the value. In some programs, this control goes by the name *High Point control.*

 To produce the corrected image shown in Figure 11-17, I dragged the midtones and highlights sliders to the positions shown in the dialog box.

 Note that when you adjust the shadow or highlights slider in Elements, the midtones slider moves in tandem. If you don't like the change to the midtones, just drag the midtones slider back to its original position.

- ✔ **Adjusting Output Levels values reduces contrast.** Levels dialog boxes also may contain Output Levels options, which enable you to set the maximum and minimum brightness values in your image. In other words, you can make your darkest pixels lighter and your brightest pixels darker — which usually has the unwanted effect of decreasing the contrast. Sometimes, you can bring an image that's extremely overexposed into the printable range by setting a slightly lower maximum brightness value. However, in Elements and Photoshop, a better approach is to use the Shadows/Highlights filter, explained next.

- ✔ **Adjust all color channels together.** For color pictures, you may be able to adjust the brightness values for the red, green, and blue color channels independently. (For an explanation of channels, see Chapter 2.)

In Elements, you select the channel that you want to adjust from the Channel drop-down list, which appears at the top of the Levels dialog box when you're editing a color photo. However, adjusting brightness levels of individual channels affects the color balance of your photo more than anything else, so I suggest that you leave the Channel option set to RGB, as it is by default.

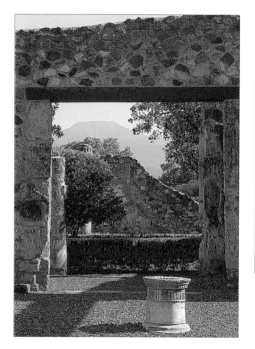

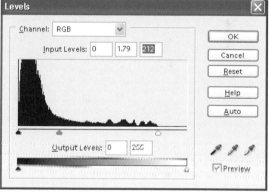

Figure 11-17: I dragged the midtones and highlights sliders to these positions to create the final image.

Using the Shadows/Highlights filter

With the Levels filter, you can darken shadows and brighten highlights. To make the opposite shift — to lighten shadows and darken highlights — poke about your photo editor to see whether it offers something akin to the Elements Shadows/Highlights filter, shown in Figure 11-18. This filter provides a more capable option than the Levels filter's Output controls or the Brightness/Contrast filter for coaxing details out of murky shadows or toning down too-bright highlights. To access the filter in Elements, choose Enhance⇨Adjust Lighting⇨Shadows/Highlights.

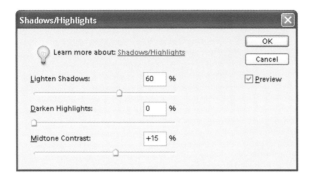

Figure 11-18: The Shadows/Highlights filter enables you to lighten shadows and darken highlights.

The street scene shown on the left in Figure 11-19 is an ideal candidate for this filter. I used the settings shown in Figure 11-18 to bring back details formerly lost in the shadows.

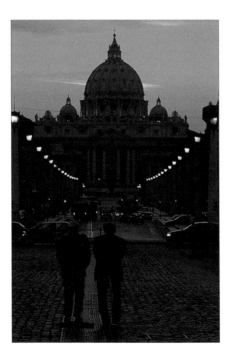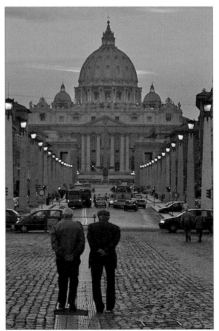

Figure 11-19: To produce the right image, I lightened the shadows and boosted midtone contrast slightly.

Depending on the image, you may need to apply both the Shadows/Highlights filter and the Levels filter. For example, although the "after" image in Figure 11-19 is vastly improved from the original, I wanted to brighten the highlights and midtones just a smidge. So I followed the Shadows/Highlight filter with the Levels filter, as shown in Figure 11-20.

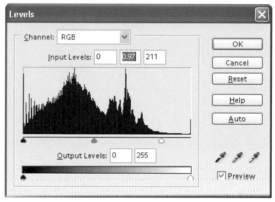

Figure 11-20: After applying the Shadows/Highlights filter, I used the Levels filter to brighten highlights and midtones a bit.

Give Your Colors More Oomph

Images looking dull and lifeless? Toss them in the photo-editing machine with a cup of Saturation, the easy way to turn tired, faded colors into rich, vivid hues.

Take the image in Figure 11-21, for example. The colors just aren't as brilliant as they were when I shot the image. All that's needed to give the photo the more colorful outlook shown on the right is the Saturation command, found in nearly every photo-editing program.

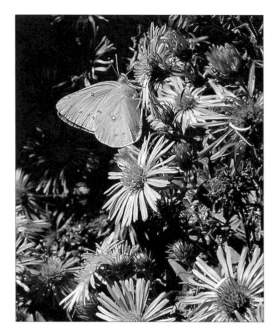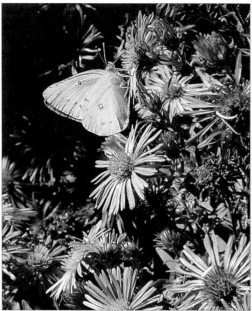

Figure 11-21: Amping up color saturation brought more life to this photo.

To access the saturation knob in Elements, choose Enhance⇨Adjust Color⇨Adjust Hue/Saturation, which opens the dialog box shown in Figure 11-22. Be sure that the Colorize box is not selected and that the Preview box *is* selected, as shown in the figure. Then drag the Saturation slider to the right to increase color intensity; drag left to suck color out of your image.

If you select Master from the Edit drop-down list at the top of the dialog box, all colors in your picture receive the color boost or reduction. You also can adjust

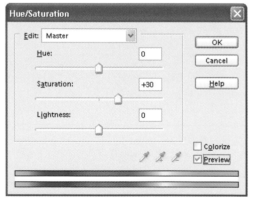

Figure 11-22: Drag the Saturation slider to the right to boost color intensity.

individual color ranges by selecting them from the list. You can tweak the reds, magentas, yellows, blues, cyans, or greens.

 For spot saturation adjustments, check to see whether your software also offers a Sponge tool. (Elements does; the tool lives near the bottom of the toolbox.) With this tool, you can drag over the areas you want to alter to add or decrease saturation. When using the Elements Sponge tool, set the Mode control on the options bar to Saturate or Desaturate, depending on what you want to do. Use the Flow control to adjust how much change the tool applies with each drag.

Help for Unbalanced Colors

Like film photos, digital photos sometimes have *color balance* problems. In other words, the pictures look too blue, too red, or too green, or exhibit some other color sickness.

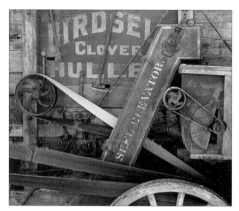

The top picture in Figure 11-23 is a case in point. I shot the photo with a camera that tends to emphasize blue tones. That's okay for pictures that feature sky or water — who doesn't enjoy a bluer sky or sea? But in this photo, which shows a portion of an antique clover huller, the tendency to favor blue creates an unwanted color cast. Notice how the belts and the top of the wooden wheel (lower-right corner) look almost navy blue? Trust me, navy blue belts and wheels are not authentic aspects of antique farm machinery.

To remove the blue cast, I used the Variations filter in Photoshop Elements. This color balancing tool is found in many photo editors, although it may go by some other moniker, such as Color Balance. The lower image in Figure 11-23 shows the corrected picture after I added red and yellow and subtracted blue and cyan. Now the belts and wheel look gray, as they should. The color-balancing act also brought out the faded red and yellow paint of the clover huller.

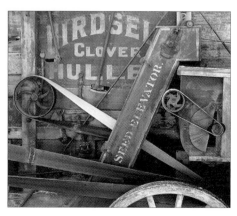

Figure 11-23: I used the Variations filter to remove the unnatural blue color cast.

To access the Variations filter, choose Enhance⇨Adjust Color⇨Color Variations. The dialog box shown in Figure 11-24 appears.

Range buttons Color thumbnails

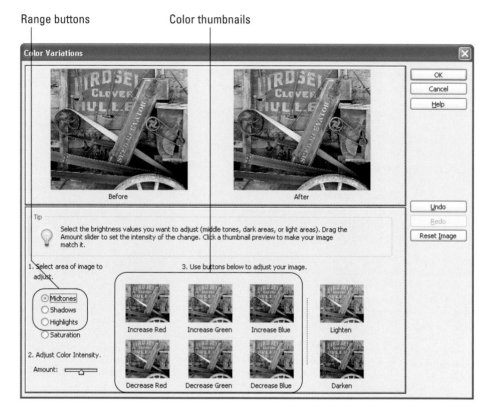

Figure 11-24: Click a color-shift thumbnail to add more of that color and subtract its opposite.

The filter controls work as follows:

- ✔ You can adjust highlights, shadows, and midtones independently. Click one of the Range buttons, labeled in Figure 11-24, to specify which component you want to alter.

- ✔ After selecting the range, use the color-shift thumbnails, also labeled in the figure, to adjust the colors.

 To add cyan, click the Decrease Red thumbnail; to add magenta, click the Decrease Green thumbnail. And to add yellow, click the Decrease Blue thumbnail.

- ✓ Use the Amount slider, located underneath the Range buttons, to control how much your picture changes with each click of a thumbnail.

- ✓ Although the Variations filter also offers controls for adjusting saturation and exposure, you get more control over those aspects of your picture if you instead use the techniques outlined earlier in this chapter.

Focus Adjustments (Sharpen and Blur)

Although no photo-editing software can make a terribly unfocused image appear completely sharp, you can usually improve things a bit by using a *sharpening filter.* Figure 11-25 shows an example of how a little sharpening can give extra definition to a slightly soft image.

The following sections explain how to sharpen your image and also how to blur the background of an image, which has the effect of making the foreground subject appear more focused.

 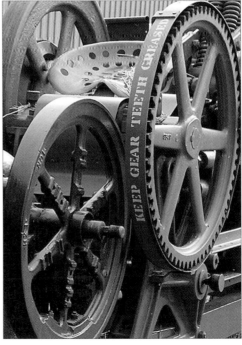

Figure 11-25: Sharpening increases contrast to create the illusion of sharper focus.

Before I show you how to sharpen your photos, though, I want you to understand what sharpening really does. Sharpening creates the *illusion* of sharper focus by adding small halos along the borders between light and dark areas of the image. The dark side of the border gets a dark halo, and the light side of the border gets a light halo.

To see what I mean, take a look at Figure 11-26, which offers close-up views of the original and sharpened photo from Figure 11-25. See the area where the light gray area meets the red area? The gray side of the border gets lighter, the red side gets darker. The border between the light gray and dark gray areas is similarly altered.

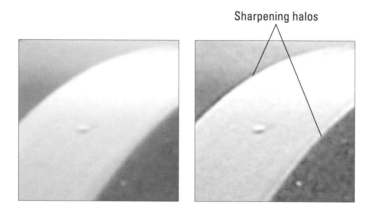

Sharpening halos

Figure 11-26: The light side of a color boundary gets lighter; the dark side gets darker.

Applying sharpening filters

Sharpening tools, like other image-correction tools I discuss in this chapter, come in both automatic and manual flavors. With automatic sharpening filters, the program applies a preset amount of sharpening to the image. You need to experiment with your automated filters, if provided, to see how much you get from each, as the effect varies from program to program.

Whatever software you use, however, you're likely to get better results by passing over the automated sharpening filters in favor of ones that give you the ability to control how the effect is applied.

Some programs provide you with a fairly crude manual sharpening tool. You drag a slider one way to increase sharpening and drag in the other direction to decrease sharpening. Elements, Photoshop, and other more advanced photo-editing programs provide you with a much more capable filter, which goes by the curious name of Unsharp Mask.

The Unsharp Mask filter is named after a focusing technique used in traditional film photography. In the darkroom, unsharp masking has something to do with merging a blurred film negative — hence, the *unsharp* portion of the name — with the original film positive in order to highlight the edges (areas of contrast) in an image. And if you can figure that one out, you're a sharper marble than I.

Despite its odd name, Unsharp Mask gives you the best of all sharpening worlds. You can sharpen either your entire image or just the *edges* — areas of high contrast, in imaging lingo. You also can control the size of the sharpening halos. And of course, you get precise control over how much sharpening is done.

To use the Unsharp Mask filter in Elements, choose Filter➪Sharpen➪Unsharp Mask. The dialog box shown in Figure 11-27 appears.

The Unsharp Mask dialog box contains three sharpening controls: Amount, Radius, and Threshold. You find these same options in most Unsharp Mask dialog boxes, although the option names may vary from program to program. Here's how to adjust the controls to apply just the right amount of sharpening:

- **Amount:** This value determines the intensity of the effect. Higher values mean more intense sharpening.

- **Radius:** The Radius value controls how many pixels neighboring an edge are affected by the sharpening — in other words, the size of the sharpening halos. Generally, stick with Radius values in the 0.5 to 2 range. Use values in the low end of that range for images that will be displayed on-screen. Values at the high end work better for printed images.

- **Threshold:** This option tells the program how much contrast must exist between two pixels before the boundary between them receives the sharpening effect. By default, the value is 0, which means that the slightest difference between pixels results in a kiss from the sharpening fairy. As you raise the value, fewer pixels are affected; high-contrast areas (edges) are sharpened, while the rest of the image is not.

Figure 11-27: For professional sharpening results, make friends with the Unsharp Mask filter.

When sharpening photos of people, experiment with Threshold settings in the 3 to 5 range, which can help keep the subject's skin looking smooth and natural. If your image suffers from graininess or noise, raising the Threshold value can enable you to sharpen your image without making the noise even more apparent.

The right combination of settings depends on your original photo. But be careful not to go overboard. Too much sharpening gives the picture a rough, grainy look. In addition, you can wind up with obvious, glowing color halos along areas of high contrast.

Blur to sharpen?

If your main subject is slightly out of focus and applying a sharpening filter doesn't totally correct the problem, try this: Select everything but the main subject, using the techniques explained in Chapter 12. Then apply a blur filter, found in most photo-editing programs, to the rest of the picture. Often, blurring the background in this way makes the foreground image appear sharper, as illustrated in Figure 11-28. In this photo, the blur effect also makes the busy background less distracting.

To apply this effect in Elements, choose Filter⇨Blur⇨Gaussian Blur. You see the dialog box shown in Figure 11-29. Just drag the Radius slider to the right to produce a more pronounced blur; drag left to reduce the blurring effect.

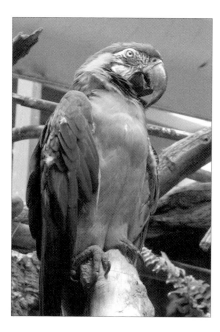
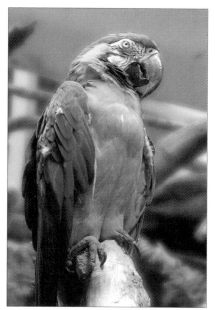

Figure 11-28: Applying a slight blur to the background makes the bird appear more in focus and also helps de-emphasize the busy background.

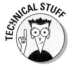

In case you're wondering, the Gaussian Blur filter is named after a mathematician with the surname Gauss, whose name also is used to describe a type of curve on which the filter is based.

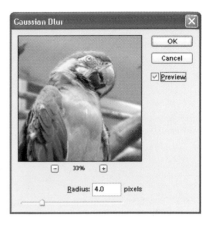

Figure 11-29: To control the amount of blurring, use the Gaussian Blur filter.

Out, Out, Darned Spots!

Sit around a coffee shop with a group of digital photographers, and you may hear the term *jaggies* tossed around. *Jaggies* comes from *jagged,* which is how digital images appear if they've been overly compressed or enlarged too much. Instead of appearing smooth and seamless, pictures have a blocky — jagged — look, especially along curved or diagonal lines. Chapter 2 offers examples of this defect.

A related problem, referred to as *noise, aliasing, artifacts,* or *color fringing,* depending on the accent of the speaker, shows up as random speckles or color halos. Whatever you call it, this defect also can be caused by too much compression. Other noise-inducers include inadequate light and a too-high ISO setting (see Chapter 6). The left image in Figure 11-30 shows an example of noise.

If your image exhibits either of these properties, blurring the picture slightly can soften the defect. For noisy photos, peruse your program's menus for a specialized filter such as the Elements Remove Noise filter, shown in Figure 11-31. This filter blurs your image to soften noise, but in a more sophisticated manner than regular blur filters.

In Elements, choose Filter➪Noise➪Reduce Noise to try it out. The controls work as follows:

- **Strength:** Drag this slider to blur *luminance noise,* which is a fancy way of referring to unnatural brightness variations.

- **Preserve Details:** This control determines what threshold Elements uses to decide what level of brightness variation constitutes noise. As you lower the value, more of your image receives the luminance blurring.

- **Reduce Color Noise:** Drag this slider to the right to increase blurring of unwanted, random color variations or speckles, known as *color noise.*

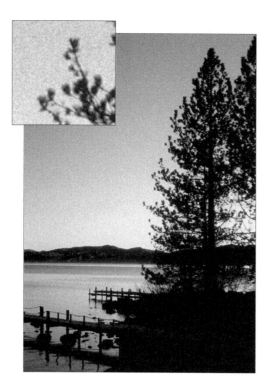 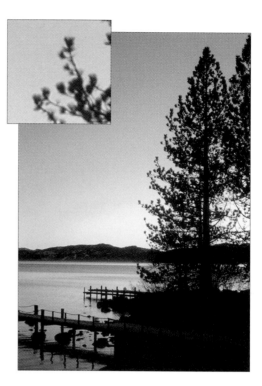

Figure 11-30: You can often soften excessive noise (left) by applying a noise-removal filter or other blurring filter (right).

As with all filters, the correct settings depend on your photo. To soften the noise in Figure 11-30, I applied the filter using the settings shown in Figure 11-31.

Also try these alternative approaches to reduce noise or jaggies:

- **Apply a regular blur filter.** If possible, apply the filter just to the area where the defects are the worst so that you don't lose image detail in the rest of the image. (Chapter 12 introduces selection outlines, which enable you to do this kind of selective editing.) Or, if your program offers a Blur tool, you can "rub away" noise by just dragging your mouse over the areas you want to blur. (Elements offers this tool.)

- **Apply a Despeckle filter.** Many photo editors provide a Despeckle filter, which essentially applies a slight blur to the image. Try applying both a regular blur filter and Despeckle and see which one does a better job on the image. One filter may blur more than the other.

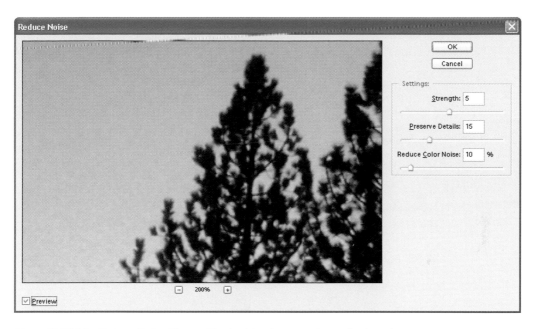

Figure 11-31: The Reduce Noise filter tackles both luminance noise and color noise.

Whichever route you go, you may need to apply a sharpening filter to restore lost focus after you blur away noise or other defects. The problem is, sharpening can make those defects visible again. If your image editor offers an Unsharp Mask filter, you can avoid this vicious cycle by raising the Threshold value above the default setting, 0.

Cut, Paste, and Cover Up

In This Chapter

▶ Making changes to specific parts of a picture

▶ Using different types of selection tools

▶ Refining your selections

▶ Moving, copying, and pasting picture elements

▶ Creating a patch to cover up flaws

▶ Cloning over unwanted elements

*R*emember the O.J. Simpson trial (how could you *not*)? At one point in the trial, the defense claimed that a photograph had been digitally altered to make it appear as though the defendant wore a specific type of shoe. That kind of claim, together with the development of photo-editing software that makes digital deception easy to accomplish, has led many people to question whether a photo can still be trusted to provide a truthful record of an event.

I can't remember the outcome of the shoe debate, but I can tell you that a photograph can just as easily speak a thousand lies as a thousand words. Of course, photographers have always been able to alter the public's perception of a subject simply by changing the camera angle, backdrop, or other compositional elements of a picture. But with photo-editing software, opportunities for putting your own spin on a photograph are greatly expanded.

This chapter introduces some basic methods that you can use to manipulate your pictures. I want to emphasize that you should use these techniques for creative expression, not for the purpose of deceit. Combining elements from four or five pictures to make a collage of your vacation memories is one thing; altering a photo of a house to cover up a big crater in the driveway before you place a for-sale ad in the real-estate section is quite another.

That said, this chapter shows you how to merge several pictures into one, move a subject from one photo to another, and cover up image flaws. Along the way, you get an introduction to *selections,* which enable you to perform all the aforementioned editing tricks, and more.

Why (And When) Do I Select Stuff?

If your computer were smarter, you could simply give it verbal instructions for how you wanted your photo changed. You could say, "Take my head and put it on Madonna's body," and the computer would do your bidding.

Computers can do that sort of thing on *Star Trek* and in spy movies. But in real life, computers aren't that clever. If you want your computer to alter a portion of a photo, you have to draw the machine a picture — well, not a picture, exactly, but a *selection outline.* This process is called *selecting.*

Selecting tells your software which pixels to change and which pixels to leave alone. For example, in Figure 12-1, I wanted to brighten the monument but leave the sky alone. So I selected the monument before applying the exposure change via the Levels filter (introduced in Chapter 11).

Selections have another use, too: They protect you from yourself. Say that you have a picture of a red flower on a green background. You decide that you want to paint a purple stripe over the flower petals . . . oh, I don't *know* why, Johnny, maybe it's just been that kind of day. Anyway, if you have a steady hand, you may be able to paint only on the petals and avoid brushing any purple on the background. But people whose hands are that steady are usually busy wielding scalpels, not photo-editing tools. Most people tackling the paint job get at least a few stray dabs of purple on the background.

If you select the petals before you paint, however, you can be as messy as you like. No matter where you move your paintbrush, the paint can't go anywhere but on those selected petals. The idea is the same as putting tape over your baseboards before you paint your walls. Areas underneath the tape are protected, just like pixels outside the selection outline.

On-screen, selection outlines are usually indicated by a blinking, dashed outline, as shown in Figure 12-1. Some people refer to the outline as a *marquee,* seeing a resemblance between the outline and the lights of a theatre marquee. Other — more imaginative — people see instead a parade of ants, and so refer to the outline as *marching ants.* Still other folks call selection outlines *masks;* the deselected area is said to be *masked.* In this book, I stick with plain ol' *selection outline.*

Selection outline

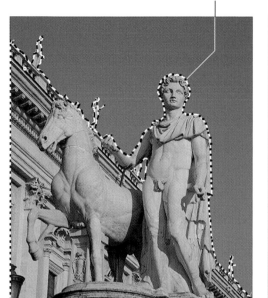

Figure 12-1: Selecting the monument before applying the Levels filter limited the adjustment to that part of the picture.

What selection tools should I use?

Most photo-editing programs provide you with an assortment of selection tools. Photoshop Elements provides the following tools, which are also found in other advanced programs (although the tool names may be different):

- **Rectangular Marquee** and **Elliptical Marquee** for creating rectangular, square, oval, and circular selection outlines
- **Lasso, Polygonal Lasso, Magnetic Lasso,** and **Selection Brush** for drawing freeform selection outlines
- **Magic Wand** for selecting pixels based on color

Which tool you should use depends on what you're trying to select. The next few sections explain how to use the various types of tools so that you can get a better idea of what each tool can help you do.

Although I provide specific instructions related to Elements, selection tools in other programs work similarly. So don't skip these pages if you don't use Elements, because much of the information applies to your program, too. (However, if you're working with a very basic entry-level program, you may get only one or two of the tools discussed here.) If you *do* use Elements, keep in mind that I don't cover all your selection possibilities due to space limitations. In other words, use this chapter as a jumping-off point for exploring your program's selection options.

Working with Elements tools

Before getting into selecting specifics, I need to share a few words about working with the Elements tools:

✏ You activate a tool by clicking its icon in the toolbox. Figure 12-2 shows the selection tools, which live near the top of the toolbox.

✏ A little triangle at the bottom of any tool icon means that two or more tools share the same slot in the toolbox. Click the triangle, labeled in Figure 12-2, to display a *flyout menu* — a little menu that flies out from the toolbox — and access the hidden tools. Then click the icon for the tool you want to use. The menu disappears, and the current tool appears in the toolbox.

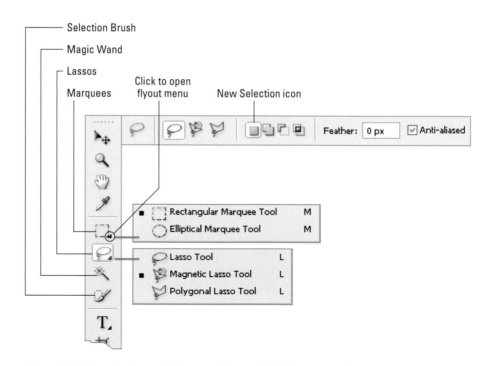

Figure 12-2: The selection tools live near the top of the Elements toolbox.

- The options bar shows controls related to the current tool. For tools that cohabitate in a flyout menu, the options bar also contains icons for the hidden tools, as shown in Figure 12-2. You can switch from one tool to another by clicking those icons instead of opening the flyout menu.

- When working with the Marquee tools, any of the Lasso tools, or the Magic Wand, be sure that the New Selection icon, labeled in Figure 12-2, is active. (This is the default setting.) The other icons enable you to modify an existing outline, as explained later in this chapter.

Selecting rectangular and oval areas

In most programs, you get at least one tool for drawing rectangular outlines and another for drawing oval outlines. Elements names these tools the Rectangular Marquee and the Elliptical Marquee; the two tools share a flyout menu (refer to Figure 12-2).

Whatever the tool name, create your selection outline by dragging from one side of the area you want to select to the other, as shown in Figure 12-3. (You won't see the direction arrow; I added that for illustration purposes.)

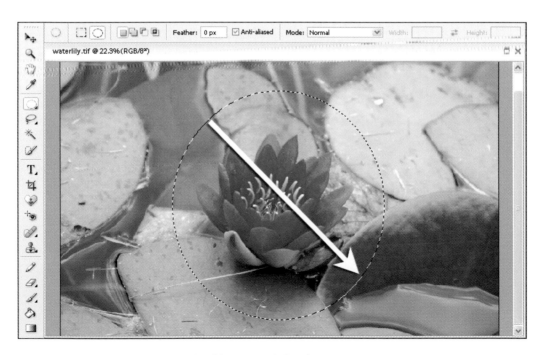

Figure 12-3: To select an area with either Marquee tool, drag from one corner to another.

You can adjust the performance of the Rectangular and Elliptical Marquee tools via the options bar, as follows:

- **Feather:** If you *feather* the outline, whatever edit you apply fades gradually from the edges of the selected area. For example, in Figure 12-4, I selected the background and filled it with white to create a framing effect (upcoming steps spell out the technique). For the top image, I set the Feather value to 0. This created the selection with no feathering, which resulted in a crisp edge to the frame. For the lower example, I set the value to 20 to produce a soft, vignette effect. You need to experiment to see what value is appropriate for your project.

- **Anti-aliased:** This option, available for the Elliptical Marquee only, smooths jagged edges that can occur when your selection outline contains curved or diagonal lines. For retouching purposes and for framing effects, this option is usually a good idea. When you're selecting a subject in order to copy and paste it into another photo, though, experiment with turning the option off.

- **Style:** Choose Normal for full control over the shape and size of the selection outline. Fixed Aspect Ratio and Fixed Size limit the tool to drawing an outline with specific proportions or dimensions, respectively. Chapter 11 explains how to use the Fixed Aspect Ratio option to crop a photo to standard frame sizes.

No feathering

Feathered

Figure 12-4: With feathering, your edit fades out gradually from the edges of the selected area.

To get a feel for the Marquee tools, follow these steps to produce a framing effect like the ones in Figure 12-4:

1. **Select the Rectangular Marquee for a rectangular frame; select the Elliptical Marquee for a round frame.**

 On the options bar, set the Mode control to Normal. When using the Elliptical Marquee, turn on the Anti-aliased check box. Also be sure that the New Selection icon, labeled in Figure 12-2, is selected. Set the Feather value as desired; remember, a value of 0 produces a crisp frame edge.

2. **Drag to enclose the area you want to keep in a selection outline.**

3. **Choose Select⇨Inverse.**

 This command reverses the selection outline. Now the background is selected instead of the area you initially enclosed in the outline.

4. **Press D to set the background paint color to white.**

5. **Press the Delete key.**

 The background is filled with white. (If you want the frame to be some other color, just set the background color to that color before you press Delete. The next chapter shows you how.) Press Ctrl+D (Windows) or ⌘+D (Mac) to get rid of the selection outline; then crop away the excess background as needed, following the instructions in Chapter 11.

If you forget to enter a Feather value before you draw your outline, you can add feathering after the fact. Just choose Select⇨Feather to display the Feather Selection dialog box, enter a feathering value, and click OK. You must add the feathering before you apply your actual change to the selected pixels, however. In the framing project, for example, you must choose the Feather command before you take Step 5.

Selecting by color

One of my favorite selection weapons ropes off pixels based on color. Elements calls its color-based selection tool the Magic Wand, while other programs call it the Color Wand, Color Selector, or something similar.

Whatever the name, the tool works pretty much the same everywhere you find it. You click on your picture, and the program automatically selects pixels that are the same color as the one you clicked.

 When you activate the Elements Magic Wand, the options bar offers the controls shown in Figure 12-5. If your software offers a color-selecting tool, you likely have access to similar options. They work as follows:

- **Tolerance:** This setting determines how closely a pixel must match the color of the one you click in order to be selected. At a low value, the tool selects only pixels that are very close in color. Raise the value to select a broader range of similar shades.

 Figure 12-6 illustrates the results of using four different Tolerance values. The little *x* in each rose indicates the position of the Magic Wand when I clicked; the yellowish tint indicates the regions included in the resulting selection. (I added the tint for the illustration; in reality, you see only a selection outline after you click.) You can enter a Tolerance value as high as 255, but anything above 100 or so tends to make the Magic Wand *too* casual in its pixel roundup. And a value of 255 selects the entire image, which you can do more easily by simply choosing Select⇨All.

- **Anti-aliased:** This one works just as described in the preceding section, so I won't go over it again here.

- **Contiguous:** Use this option to limit the tool to selecting only similarly colored pixels that are *contiguous* to the one you click. In plain English, that means that similarly colored pixels are *not* selected if any pixels of another color lie between them and the pixel you click.

Magic Wand New Selection icon

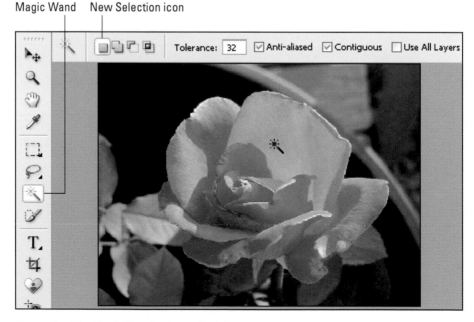

Figure 12-5: The Magic Wand selects pixels based on color.

Tolerance, 10 Tolerance, 32

Tolerance, 64 Tolerance, 100

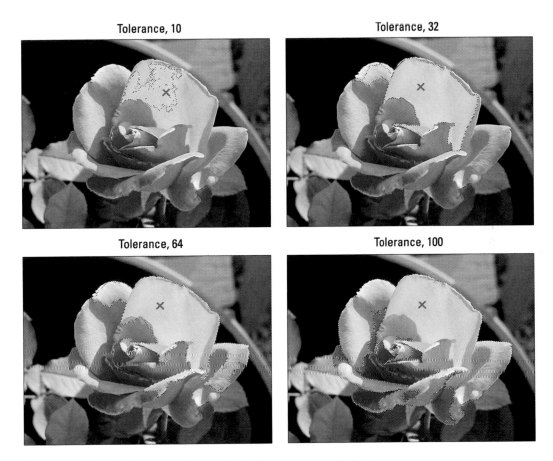

Figure 12-6: Raise the Tolerance value to select a broader range of colors.

For example, in Figure 12-7, I clicked the dark background area at the position marked by the *x*. With the Contiguous option turned on, the tool selected the area shown in the middle image. Matching areas in the lower-right corner aren't selected because areas of pink and gray lie between those matching pixels and the one I clicked. In the right example, however, I turned off the Contiguous option, so Elements selected matching pixels regardless of their location in the image. Once again, I filled the selection with a yellow tint to make the extent of the selection easier to see.

✓ **Use All Layers:** If your picture contains multiple layers, a feature explained in Chapter 13, select this check box if you want the Magic Wand to "see" pixels on all layers when creating the selection outline. Remember, though, that the outline that you create affects only the active layer — the program just takes all layers into account when drawing the selection outline.

Contiguous On

Contiguous Off

Figure 12-7: With the Contiguous option turned off, the Magic Wand selects matching pixels throughout the image.

Before clicking with the Magic Wand, make sure that the New Selection icon is active (refer to Figure 12-5).

Finding the right combination of Tolerance value and Contiguous setting takes some experimenting. If the first click doesn't produce the results you want, change the settings and simply click again to generate a new selection outline. Or use the techniques outlined in the upcoming section "Refining your selection outline" to add or subtract pixels from the selection.

Drawing freehand selections

Another popular type of selection tool enables you to select irregular areas of an image simply by tracing around them with your mouse. Well, I say "simply," but frankly, you need a pretty steady hand to draw precise selection outlines. Some people can do it; I can't. So I normally use these tools to select a general area of the image and then use other tools to select the exact pixels I want to edit. (Building selection outlines in this way is discussed in the upcoming section "Refining your selection outline.")

At any rate, this tool goes by different names depending on the software — Freehand tool, Lasso tool, and Trace tool are among the popular labels. Elements opts for Lasso, as does Photoshop. Both programs offer two variations on the Lasso, the Polygonal Lasso and the Magnetic Lasso. The three Lassos share a slot in the toolbox; again, you can switch from one tool to another by clicking the options bar icons.

To use the Elements Lasso and Polygonal Lasso, first make sure that the New Selection icon is active, as shown in Figure 12-8. Set the Anti-aliased and Feather value as desired (refer to the earlier discussion of the Marquee tools to find out about these options). Then rope off those pixels as follows:

✓ **Lasso:** Just drag around the object you want to select. When you reach the point where you began dragging, release the mouse button to close the selection outline.

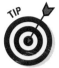

✏ **Polygonal Lasso:** This tool assists you with drawing straight segments in a freeform outline. Click to set the start of the first line, move the mouse to the spot where you want to end the segment, and then click to set the end point, as illustrated in Figure 12-8. Keep clicking and moving the mouse to draw more line segments. When you get back to the starting point of the outline, release the mouse button to close the outline.

When working with either tool, you can temporarily switch to the other one by pressing and holding the Alt key on a PC or the Option key on a Mac. Let up on the Alt (Option) key to return to the original tool you were using.

The next section explains the third tool in the Elements Lasso trio, the Magnetic Lasso.

Figure 12-8: The Polygonal Lasso assists you with drawing straight-sided selection outlines.

Selecting by the edges

If you read Chapter 11, you know that the term *edges* refers to areas where very light areas meet very dark areas. Many photo-editing programs, including Elements, provide a selection tool that simplifies the task of drawing a selection outline along an edge.

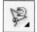 As you drag with this tool, called the Magnetic Lasso in Elements, the tool searches for edges and lays down the selection outline along those edges. Figure 12-9 shows me using this tool to create a selection outline around the Kodak Baby Brownie camera.

The process of using an edge-detection tool typically works like so:

1. **Click at the point where you want the selection outline to begin.**

Magnetic Lasso Fastening point

Figure 12-9: The Magnetic Lasso automatically places a selection outline along the border between contrasting areas.

2. **Move or drag your mouse along the border of the object you're trying to select.**

 Keep your tool cursor centered over the border, as shown in Figure 12-9. Whether you need to simply move the mouse or drag, with the mouse button depressed, depends on your software. In Elements, you can do either.

 As you move or drag the mouse, the tool automatically draws the selection outline along the border between the object and the background — assuming that at least some contrast exists between the two. At regular intervals, the program adds little squares to anchor the outline. You can see these squares, called *fastening points* in Elements, in Figure 12-9.

 You can click to create your own fastening points if needed. To remove a fastening point, move the mouse cursor over the point and press Delete.

3. **To finish the outline, place your cursor over the first point in the outline and click.**

As with color-based selection tools, you can usually control the sensitivity of edge-detection tools. In Elements, use the following options bar controls to adjust this and other aspects of the Magnetic Lasso's performance:

- ✓ **Feather, Anti-aliased:** These controls affect your selection outline as described in the earlier section, "Selecting rectangular and oval areas."

- ✓ **Width:** This control determines how far the tool can wander in its search for edges. Larger values tell the tool to go farther afield; smaller values keep the tool closer to home. You can enter any value from 1 to 256.

- ✓ **Edge Contrast:** Adjust this value to make the tool more or less sensitive to contrast changes. Use a low value if not much contrast exists between the object you want to select and the neighboring area. The maximum value is 100.

- ✓ **Frequency:** This setting affects how often the program adds fastening points. The default value usually works fine. Adding too many points can lead to a jaggedy outline, so try to go lower, if anything. Remember that you can always click to add your own fastening points, if needed.

- ✓ **Pen Pressure:** At the far right end of the options bar (not shown in Figure 12-9), the Pen Pressure control enables you to reduce the Width value on the fly when you're working with a drawing tablet and stylus. Press harder on the stylus to decrease the Width value. At normal pressure, the tool uses the Width value that you originally set on the options bar. I find it difficult to predict how much pressure will produce the Width value I want, so I don't recommend this feature.

Brushing on a selection outline

For complex selection outlines that don't lend themselves to the Magic Wand's color-based nature, the best option is a tool like the Elements Selection Brush. With this tool, you paint over the areas you *don't* want to alter, laying down a digital mask over those pixels. Think of that liquid mask solution you can paint on window glass before painting the sash, and you get the idea. Selecting this way is much easier than drawing freeform outlines with any of the Lasso or Marquee tools.

The following steps show you how to use the tool in Elements. Depending on your program, you may have access to additional tool options; Photoshop, for example, offers a Quick Mask feature that is like the Selection Brush on steroids.

1. **Grab the Selection Brush tool, labeled in Figure 12-10.**

2. **On the options bar, set the Mode control to Mask.**

3. **Display the Brushes palette by clicking the arrow labeled in Figure 12-10.**

 The icons in your palette may look different if you have changed the default display. To change the palette appearance, open the palette menu by clicking the arrow labeled in the figure.

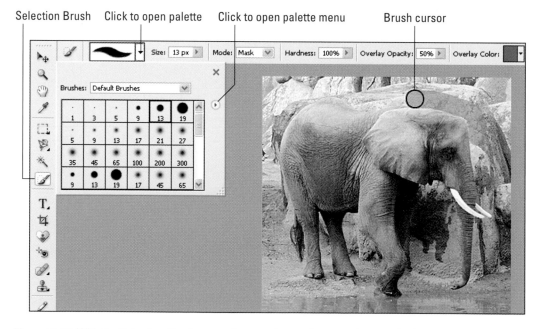

Figure 12-10: With the Selection Brush, you paint a mask over the areas that you don't want to select.

4. **Choose any of the round brushes from the first row of the palette.**

 For now, leave the Hardness value at 100 percent. Use the Size control to adjust brush size as needed.

5. **Drag over the areas you want to mask.**

 The pixels you touch are covered by a red, translucent overlay, as shown in Figure 12-10. If the overlay makes it difficult for you to see the picture, use the Overlay Opacity and Overlay Color controls on the options bar to adjust the tint.

 If you mess up and paint over areas that you don't want to mask, press and hold the Alt key (Windows) or Option key (Mac) while you drag over those areas. Now the tool removes the mask.

6. **After you apply the mask to all the areas you *don't* want to alter, set the Mode control to Selection.**

 A selection outline appears around all the pixels that were not covered by the mask.

Now that you have the basic idea, you can refine the way the Selection Brush works by adjusting the Hardness control on the options bar. At a value of 100 percent, your brush has precise edges, giving you the same final result as a nonfeathered selection outline. To soften the brush edge and create a feathered outline, lower the Hardness value. See the earlier section "Selecting rectangular or oval outlines" for information on feathering.

Selecting (and deselecting) everything

Want to make a change to your entire photo? Don't monkey around with the selection tools described in the preceding sections. Most programs provide a command or tool that automatically selects all pixels in your picture.

Building a better mouse cursor

Initially, Elements brush cursors have an icon-based look — the cursor for the Selection Brush looks like a little paintbrush, for example. The paintbrush remains the same size and shape, no matter what brush settings you use when working with the tool, which makes it difficult to tell where your next swipe will go. For an easier way to work, you can tell Elements to instead display a cursor that reflects the current brush size and shape, as you see in Figure 12-10. To make this change in Windows, choose Edit⇨Preferences⇨Display & Cursors and then set the Painting Cursors option to Brush Size. On a Mac, you access the setting by choosing Photoshop Elements⇨Preferences⇨Display & Cursors.

In some entry-level photo editors, you simply click the image with a particular selection tool, usually called a Pick tool or Arrow tool. Click once to select; click again to deselect.

Other programs provide menu commands for selecting and deselecting:

> ✔ Look on the menu that holds the selection commands for a Select All command or something similar. You can probably also find a Select None or Deselect command that gets rid of an existing selection outline.
>
> In Elements, choose Select⇨All and Select⇨Deselect. To get your last selection outline back, choose Select⇨Reselect.
>
> ✔ For the quickest route to whole-image selection, use the universal keyboard shortcut: Ctrl+A in Windows and ⌘+A on a Mac.
>
> ✔ Some programs also provide a shortcut for deselecting everything. In Elements, press Ctrl+D (Windows) or ⌘+D (Mac).
>
> ✔ In most programs, starting a new selection outline also gets rid of the existing outline. If you instead want to adjust the outline, see the next section.

Note that if your photograph includes multiple image layers, your selection outline affects only the current layer even when you use the command to select everything. If you want to make a change to all layers, you must merge the layers into one or apply the same change to each layer individually. Chapter 13 gives you the complete story on layers.

Reversing a selection outline

You can sometimes select an object more quickly if you first select the area that you *don't* want to edit and then *invert* the selection. Inverting simply reverses the selection outline so that the pixels that are currently selected become deselected, and vice versa.

Consider the left image in Figure 12-11. Suppose that you wanted to select everything but the sky. Drawing a selection outline around all the spires and ornate trimmings of the church spire, flagpole, and street lamp would take forever. But with a few swift clicks of the Magic Wand, I was able to select the sky and then invert the selection to select the buildings. In the right image, I deleted the selected area to illustrate how cleanly this technique selected the buildings.

Figure 12-11: To select these ornate structures (left), I used the Magic Wand to select the sky and then inverted the selection outline. Doloting the selected pixels (right) shows how precisely this technique selected even the intricate architectural elements.

To reverse a selection outline in Elements, choose Select➪Inverse. In other photo-editing programs, look for an Invert or Inverse command. The command typically hangs out in the same menu or palette that contains your other selection tools. But be careful — some programs (including Elements) use the name Invert for a filter that inverts the colors in your image, creating a photographic negative effect. If you find Invert or Inverse on a menu that contains special effects or color adjustments, the command probably applies the negative effect instead of inverting the selection.

Refining your selection outline

In theory, creating selection outlines sounds like a simple thing. In reality, getting a selection outline just right on the first try is about as rare as Republicans and Democrats agreeing on who should pay fewer taxes and who should pony up more. In other words, you should expect to refine your selection outline at least a little bit after you make your initial attempt.

All advanced photo-editing programs and some consumer-level programs enable you to adjust your selection outline. The preceding section explains one way to alter an outline — reversing it using the Invert command. You also can enlarge or reduce a selection outline using these techniques:

✔ **Add to a selection outline:** To enlarge the selection outline, set the selection tool to an additive mode. You can then draw a new outline while retaining the existing one.

✔ **Shrink a selection outline:** To deselect certain pixels currently enclosed in a selection outline, you set the selection tool to a subtractive mode. The tool then works in reverse, deselecting instead of selecting.

✔ **Intersect a selection outline:** Some programs go even further, enabling you to create a selection outline that encompasses the area of overlap between an existing outline and a second outline. For example, if you draw a rectangular outline and then draw a second outline that overlaps the right half of the first outline, only pixels inside the area of overlap become selected. In other words, the "intersection" of the two outlines becomes selected.

Methods for switching selection tools from their normal operating mode to the additive, subtractive, or intersection mode vary widely from program to program. In some programs, you click a toolbar icon; in other programs, you press a key to toggle the additive and subtractive modes on and off.

In Elements, you can refine selection outlines as follows:

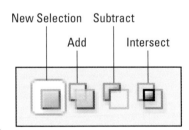

New Selection Subtract

Add Intersect

Figure 12-12: To set the selection tool mode in Elements, you can use these options bar buttons.

✔ **Adjusting outlines by using the Marquees, Lassos, or Magic Wand:** To add to the outline, press and hold the Shift key as you drag or click. To set the tool to subtractive mode, press and hold the Alt key (Windows) or Option key (Mac) instead. Alternatively, use the tool-mode buttons on the options bar. Figure 12-12 gives you a close-up look at the buttons.

✔ **Adjusting outlines by using the Selection Brush:** If you prefer to work with the Selection Brush, just change the Mode control on the options bar back to Mask. Then you can paint the mask on and off as described earlier. Switch the Mode control to Selection when you finish.

✔ **Moving a selection outline:** Using any selection tool except the Selection Brush, drag inside the outline. Or press the arrow keys on your keyboard to nudge the outline one pixel in the direction of the arrow.

✔ **Expanding or contracting an outline by a specific number of pixels:** Choose Select⇨Modify⇨Expand or Select⇨Modify⇨Contract and enter a value (in pixels) in the resulting dialog box.

Selection Moves, Copies, and Pastes

After you select a portion of your image, you can do all sorts of things to the selected pixels. You can paint them without fear of dripping color on any unselected pixels, for example. You can apply special effects or apply color-correction commands just to the selected area, leaving reality undistorted in the rest of your image.

Another common reason for creating a selection outline is to move or copy the selected pixels within the image or to another image, as I did in Figure 12-13. I took three coins from the money photo and put them into the wood image, proving once and for all to my parents that money *does too* grow on trees. I copied and pasted each coin separately so that I could rearrange them in their new home, a topic discussed later in this chapter.

Figure 12-13: After selecting and copying the coins, I pasted them into the wood image.

The following sections give you all the information you need to become an expert at moving, copying, and pasting selected portions of a photo.

You can also copy pixels using a special editing tool known as the Clone tool. This specialized tool enables you to "paint" a portion of your image onto another portion of your image, as discussed later in this chapter in "Pasting Good Pixels Over Bad."

Cut, Copy, Paste: The old reliables

You can move and copy selections using the time-honored computer commands Cut, Copy, and Paste. These commands are available in most every photo editor; usually, you find them on the Edit menu.

Before I get any further into this discussion, though, one caveat: When you paste a portion of one photo into another in many programs, including Elements, the pasted element may appear to change size. This happens if the output resolution (ppi) for both photos isn't the same. The number of pixels in the pasted element doesn't change, just the number of pixels per inch, which affects the print dimensions. If you want your copied selection to retain its original size when placed in the other image, be sure that the output resolution is the same for both pictures. (See Chapters 2, 9, and 10 for further details on resizing and resolution.)

With that bit of business out of the way, here's the Cut/Copy/Paste routine in a nutshell:

Figure 12-14: Applying the Cut command to a selection creates a background-colored hole.

- **Copy** duplicates the selected pixels and places the copy on the Clipboard, a temporary virtual storage tank. Your original image is left intact.

- **Cut** snips the pixels out of your image and places them on the Clipboard. You're left with a hole where the pixels used to be, as illustrated in Figure 12-14. In Elements, the hole takes on the current background paint color — white, in the figure. The next chapter tells you how to change the paint color.

- **Paste** glues the contents of the Clipboard into your image.

After you dump the contents of the Clipboard into your photo, you may need to adjust the position of the pasted element slightly. The next section explains how.

Adjusting a pasted object

Different programs treat pasted pixels in different fashions. In some programs, the Paste command works like super-strong epoxy — you can't move the pasted selection without ripping a hole in the image, just as when you cut a selection. In other programs, your pasted pixels behave more like they're on a sticky note. You can "lift" them up and move them around without affecting the underlying image.

Elements takes the second approach to pasting, as does Photoshop. Both programs place your pixels on a new *layer*. Layers are explained more fully in Chapter 13, but for now, just understand the following facts:

Figure 12-15: In Elements, each pasted selection appears on its own layer.

- ✓ To see all the layers in your photo, including the one containing the newly pasted pixels, choose Window➪Layers to display the Layers palette. By default, the palette appears in the Palette Bin on the right side of the program window; if you prefer, you can drag it by its top into the main workspace. The now free-floating palette appears as shown in Figure 12-15, and you can close the Palette Bin (Window➪Palette Bin).

- ✓ By default, transparent areas in a layer appear as a checkerboard pattern in the thumbnail previews in the Layers palette, as shown in the figure. Pixels on the layer below show through the transparent areas. In Figure 12-13, for example, the wood background is visible through the empty areas of the coin layers.

- ✓ To retain the individual image layers when you save your picture, save in the program's native format, PSD, or TIFF. Other formats merge the layers, which means that you can no longer manipulate the pasted element independently of the rest of the photo. Inside the Save As dialog box (discussed in Chapter 11), be sure to select the Layers check box, too.

Because your pasted element exists on its own layer, you can adjust it as necessary to fit its new home. In Elements, first click the name of the layer in the Layers palette. This makes the layer active. With the pasted layer active, use these techniques to alter its contents:

- ✔ **Move a pasted object:** Select the Move tool, labeled in Figure 12-16, and turn off the Auto Select Layer box on the options bar (not shown in figure). Then drag the element in the image window. While the Move tool is active, you also can press the arrow keys on your keyboard to nudge the element a distance of one pixel. Press Shift plus an arrow key to nudge the element ten pixels.

- ✔ **Rotate a pasted element:** Choose Image⇨Transform⇨Free Transform or press Ctrl+T (⌘+T on a Mac). A square *bounding box* appears around the layer contents, as shown in Figure 12-16. Little boxes — called *handles* — appear around the perimeter of the boundary. Don't see any handles? Enlarge the image window to reveal them.

Move your mouse outside a corner handle to display the curved rotate cursor, as shown in the figure. Then drag up or down to spin the layer. Click the Commit button, labeled in the figure, to finalize the rotation. To cancel out of a transformation, press the Esc key or click the Cancel button.

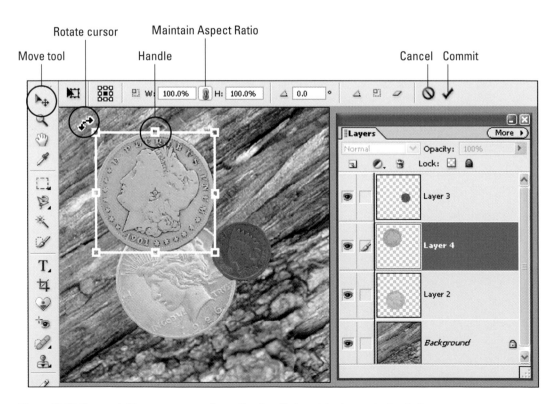

Figure 12-16: Drag outside a corner transformation handle to rotate the contents of a layer.

✔ **Resize a pasted element:** You can resize a pasted object by dragging the transformation handles, but keep in mind that doing so can lead to poor image quality. (See Chapter 2 for information about why resizing digital photos can reduce picture quality.)

To avoid distorting the element as you resize, be sure that the Maintain Aspect Ratio button on the options bar is pressed in, as shown in Figure 12-16. Again, click the Commit button to complete the resizing.

✔ **Flip the pasted element:** Choose Image⇨Rotate⇨Flip Layer Horizontal or Image⇨Rotate⇨Flip Layer Vertical. (The other flip commands flip the entire photo.)

Deleting Selected Areas

You can use the Cut command to move a selected object from your current photo to the Clipboard, where it stays until you cut or copy something else. But don't go to that trouble if all you want to do is simply remove a selected something from your picture — just press the old Delete key.

Instead of traveling to the Clipboard, your selection goes to the great pixel hunting ground in the sky. All that remains is a hole in the shape of the selection. If you're working on a layer, you see the underlying layer through the hole. For more on layers, see Chapter 13.

Pasting Good Pixels Over Bad

In addition to creating photo collages or rearranging elements in your pictures, you can also copy and paste pixels for the purpose of covering up defects in your photo. For example, in Figure 12-17, my shot of an Indianapolis landmark is spoiled by lens flare. So I selected some nearby sky, copied it, and then pasted it over the flaw.

To perform this kind of photo surgery, you use the exact same techniques outlined in the preceding sections. When covering large defects, you may need to create several "patches," copying and pasting selections from different areas of the original image.

Another option for hiding defects is to pick up the Clone tool, provided in most photo editors. With this tool, you can copy and paste pixels simply by clicking or dragging. I went this route to eliminate the blown highlights in the lemon in Figure 12-18. I simply cloned "good" lemon pixels over the defect. The right side of the figure shows a close-up of the repaired area.

Figure 12-17: I hid the lens flare with sky pixels that I selected and copied from the surrounding area.

The Clone tool has no real-life counterpart, so you need to practice with the tool for a bit to fully understand how it works. But I guarantee that after you get acquainted with this tool, you'll use it all the time.

Figure 12-18: To repair blown highlights, I cloned properly exposed pixels over the defect.

Depending on your program, the Clone tool may go by another name. In Photoshop, for example, the tool used to be known as the Rubber Stamp, which is why the tool cursor still looks like a rubber stamp in both Photoshop and Elements. In recent versions of Photoshop, the tool name was changed to Clone Stamp, which is the official name in Elements as well. For the sake of brevity, I'm just going to call it the Clone tool.

Regardless of what you call it, you use the same basic approach to clone in most programs:

1. **First, activate your Clone tool.**

 In Elements, click the tool icon in the toolbox, labeled in Figure 12-19. (Be careful not to grab the Pattern Stamp tool instead, which shares a flyout menu with the Clone tool.)

2. **Establish the *clone source*.**

 The *clone source* refers to the area of your picture that you want to clone — the source of the cloned pixels, in other words. This step sets the initial clone source. The process for setting the clone source varies from program to program.

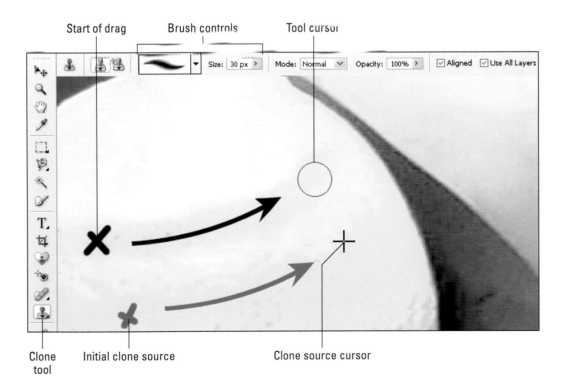

Figure 12-19: As you drag with the Clone tool, the source cursor follows in tandem, showing you what pixels are currently being copied.

In Elements, Alt+click (Windows) or Option+click (Mac) to set the clone source. When you press the Alt or Option key, your cursor temporarily changes to a little target cursor. In Figure 12-19, the red X indicates the position of my initial clone source.

3. Click on or drag over the flaw that you want to cover.

The program copies pixels from the clone source onto the pixels underneath your tool cursor.

If you drag to clone, the position of the clone source moves in tandem with the tool cursor. For example, if you drag down and to the left, you clone pixels that fall below and to the left of the initial clone source.

In Elements, a clone source cursor appears when you begin to clone. (I labeled this cursor in Figure 12-19.) You can look at the clone source cursor to see which pixels the program is about to clone. In Figure 12-19, the black X indicates the spot where I began dragging with the tool; the arrows show you the path that the tool cursor and clone source cursor took as I dragged.

Note that as explained earlier in the "Building a better mouse cursor" sidebar, I've set the Painting Cursors option to Brush Size inside the Preferences dialog box so that my tool cursor reflects the size and shape of the tool brush. (The setting applies to any tool that has a brush-based tip, not just tools that apply paint.)

You can adjust the performance of the Elements Clone tool by using the options bar controls shown in the figure. The following list describes these options, which are similar to those provided for Clone tools in other advanced photo-editing programs:

- ✔ **Brush:** You can specify the size, shape, and softness of the tool brush by using the Brush controls. When cloning in areas of sharp focus, a hard brush usually works best; in soft-focus areas, choose a soft brush. The size of your brush determines how many pixels will be cloned onto the flawed pixels with each click or drag.

- ✔ **Mode:** This option controls how the cloned pixels blend with the original pixels. In Normal mode, the cloned pixels completely obscure the underlying pixels, which is usually the goal when you're doing touch-up work. You can create a variety of different effects by playing with the other blending modes. (Chapter 13 touches on blending modes a little more.)

- ✔ **Opacity:** You can vary the opacity of the pixels you clone by using this control. I often use 60 or 70 percent opacity when using the Clone tool to blend cloned pixels with the original more naturally. But if you want your cloned pixels to completely cover the original pixels, set the value to 100 percent.

✔ **Aligned:** This control determines whether the clone source reverts to its original position — the spot you clicked to establish the clone source — each time you click or begin a new drag with the tool. When the option is turned off, the clone source cursor returns to the original position. This setting enables you to clone the same pixels repeatedly.

If you turn the Aligned check box on, the clone source cursor stays put after you click or end your drag, however. So on your next click or drag, you just continue cloning from where you left off. If you do want to clone from the same source again, you must reset the clone source (by Alt+clicking or Option+clicking).

✔ **Use All Layers:** If you're working on a photo that has multiple image layers, a feature described in Chapter 13, select this check box if you want the Clone tool to be able to "see" pixels on all layers. When the check box is turned off, the tool can clone only pixels on the active layer. So if you're working on Layer 2, for example, you can't clone pixels from Layer 1.

Enlarging the Image Canvas

When you cut and paste pictures together, you may need to increase the size of the image *canvas*. The canvas is nothing more than a virtual backdrop that holds all the pixels in your image — think of it like a blank document in a word processing program, if that helps.

Suppose that you have two images that you want to place side by side. Perhaps image A is a picture of your boss, and image B is a picture of the boss's boss. You open image A, increase the canvas area along one side of the image, and then copy and paste image B into the empty canvas area.

How you adjust the canvas varies from program to program. Look for information about canvas size, image background, or picture size in your software's Help system. Just make sure that you're changing the dimensions of the canvas and not the image itself. (See Chapter 2 for more information on changing image size.)

To adjust the canvas size in Elements, choose Image⇨Resize⇨Canvas Size to open the Canvas Size dialog box, shown in Figure 12-20. Enter the new canvas dimensions into the Width and Height option boxes. Next, use the Anchor grid at the bottom of the dialog box to specify where you want to position the existing image on the new canvas. For example, if you want the extra canvas area to be added equally around the entire image, click in the center square. You can specify the color of the new canvas area using the drop-down list at the bottom of the dialog box.

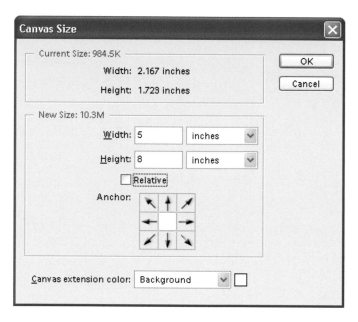

Figure 12-20: To enlarge the picture canvas in Elements, head for this dialog box.

To trim away excess canvas, reduce the Width and Height values. Again, click in the grid to specify where you want the image to be located with respect to the new canvas. Note that you can also use the Crop tool to cut away excess canvas; see Chapter 11 for information. But using the Canvas Size command is a better option if you want to trim the canvas by a precise amount — a quarter-inch on all four sides, for example.

As an alternative way of adjusting the canvas, you can select the Relative check box. Then enter the amount of canvas that you want to add or trim in the Width and Height boxes. For example, to add an inch to all four sides of the canvas, set the Width and Height values to 2 inches and then click the center anchor square. To instead cut an inch off all four sides, set both values to –2. (You must enter the minus sign.)

Amazing Stuff Even You Can Do

In This Chapter

▶ Painting on your digital photos

▶ Choosing your paint colors

▶ Removing red-eye

▶ Filling a selected area with color

▶ Changing the color of an object

▶ Creating grayscale and sepia-toned photos

▶ Using layers for added flexibility and safety

▶ Erasing your way back to a transparent state

▶ Applying special-effects filters

*F*lip through any magazine and you can see page after page of impressive digital art. A review of new computers features a photo in which lightning bolts are superimposed over a souped-up system. A car ad shows a sky that's hot pink instead of boring old blue. A laundry detergent promotion has a backdrop that looks as though Van Gogh himself painted it. No longer can graphic designers get away with straightforward portraits and product shots — if you want to catch the fickle eye of today's consumer, you need something with a bit more spice.

Although some techniques used to create this kind of photographic art require high-end professional tools — not to mention plenty of time and training — many effects are surprisingly easy to create, even with basic photo software. This chapter gets you started on your creative journey by showing you a few simple tricks that can send your photographs into a whole new dimension. In addition, you find out how to cure red-eye by using your painting tools in combination with a special pixel-blending feature.

Giving Your Image a Paint Job

Remember when you were in kindergarten and the teacher announced that it was time for finger painting? In a world that normally admonished you to be neat and clean, someone actually *encouraged* you to drag your hands through wet paint and make a colorful mess of yourself.

Photo-editing programs bring back the bliss of youth by enabling you to paint on your digital photographs. The process isn't nearly as messy as those childhood finger-painting sessions, but it's every bit as entertaining.

To paint in a photo editor, you can use your mouse or whatever pointing device you prefer to create strokes that mimic those produced by traditional art tools, such as a paintbrush, pencil, or airbrush. Or you can dump color over a large area by selecting the area and then choosing the Fill command, which paints all selected pixels in one step.

Why would you want to paint on your photographs? Here are a few reasons:

- **Change the color of an object in your photo.** Say that you shoot a picture of a green leaf to use as artwork on your Web site. You decide that you'd also like to have a red leaf and a yellow leaf, but you don't have time to wait for autumn to roll around so that you can photograph fall-colored leaves. You can make two copies of the green leaf and then paint one red and the other yellow.

- **Hide minor flaws.** Is a small blown highlight ruining an otherwise good photo? Does red-eye spoil a family portrait? Pick up a paint tool and dab over the problem pixels.

- **Express your creativity.** If you enjoy painting or drawing with traditional art tools, you'll be blown away by the possibilities presented by digital painting tools. You can blend photography and hand-painted artwork to create awesome images.

 To get an idea of the possibilities, take a look at Figure 13-1, which shows me in the process of creating a "chalk" drawing based on a photo, using the program Corel Painter IX. For users who have limited drawing experience, Painter offers a feature that assists you with this process. As you draw, the program renders the photo using the style and texture of your chosen media. The cool thing is that you can vary how much detail is reproduced by adjusting tool settings — a level of control not offered by the artistic-effects filters found in most photo-editing programs. In this photo, for example, I chose to do a soft wash behind the subject rather than faithfully reproducing the distracting background elements. Mind you, I'm an absolute novice at drawing; think of what you could do with some real skill.

- **Make friends and family look silly.** Okay, you've probably already discovered this one on your own. Admit it, now — the first thing you tried in your photo software was painting a mustache or devil horns on someone's picture, wasn't it?

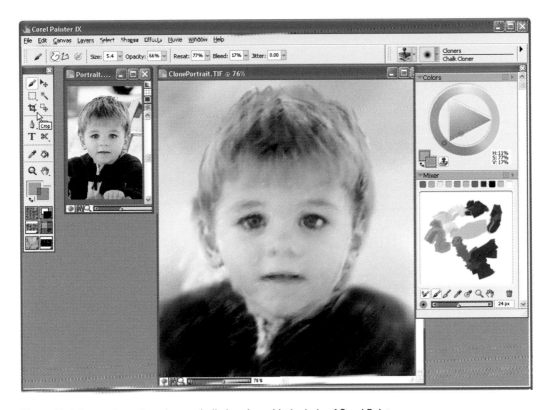

Figure 13-1: I turned my photo into a chalk drawing with the help of Corel Painter.

What's in your paint box?

Different photo editors offer different assortments of painting tools. Programs such as Corel Painter, which are geared toward photo artistry and digital painting, provide an incredible supply of paint tools and effects. You can paint with tools that mimic the look of traditional media or lay down special-effects strokes, as shown in Figure 13-2.

If you're skilled at drawing or painting, you can express endless creative notions using this kind of program. You may also want to invest in a drawing tablet, which enables you to paint with a pen-like stylus, which most people find easier than using a

Figure 13-2: Corel Painter and other programs marketed toward photo artisans enable you to create a broad range of brush stroke effects.

mouse. (Be sure that the software you choose supports this function if you take the leap.) See Chapter 4 for a look at a drawing tablet.

Keep in mind that programs that emphasize painting tools sometimes don't offer as many image-correction or retouching options as programs such as Adobe Photoshop and Photoshop Elements, which concentrate on those functions rather than painting. On the other hand, programs that focus on retouching and correction usually don't offer a wide range of painting tools. Elements, for example, provides just a couple of painting tools.

Still, you can accomplish quite a bit even with a few basic painting tools. To introduce you to the possibilities, upcoming sections show you how to use paint to perform one common retouching task and one creative project: removing red-eye and changing the color of a photo element.

You can accomplish either job using just the Elements Brush or Pencil tool, both found near the bottom of the toolbox. The Pencil produces clean, crisp strokes like the top line in Figure 13-3; the Brush tool can paint soft-edged or hard-edged strokes, as shown in the lower two lines. Most photo-editing programs provide similar tools.

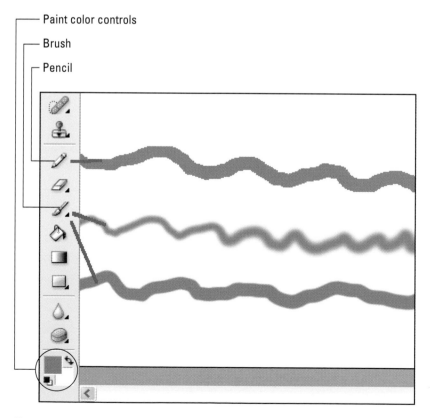

Figure 13-3: Just drag with the Pencil or Brush tool to lay down a swath of color.

With either tool, laying down paint is simple. Just click to dab on one cursor's-worth of color, or drag to create a longer stroke.

To paint a perfect horizontal or vertical stroke in Elements, press Shift as you drag. To paint a straight line at any other angle, click to set the start of the line and then Shift-click at the spot where you want the line to end.

Setting the paint color

Before you lay down a coat of paint, you need to choose the paint color. In most photo editors, two paint cans are available at any one time:

- ✓ **Foreground color:** Usually, the major painting tools apply the foreground color. In Elements, that includes the Brush and Pencil.

- ✓ **Background color:** The background color typically comes into play when you use certain special-effects filters that involve two colors. But in Elements, the Eraser tool also applies the background color if you're working on the background layer of the photo. ("Uncovering Layers of Possibility," later in this chapter, provides details.) In addition, when you delete a selected area on the background layer, the resulting hole is filled with the background color. See Chapter 12 for more on that topic.

Like many other aspects of photo editing, the process of choosing the foreground and background colors is similar no matter what program you're using. Some programs provide a special color palette in which you click the color you want to use. Some programs rely on the Windows or Macintosh system color pickers, while other programs, including Elements, provide you with a choice between the program color picker and the system color picker.

The next three sections explain how to use the Elements color picker, the Windows system color picker, and the Macintosh color picker.

Choosing colors in Photoshop Elements

In Elements, the bottom section of the toolbox contains four important color controls, labeled in Figure 13-4. The controls work as follows:

- ✓ The two large color swatches show you the current foreground and background paint colors.

- ✓ Click the Default Colors icon to reestablish the default foreground and background colors, which are black and white, respectively.

- ✓ Click the Swap Colors icon to make the foreground color the background color, and vice versa.

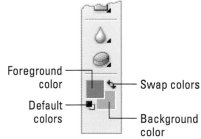

Foreground color
Swap colors
Default colors
Background color

Figure 13-4: Click the Default Colors icon to quickly restore black and white as the foreground and background colors.

Elements provides several ways to change the foreground or background color to something other than black or white. The two simplest methods are:

✓ **Eyedropper:** Grab the Eyedropper, labeled in Figure 13-5, and click a pixel in the image to lift a color from your picture and make it the foreground color. Using this technique, you can easily match the paint color to a color in your photo. To set the background color using the Eyedropper, Alt+click (Windows) or Option+click (Mac).

When the Sample Size control on the options bar is set to Point Sample, the tool exactly matches the pixel that you click. To blend a color that's a mix of several adjacent pixels, set the control to 3 by 3 Average or 5 by 5 Average.

Eyedropper

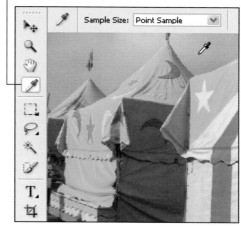

Figure 13-5: To change the foreground color to a color in your photo, click that color with the Eyedropper.

✓ **Color Picker:** Click the foreground or background color swatch in the toolbox, depending on which color you want to change. By default, the program then displays the Color Picker dialog box shown in Figure 13-6. If you get your operating system (Windows or Apple) color picker instead, close the dialog box and then head for the Elements Preferences dialog box. In Windows, choose Edit➪Preferences➪General. On a Mac, choose Photoshop Elements➪Preferences➪General. Set the Color Picker option to Adobe and then click OK.

Inside the Color Picker, you can select colors using the HSB color model or the RGB color model, both explained in Chapter 2. For most people, the HSB model is most intuitive. Click the H button to set up the dialog box as shown in Figure 13-6. Drag the color slider to set the hue and click in the color field to adjust the saturation and brightness. The New Color swatch shows you the color that you're making. When the color is just right, click OK or press Enter to close the dialog box.

If you know the exact RGB or HSB values for the color you want to use, you can just enter them into the corresponding boxes instead of using the color field and slider.

As with other Elements information given in this book, I've provided just the basics of using the Color Picker. The dialog box offers additional features that come in handy for Web designers, and I urge you to explore them if you're in that arena.

Color field Color slider New color

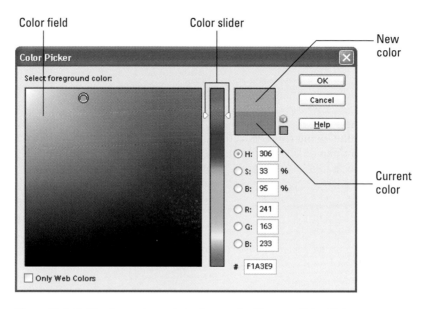

Current color

Figure 13-6: To blend a custom paint color, use the Elements Color Picker.

Choosing colors via the Windows color picker

In some Windows-based photo-editing programs, you choose paint colors using the Windows Color dialog box. Figure 13-7 shows the Windows XP version of that color picker.

Hue/Saturation cursor Color field

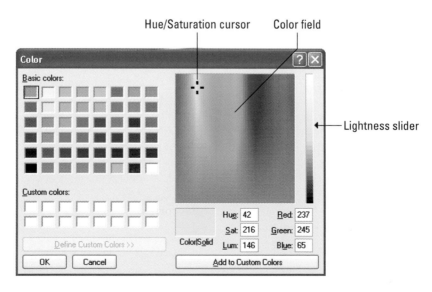

Lightness slider

Figure 13-7: You can mix custom colors in the Windows system color picker.

Here's the short course in picking a color from this dialog box:

- ✔ To choose one of the colors in the Basic Colors area, click its swatch.

- ✔ To access more colors, click the Define Custom Colors button, located just above the OK button. Clicking the button displays the right half of the dialog box, as shown in Figure 13-7. (The button is dimmed in the figure because I already clicked it.)

- ✔ Drag the crosshair cursor in the color field to choose the hue and saturation (intensity) of the color, and drag the Lightness slider to adjust the amount of black and white in the color.

- ✔ The Color/Solid swatch displays two versions of your color — the left side shows the color as you've defined it, and the right side shows the nearest solid color. See, a monitor can display only so many solid colors. The rest it creates by combining the available solid colors — a process known as *dithering*. Dithered colors have a patterned look to them and don't look as sharp on-screen as solid colors.

How many solid colors are available to you depends on the settings of your system's video card. In past years, people using puny computer systems sometimes set their video cards to display a mere 256 colors. Unless you do the same, you won't see any difference between the two sides of the Color/Solid swatch. The feature is provided for Web designers who want to be sure that even someone still using the 256-color display limit sees only undithered colors on the Web page. If that describes you, click the right side of the swatch to select the nearest solid color to the one you mixed in the color field. (But realize that other colors in your photo likely exceed the 256-color limit.)

After you choose your color, click OK to leave the dialog box.

Using the Apple color picker

If you're working on a Macintosh computer, your photo software may enable you — or require you — to select colors using the Apple color picker. The Mac OS X version is shown in Figure 13-8.

Click the Color Wheel icon to set up the dialog box as shown in the figure. Then click inside the large color

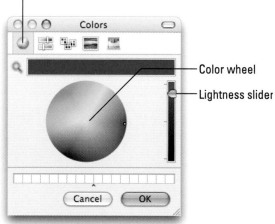

Figure 13-8: In the Apple color picker, you can blend colors by adjusting the hue, saturation, and lightness values.

wheel to choose the hue and saturation. Drag the neighboring slider to adjust brightness. The bar at the top of the dialog box shows the color you've mixed. When you're satisfied, click OK.

Exploring Brush and Pencil options

When you work with the Elements Brush tool, the options bar provides a number of controls for tweaking the tool performance. These options mimic those found in many other programs, although the implementation and feature names may vary.

To activate Elements Brush tool, just press B.

I explain what settings to use when providing steps for the projects covered elsewhere in this book. For now, just scan through the following list of options to get a general idea of what each one does:

- **Brush size, shape, and hardness:** I'll assume that size and shape are self-explanatory. Hardness refers to whether the stroke has crisp or fuzzy edges. Figure 13-3, earlier in this chapter, shows both styles.

 In Elements, you choose the brush shape from the Brushes palette, shown in Figure 13-9. To open the palette, click the arrow labeled in the figure. Then just click a brush icon. (The round brushes you see in the figure are appropriate for most photographic projects.) The numbers underneath the icons indicate the initial brush size, in pixels. But after clicking an icon, you can adjust the size via the Size control on the options bar.

 Initially, brushes are either fully hard or fully soft. (Blurry icons indicate soft brushes.) For more control, open the More Options palette, shown in the figure, and drag the Hardness slider. A value of 0 gives you the softest brush. Don't mess with the other settings until you're an advanced painter (if then).

- **Blending mode:** The *blending mode* feature enables you to mix your painted strokes with the underlying pixels in different ways. Set the blending mode for the Brush tool via the Mode control on the options bar.

 For most photo projects, the two most useful blending modes are Normal and Color. Use Normal when you want the painted pixels to cover the original pixels completely. (You also must set the Opacity value, explained next, to 100 percent.) The Color mode enables you to change the color of an object realistically. The program applies the new color to the pixels but retains the original highlights and shadows in the painted area. The upcoming section about painting out red-eye takes advantage of this mode.

Click to open Brushes palette

Click to open More Options palette

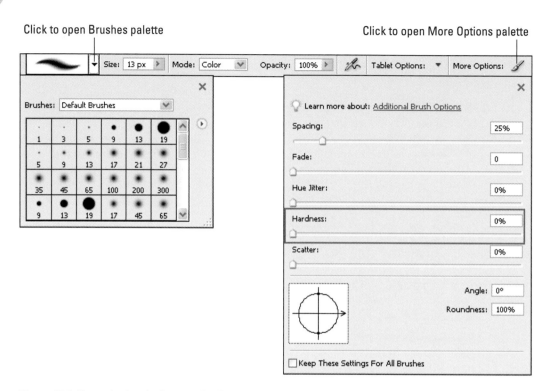

Figure 13-9: To set the brush shape and softness, open the Brushes palette.

✔ **Paint opacity:** You can make your paint strokes fully opaque, so that they completely obscure the pixels you paint over, or reduce the opacity so that some of the underlying image shows through the paint. In Figure 13-10, I defaced the wood image by painting my initials at four different opacity settings. At an Opacity value of 100 percent, my digital graffiti is fully opaque; at 25 percent, it's barely visible.

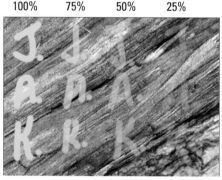

Figure 13-10: Change the paint opacity to create different effects.

✔ **Tablet options:** If you work with a drawing tablet, you may be able to adjust some brush characteristics simply by varying the amount of pressure on your stylus. Elements, for example, allows you to control five different brush behaviors with stylus pressure. However, when you're first exploring photo editing, I suggest that you disable this feature. That

way, you don't have to wonder whether your brush is acting a certain way because of pen pressure or a particular brush setting. To turn off the tablet features in Elements, open the Tablet Options palette and uncheck all five boxes, as shown in Figure 13-11.

✔ **Airbrush features:** Your software may offer a stand-alone airbrush tool. Or, like Elements, it may enable you to put your Brush tool in airbrush mode. Either way, airbrushing applies paint differently than a regular brush. The tool continues to pump out paint as long as you press the mouse button (or stylus tip), even when you don't move the cursor. As with the aforementioned tablet options, I suggest that you pass up airbrushing until you become well acquainted with how the standard painting options affect your strokes. In Elements, just make sure that the Airbrush icon is off, as shown in Figure 13-11.

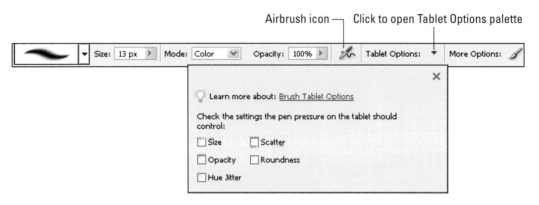

Airbrush icon — Click to open Tablet Options palette

Figure 13-11: While you're getting acquainted with the Elements Brush tool, turn off the tablet options and the Airbrush option.

 Options for the Elements Pencil tool, shown in Figure 13-12, are more limited. (Press N to select the tool quickly.) The size, shape, blending mode, and opacity controls work just like those for the Brush tool. The Pencil tool has no Hardness control because it can create only hard strokes. As for that Auto Erase box, turn it off. When you turn this feature on, the Pencil automatically switches to the background paint color whenever you paint over a pixel that matches the foreground color. I'm sure this feature has a good use; I just haven't been able to think of one.

 For greater painting flexibility, always paint on a new, independent image layer. That way, you can further adjust painted strokes after you create them by varying the opacity and blending mode of the layer itself. In addition, if you decide you don't like your painted pixels, you can get rid of them by simply deleting the layer. Read the section "Uncovering Layers of Possibility," later in this chapter, for the full story on layers.

Figure 13-12: When working with the Pencil, turn off the Auto Erase box.

Also, the default Paint and Brush cursors look like the tool icons, which doesn't give you any idea of the chosen brush size or shape. For a better way to go, visit the Preferences dialog box and change the Painting Cursors setting to Brush Size. In Windows, open the dialog box by choosing Edit⇨Preferences⇨ Display & Cursors. On a Mac, choose Photoshop Elements⇨Preferences⇨ Display & Cursors.

Painting away red-eye

Even when you shoot flash portraits in red-eye reduction mode, you may occasionally — wait, no, *often* — wind up with red-eye problems. The good news is that this defect is easy to fix; you can simply paint in the new eye color.

Many programs offer an automated red-eye removal tool, however. Some of these tools work pretty well, and if they do, they're quicker than painting over the red pixels. So before you pick up the paint, give your red-eye tool a whirl.

In Elements, follow these steps:

1. Zoom in closely on the red-eye area.

Click the image with the Zoom tool, labeled in Figure 13-13, to zoom in. To zoom out, Alt-click with the tool in Windows or Option-click on a Mac.

2. Select the Red-Eye Removal tool, labeled in Figure 13-13.

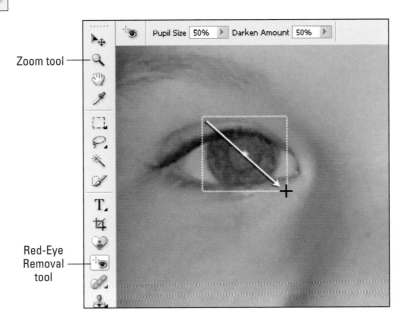

Zoom tool

Red-Eye Removal tool

Figure 13-13: The Elements Red-Eye Removal tool does a decent job on most eyes.

3. Drag to enclose the eyeball in a dotted outline, as shown in the figure.

4. Release the mouse button.

Elements replaces the red pixels with pixels that it thinks produces a natural result. If you're not happy with the outcome, choose Edit⇨Undo, play with the settings on the options bar, and try again.

Usually, if an automated red-eye tool is going to work, it does so on the first or second try. After one or two attempts, don't waste any more time. The results likely won't improve, and you can more quickly get the job done by simply using your paint tool to cover up the red.

Note that the technique that I recommend involves the use of layers, which are detailed later in this chapter. If you're not yet familiar with layers, some of this information may not make complete sense. Don't panic — just click and drag as instructed, and all will be well.

With that bit of news out of the way, here are the red-eye cover-up steps in Elements:

1. **Zoom in tightly on the red-eye area.**

2. **Pick up the Brush tool by clicking its toolbox icon or pressing B.**

3. **Set the brush size, shape, and hardness.**

 See the preceding section if you need help. For this job, you need a small, round brush. Usually, a hard or medium-soft brush works best.

4. **Set the other tool options as shown in Figure 13-14.**

 Specifically: Mode, Normal; Opacity, 100 percent; and Airbrush, off. If you work with a pressure-sensitive tablet, open the Tablet Options menu and turn off all check boxes therein.

5. **Choose Window⇨Layers to open the Layers palette.**

 Your palette may appear docked in the Palette Bin. If you want it to float freely, as in Figure 13-14, just drag it by its title bar into the image window. Then choose Window⇨Palette Bin to close the bin.

6. **Click the New Layer icon, labeled in Figure 13-14.**

 This step creates a new layer to hold your eye paint.

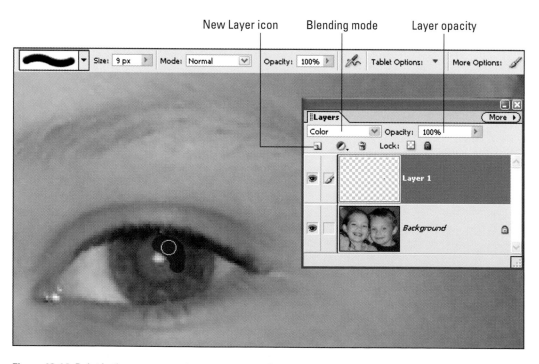

Figure 13-14: Paint in the new eye color on a separate layer, using the Color layer blending mode.

7. **In the Layers palette, set the layer blending mode to Color, as shown In Figure 13-14.**

 Similar to the painting tool blending modes described earlier, layer blending modes enable you to vary the way that the pixels on one layer mix with the ones below. Color is the best choice for this task.

8. **Set the foreground paint color to the new eye color.**

 A good trick: Press and hold the Alt key (Windows) or Option key (Mac), which temporarily accesses the Eyedropper. Then click an eye pixel that didn't turn red. Your click establishes the foreground paint color. Release the Alt or Option key to return to the Brush tool.

9. **Click on or drag over the red pixels.**

 You may need to experiment with the paint color to find just the right shade. If you spill paint outside the eye, use the Eraser, explained later in this chapter, to rub it away.

10. **When you're happy with the eyes, choose Layer⇨Merge Down.**

 This step fuses your paint layer with the underlying image.

This technique works for almost all cases of red-eye. But if the eyes are both really red and really bright, you may not be able to get the pupil as dark as it should be. The remedy is to add another new layer, this time setting the blending mode to Normal and setting the Layers palette Opacity control to 50 percent. Now paint again with black, being careful not to paint over the natural white highlights in the pupil. Tweak the effect by playing with the Layers palette's Opacity control. Again, merge the paint layer and underlying layer when you finish.

Also, animal eyes typically turn white, yellow, or green instead of red in flash pictures. You can use the preceding steps to fix your pet's eyes, unless they turned white. In that case, set the layer blending mode to Normal in Step 7. Then reduce the Opacity value in the Layers palette slightly so that you retain some of the original shadows and highlights of the eye when you paint.

Painting large areas

Dabbing out red-eye takes only a few clicks of your paint tool. But when you want to paint a larger area, using your mouse or stylus can get tedious. If your software offers a Fill command (or something like it), you have an easier option. You can select the area and then pour paint into the entire selection.

I took this approach to paint four of the white petals in Figure 13-15. In all three cases, I used the same salmon color you see on the petal labeled Normal. So why did the other three petals turn out differently? Because the Fill command, like the Brush and Pencil tools, offers a choice of blending modes. Again, *blending mode* simply refers to the way that paint pixels are mixed with the original pixels.

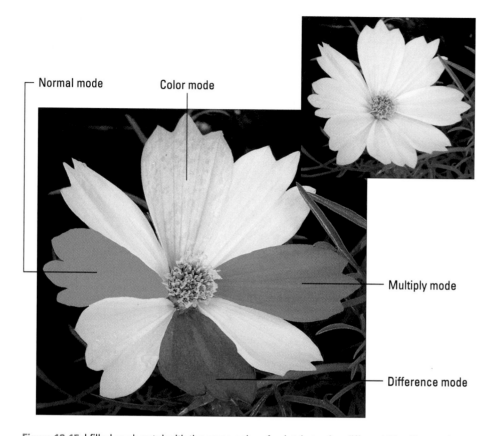

Figure 13-15: I filled each petal with the same color of paint, but using different blending modes.

As you can see, the Normal mode creates an entirely unnatural result because a normal fill pours solid color throughout your selection, obliterating the shadows and highlights of the original photograph. For a more realistic paint job, I filled the top petal using the Color mode, which retains the shadows and highlights of the underlying image.

Programs that provide blending modes tend to offer the same assortment of modes. I could provide you with an in-depth description of how different blend modes work, but frankly, predicting how a blending mode will affect an image is difficult even if you have this background knowledge. So just play around with the available modes until you get an effect you like. For fun, I filled the other two petals in Figure 13-15 using the Multiply and Difference modes.

To fill a selection with paint in Elements, follow these steps:

1. Select the area that you want to paint.

 You can skip this step if you want to paint the entire photo (or current layer, in a layered image). See Chapter 12 for help with selecting.

2. **For safety's sake, create a new layer to hold the paint.**

 You can do this by clicking the New Layer icon in the Layers palette, as described in the preceding section. (Flip back to Figure 13-14 for a look at the palette.) Alternatively, choose Layer⇨New⇨Layer. Click OK in the resulting dialog box, accepting all the default dialog box settings.

3. **Choose Edit⇨Fill Selection.**

 If you didn't create a selection outline in Step 1, this command name is Fill Layer instead of Fill Selection. Either way, you see the Fill Layer dialog box, shown in Figure 13-16, after choosing the command.

Figure 13-16: Use the Fill command to dump color into a large area of your photo.

4. **Set the fill options.**

 - Select your paint color from the Use drop-down list.

 - Set the Mode and Opacity options at Normal and 100 percent, respectively. You can more easily adjust these two characteristics by using the controls in the Layers palette after filling the selection. When you use the Layers palette controls, you can see the results of your changes in the image window, a benefit you don't get inside the Fill Layer dialog box.

 - Turn off the Preserve Transparency option.

5. **Click OK to close the dialog box and pour paint into the selection.**

6. **In the Layers palette, adjust the blending mode and opacity as needed.**

 Again, refer to Figure 13-14 for a look at these two controls.

7. **When you're satisfied with the paint job, choose Layer⇨Merge Down to permanently glue the paint layer to the original image.**

TIP

When you want to fill a selection with the current foreground color, you can bypass the Fill Layer dialog box by simply pressing Alt+Delete (or Option+ Delete on a Macintosh). Press Ctrl+Delete (or ⌘+Delete) to fill the area with the background color.

One final word about painting: I suggest that you ignore the Elements Paint Bucket tool, which is also provided for the purpose of filling large areas. When you click with the tool, it hunts for pixels that match the color you clicked, just like the Magic Wand selection tool. Then it paints all those pixels. The problem is that it's difficult to find exactly the right spot to click to color only the pixels you want to paint. For faster, more accurate results, create your selection outline and then use the Fill Layer command instead.

Smudging Paint

The Smudge tool, found in many photo editors, isn't so much a painting tool as a paint-smearing tool. Producing an effect similar to what you'd get if you dragged your finger through a wet oil painting, the tool takes the color underneath your cursor and smears it over other pixels that you drag over.

To get an idea of the kind of effects you can create with the Smudge tool, see Figure 13-17. I used the tool to give my vintage toucan pitcher a new 'do. To create the effect, I just dragged upward from the crown of the bird.

Figure 13-17: I used the Smudge tool to give my toucan a change of hairstyle.

In Elements, the Smudge tool is located near the paint color controls, sharing a flyout menu with the Blur and Sharpen tools. As shown in Figure 13-18, the options bar for this tool offers a Brushes palette, Size control, and Mode control, just like the Brush tool. Refer to the earlier section, "Exploring Brush and Pencil options" for the scoop on these controls. You also have access to some smudging-only options:

✔ **Finger Painting:** For standard smudging, turn this option off, as shown in Figure 13-18. When the option is enabled, the Smudge tool smears the current foreground paint color over your image instead of the color that's under your cursor at the start of your drag.

✔ **Strength:** You also can adjust the impact of the Smudge tool by using the Strength control. At full strength, the Smudge tool smears the initial color over the full length of your drag. At lower strengths, color isn't smeared over the entire distance. I used a setting of 90 on my toucan.

Smudge tool Cursor New Layer icon

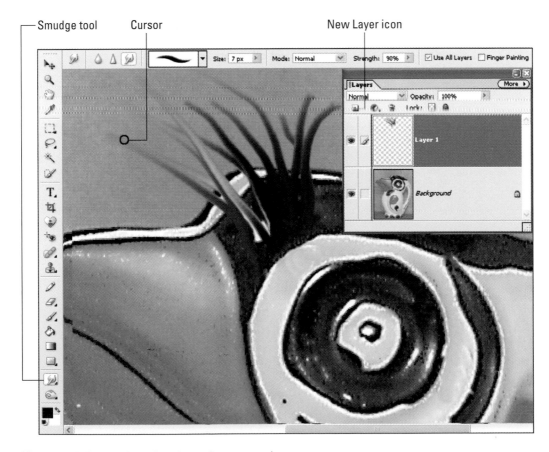

Figure 13-18: Drag with the Smudge tool to smear paint.

 ✓ **Use All Layers:** When you select this option, the Smudge tool smears colors from every visible image layer. This enables you to do your smudging on a layer separate from the rest of the photo, as shown in Figure 13-18. To create a new layer, click the New Layer icon in the Layers palette, visible in the figure. (See the section "Uncovering Layers of Possibility," later in this chapter, for more information about working with image layers.)

Spinning Pixels around the Color Wheel

Another way to play with the colors in your image is to use the Hue filter, if your photo editor provides one.

The Hue filter takes pixels on a ride around the color wheel, which is a circular graph of available hues. Red is located at the 0-degree position on the circle, green at 120 degrees, and blue at 240 degrees, as shown in Figure 13-19. When you apply the filter, you send pixels so many degrees around the wheel. If you start with red, for example, and set the filter value to 120 degrees, your pixel travels 120 degrees clockwise and becomes green.

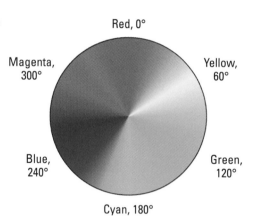

Figure 13-19: The Hue filter is based on the color wheel.

To change the apple color in the middle image in Figure 13-20, for example, I first selected the apple. Then I set the filter value to –83 degrees, spinning the red apple pixels counterclockwise around the wheel to the purple position.

Original | Hue | Filled

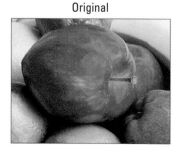 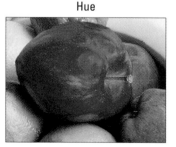 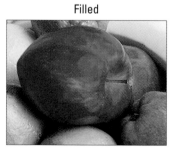

Figure 13-20: Changing colors via the Hue filter produces slightly different results than painting the pixels using the Color blending mode.

Compare this result with the apple on the right, which I filled with purple paint using the Color blending mode. At first glance, the results look similar. But with a Color-mode paint job, all pixels are filled with the same hue — in the apple, for example, you get lighter and darker shades of purple, but the basic color is purple throughout. The Hue filter shifted the red apple pixels to purple but shifted the yellowish-green areas near the center of the fruit to light pink. Also, a Color fill does not affect black or white pixels, while the Hue filter does not affect white, black, or gray pixels.

To recolor pixels with the Hue filter in Elements, first select those pixels, getting help from Chapter 12 if needed. Then choose Enhance⇨Adjust Color⇨ Adjust Hue/Saturation. You see the dialog box shown in Figure 13-21. Drag the Hue slider to shift the color of the selected area. (Turn on the Preview check box so that you can see the results of your changes in the image window.) Click OK to close the dialog box.

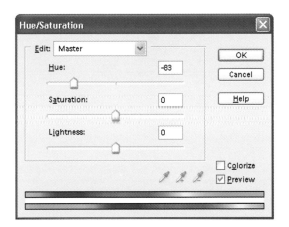

Figure 13-21: Drag the Hue slider to shift the color of all selected pixels.

Creating a Tinted or Grayscale Photo

Many digital cameras enable you to shoot grayscale or sepia-toned images. However, I suggest that you instead capture your images in full color and then create grayscale or sepia versions using your photo software. You get more control over the final image going that route. Additionally, although you can always use your photo software to go from full-color to grayscale or sepia, the opposite isn't possible.

Even the most basic photo-editing programs typically offer one-click filters for creating grayscale or sepia images. In Elements, for example, you can produce a grayscale photo by choosing Enhance➪Adjust Color➪Remove Color, as I did for the photo in Figure 13-22. (Be sure to choose Remove Color, not Remove Color Cast.)

Note that the Remove Color command turns your picture gray but leaves it in the RGB color mode, which means that you can then paint on the photo using colored paint if you like. When you paint using the Color blending mode, discussed earlier, you can create the look of a hand-tinted photo this way.

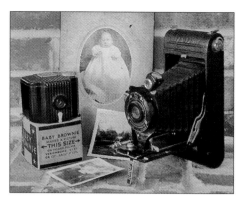

Elements doesn't provide a one-step sepia-toning filter, but the effect is easy to create just the same. Simply choose Enhance➪Adjust Color➪ Adjust Hue/Saturation to open the Hue/Saturation dialog box, as shown in Figure 13-23. Select the Colorize check box and then drag the Hue slider until you find a tint color you like. You're not limited to sepia

Figure 13-22: Most photo editors offer a one-click filter that converts a color photo to a grayscale image.

tones — you can choose any tint that suits your eye. Tweak the effect by using the Lightness and Saturation sliders in the dialog box.

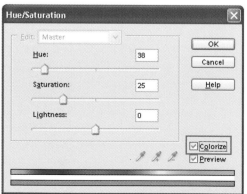

Figure 13-23: The Colorize option in the Hue/Saturation dialog box is the key to a sepia-toned photo in Elements.

Be sure to save your grayscale or tinted photo with a different name from the original! Otherwise, you overwrite the original image, and you can't get your original colors back if you need them later.

Uncovering Layers of Possibility

Photoshop Elements, Photoshop, and many other photo-editing programs provide an extremely useful feature called *layers*. Layers sometimes go by other names, such as Objects, Sprites, or Lenses. But whatever the name, this feature is key to creating many artistic effects and is also extremely helpful for ordinary retouching work.

To understand how layers work, think of those clear sheets of acetate used to create transparencies for overhead projectors. Suppose that on the first sheet, you paint a birdhouse. On the next sheet, you draw a bird. And on the third sheet, you add some blue sky and some green grass. If you stack the sheets on top of each other, the bird, birdhouse, and scenic background appear as though they are all part of the same picture.

Layers work just like that. You place different elements of your image on different layers, and when you stack all the layers on top of each other, you see the *composite image* — the elements of all the layers merged together. Where one layer is empty, pixels from the underlying layer show through.

You gain several image-editing advantages from layers:

- **You can shuffle the *stacking order* of layers to create different pictures from the same layers.** (Stacking order is just a fancy way of referring to the arrangement of layers in your image.) Figures 13-24 and 13-25 offer an example. Both images contain three layers: one for the pond and trees, one for the iguana, and one for the water lily. Next to each picture, you can see the Elements Layers palette, which shows the stacking order. Checkerboard areas indicate empty portions of the two top layers. (The next section details the palette.)

 The pond-and-trees scene occupies the bottom layer in both pictures. In the first image, I put the iguana on the second layer and placed the water lily on the top layer. Because the lily obscures most of the reptile layer, the picture appears to show nothing more menacing than a giant, mutant water lily. Reversing the order of the top two layers reveals that what appeared to be the stem of the flower actually is the tail of a science experiment gone wrong.

 To make the end of the tail appear to be immersed in the water, I partially erased it. You can read more about this technique in "Editing a multilayered image," later in this chapter.

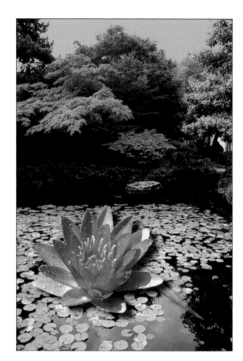 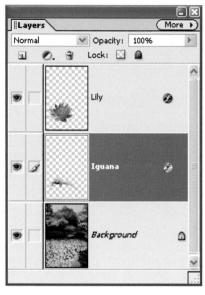

Figure 13-24: When the lily layer is at the top of the layer stack, it obscures the iguana that lives on the middle layer.

✔ **Layers make experimenting easier.** You can edit objects on one layer of your image without affecting the pixels on the other layers. So you can apply paint tools, retouching tools, and even image-correction tools to just one layer, leaving the rest of the image untouched. You can even move or delete an entire layer without repercussions.

Suppose that you wanted to get rid of the water lily, for example, so that the iguana would appear to walk on water. If the lily, reptile, and background all existed on the same layer, deleting the lily would leave a flower-shaped hole in the image. But because the three elements are on separate layers, you can simply delete the lily layer. In place of the jettisoned flower petals, the water from the background layer appears.

✔ **You can vary layer opacity to create different effects.** Figure 13-26 shows an example. Both images contain two layers: The rose is on the top layer, while the faded wood occupies the bottom layer. In the left image, I set the opacity of both layers to 100 percent. In the right image, I lowered the opacity of the rose layer to 50 percent so that the wood image is partially visible through the rose. The result is a ghostly rose that almost looks like part of the wood.

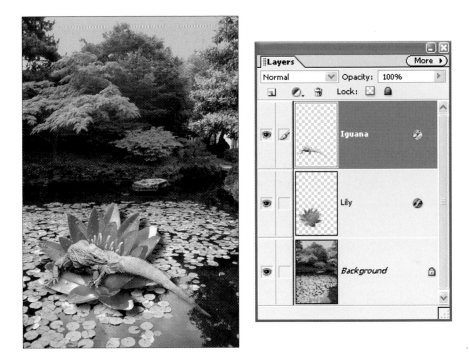

Figure 13-25: Swapping the order of the top two layers reveals the iguana

Figure 13-26: At left, the rose layer rests atop the wood layer at 100 percent opacity. At right, I set the rose layer opacity to 50 percent, turning the rose into a ghost of its former self.

✔ **You can vary how the colors in one layer merge with those in the underlying layers by applying different blending modes.** Layer blending modes work just like the fill and paint blending modes discussed earlier in this chapter. In Figure 13-27, for example, I set the rose layer back to 100 percent opacity. But instead of using the Normal blending mode, as I did for Figure 13-26, I set the rose layer's blending mode to Color Burn.

✔ **In some programs, you can apply an assortment of automatic layer effects.** Elements, for example, provides an effect that adds a drop shadow to the layer. If you move the layer, the shadow moves with it. (To explore the effects, open the Styles and Effects palette via the Window menu.) I took advantage of this feature to add subtle shadows underneath the water lily and iguana in Figures 13-24 and 13-25.

Figure 13-27: Here, the rose was layered on top of the wood at 100 percent opacity, but with the layer blending mode set to Color Burn.

Not all photo-editing programs provide all these layer options, and some entry-level programs don't provide layers at all. But if your program offers layers, I urge you to spend some time getting acquainted with this feature. I promise that you will never go back to unlayered editing after you do.

Layers do have one drawback, however: Each layer increases the file size of your image and forces your computer to expend more memory to process the image. So after you're happy with your image, you should smash all the layers together to reduce the file size — a process known as *flattening* or *merging,* in image-editing parlance.

After you merge layers, though, you can no longer manipulate or edit the individual layer elements without affecting the rest of the image. So if you think you may want to play around with the image more in the future, save a copy in a file format that supports layers. Check your software's Help system for specifics on flattening and preserving layers. If you want more specifics on using layers, the next sections provide some basics about layer functions in Elements. Although the steps for taking advantage of layer functions vary from program to program, the available features tend to be similar no matter what the program. So reading through the instructions I give for Elements should give you a head start on understanding your program's layering tools.

Working with Elements layers

To view, arrange, and otherwise manipulate image layers in Photoshop Elements, you need to display the Layers palette, shown in Figure 13-28. To open the palette, choose Window➪Layers. As I did elsewhere in this book, I dragged the palette out of the Palette Bin to create a free-floating entity.

Figure 13-28: The Layers palette is key to managing layers in Elements.

Here's a quick tour of the Layers palette:

- ✔ Each layer in the image is listed in the palette. To the left of the layer name is a thumbnail view of the layer contents.
- ✔ By default, transparent areas appear as a checkerboard pattern, as shown in the figure.
- ✔ Only one layer at a time is *active* — that is, available for editing. The active layer is highlighted in the Layers palette. In Figure 13-28, the Iguana layer is active. To make a different layer active, click its name in the palette.

✔ Speaking of layer names, they're assigned by default as Layer 1, Layer 2, and so on. To rename a layer, double-click its name in the palette.

✔ The eyeball icon indicates whether the layer is visible in the image. Click the icon to hide the eyeball and the layer. Click in the now-empty eyeball column to redisplay the layer.

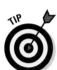

✔ You can quickly add or delete a layer by clicking the New Layer and Trash icons at the top of the palette. For more on adding and deleting layers, pass your peepers over the next section.

✔ Click the Adjustment Layer icon to create a special type of layer that enables you to apply color and exposure changes without permanently altering the original image. Space constraints prevent me from covering this feature, but it's very worthwhile to explore on your own.

✔ The Blending Mode menu and Opacity control enable you to adjust the way that pixels on a layer blend with pixels on the layer below. These controls work just like the blending mode and opacity controls described earlier, in the discussion about the paint tools and Fill command, except that the controls in the Layers palette affect pixels that already exist on a layer. By contrast, the controls for the paint tools and Fill command affect pixels that you're about to paint.

✔ The Lock controls near the top of the palette enable you to "lock" the contents of a layer, thereby preventing you from messing up a layer after you get it just so. The leftmost of the two lock controls prevents you from making any changes to transparent parts of the layer; the right control prevents you from altering the entire layer. However, in either case, you can still move the layer up and down in the layer stack.

✔ The little *f* icon to the right of a layer name indicates that you've applied a special effect via the Styles and Effects palette. Double-clicking the icon, labeled *Effects icon* in Figure 13-28, opens a dialog box where you can tweak the effect.

To preserve independent layers between editing sessions, you must save the image file in a format that *supports* layers — that is, can deal with the layers feature. In Elements, go with the program's native format, PSD, or TIFF. Be sure to select the Layers check box in the Save As dialog box as well. See Chapter 11 for more details about saving files.

Adding, deleting, and flattening layers

Every Elements image starts life with one layer, named *Background* layer. You can add and delete layers as follows:

✔ **Add a new, empty layer:** Choose Layer⇨New⇨Layer and then click OK in the resulting dialog box. Or, even faster, just click the New Layer icon in the Layers palette. (Refer to Figure 13-28.) Your new layer appears directly above the layer that was active at the time you clicked the icon. The new layer becomes the active layer automatically.

✓ **Duplicate a layer:** Drag the layer to the New Layer icon. Or click the layer in the Layers palette and then choose Layer⇨New⇨Layer via Copy.

✓ **Delete a layer:** Drag the layer name to the Trash icon in the Layers palette. Or click the layer name, choose Layer⇨Delete Layer, and then click Yes in the confirmation dialog box. All pixels on the layer disappear.

✓ **Combine all layers (*flatten* the image):** Flattening an image reduces the file size and the amount of muscle your computer needs to process your edits. After you flatten the image, however, you can no longer manipulate the layers independently. So you may want to make a backup copy of the picture in its multilayered state before you go ahead. Then choose Layer⇨Flatten Image.

✓ **Merge selected layers:** In addition to flattening all layers, you can merge just two or more selected layers:

- To merge a layer with the layer immediately underneath, click the upper layer in the pair and then choose Layer⇨Merge Down.

- To merge two layers that aren't adjacent, or to merge more than two layers, first hide the layers that you *don't* want to fuse together. (Click their eyeball icons in the Layers palette.) Then choose Layer⇨ Merge Visible. After you merge the visible layers, redisplay the hidden layers.

Editing a multilayered Image

Editing multilayered images involves a few differences from editing a single-layer image. Here's the scoop:

✓ **Changing layer stacking order:** Drag a layer name up or down in the Layers palette.

✓ **Selecting the entire layer:** To select an entire layer, just click its name in the Layers palette. For some commands, however, you must choose Select⇨Select All to create a layer-wide selection outline. (If a command that you want to use appears dimmed in a menu, this is likely the cause.)

✓ **Selecting part of a layer:** Use the selection techniques outlined in Chapter 12 to create a selection outline as usual. Then click the layer name in the Layers palette, if the layer isn't already the active layer.

A selection outline always affects the active layer, even if another layer was active when you created the outline.

✓ **Copy a selected area to a new layer:** Press Ctrl+J in Windows; press ⌘+J on a Mac. Or choose Layer⇨New⇨Layer via Copy. Your selection goes on a new layer immediately above the layer that was active when you made the copy.

✓ **Deleting a selection:** On any layer but the background layer, deleting a selection creates a transparent hole in the layer, and the underlying pixels show through the hole. If you delete a selection on the

background layer, the hole becomes filled with the current background color. (See the earlier section "Setting the paint color" to find out how to change the background color.)

✓ **Erasing on a layer:** On any layer but the background layer, you can also use the Eraser tool to rub a hole in a layer, as I did in Figure 13-29. In the top image, you see my iguana/flower combo as it originally appeared — notice the iguana's tail. I partially erased the end of the tail so that it appears to be under water, as shown in the lower image.

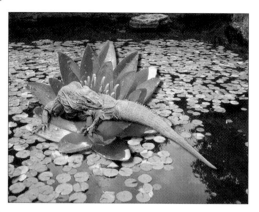

As with the Elements painting tools, you can adjust the impact of the Eraser by changing the Opacity value on the options bar. At 100 percent, you swipe the pixels clean; anything less than 100 percent leaves some of your pixels behind, making them translucent. For my iguana tail, I used a soft brush and set the tool opacity to 50 percent. Figure 13-30 shows this process. I hid the bottom, pond layer so that you can see what I'm erasing more clearly. Again, the checkerboard pattern indicates transparent pixels.

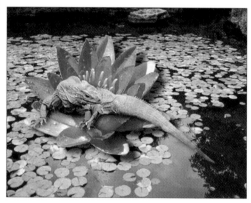

Figure 13-29: I used the Eraser tool to partially erase the end of the iguana's tail so that it looks as though it is under water.

✓ **Erasing on the background layer:** On the background (bottom) layer, applying the Eraser tool doesn't result in a transparent area. Instead, the erased area is filled with the current background color, just as when you delete something from the background layer.

✓ **Moving a layer:** Click the layer name in the Layers palette to select the layer. Then drag in the image window with the Move tool, labeled in Figure 13-30. If the Auto Select Layer check box is selected on the options bar, clicking any pixel on a layer automatically selects the layer that contains that pixel.

✓ **Transforming a layer:** After clicking the layer name in the Layers palette, use the commands on the Image⇨Transform and Image⇨Rotate menus to rotate, flip, and otherwise transform a layer. You can use the same

techniques and commands as when you transform a selection; Chapter 12 offers details. (Be sure to use the Rotate commands that include the word *Layer* in the name, or you affect the entire image.)

Resizing and rotating image elements can damage your image quality. You can typically reduce your image without harm, but don't try to enlarge the image very much, and don't rotate the same layer repeatedly.

✒ **Converting the background layer to a regular layer:** Click the background layer name in the Layers palette and then choose Layer⇨New⇨Layer from Background. Click OK in the dialog box that appears.

After you take this step, you can manipulate the background layer as you can any other layer. You also can make parts of the layer transparent. However, if you save the file in a format that doesn't support layers, any transparent pixels on the bottom layer are filled with solid color. When you save a file in the JPEG format, you can choose the color that fills those transparent areas; head to Chapter 10 for details.

Eraser ⌐ Move tool

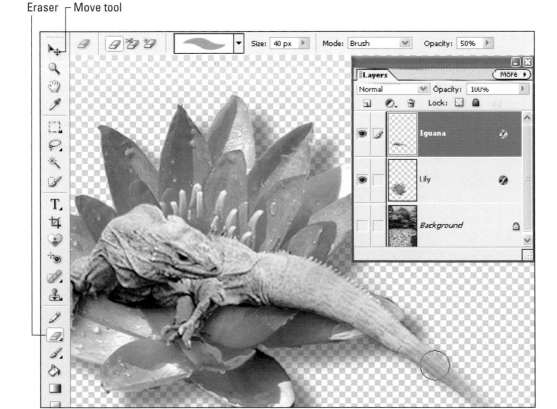

Figure 13-30: The checkerboard areas indicate transparent pixels.

Building a multilayered collage

Layers are useful on an everyday-editing basis because they provide you with more flexibility and security. But layers also shine in the creation of photo collages like the one in Figure 13-31. I put this collage together for a marketing piece for my part-time antiques business, which focuses on the kind of small, whimsical decorating items featured in the image.

Figure 13-31: Here you see the individual collage elements, shown according to their stacking order in the composite image.

To help you understand the process of creating a collage — and hopefully provide you with a little inspiration — the following list outlines the approach I took to produce this image:

1. I opened each of the collage images individually and did whatever color correction and touch-ups were needed to get the images in good shape. I also set the image resolution and dimensions using the steps outlined in Chapter 9. Then I saved and closed the images.

2. To begin building the collage, I first opened the brick image.

3. One by one, I opened the other collage images and selected, copied, and pasted the subjects into the brick picture. You can find out how to select, copy, and paste in Chapter 12.

4. I kept each collage element on its own layer, which meant eight layers altogether. You see the stacking order of the layers in Figure 13-31. I repositioned and rotated the individual layers, playing around with different compositions until I arrived at the final image.

 In a few cases, I scaled individual elements down slightly, using the Free Transform command discussed in Chapter 12. (Remember, reducing a photo element is usually harmless; enlarging it usually does noticeable damage.) With the exception of the elf's head and the bottle stopper (that's the little guy in the bowler hat), I oriented the objects in a way that moved at least some of the original image off the canvas area.

5. To make the elf's head appear partially in front of and partially behind the iron, I put the elf layer under the iron layer. Then I used the Eraser tool to wipe away the iron pixels around the elf's ears and chin.

6. I saved one copy of the image in its layered state so that I could retain the layers for further editing in case the mood to do some rearranging hit me. Then, because I needed to turn this image over to the folks in the publisher's production department for printing, I flattened the image and saved it as a TIFF file. (See Chapter 9 for details on saving TIFF files.)

Working with multiple images and large images such as this collage can strain even the most hardy computer system. So be sure to save your collage at regular intervals so that you're protected in the case of a system breakdown. And be sure to save in your photo software's native format; other formats may flatten all your layers together.

Turning Garbage into Art

Sometimes, no amount of color correction, sharpening, or other editing can rescue an image. The top-left photo in Figure 13-32 is an example. I shot this cityscape just past sunset, and I knew I was pushing the limits of my camera. Just as I feared, the image came out very grainy due to the dim lighting.

After trying all sorts of corrective edits, I decided that this image was never going to be acceptable in its "real" state. That is, I wasn't able to capture the scene with enough detail and brightness to create a decent printed or on-screen image. Still, I really liked the composition and colors of the picture. So I decided to use it as a basis for some digital creativity.

Original

Watercolor

Glowing Edges

Crystallize

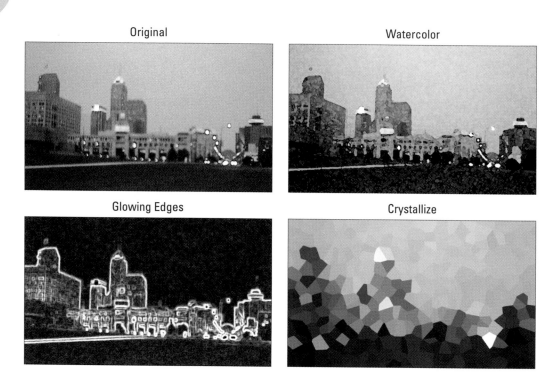

Figure 13-32: Don't delete out-of-focus or grainy pictures automatically; with the help of special effects filters, they may provide the basis for some interesting artwork.

By applying different special-effects filters, I created the three other images in the figure. For these pictures, I used filters found in Elements. You can find similar filters — or equally entertaining filters — in other programs.

In just a few seconds, I was able to take a lousy photograph and turn it into an interesting composition. And these samples are just the beginning of the creative work you can do. You can combine different filters, play with layering and blending modes, and use any of the other editing tricks discussed throughout this chapter and the others in this part of the book to create colorful, inventive artwork.

In other words, the artistic possibilities you can achieve with digital photos aren't limited to the scene you see when you look through the viewfinder. Nor are you restricted to the image that appears on your screen when you first open it in your photo software. So never give up on a rotten picture — if you look hard enough, you can find art in them-there pixels.

Part V
The Part of Tens

The 5th Wave By Rich Tennant

"I think you've made a mistake. We do photo retouching, not family portrai....Oooh, wait a minute — I think I get it!"

In this part . . .

Some people say that instant gratification is wrong. I say, phooey. Why put off until tomorrow what you can enjoy this minute? Heck, if you listen to some scientists, we could all get flattened by a plunging comet or some other astral body any day now, and then what will you have for all your waiting? A big fat nothing, that's what.

In the spirit of instant gratification, this part of the book is designed for those folks who want information right away. The three chapters herein present useful tips and ideas in small snippets that you can rush in and snag in seconds. Without further delay. *Now,* darn it.

Chapter 14 offers ten techniques for creating better digital images; Chapter 15 gives you ten suggestions for ways to use your images; and Chapter 16 lists ten great Internet resources for digital photographers.

If you like things quick and easy, this part of the book is for you. And if instant gratification is against your principles, you may want to . . . look up! I think that big, black ball in the sky is an asteroid, and it's headed this way!

14

Ten Ways to Improve Your Digital Images

In This Chapter

▷ Capturing the right number of pixels

▷ Choosing the optimum JPEG compression setting

▷ Composing a scene for maximum impact

▷ Lessening noise

▷ Perfecting your shutter-button technique

▷ Dissing digital zoom

▷ Correcting flaws inside your photo software

▷ Choosing paper for the best printed output

▷ Spending quality time with your camera

▷ Paying attention to the manufacturer's instructions

igital cameras have a high "wow" factor. That is, when you whip out your camera and start taking pictures, you have a good chance that some bystander will say, "Wow!" and ask for a closer look. Sooner or later, though, people stop being distracted by the flashy technology of your camera and start paying attention to the quality of the pictures you turn out. And if your images are poor, whether in terms of photo quality or composition, the initial "wows" turn to "ews," as in "Ew, that picture's *terrible*. You'd think after spending all that money on a digital camera, you could come up with something better than *that*."

So that you don't embarrass yourself — photographically speaking, anyway — this chapter presents ten ways to create better digital images. If you pay attention to these guidelines, your audience will be as captivated by your pictures as they are by your shiny digital camera.

Remember the Resolution!

When you print digital photos, the image output resolution — the number of pixels per linear inch, or ppi — has a big impact on picture quality, as illustrated by Figure 14-1. The first image has a resolution of 300 ppi; the second, 75 ppi.

Figure 14-1: The poor quality of the right image is due to a lack of pixels.

Most digital cameras offer a few different capture settings, each of which delivers a certain number of pixels. Before you take a picture, consider how large you may want to print the photo. Then select the capture setting that delivers enough pixels to print a good picture at that size. For most printers, you need at least 200 pixels per inch, so just multiply your desired print size by that number to determine your pixel requirements. (The Cheat Sheet at the front of the book offers a resolution reference table for math-haters in the crowd.) Your printer may produce better results when fed more pixels, however, so check the manual and experiment with different pixel counts.

Remember that you usually can get rid of excess pixels in your photo software without affecting picture quality, but you almost never get good results from adding pixels. In other words, it's better to wind up with too many pixels than too few.

For the complete lowdown on resolution, see Chapter 2.

Don't Overcompress Your Images

Today's digital cameras commonly store images in the JPEG *(jay-peg)* file format. As the image is saved, it goes through a process known as *JPEG compression.* JPEG compression dumps some image data in order to create smaller picture files, enabling you to fit more pictures on a memory card. This process is sometimes referred to as *lossy compression* because it results in a loss of picture data.

Most cameras give you a choice of JPEG settings, each of which applies a different amount of compression. In most cases, these settings have quality-related names — Best, Better, Good, for example, or Fine and Normal. That's appropriate because JPEG compression affects picture quality. The more JPEG compression you apply, the more image data you lose, and the lower the photo quality.

Some cameras also enable you to shoot in other formats, notably TIFF and Camera Raw, which do not apply lossy compression. Your picture files will be substantially larger, however, and you may notice little difference between a JPEG picture taken at the highest quality setting and a picture taken using the other two formats.

Compression and pixel count work together to determine picture quality. Combine heavy compression with too few pixels, and you get a blurry, blocky mess like you see in Figure 14-2. This image shows the low-resolution photo from Figure 14-2 after it was subjected to maximum JPEG compression.

To find out more about this issue, flip to Chapter 5.

Figure 14-2: Low resolution combined with heavy JPEG compression results in unacceptable picture quality.

Look for the Unexpected Angle

As explored in Chapter 7, changing the angle from which you photograph your subject can add impact and interest to the picture. Instead of shooting a subject straight on, investigate the unexpected angle — lie on the floor and get a bug's-eye-view, for example, or perch yourself on a sturdy chair and capture the subject from above.

As you compose your scenes, also remember the rule of thirds — divide the frame into vertical and horizontal thirds and position the main focal point of the shot at a spot where the dividing lines intersect. And quickly scan the frame for any potentially distracting background elements before you press the shutter button.

For more tips on how to take better digital photos, see Chapters 6 and 7.

Turn Down the Noise

Digital photos sometimes suffer from a defect called *noise,* which makes your image appear as though someone sprinkled colored sand over it. (Chapter 6 provides an illustration.)

You can combat noise in two ways:

- Add light, either by using your camera's flash or switching on some other light source. Noise typically appears when the lighting is too dim.

- If your camera offers a choice of *ISO settings,* try lowering the ISO value, too. This control increases your camera's sensitivity to light, allowing you to shoot in dim lighting. But on many cameras, a high ISO setting has the unwanted side effect of increasing noise. Of course, as you lower the ISO value, you need to add light to capture a good picture.

For times when you can't eliminate noise, see Chapter 11 for tips on how to soften the defect in a photo-editing program.

Press the Shutter Button Correctly

This tip usually sounds silly to people who hear it for the first time. But one of the most common reasons for improperly exposed or out-of-focus pictures is improper shutter-button technique.

Most digital cameras feature automatic exposure and automatic focus. For these automatic mechanisms to work correctly, you must take a two-step approach to snapping a picture.

After framing the shot, press the shutter button halfway and hold it there. In a second or two, the camera beeps or displays a light, which is your signal that the focus and exposure have been set. You can then press the shutter button the rest of the way to record the image.

If you merely jab the shutter button down in one quick press, you don't give the camera the brief moment it needs to set exposure and focus properly.

Turn Off Digital Zoom

Digital zoom is a feature offered on most digital cameras. From its name, you'd naturally expect that digital zoom does the same thing as an optical (traditional) zoom lens — that is, make faraway objects appear closer and larger in the frame.

In truth, though, digital zoom is simply a software process that enlarges the existing image and then crops away the perimeter. You get exactly the same results as if you had done this enlarging and cropping in a photo-editing program. As covered in Chapter 2, enlarging a digital photo can reduce picture quality, which is why I recommend turning off digital zoom.

Digital zoom also does not affect *depth of field* — the zone of sharp focus — like a real zoom lens. For more about depth of field and working with an optical zoom, see Chapters 6 and 7, respectively.

Take Advantage of Your Photo Editor

Don't automatically toss photos that don't look as good as you would like. With some judicious use of your photo software's retouching tools, you can brighten underexposed images, correct color balance, crop out distracting background elements, and even cover up small blemishes.

Part IV explores some basic techniques you can use to enhance your images. Some are simple, requiring just one click of the mouse button. Others involve a bit more effort but are still easily mastered if you put in a little time.

Being able to edit your photographs is one of the major advantages of digital photography. So take a few minutes each day to become acquainted with your photo software's correction commands, filters, and tools. After you start using them, you'll wonder how you got along without them.

Print Your Images on Good Paper

As discussed in Chapter 9, the type of paper you use when printing your images can have a dramatic effect on how your pictures look. The same picture that appears blurry, dark, and oversaturated when printed on cheap copy paper can look sharp, bright, and glorious when printed on special glossy photographic paper.

If you're having your digital photos printed at a retail lab, you can count on getting good quality paper. But if you're doing the job on a home printer, check your printer's manual for information on the ideal paper to use with your model. Some printers are engineered to work with a specific brand of paper, but don't be afraid to experiment with paper from other manufacturers. Paper vendors are furiously developing new papers that are specifically designed for printing digital images on consumer-level color printers, so you may just find something that works even better than the recommended paper.

Practice, Practice, Practice!

Digital photography is no different from any other skill in that the more you do it, the better you become. So shoot as many pictures as you can, in as many different light situations as you can. As you shoot, jot down the camera settings you used and the lighting conditions at the time you snapped the image. Later, evaluate the pictures to see which settings worked the best in which situations.

If your camera stores the capture settings as EXIF metadata in the image file, as most new cameras do, you don't need to bother writing down settings for each shot. Instead, you can use a special piece of software to view the capture settings for each image that you download to your computer. See Chapter 4 for more information on this option.

After you spend some time experimenting with your camera, you'll start to gain an instinctive feel for what tactics to use in different shooting scenarios, increasing the percentage of great pictures in your portfolio. As for those pictures that don't make the grade, keep them to yourself, suggests Alfred DeBat, technical editor for this book and an experienced professional photographer. "Never share your bad photos! Show your friends and family ten really outstanding pictures, and they will say, 'Wow! You really are a great photographer.' If you show them 50 great photos and 50 mediocre shots, they won't be impressed with your abilities. So bury your bad pictures if you want to build a reputation as a good photographer."

Read the Manual (Gasp!)

Remember that instruction manual that came with your camera? The one you promptly stuffed in a drawer without bothering to read? Go get it. Then sit down and spend an hour devouring every bit of information inside it.

I know, I know. Manuals are deadly boring, which is why you invested in this book, which is so dang funny you find yourself slapping your knee and snorting milk through your nose at almost every paragraph. But you aren't going to get the best pictures out of your camera unless you understand how all its controls work. I can give you general recommendations and instructions in this book, but for camera-specific information, the best resource is the manufacturer's own manual.

After your initial read-through, drag the manual out every so often and take another pass at it. You'll probably discover the answer to some problem that's been plaguing your pictures or be reminded of some option that you forgot was available. In fact, reading the manual has to be one of the easiest — and most overlooked — ways to get better performance out of your camera.

Ten Great Uses for Digital Images

In This Chapter

▷ Posting online photo albums

▷ Turning your favorite pictures into a screen saver

▷ Pasting photo wallpaper onto your computer desktop

▷ Creating "oil paintings" and other digital art out of photos

▷ Putting your smiling face on a coffee cup or T-shirt

▷ Publishing custom calendars, greeting cards, or stationery

▷ Adding pictures to spreadsheets and databases

▷ Creating photo name badges and business cards

▷ Showing 'em what you mean

▷ Printing and framing your best work

Most people are aware of the two most common uses for digital images: adding pictures to Web sites and sending photos via e-mail. But sharing pictures online is just the start of the fun. This chapter introduces you to several creative photo projects, including turning a picture into digital art and publishing a photo calendar. And just in case you need a reason other than pleasure to justify your camera purchase, this chapter also suggests some practical business and household uses for digital photos.

Creating Online Photo Albums

Want an easy way to show off your pictures? Check out online photo-sharing sites. Using simple tools provided at these sites, you can create digital photo albums and post them online. You can then invite friends and family to view your pictures at the site. Even better, the people who view your albums can order prints through the site, saving you the trouble and expense of making copies for everyone.

Posting and sharing albums is usually free. You pay only for prints that you order. To get started, check out these leading photo-sharing sites:

- www.kodakgallery.com (formerly Ofoto)
- www.shutterfly.com
- www.snapfish.com

Chapter 10 offers a look at an online album that I created at Snapfish; you can get a glimpse of the Kodak photo-sharing site in Chapter 1.

One word of caution: Don't rely on a photo-sharing site for storage of important, irreplaceable photos. If the site experiences problems with its equipment — or worse, goes out of business — you can lose your photos. Many sites delete your online images if you don't buy any prints or other photo products within a certain period of time, too. See Chapter 4 for guidance about more secure image-storage options.

Putting Together a Screen Saver

In the early years of computing, a monitor could be damaged if the same text or graphics stayed on-screen for a long time. To address that problem, the *screen saver* was born. A screen saver is a series of images that display automatically any time the system is idle for a period of time.

With today's monitors, screen savers aren't necessary, but they do offer a great way to display your favorite photos. You can replace the generic screen savers that ship with most computers with a custom screen saver that features your favorite images.

Before you begin, make sure that your photos are in the JPEG file format. If not, follow the instructions in Chapter 10 for saving JPEG files.

Here's how to create a screen saver in Windows XP:

1. **Put the pictures that you want to use for the screen saver in the My Pictures folder.**

 This folder is located within the My Documents folder on your computer's hard drive.

2. **Right-click an empty area of the computer desktop to display a small pop-up menu.**

3. **On the pop-up menu, click Properties.**

 You see the Display Properties dialog box.

4. **Click the Screen Saver tab to reveal the options shown in Figure 15-1.**

Display Properties

Themes | Desktop | Screen Saver | Appearance | Settings

Screen saver

My Pictures Slideshow

(None)
3D FlowerBox
3D Flying Objects
3D Pipes
3D Text
ACDSee Screen Saver
Beziers
Blank
Jasc Paint Shop Photo Album 5
Marquee
My Pictures Slideshow
Mystify
PhotoShow
Starfield
Windows XP

Settings | Preview

ume, password protect

power settings and save energy,

Power...

Cancel | Apply

Figure 15-1: Use your favorite photos as a screen saver.

5. **From the Screen Saver drop-down list, choose My Pictures Slideshow, as shown in the figure.**

 The photos in your My Pictures folder start to scroll through the preview area at the top of the dialog box. You can customize the screensaver operation by using the options underneath the drop-down list. Click the Settings button to access additional options.

6. **Click OK to close the dialog box.**

If you're a Mac user, the following steps show you how to create a screen saver in OS X:

1. **Put the images you want to use for your screen saver in a single folder.**

 The folder name and location don't matter; just make sure that the folder contains only your screen saver images.

2. **Open the Apple menu and choose System Preferences.**

 The System Preferences dialog box appears.

3. **Click the Show All icon in the upper-left corner of the dialog box.**

 The dialog box now displays icons for all the available preferences settings.

4. **Click the Desktop & Screen Saver icon.**

5. **Click the Screen Saver button to display the options shown in Figure 15-2.**

6. **In the left side of the dialog box, select the folder that contains your screen-saver photos.**

 The preview area starts displaying the photos in the folder. Customize the screen saver operation by using the options underneath the preview. Click the Options button to uncover additional settings.

7. **Close the Desktop & Screen Saver dialog box.**

Figure 15-2: In Mac OS X, head for the Desktop & Screen Saver area of the System Preferences dialog box.

If you have trouble with any part of this process, your photo-editing program or cataloging software may provide some assistance. Many entry-level programs offer a wizard that automatically sets up a screen saver.

Hanging Photo Wallpaper

Wallpaper is the official name of the image that appears on your computer *desktop* — the main computer screen. Instead of sticking with the standard Windows or Mac wallpaper, you can plaster one of your favorite photos on the desktop, as I did in Figure 15-3.

Figure 15-3: Select a favorite photo to use as your desktop wallpaper.

If you want the photo to fill a specific amount of the desktop, visit Chapter 10 for instructions on how to size photos for the screen.

As with screen saver photos, make sure that your wallpaper photo is in the JPEG format. See Chapter 10 if you need help saving a file in that format. (You may be able to use other formats, too, depending on your operating system.)

In Windows XP, follow these steps:

1. **Open the Desktop Properties dialog box.**

 You can do so by right-clicking an empty area of the computer desktop and then choosing Properties from the pop-up menu.

2. **Inside the dialog box, click the Desktop tab to display the options shown in Figure 15-4.**

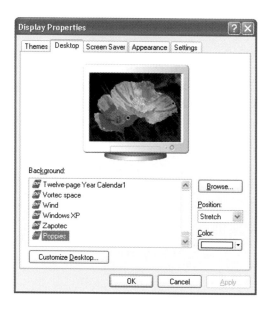

Figure 15-4: Click the Browse button to select the photo you want to use as your wallpaper.

3. **Click the Browse button to open the Browse dialog box.**

This dialog box works like any dialog box you use to open a picture file.

4. **Select the photo you want to use and click Open to close the Browse dialog box.**

Your picture appears in the preview area of the Desktop Properties dialog box, as shown in Figure 15-4. Use the other dialog box options to customize your new wallpaper and then click OK.

Here are the steps in Mac OS X:

1. **Choose System Preferences from the Apple menu to open the System Preferences dialog box.**

2. **Click the Desktop & Screen Saver icon.**

Don't see the icon? Click the Show All icon at the top of the dialog box. The dialog box then displays all the available System Preferences icons.

3. **Click the Desktop button inside the Desktop & Screen Saver dialog box.**

4. **Using the folder list on the left side of the dialog box, locate the folder that contains your photo.**

5. **In the thumbnail area of the dialog box, click the thumbnail for the photo you want to use.**

 You can customize the wallpaper using the other options in the dialog box. Close the dialog box when you finish.

Giving Photos an Artistic Twist

Nearly every photo-editing program offers an assortment of special-effects filters. Many of these filters make your photo appear as if you created it using traditional art media — oil paint, watercolor, chalk, and so on. Other filters create wild, futuristic effects, like the one you see in the right image in Figure 15-5. I created this effect using the Glowing Edges filter in Photoshop Elements.

Figure 15-5: I created this cool effect using a simple, one-step filter in Photoshop Elements.

Aside from offering a fun creative endeavor, special-effects filters can help rescue a picture that's slightly out of focus. Try applying a watercolor filter to your soft-focus pictures, for example. A real watercolor painting usually has a soft look, so no one will be the wiser that your original photo wasn't sharp as a tack. See Chapter 13 for some more examples of using special effects to hide picture flaws.

Putting Your Mug on a Mug

If you own a photo printer, it may come with accessories that enable you to put your images on mugs, T-shirts, and other objects. Online photo-sharing sites such as those listed earlier in this chapter also can create these photo wares for you.

Being a bit of a jaded person, I expected rather cheesy results from these kinds of projects. But after I created my first set of mugs and saw the professional-looking results, I was hooked. I chose four different images featuring my parents, my sisters, and my nieces and nephews and placed each image on a different mug.

Call me sentimental, but I can envision these mugs being around for generations (assuming nobody breaks one, that is) to serve as a reminder of how we twentieth-century Kings once looked. Hey, 100 years ago, nobody thought that old tintype photographs would be considered heirlooms, right? So who's to say that my photographic mugs won't be treasured tomorrow? In the meantime, the family members who have laid claim to the mugs I created seem to be treasuring them today.

Printing Photo Calendars and Cards

Many photo-editing programs include templates that enable you to create customized calendars featuring your images. The only decision you need to make is which picture to put on December's page and which one to use on July's. You can also find templates for designing personalized greeting cards and stationery.

If your photo editor doesn't include such templates, check the software that came with your printer. Many printers now ship with tools for creating calendars and similar projects.

When you want more than a handful of copies of your creation, you may want to have the piece professionally reproduced instead of printing each copy one by one on your own printer. You can take the job to a quick-copy shop or to a commercial service bureau or printer. Most online photo-sharing sites also offer this service.

Including Visual Information in Databases

You can add digital images to company databases and spreadsheets in order to provide employees with visual as well as text information. For example, if you work in human resources, you can insert employee pictures into your employee database. Or if you're a small-business owner and maintain a product inventory in a spreadsheet program, you can insert pictures of individual products to help you remember which items go with which order numbers. Chapter 1 includes an example of a spreadsheet that I created in Microsoft Excel to track the inventory in my antique shop.

Merging text and pictures in this fashion isn't just for business purposes, though. You can take the same approach to create a household inventory for your personal insurance records, for example.

Putting a Name with the Face

You can put digital pictures on business cards, employee badges, and nametags for guests at a conference or other large gathering. I love getting business cards that include the person's face, for example, because I'm one of those people who never forgets a face but almost always has trouble remembering the name.

Several companies now offer special, adhesive-backed sticker paper for inkjet printers. This paper is perfect for creating badges or nametags. After printing the image, you simply stick it onto your preprinted badge or nametag.

Exchanging a Picture for a Thousand Words

Don't forget the power of a photograph to convey an idea or describe a scene. Did your roof suffer damage in last night's windstorm? Take pictures of the damage and e-mail them to your insurance agent and roofing contractor. Looking for a bookcase that will fit in with your existing office decor? Take a picture of your office to the furniture store, and ask the designer for suggestions.

Written descriptions can be easily misunderstood and also take a lot longer to produce than shooting and printing a digital image. So don't tell people what you want or need — show 'em!

Hanging a Masterpiece on Your Wall

Many ideas discussed in this chapter capitalize on the special capabilities that going digital offers you — the ability to display images on-screen, incorporate them into publishing projects, and so on. But you can also take a more traditional approach and simply print and frame your favorite images.

Getting prints made is easier and cheaper than ever, too. You can simply take your camera memory card into any retail photofinishing lab and have prints made in an hour, just as you can do with film. Or, for even more convenience, you can upload your picture files to the lab's Web site, place your order, and pick up the prints when time permits. You can even have those prints made at a lab across the country — a great way to get your pictures to faraway friends and family.

Of course, you can always print your own pictures on a home or office photo printer, too. Today's printers produce excellent results, and you can choose from a variety of specialty papers to lend some additional interest to your prints.

For details about both retail and do-it-yourself printing, visit Chapter 9. That chapter also provides tips for making sure that your prints don't fade or otherwise deteriorate before their time.

Ten Great Online Resources for Digital Photographers

In This Chapter

▶ Digital Photography Review

▶ Imaging Resource

▶ Megapixel.net

▶ PCPhoto Magazine

▶ PCPhotoREVIEW.com

▶ Shutterbug

▶ Digital photography newsgroup

▶ Printing newsgroup

▶ Manufacturer Web sites

▶ This book's Web site

*I*t's 2 a.m. You're aching for inspiration. You're yearning for answers. Where do you turn? No, not to the refrigerator. Well, okay, maybe just to get a little snack — some cold pizza or leftover chicken wings would be good — but then it's off to the computer for you. Whether you need solutions to difficult problems or just want to share experiences with like-minded people around the world, the Internet is the place to turn. At least, it is for issues related to digital photography. For anything else, talk to your spiritual leader, psychic hotline, Magic 8-Ball, or whatever source you usually consult.

This chapter points you toward some of my favorite online digital photography resources. New sites are springing up every day, so you can no doubt uncover more great pages to explore by doing a Web search on the words "digital photography" or "digital cameras."

 Note that the site descriptions provided in this chapter are current as of press time. But because Web sites are always evolving, some of the specific features mentioned may be updated or replaced by the time you visit a particular site.

Digital Photography Review

www.dpreview.com

Click here for a broad range of digital photography information, from news about recently released products and promotional offers to discussion groups where people debate the pros and cons of different camera models. An educational section of the site is provided for photographers interested in delving into advanced picture-taking techniques.

Imaging Resource

www.imaging-resource.com

Point your Web browser to this site for equipment-buying advice and digital photography news. An especially helpful "Getting Started" section of the site offers thorough, easy-to-understand answers to frequently asked questions about choosing and using digital cameras. In-depth product reviews and discussion forums related to digital photography round out this well-designed site.

Megapixel.net

www.megapixel.net

Home to a monthly online magazine offered in English and French, this site offers in-depth product reviews and technical information, as well as articles covering all aspects of digital photography. The site also maintains an excellent glossary of photographic terms and is home to several discussion groups.

PCPhoto Magazine

www.pcphotomag.com

Geared to beginning digital photographers, the bimonthly print magazine *PCPhoto* makes articles from past issues available at its Web site. Along with equipment reviews, the magazine offers tutorials on photography and photo editing as well as interviews with noted photographers.

PCPhotoREVIEW.com

www.pcphotoreview.com

Whether you're shopping for your first camera or looking for accessories to enhance your digital photography fun, this site helps you make good choices. You can find hardware and software reviews as well as discussion groups where you can share information with other users. A glossary of digital photography terms and explanations of camera features make this site even more useful.

Shutterbug

www.shutterbug.net

At this site, you can explore the online version of the respected magazine *Shutterbug,* which offers how-to articles and equipment reviews related to both film and digital photography. Comprehensive reviews provide extensive information about digital cameras and other imaging tools.

Digital Photography Newsgroup

rec.photo.digital

For help with specific technical questions as well as an interesting exchange of ideas about equipment and approaches to digital photography, subscribe to the rec.photo.digital newsgroup. (For the uninitiated, a *newsgroup,* also called a *discussion group,* is not a Web site, but a discussion forum where folks with similar interests send messages back and forth about a particular topic.)

Many of the people who participate in this newsgroup have been working with digital imaging for years, while others are brand new to the game. Don't be shy about asking beginner-level questions, though, because the experts are happy to share what they know.

You can use your Web browser's newsgroup reader to participate (the software's Help system should explain how). Or point your browser to www.google.com to access a newsgroup portal offered by the popular Google search engine. Click the Groups link to load the main newsgroup page. Then type the newsgroup name in the Search box and click the Search button to display newsgroup messages.

Printing Newsgroup

comp.periphs.printers

Shopping for a new photo printer? Having trouble making your existing printer work correctly? Check out this newsgroup, which deals specifically with issues related to printing.

Newsgroup members debate the pros and cons of different printer models, share troubleshooting tips, and discuss ways to get the best possible output from their machines.

Manufacturer Web Sites

Just about every manufacturer of digital-imaging hardware and software maintains a Web site. Typically, their sites are geared to marketing the company's products, but many also offer terrific tutorials and other learning resources for newcomers to digital photography. Sites that rank high on my list include the following:

- **Kodak (www.kodak.com):** Take a look at the Taking Great Pictures area.

- **HP (www.hp.com):** Take advantage of the free online classes offered in the Home and Home Office section of the site.

- **Fujifilm (www.fujifilm.com):** Find your way to the Picture Your Life pages offered in the Consumer Products section of this site.

- **Wacom Technologies (www.wacom.com):** Click the Tips link for photo retouching tips and creative inspiration.

- **Adobe (www.adobe.com):** Travel via the Support link to the Adobe Studio area for tutorials and feature articles related to photo editing and digital painting.

Many vendors also make updates to software available through their Web sites. For example, you may be able to download an updated printer driver or a patch that fixes a bug in your photo software.

This Book's Companion Site

www.dummies.com/go/digitalphotofd5e

Bookmark the companion site for this book, too. I've posted the sample images shown in Figure 16-1 so that you can work along with the projects and examples. To keep download times short, the photos are low-resolution copies of the pictures used in the book. All pictures are in the JPEG format. (Forgive me for not including images that feature people; I know you'll understand that I don't feel comfortable putting pictures of friends and family online for all the world to access.)

You can also find links to software vendor Web sites here. At many of these sites, you can download free trials of the programs mentioned in this book. It's a great way to "try before you buy" and make sure that a program really meets your needs.

Figure 16-1: You can find these images on the book's companion Web site.

Glossary

. .

*C*an't remember the difference between a pixel and a bit? Resolution and resampling? Turn here for a quick refresher on that digital photography term that's stuck somewhere in the dark recesses of your brain and refuses to come out and play.

24-bit image: An image containing approximately 16.7 million colors.

aliasing: Random color defects, usually caused by too much JPEG compression.

aperture: An opening made by an adjustable diaphragm, which permits light to enter the camera lens and reach the image sensor.

aperture-priority autoexposure: A semi-automatic exposure mode; the photographer sets the aperture, and the camera selects the appropriate shutter speed to produce a good exposure.

artifact: Noise, an unwanted pattern, or some other defect caused by an image capture, file compression, or a processing problem.

aspect ratio: The proportions of an image. 35mm film has an aspect ratio of 3:2; the standard digital camera aspect ratio is 4:3.

autoexposure: A feature that puts the camera in control of choosing the proper exposure settings. *See also* aperture-priority autoexposure and shutter-priority autoexposure.

bit: Stands for *binary digit;* the basic unit of digital information. Eight bits equals one *byte.*

bit depth: Refers to the number of bits available to store color information. A standard digital camera image has a bit depth of 24 bits. Images with more than 24 bits are called *high-bit images.*

burst mode: A special capture setting, offered on some digital cameras, that records several images in rapid succession with one press of the shutter button. Also called *continuous capture* mode.

byte: Eight bits. *See* bit.

Camera Raw: A file format offered by some digital cameras; records the photo without applying any of the in-camera processing that is usually done automatically when saving photos in other formats. Also known as *Raw.*

CCD: Short for *charge-coupled device.* One of two types of imaging sensors used in digital cameras.

CIE Lab: A color model developed by the Commission Internationale de l'Eclairage. Used mostly by digital-imaging professionals.

cloning: The process of copying one area of a digital photo and "painting" the copy onto another area or picture.

CMOS: Pronounced *see-moss.* A much easier way to say *complementary metal-oxide semiconductor.* A type of imaging sensor used in digital cameras; used less often than CCD chips.

CMYK: The print color model, in which cyan, magenta, yellow, and black inks are mixed to produce colors.

color correction: The process of adjusting the amount of different colors in an image (for example, reducing red or increasing green).

color model: A way of defining colors. In the RGB color model, for example, all colors are created by blending red, green, and blue light. In the CMYK model, colors are produced by mixing cyan, magenta, yellow, and black ink.

color temperature: Refers to the amount of red, green, and blue light emitted by a particular light source.

CompactFlash: A type of removable memory card used in many digital cameras. A miniature version of a PC Card — about the size and thickness of a matchbook.

compositing: Combining two or more images in a photo-editing program.

compression: A process that reduces the size of the image file by eliminating some image data.

depth of field: The zone of sharp focus in a photograph.

digital zoom: A feature offered on most digital cameras; crops the perimeter of the image and then enlarges the area at the center. Results in reduced image quality.

downloading: Transferring data from one computer device to another.

dpi: Short for *dots per inch.* A measurement of how many dots of color a printer can create per linear inch. Higher dpi means better print quality on some types of printers, but on other printers, dpi is not as crucial.

DPOF: Stands for *digital print order format.* A feature offered by some digital cameras that enables you to add print instructions to the image file; some photo printers can read that information when printing your pictures directly from a memory card.

driver: Software that enables a computer to interact with a digital camera, printer, or other device.

dye-sub: Short for *dye-sublimation.* A type of printer that produces excellent digital prints.

edges: Areas where neighboring image pixels are significantly different in color; in other words, areas of high contrast.

EV compensation: A control that slightly increases or decreases the exposure chosen by the camera's autoexposure mechanism. EV stands for exposure value; EV settings typically appear as EV 1.0, EV 0.0, EV –1.0, and so on.

EVF: An electronic viewfinder, which delivers an electronic pixel version of what the camera lens actually captures through a small viewfinder display. Different from an optical viewfinder, which employs lenses to approximate the camera lens view.

EXIF metadata: *See* metadata.

file format: A way of storing image data in a file. Popular image formats include TIFF and JPEG.

flash EV compensation: A feature that enables the photographer to adjust the strength of the camera flash.

FlashPix: A file format used by some earlier models of digital cameras; now supported by only a handful of software programs.

f-number, f-stop: Refers to the size of the camera aperture. A higher number indicates a smaller aperture. Written as f/2, f/8, and so on.

gamut: Say it *gamm-ut.* The range of colors that a monitor, printer, or other device can produce. Colors that a device can't create are said to be *out of gamut.*

Gaussian blur: A type of blur filter available in many photo-editing programs; named after a famous mathematician.

GIF: Short for *graphics interchange format.* A file format often used for Web graphics; not suitable for photos because it can't handle more than 256 colors.

gigabyte: Approximately 1,000 megabytes, or 1 billion bytes. In other words, a really big collection of bytes. Abbreviated as GB.

grayscale: An image consisting solely of shades of gray, from white to black.

histogram: A graph that maps out brightness values in a digital image; usually found inside exposure-correction filter dialog boxes.

HSB: A color model based on hue (color), saturation (purity or intensity of color), and brightness.

HSL: A variation of HSB, this color model is based on hue, saturation, and lightness.

ISO: Traditionally, a measure of film speed; the higher the number, the faster the film. On a digital camera, raising the ISO allows faster shutter speed, smaller aperture, or both, but also can result in a grainy image.

jaggies: Refers to the jagged, stair-stepped appearance of curved and diagonal lines in low-resolution photos that are printed at large sizes.

JPEG: Pronounced *jay-peg*. The primary file format used by digital cameras; also the leading format for online and Web pictures. Uses *lossy compression,* which sometimes damages image quality.

JPEG 2000: An updated version of the JPEG format; not yet fully supported by all Web browsers or other computer programs.

Kelvin: A scale for measuring the color temperature of light. Sometimes abbreviated as *K*, as in 5000K. (But in computerland, the initial *K* more often refers to kilobytes, as described next.)

kilobyte: One thousand bytes. Abbreviated as *K*, as in 64K.

LCD: Stands for *liquid crystal display.* Often used to refer to the display screen included on most digital cameras.

lossless compression: A file-compression scheme that doesn't sacrifice any vital image data in the compression process. Lossless compression tosses only redundant data, so image quality is unaffected.

lossy compression: A compression scheme that eliminates important image data in the name of achieving smaller file sizes. High amounts of lossy compression reduce image quality.

marquee: The dotted outline that results when you select a portion of your image; sometimes referred to as *marching ants.*

megabyte: One million bytes. Abbreviated as MB. *See* bit.

megapixel: One million pixels.

Memory Stick: A memory card used by most Sony digital cameras and peripheral devices. About the size of a stick of chewing gum.

metadata: Extra data that gets stored along with the primary image data in an image file. Metadata often includes information such as aperture, shutter speed, and EV setting used to capture the picture, and can be viewed using special software. Often referred to as *EXIF metadata;* EXIF stands for *Exchangeable Image File Format.*

metering mode: Refers to the way a camera's autoexposure mechanism reads the light in a scene. Common modes include spot metering, which bases exposure on light in the center of the frame only; center-weighted metering, which reads the entire scene but gives more emphasis to the subject in the center of the frame; and matrix, pattern, or multizone metering, which calculates exposure based on the entire frame.

MultiMediaCard: A type of memory card used by some digital cameras.

noise: Graininess in an image, caused by too little light, a too high ISO setting, or a defect in the electrical signal generated during the image-capture process.

NTSC: A video format used by televisions and VCRs in North America. Many digital cameras can send picture signals to a TV or VCR in this format.

optical zoom: A traditional zoom lens; has the effect of bringing the subject closer and shortening depth of field.

output resolution: The number of pixels per linear inch (ppi) in a printed photo; the user sets this value inside a photo-editing program.

PAL: The video format common in Europe and several other countries. Some digital cameras sold in North America can output pictures in this video format (*see also* NTSC).

PCMCIA Card: A type of removable memory card used in some digital cameras. Now often referred to simply as PC Cards. (PCMCIA stands for *Personal Computer Memory Card International Association.*)

PictBridge: A universal standard that allows digital cameras and photo printers to connect directly by USB cable, without the computer serving as a middleman. Any PictBridge camera can connect to any PictBridge printer, regardless of whether both are made by the same manufacturer.

pixel: Short for *picture element.* The basic building block of every image.

platform: A fancy way of saying "type of computer operating system." Most folks work either on the Windows platform or the Macintosh platform.

plug-in: A small program or utility that runs within another, larger program. Many special-effects filters operate as plug-ins to major photo-editing programs such as Adobe Photoshop Elements.

ppi: Stands for *pixels per inch.* Used to state image output (print) resolution. Measured in terms of the number of pixels per linear inch. A higher ppi usually translates to better-looking printed images.

Raw: *See* Camera Raw.

Raw converter: A software utility that translates Camera Raw files into a standard format that photo-editing programs can read. Required to open or edit Raw files.

resampling: Adding or deleting image pixels. A large amount of resampling degrades images.

resolution: A term used to describe the capabilities of digital cameras, scanners, printers, and monitors; means different things depending on the device. (See Chapter 2 for details.)

RGB: The standard color model for digital images; all colors are created by mixing red, green, and blue light.

SD Card: A type of memory card used in many digital cameras; stands for *Secure Digital.*

sharpening: Applying an image-correction filter inside a photo editor to create the appearance of sharper focus.

shutter: The device in a camera that opens and shuts to allow light into the camera.

shutter-priority autoexposure: A semi-automatic exposure mode in which the photographer sets the shutter speed and the camera selects the appropriate aperture.

shutter speed: The length of time that the camera shutter remains open, thereby allowing light to enter the camera and expose the photograph.

slow-sync flash: A special flash setting that allows (or forces) a slower shutter speed than is typical for the normal flash setting. Results in a brighter background than normal flash.

SmartMedia: A thin, matchbook-sized, removable memory card used in some digital cameras.

TIFF: Pronounced *tiff,* as in a little quarrel. Stands for *tagged image file format.* A popular image format supported by most Macintosh and Windows programs.

TWAIN: Say it *twain,* as in "never the twain shall meet." A special software interface that enables image-editing programs to access images captured by digital cameras and scanners.

unsharp masking: The process of using the Unsharp Mask filter, found in many image-editing programs, to create the appearance of a more focused image. The same thing as *sharpening* an image, only more impressive sounding.

uploading: The same as downloading; the process of transferring data between two computer devices.

USB: Stands for *Universal Serial Bus.* A type of port now included on most computers. Most digital cameras come with a USB cable for connecting the camera to this port.

white balancing: Adjusting the camera to compensate for the type of light hitting the photographic subject. Eliminates unwanted color casts produced by some light sources, such as fluorescent office lighting.

xD-Picture Card: A type of memory card used in digital cameras.

Index

• *Numerics* •

24-bit image, 355

• *A* •

about this book
 companion Web site, 353–354
 overview, 3–7
 Photoshop Elements instructions,
 232–234
AC adapters, 74
accessories. *See* camera accessories
Action scene mode, 141
action shots
 adjusting shutter speed for, 124–125
 buying cameras for, 73
 composing, 151–154
 lowering resolution for, 153, 154
active layers, 321
adjustment layers, 250
Adobe Photoshop, 89–90
Adobe Photoshop Elements
 about, 90
 adjustment layers, 250
 applying blur filters, 262–263
 Brightness/Contrast adjustments,
 248–240
 brushes and pencil options, 303–306
 choosing colors in, 299–301
 Clone tool, 289–293
 color balancing, 257–259
 creating Web gallery, 210–211
 cropping images, 244–247
 editing shadows and highlights, 252,
 253–255
 enlarging image canvas, 293–294
 instructions for, 232–234
 Layers palette, 321–322
 Magic Wand tool, 269, 274–276
 Magnetic Lasso tool, 269, 278–279
 midtone adjustments in, 251–253
 opening images in, 234–236
 paint tools in, 297–299
 previewing compression effects,
 222–224
 Rectangular and Elliptical Marquee
 tools, 269, 272, 273, 284
 reducing noise, 263–265
 reverting to saved image, 242
 saturation adjustments, 255–257
 Selection Brush, 269, 280–281, 284
 selection tools, 269–270
 setting print size and output resolution,
 199–200
 sharpening images, 260–262
 sizing images for screen, 215–217
 Smudge tool, 312–314
 special tips for, 5
 stitching panoramas, 155–156
 straightening horizon line, 242–244
 thumbnail previews in, 235
 toolbox and flyout menus for, 270
 undoing and redoing edits, 240–241
 Unsharp Mask, 261
Airbrush tool, 305
aliasing, 355
antishake features, 59
aperture
 defined, 41, 355
 digital cameras and, 43
 f-stops and, 41–42, 123

aperture *(continued)*
 scene modes effect on, 141
 shifting depth of field, 139–140
aperture-priority autoexposure
 defined, 69, 355
 switching between shutter-priority and, 124
 using, 123
archiving images
 prints, 189–190
 reliability of digital media for, 85
 removable media for, 84–86
artifacts, 355
artificial light, 131–132
aspect ratios
 adjusting resolution settings and, 109, 110–111
 cropping to fit, 246–247
 defined, 355
auto shut-off feature, 100
autoexposure. *See* automatic exposure
autofocus feature, 67, 137–138
automatic bracketing, 69
automatic exposure. *See also* aperture-priority autoexposure; shutter-priority autoexposure
 about, 120–121
 defined, 355
 metering modes for, 70, 121–123
automatic flash, 63
auto-rotate feature, 100–101

• B •

backgrounds
 color for, 299–300
 converting to regular layer, 325
 uncluttered, 146
backing up images, 237
backlighting, 134–136
banding, 44

batteries
 about, 74
 conserving, 100
 improving performance with fresh, 154
bit, 44, 355
bit depth, 44
blending mode
 using, 303, 309–310
 varying color with layer, 320
blooming, 53
blur filters, 262–263, 264
blurry images, 138
brightness
 adjusting, 248–250
 defined, 27
 settings for monitor, 100
brushes
 Brush tool, 303–305
 customizing cursor for, 281
 setting options for, 303–304
Brushes palette, 303
burning CDs, 84–85
burst mode
 about, 151–152
 defined, 355
 stopping action with, 153–154
business card with photos, 347
buying cameras. *See also* camera accessories
AC adapters, 74
batteries, 74
choosing flash features, 63–64
choosing SLR or point-and-shoot cameras, 60–62
considering lenses, 64–68
costs of, 20, 21–23, 61
discount store bargains, 70
hardware, software, and accessories, 23
hybrid cameras, 62–63
internal camera computers, 72–73
memory cards, 22, 56–58, 79

no film and processing costs, 21
options for action photography, 73
reading reviews before, 76
self-timer mechanisms, 72
software for image editing, 75
styles and prices, 22
testing feel of camera in hands, 75
tripod mount, 74–75
types of file formats, 53–56
understanding exposure specs, 68–70
USB connections, 75
video-out capabilities, 71–72
buying photo printers, 184–188,
 191–195, 197
byte, 355

• *C* •

cable transfer of images, 162, 166–169
calendars, 346–347
camera accessories, 77–96
 download devices, 81–83
 drawing tablets, 95, 304–305
 image-cataloging software, 91
 image-editing software, 87–90
 jigsaw puzzles, 92–93
 LCD hoods, 94
 media for storing files, 83–86
 memory cards and media, 78–80
 portable storage units, 86–87
 slide-show, special-effects, and painting
 programs, 92
 special adapters and lenses, 93
 tripods, 94
camera cases, 94
camera docks, 82
camera phones, 63
Camera Raw file format
 about, 54, 106–108
 converting, 173–176, 236
 defined, 355

removing noise from Raw files, 175
 saving original of converted files, 176
camera settings, 99–115
 about image file formats, 102
 adjusting ISO settings, 118–120, 158, 334
 Camera Raw, 106–108
 DNG file format, 108
 experimenting with, 114–115
 JPEG file format, 102–106
 resolution adjustments, 108–111
 TIFF file format, 54, 106
 understanding basic, 100–101
 white balance adjustments, 111–114
cameras
 See also buying cameras
 See also camera accessories
 See also camera settings
 See also resolution
 about, 12–13
 accessing images via computer, 170
 basic settings for, 100–101
 cases for, 94
 compatibility with computer
 platforms, 50
 connecting to computer, 167
 converting proprietary camera files,
 176
 costs of, 20, 21–23, 61
 exposure, 40–44
 fixed-focus, 136–137
 JPEG compression for images, 53–54,
 102–106
 lag time of, 20–21
 memory cards, 22, 56–58
 monitors and viewfinders for, 58–60
 names for compression settings, 55–56
 picture quality options, 50
 reading reviews of, 76
 resolution of, 38, 51–52
 reviewing images in, 20, 100, 154

cameras *(continued)*
 scene modes, 140–141
 sending images to TV/DVD player,
 227–228
 studying manual for, 336–337
 styles and prices of, 22
 testing feel of, 75
 transfer utilities, 163, 168–169
 transferring images via cable,
 162, 166–169
Canvas Size dialog box (Photoshop
 Elements), 294
card readers
 downloading images from, 164–166
 using, 57
CCD (charge-coupled device)
 CMOS versus, 53
 defined, 26, 356
CD-R/CD-RW media, 86
CD-ROM drives
 file storage with, 84–85
 using CD-R or CD-RW media, 86
center-weighted metering, 70, 121, 122
chips
 ISO ratings and sensitivity of, 43–44
 noise and CMOS, 53
CIE Lab color model, 47, 356
clipping, 175
clone source, 291
Clone tool, 289–293
cloning, 356
Cloud Dome, 134
CMOS (complementary metal-oxide
 semiconductor)
 CCD versus, 53
 defined, 26, 356
CMYK color model
 defined, 46, 356
 inkjet printers and, 193, 196
collages, 326–327

color
 balancing, 257–259
 blending, 320
 changing with Hue filter, 314–315
 choosing in Photoshop Elements,
 299–301
 file size and image, 35
 how eyes perceive, 27
 saturation adjustments for, 255–257
 selecting image area by, 273–276
color artifacts, 54, 103
color channels. *See also* color models
 adjusting, 252–253
 defined, 27
color correction, 356
Color dialog box (Windows XP), 301–302
color management systems, 204
color models
 CIE Lab, HSB, and HSL, 47
 CMYK, 29, 46, 193, 196, 356
 defined, 356
 RGB, 27–29, 45, 196, 360
 sRGB, 45
color noise, 263
Color Picker (Photoshop Elements),
 300, 301
color temperature, 111–112, 356
Color Variations dialog box (Photoshop
 Elements), 257–259
Colors dialog box (Mac OS X), 301–302
CompactFlash, 356
compositing images, 147–149, 356
composition, 143–158
 avoiding grainy or blotchy photos,
 157–158
 backlighting, 135–136
 capturing action, 151–154
 cropping, 244–247
 effect of digital zooms, 151, 335
 improving with practice, 336
 optical zooms for, 149–150

panoramic images, 154–157

parallax error, 146–147

planning composited images, 147–149

rules of, 144–146, 333–334

shooting from unexpected angles, 144, 145, 333

compression

avoiding overcompression, 333

camera names for settings, 55–56

defined, 356

lossless and lossy, 358

working with JPEG, 53–54, 102–106

computer monitors. *See* displays, computer

computers. *See also* displays, computer; Macintosh computers; Windows computers

accessing images via, 170

camera compatibility with, 50

connecting camera to, 167

internal camera, 72–73

continuous-capture mode, 73

contrast

adjusting, 248–250

reducing, 252

controlling exposure and focus, 117–141

adjusting ISO settings, 118–120, 158, 334

applying exposure compensation, 125–127

autofocus feature, 137–138

automatic exposure feature, 120–121

choosing metering modes, 70, 121–123

flash photography for, 128–136

focusing manually, 139

scene modes, 140–141

shifting depth of field, 139–140

working with fixed-focus cameras, 136–137

convergence, 66

converting

proprietary camera files, 176

Raw files, 173–176, 236

Copy command, 286

copyrighting images, 220

costs. *See* buying cameras

creativity, 295–328. *See also* layers

adding special effects, 327–328, 345–346

brushes and pencil options for, 303–306

building multilayered collage, 326–327

changing colors with Hue filter, 314–315

creating tinted or grayscale photos, 315–317

digital photos and, 14, 17–18

layers and, 317–320

paint tools for, 297–299

painting large areas, 309–312

painting on images, 296–297

red-eye corrections, 306–309

selecting paint colors, 299–303

smudging paint, 312–314

cropping images

fitting aspect ratios, 246–247

resolution and, 51–52

using Elements Crop tool, 244–246

cursors

clone source, 291, 292

customizing brush, 281

Selection Brush, 280

tool, 291

Cut command, 286

● *D* ●

DAM (digital asset management), 83, 91

database illustrations, 16, 347

date and time settings, 100

deleting

layers, 323

selected areas, 289

depth of field

defined, 356

focal length and, 67

optical zoom and, 335

scene modes effect on, 141

depth of field *(continued)*
 shifting, 139–140
 zooming in on subject and, 150
Despeckle filter, 264
digital asset management (DAM), 83, 91
digital cameras. *See* cameras
digital film. *See* memory cards
digital images. *See* images
Digital Negative Format (DNG) file
 format, 108
Digital Photography newsgroup, 351–352
Digital Photography Review, 350
digital print order format (DPOF),
 73, 195, 357
digital video cameras, 62. *See also* video
digital watermarks, 220
digital zoom
 defined, 356
 effect of, 151, 335
 optical versus, 67
displays, computer
 color matching for printer output and,
 203–205
 pixel dimensions for screen use,
 33–34, 36
 resolution and size of image, 213–215
dithering, 302
DNG (Digital Negative Format) file
 format, 108
docking stations, 82
documenting with images, 347–348
Dodge and Burn tools, 250
dots per inch (dpi), 38–39, 193, 356
downloading, 162–172
 about, 57
 from card readers or adapters, 164–166
 defined, 356
 devices for image, 81–83
 methods of, 162
 progressive and nonprogressive, 221
 time required for, 219

 transferring via cable, 162, 166–169
 troubleshooting tips for, 170–172
downsampling pixels, 36, 37, 39, 198
dpi (dots per inch), 38–39, 193, 356
DPOF (digital print order format),
 73, 195, 357
drawing tablets, 95, 304–305
drivers
 defined, 357
 TWAIN, 169–170
DVD players, 227–228
DVDs for file storage, 85
dye-sub printers, 187–188, 190, 357

• E •

edges
 defined, 357
 selecting, 278–279
editing images, 231–294
 adjusting focus, 259–263
 adjusting pasted objects, 287–289
 basic rules for, 237
 brushing on selection outlines,
 280–281, 284
 choosing images by color, 273–276
 color balancing, 257–259
 creating tinted or grayscale photos,
 315–317
 cropping, 244–247
 cutting, copying, and pasting
 selections, 286–287
 deleting selected areas, 289
 drawing freehand selections, 276–277
 edge-detection tools for selections,
 278–279
 editing multilayered images, 323–325
 enlarging image canvas, 293–294
 exposure and contrast, 248–255
 feathering outlines, 272–273

layers and, 317–320

learning software for, 335

making selections in images, 268

opening images, 234–236

performance while, 234

rectangular and oval selections, 271–273

reducing noise, 263–265

refining selection outlines, 283–284

repairing flaws with Clone tool, 289–293

reversing selection outlines, 282–283

reverting to saved image, 242

saturation adjustments, 255–257

saving images, 237–240

selecting all, 281–282

shadows and highlights, 252, 253–255

straightening photos, 242–244

tools for selection, 269–270

undoing edits, 240–241

using Photoshop Elements, 232–234

electronic viewfinders (EVFs), 357. *See also* viewfinders

Elliptical Marquee tool, 269, 271–273, 284

e-mailing images, 211, 224–226

erasing on layers, 324

EV (exposure value)

applying, 125–127

defined, 69, 357

EVFs (electronic viewfinders), 357. *See also* viewfinders

EXIF (exchangeable image format), 96, 100

exposure, 40–44. *See also* controlling exposure and focus

adjusting, 40–41

applying exposure compensation, 125–127

automatic, 70, 120–123, 355

bracketing shots, 69, 131

controlling brightness and contrast, 248–250

locking, 153, 157

shutter- and aperture-priority autoexposure, 69, 123

understanding, 68–70

external flash units, 130

Eyedropper, 300

• F •

fastening points, 278, 279

feathering outlines, 272–273

File Browser (Photoshop Elements), 235–236

file formats. *See also* JPEG file format; Raw file format

converting proprietary camera, 176

converting Raw, 173–176, 236

defined, 357

DNG, 108

EXIF, 96, 100

FlashPix, 357

GIF, 219, 220, 221, 357

saving images in native, 239

TIFF, 54, 106, 205–207

types of, 53–56, 102

files. *See also* file formats

backing up original image, 237

layers and size of, 320

memory card capacity for, 78–79

pixel density and size of, 34–35, 40, 220

Fill Layer dialog box (Photoshop Elements), 311, 312

fill-flash mode, 63, 128

film speed, 43, 118

filters

adding special effects with, 327–328, 345–346

adjusting Brightness/Contrast, 248–250

adjusting midtones with Levels, 251–253

applying blur, 262–263, 264

filters *(continued)*
 avoiding automated, 237
 Hue, 314–315
 special effects, 327–328
 using sharpening, 260–262
firmware, 75
fixed-focus cameras, 67, 136–137
flash
 choosing features of, 63–64
 EV compensation, 357
 external, 130
 slow-sync, 63, 130, 360
 turning off, 129
 types of, 63–64
flash photos
 action shots, 153
 bracketing images, 69, 131
 compensating for backlighting with, 134–136
 diffusing reflection, 133–134
 fill-flash mode, 63, 128
 options for, 128
 shooting shiny objects, 133–134
 spot lights and studio setups, 131–132
FlashPix file format, 357
flattening layers, 323
flipping
 layers, 324–325
 pasted objects, 289
floppy disks, 84
flyout menus for Photoshop Elements, 270
focal length, 64–66
focus. *See also* controlling exposure and focus
 autofocus feature, 67, 137–138
 fixed-focus cameras, 67, 136–137
 focusing lenses, 67–68
 locking, 67, 153
 manual, 139
 pressing shutter button correctly, 334–335

scene modes effect on depth of field, 141
 sharpening images, 259–263
 shifting depth of field, 139–140
foreground color, 299–300
framing scenes, 145
f-stops
 aperture size and, 41–42, 123
 defined, 41, 357

• G •

gamut, 45, 357
Gaussian Blur, 262–263, 357
GIF (Graphics Interchange Format) file format
 avoiding for Web photos, 219, 220
 defined, 357
 interlacing, 221
gigabyte, 358
glossary, 5, 355–361
grainy photos, 43, 157–158
Graphics Interchange Format file format.
 See GIF file format
grayscale photos
 about, 46
 choosing printers for, 193
 creating, 315–317
 defined, 358
 file size of, 35
greeting cards, 346–347

• H •

hardware
 hard drives for storage, 83–84
 needed for digital photography, 23
high-bit images, 44
highlights, 252
histograms, 251, 358
History palette (Photoshop Elements), 241

hot shoes, 64
hot swapping, 166
household records, 16–17
HSB color model, 47, 358
HSL color model, 47, 358
Hue/Saturation dialog box (Photoshop
	Elements), 256, 314–315, 316
hybrid cameras, 62–63
hyperlinks
	images as, 219
	to vendor sites, 5

● *I* ●

icons used in book, 5–6
image size
	calculating maximum print size,
		198–199
	pixel dimensions versus, 30
image-cataloging software, 91
image-editing software, 87–90
	for advanced users, 89–90
	drawing tablets with, 95, 304–305
	for new users, 88–89
	printing images from, 201–202
images. *See also* editing images;
		improving images; on-screen images
	accessing via computer, 170
	adding special effects, 327–328, 345–346
	advantages of digital, 12–19
	bracketing, 69, 131
	camera-assigned names for, 172
	choosing by color, 273–276
	compensating for backlighting, 134–136
	compositing, 147–149, 356
	copyrighting and protecting, 220
	correcting on-board, 72–73
	creativity with, 14, 17–18
	defined, 12
	diffusing flash reflection, 133–134
	documenting with, 347–348

downloading, 162–172
e-mailing, 211, 224–226
enlarging canvas for, 293–294
instant review of, 20, 100, 154
making selections in, 268
memory card capacity for, 78–79
painting on, 296–297
panoramic, 154–157
playing on television, 71–72
progressive and nonprogressive, 221
publishing TIFF, 205–207
quality options for, 50
quality of resized and rotated, 324
recovering erased, 173
repairing flaws in, 289–293
resizing for screen, 215–218, 324
resolution and megapixels, 51–52, 109
reviewing metadata to improve, 96, 336
saving, 237–240
searching for, 100
sharpening, 259–263
shooting no-flash, 129
software for organizing, 177–180
straightening, 242–244
tinted or grayscale, 315–317
tips for using, 339–348
using in multimedia presentations, 212
viewing on TV, 226–228
Web viewing of, 218–220
image-transfer software, 163, 168–169
imaging array, defined, 26
Imaging Resource Web site, 350
improving images, 331–354. *See also*
	composition
	adjusting image output resolution, 332
	editing photos, 335
	effect of digital zooms, 67, 151, 335
	practice for, 336
	pressing shutter button correctly,
		334–335
	printing on good paper, 335–336

improving images *(continued)*
 reducing noise, 263–265, 334
 reviewing metadata for, 96, 336
 special effects for, 346
 studying camera manual, 336–337
 watching effect of compression, 333
inkjet printers
 about, 185–186
 CMYK color model and, 193, 196
 color matching for, 204
 comparison shopping for, 191
 costs of prints, 194–195
inks
 costs of, 187
 life expectancy of prints, 189–190
 lowering costs of inkjet, 194–195
inline graphics, 226
interlacing, 221
ISO
 adjusting settings, 118–120, 158
 chip sensitivity and, 43–44
 combating noise with, 119, 120, 334
 defined, 358
 exposure and, 70

• J •

jaggies, 263, 358
jigsaw puzzles, 92–93
JPEG+Raw file format, 108
JPEG (Joint Photographic Experts
 Group) file format
 about, 53, 54, 221
 camera compression settings for,
 53–54, 102–106
 defined, 358
 effects of compression, 222–224, 333
 EXIF variant of, 96
 lowering compression settings, 158
 saving Web photos in, 219
JPEG 2000, 358

• K •

Kelvin scale, 111, 358
kilobyte, 358
Kodak EasyShare Gallery, 15, 211–212

• L •

lag time for digital cameras, 20–21
Landscape scene mode, 67, 141
laser printers, 186–187
Lasso tool, 269, 276, 277, 284
layers
 active, 321
 adding, deleting, and flattening, 322–323
 adjustment, 250
 building multilayered collage, 326–327
 changing stacking order, 317
 editing on, 237, 317–320
 erasing on, 324
 how they work, 317
 Layers palette, 321–322
 modifying multilayered images, 323–325
 pasting selections on, 287
 saving files with, 322
 varying opacity, 318
Layers palette (Photoshop Elements),
 321–322
LCD (liquid crystal display), 358
LCD monitors. *See* monitors, camera
lenses, 64–68
 about special adapters and, 93
 adapters for SLR, 68
 fixed-focus, 67
 focal lengths, 64–66
 focusing, 67–68
 multiplication factor for, 61
 normal, 65
 optical versus digital zoom, 67
 telephoto, 65
 wide-angle, 65
 zoom, 149–151

Levels dialog boxes (Photoshop Elements), 251–253, 255
light
 artificial, 131–132
 color temperature of, 111–112, 356
 diffusing flash reflection, 133–134
 increasing, 158
 reducing, 135
 transferring into images, 26
light tents, 134
line art, 46
links. *See* hyperlinks
local printing labs, 182–183
locking
 exposure, 153, 157
 focus, 67, 153
lossless and lossy compression, 358
luminance noise, 263

• *M* •

Macintosh computers
 camera compatibility with, 50
 card readers with, 164–165, 166
 Colors dialog box, 302–303
 connecting camera to, 167
 creating screen savers, 341–343
 instructions for, 3
 Open dialog box, 235
 recovering erased images, 173
 Save As dialog, 238, 239
 tips for downloading images, 171
 wallpaper, 344–345
macro mode, 67
Magic Wand tool, 269, 273–276, 284
Magnetic Lasso tool, 269, 277, 278–279, 284
maintenance
 memory cards, 80
 printer, 203
manual exposure, 69

marquee, 358
matrix metering, 70, 121, 122
media
 archival reliability of digital, 85
 removable, 84–86
megabyte, 359
Megapixel.net, 350
megapixels
 defined, 359
 resolution and, 51–52, 109
memory card readers, 81–82
memory cards, 78–80
 about, 78
 built-in versus removable, 56–58
 buying, 22, 56–58, 79
 capacity of, 78–79
 downloading images with card readers, 164–166
 illustrated, 57
 maintenance of, 80
 pixel density and, 35
 portable storage units for, 86–87
 printing from, 58, 82–83, 195
 transferring images from, 162
 using, 56–58
 viewing images on TV from, 228
Memory Stick, 359
metadata
 defined, 359
 reviewing to improve images, 96, 336
 setting date and time, 100
metering modes
 choosing, 121–123
 defined, 359
 experimenting with EV and, 126–127
 selecting for backlit photos, 136
 types of, 70, 121, 122
Microsoft Outlook Express, 225–226
midtones
 adjusting, 252
 defined, 249

monitors, camera
 about, 58–59
 adjusting brightness, 100
 assessing exposure on, 131
 checking images for parallax error,
 146–147
 instant review with, 20, 100, 154
 LCD hoods for, 94
 resolution of, 38
 swiveling, 59–60
moving pasted objects, 288
mugs, 346
multimedia presentations, 212
MultiMediaCard, 359
multiplication factor, 61

• *N* •

nametags with photos, 347
native format, 176, 239
newsgroups
 Digital Photography, 351–352
 printing, 352
Nighttime scene mode, 141
noise
 CMOS chips and, 53
 defined, 359
 ISO settings and, 119, 120, 334
 reducing, 263–265, 334
 removing from Raw files, 175
NTSC (National Television Standards
 Committee) output, 71, 101, 228, 359

• *O* •

on-board image correction, 72–73
online photo gallery, 210–211
online resources, 349–354
 book's companion Web site, 353–354
 Digital Photography newsgroup,
 351–352

Digital Photography Review, 350
Imaging Resource, 350
manufacturer Web sites, 352–353
Megapixel.net, 350
PCPhoto Magazine, 351
PCPhotoREVIEW.com, 351
printing newsgroup, 352
Shutterbug, 351
on-screen images, 209–228. *See also* Web
 images
 creating Web gallery, 210–211
 e-mailing, 211, 224–226
 monitor resolution and size of, 213–215
 photo-sharing sites, 211–212
 preparing for Web sites, 218–220
 previewing JPEG compression effects,
 222–224
 progressive and nonprogressive, 221
 screen savers, 212
 sizing images for screen, 215–218
 slide shows, 92, 213
 using in multimedia presentations, 212
 viewing on TV, 226–228
opacity
 changing paint, 304
 varying layer, 318
optical zoom
 defined, 359
 depth of field and, 335
 digital versus, 67
 using for composition, 149–150
optimizing printer output, 202–203
ordering prints, 182–184
output resolution
 adjusting, 332
 defined, 359
 ppi and, 38–39, 360
 for printing, 31–33
 raising, 39
overexposure, 40

• P •

painting
 adding blending modes to, 309–310
 on images, 296–297
 large areas, 309–312
 out red-eye, 306–309
 selecting colors for, 299–303
 smudging paint, 312–314
 software for, 92
 tools for, 297–299
PAL (phase alteration line-rate), 71, 101, 359
Palette Bin (Photoshop Elements), 232, 233
panoramic images, 154–157
paper stock, 197–198, 335–336
parallax error, 146–147
Paste command, 286
pasting images, 286, 287–289
PC card adapters, 82
PC cards, 82, 359
PCPhoto Magazine, 351
Pencil tool, 305–306
photo albums
 creating, 180, 339–340
 sharing online, 15
Photo Bin (Photoshop Elements), 232, 233
photo organizers, 177–180
photo printers. *See* printers
photography. *See also* composition
 adjusting exposure, 40–41
 advantages of digital, 1
 composition rules, 144–146, 333–334
 creating panoramic images, 155–157
 film and ISO numbers, 43, 118
 history of, 1
 improving with practice, 336
 reviewing metadata to improve, 96
 shooting from unexpected angles, 144, 145, 333
 transferring light to images, 26

photo-sharing Web sites, 211–212
Photoshop, 89–90
Photoshop Elements. *See* Adobe Photoshop Elements
PictBridge technology, 73, 359
pixels. *See also* resolution
 defined, 29, 360
 expanding selection outline by, 284
 file size and, 34–35, 40, 220
 pixel dimensions, 30
 print quality and, 31–33, 36, 39, 109
 resampling, 36–38, 200, 360
 resizing images for screen, 215–217
 resolution and, 29–33, 36, 39, 108–111
 screen images and, 33–34
pixels per inch (ppi), 38–39, 360
platforms, 360. *See also* computers; Macintosh computers; Windows computers
plug-ins, 360
pointillism, 29
Polygonal Lasso tool, 269, 276, 277, 284
Portrait scene mode, 67, 140, 141
posterization, 44
PostScript-compatible printers, 195
ppi (pixels per inch), 38–39, 360
presentations, 16–17, 212
printer cables, 203
printers. *See also* inkjet printers; printing; prints
 buying photo, 184–188, 191–195, 197
 choosing paper for, 197–198, 335–336
 CMYK color model and, 196
 color matching, 203–205
 comparing, 192–195
 dye-sub, 187–188, 190
 inkjet, 185–186
 laser, 186–187
 maintenance for, 203
 optimizing output from, 202–203
 PostScript-compatible, 195

printers *(continued)*
 printing from memory card, 58, 82–83, 195
 resolution of, 38–39
 selecting, 191–195, 197
 Thermo-Autochrome, 188
printing
 images from image-editing software, 201–202
 from memory card, 58, 82–83, 195
 only good images, 19
 output resolution for, 31–33
prints
 calculating size for, 198–200
 costs of inkjet, 194–195
 displaying favorite, 348
 life expectancy of, 189–190
 ordering, 182–184
 pixel dimensions versus size of, 30
 protecting, 190
 resolution of, 31–33, 36, 39, 109
programmed autoexposure, 120–121
progressive and nonprogressive images, 221
proprietary camera file formats, 176, 239
protecting prints, 190

• *Q* •

quality
 options for picture, 50
 pixels and print resolution, 31–33, 36, 39, 109
 resized and rotated images, 324
 troubleshooting print, 202–203

• *R* •

RAM requirements, 234
Raw converter, 54, 107, 360

Raw file format
 about, 54, 106–108
 converting, 173–176, 236
 defined, 355
 removing noise from Raw files, 175
 saving original of converted files, 176
recording images on videotape, 228
recovering erased images, 173
Rectangular Marquee tool, 269, 271–273, 284
red-eye reduction
 automated, 63, 129
 paint techniques for, 306–309
redoing edits, 241
reducing
 light on objects, 135
 noise, 263–265, 334
refining selection outlines, 283–284
reflections, 133–134
removable memory cards, 56–58
repairing images, 289–293
resampling pixels, 36–38, 200, 360
resizing
 image quality and, 324
 images in pixels, 215–217
 in inches, 217–218
 pasted objects, 289
resolution, 29–40. *See also* output resolution
 about pixels, 29–31, 108–111
 adjusting image output, 332
 avoiding pixelated images, 158
 defined, 360
 lowering for action shots, 153, 154
 megapixels and, 51–52, 109
 memory card capacities and, 78–79
 overview of, 39–40
 pixels and print quality, 31–33, 36, 39, 109
 types of, 38–39

restocking fees, 76, 197
reversing selection outlines, 282–283
reverting to saved image, 242
reviewing
 images in camera, 20, 100, 154
 metadata to improve images, 96, 336
RGB color model
 about, 27–29, 45, 196
 defined, 360
rotating
 layers, 324–325
 pasted objects, 288
rule of thirds, 145

• S •

Save As dialog, 238, 239
saving
 files with layers, 322
 grayscale images, 317
 images, 237–240
 native format files, 239
 original Raw files, 176
 Web photos in JPEG, 219
scanners, 19–20
scene modes, 70, 140–141
screen savers
 about, 212
 creating, 340–343
SD Card, 360
searching for images using metadata, 100
SECAM, 101
Selection Brush, 269, 280–281, 284
selection outlines, 268
selections, 268–279
 brushing on outline for, 280–281, 284
 choosing images by color, 273–276
 cutting, copying, and pasting, 286–287
 deleting, 289
 drawing freehand, 276–277
 edge-detection tools for, 278–279

editing in multilayered images, 323–324
 making in images, 268
 rectangular and oval areas, 271–273
 refining outline of, 283–284
 reversing outlines of, 282–283
 selecting all, 281–282
 tools for, 269–270
selective editing, 237
self-timer mechanisms, 72, 138
sepia-toned photos, 315–317
Seurat, Georges, 29
shadows, 252, 253–255
sharing photos, 15
sharpening, 114, 259–263, 360
shooting from unexpected angles,
 144, 145, 333
shutter
 defined, 360
 lag time, 20–21
shutter button
 illustrated, 41
 pressing correctly, 334–335
shutter speed
 about, 42–43
 adjusting for action shots, 124–125
 defined, 41, 360
 scene modes effect on, 141
Shutterbug, 351
shutter-priority autoexposure
 composing action shots using, 153–154
 defined, 69, 123, 360
 switching between aperture-priority
 and, 124
single lens reflex cameras. See SLR
 cameras
slave flashes, 64, 130
slide shows, 92, 213
slow-sync flash, 63, 130, 360
SLR (single lens reflex) cameras
 about, 60–62
 lens adapters for, 68

SmartMedia, 361
smudging paint, 312–314
Snapfish, 211–212
snapshot printers, 192. *See also* printers
software. *See also* Adobe Photoshop
 Elements
 digital jigsaw puzzles, 92–93
 image-cataloging, 91
 image-editing, 75, 87–90
 image-transfer, 163, 168–169
 learning to use photo editors, 335
 photo organizers, 177–180
 printing images from photo-editing or
 cataloging, 201–202
 RAM and performance of image-editing,
 234
 slide-show, special-effects, and painting
 programs, 92
 TWAIN-compliant, 170, 361
sound effects for cameras, 101
special effects
 adding, 327–328, 345–346
 programs for, 92
Sponge tool (Photoshop Elements), 257
spot metering, 70, 121, 122
sRGB color model, 45
stacking order of layers, 317
straightening horizon line, 242–244
studio setups, 132
studying camera manual, 336–337
subjects, photographing, 146
super floppy disks, 84
swiveling monitors, 59–60
system requirements for cameras, 50

• T •

Tagged Image File Format. *See* TIFF file
 format
telephoto lenses, 65
television. *See* TV
thumbnails, 235

TIFF (Tagged Image File Format)
 about, 54, 106
 defined, 361
 preparing TIFF photos for publication,
 205–207
time-lapse photography features, 72
tinted images, 315–317
toolbox for Photoshop Elements, 270
tripods
 avoiding blurry images, 138
 camera mount for, 74–75
 using, 94
troubleshooting
 downloading images, 170–172
 print quality, 202–203
turning off
 flash, 129
 instant review feature, 154
TV
 formats for, 101
 playing camera images on, 71
 viewing images on, 226–228
TWAIN drivers, 169–170, 361

• U •

underexposure, 40
undoing edits, 240–241
units of measure
 resizing images in inches, 217–218
 resizing images in pixels, 215–217
unsharp mask, 261, 361
uploading, 361
upsampling pixels, 36–37, 198
USB (Universal Serial Bus)
 checking for enabled ports, 172
 connections with, 81
 defined, 361
 plugs and ports, 167, 168
 purchasing cameras with USB
 connections, 75

• V •

video
 cameras with video-out capabilities, 71–72
 digital video cameras, 62
 formats for, 101
 recording images on, 228
viewfinders
 advantages of, 60
 defined, 357
 as optional feature, 58–59
viewing metadata, 96

• W •

wallpaper, 213, 343–345
Web images
 avoiding GIF file format, 219, 220
 copyrighting and protecting, 220
 creating photo gallery, 210–211
 preparing, 218–220
Web sites
 book's companion, 353–354
 Digital Photography Review, 350
 Imaging Resource, 350
 links to vendor, 5
 manufacturer, 352–353
 Megapixel.net, 350
 ordering prints online, 182–183
 PCPhoto Magazine, 351
 PCPhotoREVIEW.com, 351
 photo-sharing, 211–212
 preparing images for, 218–220

 sharing photo albums, 339–340
 Shutterbug, 351
Webcams, 62
white balance
 adjusting settings for, 112–114
 artificial lighting and, 132
 defined, 112, 361
 using, 68
wide-angle lenses, 65, 66
Windows computers
 camera compatibility with, 50
 connecting camera to, 167
 creating screen savers, 340–341, 343
 Open dialog box, 235
 recovering erased images, 173
 Save As dialog, 238, 239
 tips for downloading images, 171–172
 using card readers with, 164, 166
 using Color dialog box, 301–302
 wallpaper, 343–344
wireless transfer of images, 162–163
wizards, 88

• X •

xD-Picture Card, 361

• Z •

zoom images
 effect of digital zoom, 151, 335
 optical versus digital zooms, 67
 using optical zooms, 149–150